Dedalus Original Fi

THEO]

C000006296

Christopher Harris was born ir
ing art, he had a vast array of different jobs before returning to
university to take a degree in biology and teach science. He
now lives in Birmingham, with his wife, a university lecturer,
and writes full-time.

Theodore is his first novel.

Christopher Harris

Theodore

Dedalus

Eastern Arts
Board **Funded**

Published in the UK by Dedalus Ltd, Langford Lodge, St Judith's Lane, Sawtry, Cambs, PE17 5XE

ISBN 1 873982 49 6

Dedalus is distributed in the United States by Subterranean Company, P.O. Box 160, 265 South Fifth Street, Monroe, Oregon 97456

Dedalus is distributed in Australia & New Zealand by Peribo Pty Ltd, 58 Beaumont Road, Mount Kuring-gai, N.S.W. 2080

Dedalus is distributed in Canada by Marginal Distribution, Unit 102, 277 George Street North, Peterborough, Ontario, KJ9 3G9

Dedalus is distributed in Italy by Apeiron Editoria & Distribuzione. Località Pantano, 00060 Sant'Oreste (Roma)

Typeset by RefineCatch Limited, Bungay, Suffolk
Printed in Finland by Wsoy

In memory of Jonathan Inglis, 1951–1997

CONTENTS

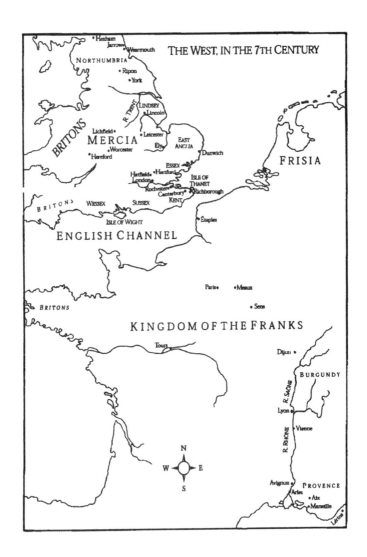

THE WEST, IN THE 7TH CENTURY

• Hexham
Jarrow
Wearmouth

NORTHUMBRIA

• Ripon
• York

R. TRENT
LINDSEY
• Lincoln

BRITONS

Lichfield •
MERCIA
• Leicester
• Worcester
EAST ANGLIA
• Hereford

Ely •
ESSEX
Hatfield • • Hartford
London
Rochester
Canterbury •
Richborough
KENT
• Dunwich

FRISIA

ISLE OF THANET

BRITONS
WESSEX
SUSSEX
ISLE OF WIGHT

Étaples

ENGLISH CHANNEL

Paris •
• Meaux

• Sens

BRITONS

KINGDOM OF THE FRANKS

Tours
Dijon •

BURGUNDY

R. SAÔNE

Lyon •
• Vienne

R. RHÔNE

N
W — E
S

Avignon •
PROVENCE
Arles
• Aix
• Marseille

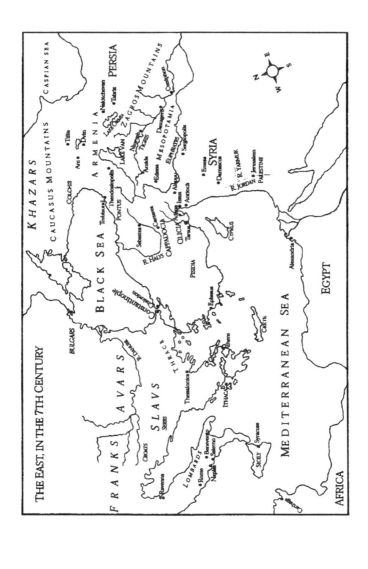

TRANSLATOR'S NOTE

Theodore's manuscript was found where one would expect to find it, in Canterbury. The precise circumstances of its discovery, if that is the right word, cannot be gone into here, even though my inability to produce the original for inspection has led some to doubt its authenticity. How, it has been asked, could such an important document, which throws much needed light on one of England's obscurest periods, have lain unnoticed for over a thousand years? The answer, I think, is that it was not overlooked, but suppressed, some time in the last three hundred years.

There are several possible reasons for this. Theodore was a Byzantine Greek, whose achievements, if acknowledged, might seem to undermine the supposedly home grown nature of the English Church. He was also born a heretic, and never entirely shook off his Dualist world view. But it seems most likely that those who suppressed the manuscript found it difficult to accept that the real founder of the Church in England was a homosexual. Theodore, as he makes clear, had a long, though intermittent, relationship with his fellow monk and pupil Hadrian. That friendship brought Theodore to England, and gave him strength to overcome the difficulties he faced in his unlooked-for vocation.

Let me set out my reasons for believing that Theodore's manuscript is authentic. It is a square, fat codex written in Greek, in the right sort of ink, on parchment appropriate to the late 7th century, with heavily damaged covers that obviously date from several centuries later. The script is not the decorative uncials of bibles and hagiographies, but a tiny minuscule, of the sort used by clerks and tradesmen. This, though apparently an anachronism, is a point in its favour. A faker,

who might have preferred Latin, would surely have used the familiar and decorative script of religious and literary works, and could hardly have resisted adding some of the elaborate decorations for which English scriptoria were famous. Theodore tells us that he worked as a clerk, had no skill as an illustrator, and disliked the scriptorium. He also disliked the exaggerated, pseudo-classical literary style of his time, preferring the everyday Greek of anecdote and conversation, of which there are few other examples from this period. Some passages of the book are written in Old English, and Hadrian's postscript is in Latin, with a strong North African flavour, much like the Latin of St Augustine of Hippo. This mixture of languages and styles would defeat the most dextrous of fakers, and I myself had to seek help with the Anglo-Saxon passages. Only the fact that my collaborator has begged for anonymity prevents me from thanking her now.

If we accept the manuscript itself as genuine, can we rely on Theodore's account of his own life? That question could be asked of any autobiography or memoir, and is especially pertinent where few corroborative materials are available. What Theodore tells us about his appointment and subsequent career as Archbishop of Canterbury is confirmed by, though it could equally be derived from, Bede. But Bede tells us nothing of Theodore's early life, beyond the place and year of his birth. Theodore lived for a long time, travelled widely, and claimed a part, though an unobtrusive one, in many important events. Unfortunately, he lived at a time of which we know very little, in places since devastated by war and disaster. There are no Byzantine sources for his life, and the history of his times is sketchy, often derived from non-Greek materials. The epic poems of George the Pisidian, still extant, though not much admired, do not mention the secretary who helped compose them. A few details of Theodore's life are given by Anglo-Saxon historians or chroniclers, but they add little to what is told by Bede, and may, in any case, be wrong. If some medieval hagiographer wrote a *Life of Saint Theodore*, it has not survived, leaving its subject in deeper obscurity than his predecessor St Augustine of Canterbury, or his rival St Wilfrid.

Is it likely, one might ask, that Theodore was as ubiquitous and resourceful as he claims, and yet was unknown until chosen by the Pope as Archbishop? I think it is. It seems to me entirely plausible that Theodore lived and worked in the manner he describes, respected by his superiors, but prevented by his personality from achieving prominence in a society that valued conformity and orthodoxy. Even Bede admits that Theodore was not the first choice for the job at which he later excelled. We may doubt some of the details of what Theodore tells us, and it may be that, like some other writers, he exaggerated his own importance. But there is no need to reject the whole of his story because some of it is unsupported by firm evidence.

In fact, some evidence does survive. There is, for example, Bede's reference to a *Life and Sufferings of St Anastasius*, a Persian who was martyred after he converted from Zoroastrianism. Theodore knew the cult of Anastasius in Syria, carried the saint's bones to Italy, and may have taken the *Life* to England. However, in view of what Bede says of the *Life's* imperfect style, we cannot attribute its authorship to Theodore.

Theodore also tells us that, while resident at the monastery of Saint Anastasius, near Naples, he wrote a book advocating (wrongly, as we now know) the authenticity of the writings of pseudo-Dionysius the Areopagite. This book was lost when Theodore left the monastery for Rome, and no copy of it is extant. But the great 9th century bibliophile Photios, in his famous library list, describes a pamphlet asserting the genuineness of pseudo-Dionysius by a writer, otherwise unknown, called Theodore. This, I think, is conclusive proof that Theodore's account of his early life can be accepted as reliable.

Christopher Harris
1999

1

CANTERBURY

A.D. 680

"Theodore?"

It was Hadrian. He left the door open as he stepped in, allowing bright light from the courtyard to flood into the room. I sat up and rubbed my eyes.

"Are you awake?" he asked. Hadrian's words, or perhaps the tone with which he said them, reminded me of the time we first shared a bed, nearly thirty years earlier, on the pretext, not entirely false, of studying Plato's *Symposium*.

"Of course I am awake," I said. "I may be old, but I don't sleep all day. I was thinking."

"In the dark? With your eyes closed?" He stood just inside the doorway.

"I find it helps."

I got up from my bed and took a few careful steps towards him. Beyond the doorway I could see cracked paving, mottled with dry moss and lichen. The afternoon sun cast strong shadows among the pillars that edged the empty courtyard. Elsewhere, in cool rooms, lessons were being taught, and books read or copied. Perhaps some of the monks, like me, slept quietly between prayers. But they would wake, and their work would be done. There was no need for harsh discipline or self-mortification. There was barbarism enough outside. The monastery was a small, enclosed space, that Hadrian had made civilised, giving us a refuge from which he could spread learning and I could govern the Church. It had been our home for fifteen years. Sometimes, in the still heat of summer, when the stones feel warm even at night, it is possible to imagine oneself back in the South. But only in the summer. In the winter, when the moss is green and the stones are slippery and wet, I know that I have come to the world's misty northern edge.

I should have some rosemary, lavender and thyme planted. Even in winter, their scent would remind me of the Mediterranean.

"I am sorry to disturb you," Hadrian said. He knew very well that I had been asleep. "But I have just heard. Wilfrid is back."

The expression on his dark face, lit from behind, was impossible to make out.

"In Canterbury?" I asked. It was not good news.

"No. He has landed at Rochester."

"That's close enough."

"He wouldn't dare come here," Hadrian said. "He knows he lied about you."

"He probably believes every word he said. Liars usually do."

"Even he couldn't believe that it was your idea to send Dagobert back to France."

"Did he say that?"

"He swore it on the holiest of his relics."

"His retinue must look like a funeral procession with all the saints' bones he collected in Rome."

"Whether it was with bones or oaths, he must have impressed the Franks." Hadrian paused for a moment, then took my arm and helped me into a chair.

"The Franks let him go," he said. "They wouldn't let me go."

"It was a long time ago. Can you not forget?"

"No."

"I didn't like leaving you," I said.

"But you did."

"I had no choice. And I spent most of that winter worrying about you."

"Did you really worry about me?" He drew up a stool and sat beside me.

"Of course," I said, taking his hand. "Nothing I have ever done has caused me more pain than leaving you behind in France. I knew you were ill, but not how to cure you. Despite my reputation, my medical knowledge is limited. I don't know how to cure a man overcome by melancholy."

16

"You once told me that you cured the Emperor's melancholy."

I had forgotten I had told him that.

"I was lucky," I said. "His melancholy had a cause, which I correctly guessed. But I did not know the cause of your melancholy."

"Cause? Must everything have a cause?"

"Of course it must."

"A cause that you can see?"

"Not see, perhaps, but infer."

"Then what do you infer about my illness?"

I was surprised by his question. Hadrian had never been keen to discuss his illness and the changes it had made in him. I thought for a moment before answering.

"I infer that it was caused by some shame or failure. As soon as you came to Rome, I saw that you had changed. But I didn't know what was wrong. I should have asked you then, not left it until it was too late. By proposing me as Archbishop, you made sure I had no time to think about anything else. And then there were our difficulties in France. You were quite ill when we reached Sens. You were almost raving."

"It was a fever," he said firmly.

"It was more than that. You said we were being punished for what we had done."

"Did I say that? Surely not."

"You did. And when I rode on to Paris without you I felt doubly guilty."

"It wasn't your fault." Hadrian let go of my hand.

"Then what changed you?"

He stood, and walked over to the window, then slipped the wooden peg from its slot, opened the shutter and looked out. From the chapel, I could hear inexpert chant. Hadrian waited for a while, thinking or listening, before returning and giving me an answer.

"It was when they made me Abbot, I suppose."

"Were you unwilling?"

"No. It was an honour. At the time I thought it was entirely

17

deserved. But not everyone agreed. There was a party that thought me too young."

"Was that all?"

"Perhaps they disapproved of our friendship."

"Did they say so?"

"It was not what they said, but what they did." He cupped his face in his hands. For a moment I thought he was going to cry, but he rubbed his forehead, gently pressing with the tips of his fingers, then lowered his hands and looked at me calmly. His face, once as smooth and brown as a nut, had sagged and wrinkled like a bletted medlar. His hair was grey. But his dark eyes were still bright with the intelligence that had impressed me when we first met. That, at least, had not changed. He drew breath, but before he could speak, the doorway darkened and he turned to see who was there.

"Archbishop?" It was Titillus, my secretary. "And Father Abbot," he said, seeing Hadrian. "Are you busy?"

"Is it important?"

"I have just heard that Wilfrid is back."

"I know. Hadrian has just told me."

"I am sorry. But I thought you ought to know. He has been spreading more lies about you."

"Hadrian has told me."

"But it's so unfair," he said, hesitating in the doorway. His yellow hair stood like corn-stubble round his tonsure. "I saw the results of his lies in Rome," he said. "Everyone there believes him humble, innocent and virtuous. They think you are capricious and corrupt. Now he will spread the same lies in England."

"He is better known here. He will not be believed so quickly."

I turned back to Hadrian, but his expression had changed. I could see that he would reveal nothing more. Titillus was still waiting uncertainly. I thought his trip to Rome had cured him of his youthful awkwardness.

"Sir?" he said.

"Yes?"

"Why should Wilfrid be allowed to get away with his wickedness?" His face was flushed and indignant.

"Titillus, I am touched by your concern, but remember, you are only a clerk. You should not speak ill of a bishop."

"I am sorry, Sir. If I have done wrong, then you must give me a penance. But I was only speaking the truth. I saw how Wilfrid behaved in Rome. Thanks to him there is a judgement against you in the Papal archives, and all France and Italy believe you to be a liar and a schemer. He is sure to make more trouble now."

"I don't think it is quite as bad as that," I said, though it probably was. Hadrian had picked up a wax tablet from the table, and was reading some notes I had scribbled on it.

"Archbishop?" Titillus tentatively took a couple of steps into the room.

"Yes?"

"You must tell your side of the story."

"I already have. I wrote to His Holiness, but he didn't believe me."

"You must tell how you advanced Wilfrid, and how he betrayed you. You must tell of all your deeds as Archbishop. Then everyone will be able to judge between you and him."

"It might be more dignified to stay silent."

"But you have often talked of your life." Titillus stepped forward again and gripped his tunic with both hands, steadying himself before continuing. "You have seen such a lot. Now that I have seen Rome, I know that there are more wonders there than you told me of. You have spoken of the East, and of Constantinople and Antioch. They must be full of wonders too."

"If you want a tale full of wonders, listen to your English bards."

"Pagan wonders perhaps, but they mostly sing of battles."

"I have seen battles, as well as what you call wonders."

"I know. I have heard you talk of the war against the Persians."

"That was a long time ago."

Titillus paused, aware, perhaps, that he had said more than

he intended. Then he gripped his tunic again and said: "You must write it in a book. The story of your life."

"Who writes his own life?"

"Saint Augustine did," said Hadrian, looking up from the tablet, which he had absent-mindedly rubbed smooth. He knew how much I disliked the *Confessions*.

"Most men wait until they are dead, then let others write their lives. If they are worthy."

"But Sir," said Titillus "The lives of saints are written by men who knew them. Who can know the whole of your life when you are dead?"

"I am no saint. I am far from perfect. And I am very tired. I think I would like to be left alone."

Titillus looked disappointed, but he left, stumbling clumsily over the uneven paving as he tried to walk respectfully backwards. Hadrian led me to the bed.

"Shall I stay?" he asked.

"No. I will rest."

I lay on the bed, not sleeping, but brooding.

Though Titillus sometimes seemed awkward, he was no fool. In his clumsy way he had planted a powerful idea in my mind. However, knowing little of literature, he did not know how novel it was. Few men have written of their own lives, and those who have, have had some ulterior purpose. Caesar wrote to justify his actions, but revealed little of his character. Was that what Titillus expected me to do? Saint Augustine wrote to glorify himself, not God. His *Confessions* are boasts. Those who catalogue their sins in public wish the world to know that they have virtue to spare.

A long time ago in Constantinople, while staying in the house of a rich man, I saw myself in a mirror for the first time. Of course, I had seen my reflection before, but distorted in the rippled water of the washing bowl. When I held up that disc of polished silver I saw myself clearly, as others did. I met my own gaze, as only lovers do. I looked, curiously, wondering what my reflection revealed. But it revealed nothing. In a way, I was as much a stranger to myself as anyone else seen for the first time.

Yet Titillus was right. No one is better qualified to describe my thoughts and actions than I am, and if others are better qualified to describe the times I have lived through, none has done so. But is my life worth remembering? If I have brought orthodoxy and learning to England, the English will be orthodox and learned after my death, whether they remember me or not. But Wilfrid claims the credit for what I have done, and he will make sure he is remembered. He will make himself seem better than me.

Before the Pope sent me here to govern the English Church, I wandered, driven by events, distracted by books, deceived by ideas, shamed by inopportune lusts. It is not much to boast of. If my life is of any interest, it is for what I have seen, not for what I have done.

I lay uneasily, wavering between pride and modesty. If I told my story, it would have to be done without boasting or complaining. The facts might inform, if I told them plainly. I might even set an example, by avoiding the archaisms, extravagant metaphors, forced similes and irrelevant allusions to Homer that disfigure so many of the writings of this decayed age.

By the time I rose for Vespers, I knew that I would do it. I would write the story of my life.

2

TARSUS

A.D. 602–618

I was born in 602, though dates were not reckoned that way then. I learned to count years from the Incarnation of Our Lord from a monk in Rome, a Persian, of all things, who claimed to have invented the system. It seems better, to me, than counting from the Creation, or the Flood, or the foundation of Rome, or the accession of some emperor or other.

My own incarnation cannot have been a cause of rejoicing for my parents, whose heresy taught them that to propagate the human race is to propagate evil. Yes, my parents were heretics. I cannot tell my story without revealing that. They were Dualists, members of an eastern sect hated and persecuted by Christians. They died for their beliefs, leaving me to be claimed by the Church. Had they known what I would become, they would have been appalled. But I have not forgotten them, or what they believed. Perhaps there is still something of the heretic in me. If so, it is not an aspect of myself that I treasure. It is a flaw in my character, a disability. It nags at me, like the ghostly pain of a missing limb, reminding me what I once was, and might have been. It is a shifting, shapeless doubt, which undermines faith and prevents commitment. Yet, despite my doubts, and my origins, I have become an upholder of orthodoxy.

My earliest memories are of fire and flour. I played among great jars of flour that were filled and emptied several times a day. Everything was covered in flour, though my father always fussed about it. He said that if it was left to build up we would soon be invaded by vermin. I liked to help with the sweeping, but only so I could beat the floor and raise great clouds of flour, which covered me as well as everything else. I was usu-

ally beaten for that, and tried to hide in the empty jars, or climb into the kneading troughs. I liked to poke fingers into the salt pots, empty the water jars, or rearrange the piles of wood that stood ready to fire the oven. The most interesting jar was that containing the leaven, a lump of fermented dough, kept ready to start the next batch. It seemed to grow as I watched, and gave off a peculiar sour smell. I was fascinated by the mites and weevils that thrived in odd corners despite our sweeping. Their colonies seemed like miniature worlds, reflecting the one I could see beyond the counter at the front of the long, narrow shop. Whenever the oven was opened, its red mouth drew my attention, and I stopped to stare into it. The patterns of the flames also suggested another world, amorphous and changing, into which the door led.

My father's shop, which he shared with my uncle, was in a row with all the other bakers. Each had a speciality: round loaves, raised loaves, barley bread, rye bread, poppy seed rolls, cakes or sweet pastries. Some made flat breads flavoured with olives, cheese, onion or garlic. These were bought to be eaten in the street as snacks. The street was always busy. Everyone eats bread, rich or poor, and they need it at all times of the day. Every community has a place where gossip and rumour are exchanged. In the country it is the village well, but in Tarsus it was the street of the bakers. When I was bored, or had been beaten too often, I liked to explore the other shops. There, the pots and jars contained different, more interesting ingredients. I particularly liked the cake and pastry shops, whose pots contained honey, nuts, dried fruit and spices. I could often cadge samples, and wandered about eating handfuls of almonds or raisins. Beyond the bakers were the makers of sweetmeats, full of much imagined treats, but I was never allowed in their shops.

At the back of the shops was a yard where the milling was done, and donkeys trudged in circles all day, turning quern-stones. They must have been docile to do the work, but they seemed huge and savage beasts to me, always threatening to lash out with sharp hooves or teeth. The slaves who drove the donkeys seemed equally fearsome, and sometimes did lash out,

if I got in the way. The mill was operated by the bakers' guild, which also owned the shops. Each baker paid dues, which covered the rent of the shop as well as guild membership. The guild supervised training, deciding who could be allowed to take on apprentices, as well as regulating prices and standards.

My father specialised in the white breads bought by the better off. He made raised Cappadocian bread and soft, fluffy rolls, using the finest flour. I watched him sieving the flour through sheets of linen, adding salt from the pot, then mixing in oil and leaven. Only the best flour, well kneaded, made a dough elastic enough to rise well, and each baker kept his own stock of yeast, which he thought better than any other. If I had wandered away, I always returned in time to see the loaves taken out of the oven, and breathe in the rich, almost suffocating smell. Sometimes I was allowed to stand at the counter, handing bread to the customers already waiting in the street. I liked to feel the coins, warm from their hands, and hear the sound as they clinked into the jar under the counter.

The customers were fussy about the type and texture of their bread, and in that they were supported by the old philosophers. Bread, like all food, is made of the elements, and affects our humours. Phlegmatic types should stick to crusty bread, leaving the crumb for the choleric. A good baker must know his customers, and have ready loaves that are well done, or not, as required. Of course, only the rich can afford this choice, the poor have to eat ryebread, and be glad of it, whatever the state of their health.

I do not know what our sect was called. There are many such heretical groups in the East. Some consider themselves to be Christians, others do not. They are called by many names, mostly uncomplimentary. Among ourselves we were the Good People, or just the People.

Many years later I met a Persian priest, and learned from him something of the philosophy of Dualism. It is a religion more dramatic, and dangerous, than Christianity, in which the universe is thought to be a battleground between the forces of Good and Evil. Its followers believe that, when the world was

made, some particles of goodness, in the form of light, were trapped in evil matter. The goal of the devout Dualist is to reduce the quantity of evil in the world, and free the light from its material prison. This is achieved by, as far as possible, abstaining from all carnal pleasures.

As a child I was unaware of this cosmic struggle, which, in our everyday lives, was manifested in a complex set of rules concerning cleanliness. The outward signs of our heresy were an absence of crosses or other Christian signs in our houses, and a refusal to attend church. Though these signs must have been noted by our neighbours, I do not remember any trouble at first, only some name-calling from other children.

My parents attended meetings in the houses of those they called the Elect. They were the members of the sect who had achieved perfection by renouncing everything material. Children were not taken to these meetings, but from what I managed to overhear, it seemed that worship took the form of doing housework. The Elect ate no meat, but lived on fruit and vegetables, which they could neither pick nor cook. They could not touch dirt, though their houses had to be kept clean. My parents were always preparing food, making up baskets of fruit, or rushing out with bundles of cleaning equipment. Our house, like the shop, was also kept very clean, and it puzzled me that when we were called names, the names suggested dirt or squalor. I knew that we were not dirty, and the injustice hurt me. I wanted to shout back that we were cleaner than they were, but I was forbidden to answer.

I first noticed that things were going wrong when unsold loaves began to build up at the end of the day. Our customers would not buy stale bread, so these loaves were sold to a shop that specialised in spoiled food for the poor. My father and uncle grumbled, reduced the number of batches they baked, then cut the order of flour from the guild's millers. Guild officers soon visited the shop, and I watched from behind the flour jars while they questioned my father and uncle. They seemed to say that we were growing careless, and baking inferior bread. They hinted that customers had complained of contamination. If we did not improve the bread and stop the

complaints, we would lose guild membership as well as trade. After the officers left, my father and uncle exchanged a few sharp words, but there was nothing they could do, and the decline in trade continued. Then we started to find dead rats in the flour. My father wanted to complain to the millers, but my uncle stopped him. The guild officers would soon hear about it, and their suspicions would be confirmed. We had never been troubled by rats before, but, just in case, we swept even more often. The rats continued to appear, and were clearly being put into the jars by someone.

One morning we heard loud shouting, and banging on the shutters. My uncle opened them, expecting early customers, but was driven back by stones and rubbish thrown by a crowd. They were calling us 'dirty heretics', and saying that we put blood in the bread, to poison good Christians. I suppose they meant menstrual blood, that is the usual accusation, though sometimes heretics are accused of contaminating food with the blood of sacrificed babies. I did not understand much except their anger, but afterwards my father explained that they were customers who thought the bread was dirty. But they were not our usual customers, or their servants, and I knew that there was nothing bad in the bread. I had watched it being made. When we cleaned up the shop, we found dead rats among the rubbish the crowd had thrown. After that, hardly anyone bought our bread. The few who did were jeered at by the crowd, and did not come back. There was soon no point in baking, and the flour order was stopped altogether. The guild officers were soon back, and said that if we did not restore our order we would lose our membership, and be closed down. My uncle attempted to argue, but my father seemed already defeated. There was nothing to be done, so we relinquished the shop and went home.

For a few weeks, we waited, growing hungrier as food and money ran out. We did not go out much. My parents no longer attended the Elect, though they anxiously washed and cleaned everything in our house. Outside, the streets were dominated by two gangs, the Greens and the Blues. People

said that the gangs were a new thing, and that they had appeared in Tarsus at the same time as the rats. If so, that was appropriate, as both rats and gangs were signs of decay, and symptoms of the Empire's collapse. Everyone was afraid of the gangsters. They could be seen in the squares and markets, or outside the churches, lounging and strolling, insolently displaying their power. Both gangs adopted a similar style of dress, which was quasi-barbaric, supposedly borrowed from the Persians or Avars. Few, if any, of those street-corner toughs can have seen an Avar, though they were soon to meet the Persians, but they invented freely. They grew their hair long and tied it in knots, cut it short to make it stand on end, or shaved it into crests and tufts. Those who could grew long beards, which they curled or plaited. Their clothes were the opposite of those worn by the ordinary citizen: tight where they should have been loose, loose where they should have been tight, elaborately tucked, puffed, slashed and billowed. They pierced their ears and noses with rings and pins. Those who dared led large dogs on chains. Despite the strict law against civilians carrying weapons, all were armed.

They came for us at night, though there was no need. They would have found us there at any time. I had feared it. At six I was old enough to see that we were in danger, and who from. But my parents must have anticipated every detail: the smashing of the door, the swaggering entry of the Blues, the sneering accusations, the disappointed eyeing up of meagre possessions, the hanging back of neighbours' sons, newly and self-consciously barbarised. They must have rehearsed it all in their minds, and in their dreams.

We all hope we will face danger bravely and fear that we will not, and in the event my family behaved with dignity. They did not allow themselves to be provoked. They knew, more than their attackers, the degree of their poverty. Perhaps they were fortified by their religion. The wickedness of the world was being amply demonstrated.

The door was kicked open by a large man with his hair shaved except for a spiky crest. He called over his shoulder:

"They're here."

27

More men followed him, pushing into the small room until it was almost full. I could smell the drink on their breath. They were dressed in the barbarian style, their bright clothes fastened with stolen jewellery. They waved curved Avar-style daggers. Two priests were with them, dully dressed and quiet. The crested man turned to the priests and said:

"Here they are, the filthy devil-worshippers."

"We are not devil-worshippers," my father said.

"You shut up!" said the crested man. "We'll tell you what you are."

"And we are not filthy. We take great care to avoid contamination by dirt."

"I said shut it!" This time he pushed his dagger at my father's throat.

"Wait," said one of the priests. "We must establish the truth before we go on."

"Well do it quickly. We haven't got all night. There's plenty more filth to be disposed of."

The priest looked at my father and asked him:

"Are you a Christian?"

"We worship the true God."

"Liar! You worship the Devil."

"We do not worship him, we worship God. But we know the power of evil, and try to avoid it."

"Then who were the sacrifices for, if not the Devil."

"What sacrifices?"

"Don't you lie to the priest," said the crested man. "We know you kill babies. And we know what you do with the blood."

"Well?" said the priest.

"We make no sacrifices. We do not even eat meat. Look at this house. It is perfectly clean, and you will find no blood anywhere."

"Don't give us that! We know you kill them." The crested man waved his dagger again. The priest thought for a moment, then asked:

"You say you worship God?"

"Yes."

"Do you accept that the Saviour has two natures, human and divine, separate but fused, each whole and perfect?"

My mother burst into tears when my father looked at her. He looked away, and said nothing.

"Answer the question," said the crested man.

"No."

"No, you will not answer, or no, you do not believe?"

"I do not believe that God came to earth in material form. He cannot have mingled himself with corrupt matter. He has only one nature."

"What does he mean by that?" said the crested man.

"He means," said the priest, "that he is a filthy heretic."

My parents allowed themselves to be led away. I do not know what happened to them, but I can guess. I was taken away by one of the priests. The Church claimed, and still claims, those members of heretic families too young to understand their error. In the dark, I was pulled out into the street, where I could see burning houses, and crowds milling about noisily. A few streets away, I was pushed through a doorway into a room full of children. There must have been two dozen, all, by that time, crying, and guarded by two worried-looking Blues. Soon I was crying too, and the guards, tired of the noise, shouted at us to stop. That made us worse, but after a while the noise died down. We were tired, but could not sleep. What we feared most had just happened, but that did not exhaust our fear. We began to fear things we could not imagine. Every so often one of us would start crying again, or sniffling. What was left of the night seemed endless.

At dawn more priests arrived with ropes. Without looking at us, they told the guards to tie us together. In one long line, with a priest and guard at each end, we were marched away from the streets I knew, out towards the suburbs. We passed through an arched gateway where lounging Blues jeered. Instead of narrow alleys faced with shops and windows, we were soon in a district of large, inward-looking houses, with only the tops of palm trees showing above their blank, white walls. I had never been outside the city walls before, and the sight of those enclosed houses was oddly comforting. As we

were dragged away from the suburbs, I imagined myself safe within high, white walls. Outside the city there was little shade. I was hot, thirsty, and the ropes bit into my wrists. At noon, in a grove of palms by the River Cydnus, we stopped to rest. We were given bread and water, but not untied. In the afternoon we were led to a church.

As a Christian I suppose I should be glad at what happened next, but as a small boy I was terrified. We were taken inside and baptised. I had never entered a church before, it was full of symbols I had been taught to fear and despise, and we went through a ritual that I did not understand. I do not know why they baptised us then and there without instruction. Perhaps, though young, we were too deeply tainted with heresy. The Church would claim us, but not as we were. We were told by a priest that, whatever we had been before, we were now proper Christians, and in the care of the Church. We would be taught, and looked after, until we were old enough to make our own way.

Then we were handed over to the monks.

In troubled times men rush to enter monasteries, sure of a bed, clothing, regular meals, care if they fall ill, and freedom from debt, taxation or military service. As cities have emptied, and schools have closed, monasteries have filled with scholars and teachers. I had no choice, and the circumstances of my arrival were distressing, but it soon came to seem a safe and pleasant place. It lay a few miles outside Tarsus, in the strip of rich, green land that follows the river. The high walls that surrounded its dark, cool buildings seemed to offer protection from the hostile world outside, which we soon began to forget. It was not, after all, the monks who had burned our houses or attacked our families. Once they had made it plain that there could be no backsliding into heresy they were kind enough.

I lived in that monastery for ten years, and it made me what I am. It was, perhaps, an exaggeration to say that we were looked after, as we had to look after ourselves. Older boys were put in charge of us. They allocated tasks and made sure

they were done. They enforced the rules and punished wrongdoers. Deprived of our families, we wished only to be approved of, and came to depend on them. Strong emotions were generated, and expertly manipulated. The monks were more remote. We went to them for lessons, and they seemed all-knowing, but they could not be friends or confidants.

We had to wash and mend our own clothes, and were made to weave baskets and rush mats, some of which were sold in Tarsus. The dormitories, like the rest of the monastery, were built from mud brick, which steadily crumbled to dust in the scorching Cilician summers. We swept ceaselessly with brushes that we made ourselves. There was food to grow, and to cook. In the spring we hoed the hard soil and carried water to the seeds we sowed. In the summer and autumn we picked fruit. In the winter, when cold winds blew down from the Taurus Mountains, we pruned the trees and vines. We constantly picked and podded beans, storing them in huge baskets, where heat and insects competed to make them inedible. When they were dry, we ground the beans, then made them into a thin porridge, which we ate nearly every day. If we were lucky, and were allowed extra oil, we made fried bean-meal cakes. Hippocrates recommends beans, though Galen warns against them. I do not think they did me any harm, though I would have welcomed a more varied diet.

My education, rather to my surprise, began with music, something I had not encountered before. We were taught songs, which we sang while clapping or beating small drums. The simple tunes and rhythms helped us learn the words whose meaning we would only understand later. As we learned more of these simple songs, then progressed to psalms and hymns, we gradually shed our heresy and became Christians. We learned to read, write and count, scratching letters on tablets of soft wax. Later we studied arithmetic and geometry. We memorised the Scriptures, and were instructed in theology, or rather, Christology. We were drilled in Greek grammar, and some of us learned Latin, which was still the official language of the Empire.

The Greek of the Bible, as all scholars acknowledge, is

inelegant, and we were encouraged to study the sermons of Saint John Chrysostom as models of Christian rhetoric. Antique writers, to whom we were obliged to look for examples of style, were represented by short extracts in anthologies, which were full of polished passages free from any taint of paganism. Homer could not be freed from paganism, but his style is exemplary, and the stories are famous. We were allowed to read the *Iliad* and *Odyssey* in full. Many of my childish daydreams began with the martial friendship of Achilles and Patroclus, or the wanderings of Odysseus.

Within those limits, the monks did their best, and I could not have learned what I later did without that foundation.

I had escaped the outside world, but some news reached us. The Abbot, a thin, bony man with a terrifying stare, sometimes included a topical reference in his long and rambling sermons. His descriptions of tyranny, civil war, gangsterism and religious conflict, though heavily disguised in the language of the Old Testament, usually made the seclusion of the monastery seem more agreeable. I knew what Tarsus was like, and if the rest of the Empire was just as bad, I was happy to be safe behind high walls. But a few years after I arrived at the monastery, the Abbot revealed something that unsettled us all. After morning prayers, instead of sending us to work, he kept us in the chapel and addressed us, adopting the grim tone he used for cataloguing the smitings and begettings of the Israelites. He told us that the new Emperor, whom he had previously hailed as a hero, had committed a sin so bad that it could not be named, still less described.

"It goes against God's laws," the Abbot said. "But we must still pray for His Majesty the Emperor. We must pray for his guidance from error!"

He led us in prayer, then spoke again, taking a gloomy pleasure in his words:

"Even now, God is preparing to chastise us. We are to be punished for the Emperor's sins. A Persian army is on its way to Cilicia. Tarsus is certain to be attacked!"

When the Abbot dismissed us, we rushed to our work, but

could not concentrate, either on lessons or chores. We chattered constantly, despite the older boys' attempts to keep us quiet. They were as excited as we were, and so were the monks. Little work was done that day. It seemed pointless to learn Latin grammar, or to sweep or weave baskets, when we might soon be slaughtered or carried off into slavery. That night, in the dormitory, the older boys speculated about the Emperor's sin. The word *incest* was whispered, and explained to the younger boys. I was only just becoming aware of the promptings of lust, which I understood only as something to be resisted. While I lay uneasily on my prickly mattress, thinking about sin, the other boys told stories of King Chosroes and the cruelties of the pagan Persians. The high walls of the monastery no longer seemed so reassuring, yet there was an anticipatory pleasure mixed with our fear.

In Tarsus the citizens did not panic. The news seemed to concentrate their minds. The city had been neglected while the Empire declined, and the arrival of the Persians might be an opportunity rather than a misfortune.

For a day or two, the factions were confident. The leaders of the Greens and the Blues forgot their rivalry and formed themselves into a militia to defend the city. They put on their most extravagant clothes, polished their weapons, and paraded in the streets. The citizens, despite their cheering, were not impressed. The clothes, so intimidating before, seemed laughable now. The weapons, good for cutting throats in back streets, were obviously inadequate to defeat an invading army. The factions seemed to realise that, and on the third day they paraded in plain clothes. Some also carried improvised weapons: sharpened agricultural implements, or poles with daggers lashed to their ends. Perhaps the makeshift nature of these weapons made their bearers think about how war might actually be fought, and how it might differ from street-fighting. Whatever the reason, that was the last parade. After that the Greens and the Blues disappeared. Some escaped into the mountains or hid in cellars. A few attempted to enrol at the monastery. Others reappeared in the guise of ordinary

citizens, the former leaders of whom now realised that they had better prepare to surrender. A committee was formed, ceremonial clothes were prepared, and keys to the city were found. For a few more days the life of the city was paralysed. No one could think of anything except the Persians.

When the first Persians arrived at Tarsus, they were not the huge army we had imagined, but a small advance party, little more than scouts. They looked like ordinary soldiers, not the barbaric fantasies of the gangsters. They were not interested in hearing speeches of welcome. But their commanding officer was glad to advance his career by receiving the keys. Later more soldiers arrived, and a small garrison was left in the city.

The Abbot seemed disappointed that we had escaped an inevitable doom. He addressed us again, telling us that Chosroes was now our King, and that we were subjects of the Persian Empire. He read us a long passage from Jeremiah, in which there was no smiting, but many confusing comparisons between baskets of figs and cups of wine. We were supposed to draw the conclusion that a Babylonian captivity was imminent, and we had heard terrible stories about other cities the Persians had conquered. In Jerusalem, they sacked churches, looted monasteries, and massacred priests and monks. The Abbot may have been hoping for martyrdom, but there was little trouble in Tarsus. The Persian garrison ignored the monastery, and took only taxes from the citizens. Perhaps God's failure to punish us indicated that we were not very important, either to Him or to King Chosroes.

We prayed, and we returned to our work, for which I was glad. I was determined to learn as much as I could, while I had the chance. I enjoyed my studies, and was successful at most subjects, though I was rather puzzled by theology. Some of the things we were asked to believe could not be as simple as the monks pretended. The question of the Incarnation had divided the Church for centuries, and, as I approached the age of sixteen, it troubled me. Perhaps my interest in the Incarnation was no more than a bewildered youth's attempt to deny a growing awareness of fleshly desires. But the difficulty of

accepting that God, all-powerful and omnipresent, could have allowed Himself to be constrained in the fleshy prison of a human body, had caused many, including my parents, to abandon Christianity for a simpler faith. Others, remaining Christian, denied God's presence on earth, thinking Christ either an illusion, or just a man adopted by God. Yet orthodoxy requires us to believe that Christ is both God and man, each perfect and separate, both mystically fused, rather as body and soul are fused in man. It seemed to me that the Trinity, the natures of Christ, and the relationships between them, were problems that could be explored, if not finally explained, by theorems of the sort used in geometry. Whenever I tried to propose the idea, the monks looked embarrassed, and said that there were mysteries that we just had to accept. When I persisted, I was told to stop interrupting the lesson with questions, and learn what I was told to learn. They knew what I did not, that theological disputes had weakened the Empire, and contributed to its imminent collapse. Perhaps, had I thought harder, I might have had more sympathy for their point of view. I had recently been made an assistant teacher, and I found my work much easier if the younger boys I taught did not ask awkward questions.

I assumed that, at sixteen, I would become a full member of the community and devote the rest of my life to teaching. When the Abbot summoned me to his room, I thought I knew what he would say. He began by praising my work, and thanking me for the teaching I had done. He went on to say that I was an exceptional pupil, one of the best they had taught. My knowledge of Greek was excellent, and I showed promise in mathematics and music. My enthusiasm for theology, he said, was very creditable.

His stare was no longer terrifying. His manner was regretful, almost apologetic. His eyes, so piercing that they could silence a chapel full of boys, would not meet mine. I was wondering why I had ever been scared of him when he said:

"The monastery cannot do justice to your abilities. You must continue your studies, but not here. There is nowhere nearby that is suitable. There used to be schools all over the

East. Antioch, Edessa, Beirut. . ." His bony shoulders shuddered as he thought of learned and pious monks dragged from their desks and sold into slavery by the Persians. "You must go away," he said.

"But where?"

"Athens."

I protested that his scheme was impossible, citing, not, as might have been seemly, my own unworthiness, but the Persian occupation.

"There will be no difficulty," he said. "You will travel by sea. I will give you letters of introduction, and once you reach Athens I am sure you will have no difficulty finding teachers."

Despite the Abbot's praise of my work and ability, I felt as though I was being dismissed, almost expelled. The monastery had become my home, and I had no wish to leave it for the outside world, which, my small experience told me, was hostile and dangerous. A few days later I returned to the Abbot, told him that I felt unworthy of the education he proposed for me, and volunteered to remain at the monastery as a teacher. He refused my offer, gave me letters of introduction and a little money, and sent me away. This experience, bewildering at the time, has since become familiar. Several times, in later life, I have been sent away from monasteries in similar circumstances. There must be some flaw in my nature, perhaps a lingering symptom of my parents' heresy, that makes me, almost without knowing it, turn against communities that have made me welcome.

Despite my reluctance to leave the monastery, once outside its walls I felt exhilarated. I was starting a new life. For the first time, I was alone, and free. As I walked to the coast I daydreamed about Athens, imagining myself debating with philosophers, or dazzling bishops with theological theorems. Perhaps I would become a bishop, or a theologian. The Patriarchate or Papacy might not be beyond one who could refute with mathematical certainty the errors of the heretics. I imagined my life stretching ahead, free of obstacles, like the dusty plain I was crossing. Everything seemed possible.

At the coast I found a few patched and dilapidated fishing

boats. Some fishermen had upended one of them, and were daubing its hull with pitch. They seemed amused by the idea of sailing to Athens, but let me stay with them for the night. They gave me food: a sort of soup with every kind of fish boiled up together, and afterwards I slept in a hut, curled up among nets and ropes.

For a few more days I followed the coast, scrambling along the rocky shore. I questioned everyone I met, but was always told the same thing. Greece was overrun by savage Slav tribesmen. Athens had been sacked. No one was sailing west any more. I was fed regularly on fish soup, but it became clear to me that I was not going to reach Athens. The Abbot must have known. Why had he deceived me?

Feeling helpless and defeated, I decided to go back to Tarsus.

As I approached the city I began to regret my decision to return. The suburbs were empty, and many of the high-walled houses that had once seemed so safe were ruined or abandoned. Saint Paul's Gate was guarded by Persian sentries, big, black-bearded men armed with spears and swords. I hesitated for a moment when I saw them, but kept walking. To turn back would have made them suspicious. When I got closer, the guards did not seem so impressive. They wore absurd felt hats, domed like eggshells, their baggy trousers were tattered and stained, and their spears were little more than poles. Clearly, King Chosroes had not sent his best troops to guard Tarsus. I tried to look purposeful, as though I passed the gate every day and knew exactly where I was going. The guards idly watched as I walked past them, into the city. They did not move out of the shade, their swords remained sheathed, and their spears were left resting against the wall. They cannot have thought me important. I was young, my cloak and tunic were dusty, and I carried no baggage. I walked on quickly, along the deserted main street to the city centre.

The market place was almost empty, as were most of the shops. A few peasants squatted by piles of vegetables, but they had no customers. Persian soldiers lounged on street corners,

just as the Greens and the Blues had once done. I kept walking, through narrow streets like those I had lived in as a child. But I did not recognise the streets, and their few inhabitants glared at me suspiciously. Some threw stones. They, I realised, were the people who had persecuted my parents. Now their houses were wrecked, and their livelihoods lost. That thought gave me pleasure at first, and helped me bear their hostility. I wandered, losing myself in gloomy alleys, stumbling over scattered rubble, sometimes emerging into parched and empty squares. I slowly realised that there was nowhere for me to go. I had mistakenly thought of Tarsus as my home, but, though I had lived in or near the city for sixteen years, it was completely strange to me. My real home was the monastery, from which I had been expelled.

I trudged the streets, looking for somewhere I could rest, but I kept finding myself back in the market square. Some of the soldiers, seeing me again, began to stare. I walked on. I had been walking all day. I was hungry, thirsty, and needed a place to sleep. The city's few surviving taverns were full of Persians. There seemed to be nowhere a traveller could go. Then I saw the church of Saint Paul. I had not been inside it before, its doors were open, there were no Persians lounging on its steps, and its dark interior looked invitingly cool.

It was there that I met Nicholas.

I was in the nave, examining a series of mosaics depicting the voyages of Saint Paul. There was nothing else to do, and the pictures fed my sense of failure in a way that was almost alarmingly satisfying. Rome, Thessalonika, Jerusalem, even Antioch, seemed impossibly remote. The Apostle was a much more resolute traveller than I had proved to be. The mosaics were damaged, and loose tesserae were scattered about the floor. I stood miserably, staring at a scene in which Paul converted an Athenian, perhaps Dionysius the Areopagite, though the inscription was defaced. A voice said:

"Are you lost?"

"No. Returned," I said, and looked round, into his face. Nicholas was taller than me, and older. He had dark, curly hair and a straight nose, like an antique statue. His eyes had the sad

sincerity of a mosaic saint. I knew then that I wanted him to be kind to me.

"Are you hungry?" he asked.

"Yes." I was hungry, and not just for food. The sight of Nicholas had awoken in me another need, one I could not define or put a name to.

"Come with me," he said, taking my arm. "Come to my mother's house."

Nicholas led me out of the church, back into the narrow streets from which I had just fled.

"You were looking at the mosaics of Saint Paul."

"Yes," I said, unwilling to admit my feelings of failure.

"He is too well thought of in Tarsus."

"That's hardly surprising. He was born here."

"Do you not think him too worldly?"

Nicholas seemed completely confident. I knew I was safe walking with him.

"Worldly?" I said.

"We should renounce the world, not rush around it like he did."

"He was a missionary."

"We must deny ourselves before we can save others."

"He went into the desert to find his faith."

"The desert!" Nicholas said. "Do you know the story of Saint Antony?"

"Yes." I had heard it often enough at school.

"Saint Antony withdrew from the world. He lived in a tomb. He renounced his inheritance when he was twenty years old. I am almost twenty." He stopped at the corner of a narrow street and looked intently at me. "We must follow his example," he said. "We must renounce the world, and deny ourselves. We must ennoble the spirit by mortifying the flesh. Saint Antony did that, though he was terribly tempted. He came out of the wilderness and made himself a leader. All the hermits of the desert followed him."

Then he took my arm, gripping it firmly as though he feared I might escape, and led me into the alley. A few paces later, we stepped through an arch into a small yard where a

39

fountain trickled feebly into a broken gutter, barely dampening the cracked tiles around it.

"It's here," he said. "My mother has to share this yard. It's not much of an inheritance, but I mean to renounce it."

The house was small and dark, though it seemed welcoming enough after my recent wanderings.

"We'd better get rid of those filthy clothes," Nicholas said. I took off my tunic and dropped it on the floor, noting that Nicholas, despite his professed longing for self-denial in the desert, was looking at my unwashed body with distaste. He summoned a servant, who took away my clothes and brought me water.

Nicholas watched while I washed. At school, we had seldom seen each other naked. That led, the monks implied, to a terrible and nameless sin. I found his attention disturbing, though not unpleasant. I could not help wondering what the monks had been so afraid of.

"Origen went further," he said, perhaps noticing my incipient arousal. "He had himself castrated, to be sure of chastity."

"Origen was not strictly orthodox," I said, quickly pulling on the clean tunic the servant had left out for me.

"No. He was wrong about salvation. It can't be universal. It has to be earned. Only a few will be saved."

The servant brought some food, and Nicholas's mother joined us to eat it. The house was too small to have separate quarters for women. She was a rather forbidding woman, in whom the same features that made Nicholas beautiful were composed, in a way that should have warned me of what was to come, in an expression of permanent, wounded, reproach.

"Nicholas is determined to renounce all this," she said, looking around her as though the house was a palace. "If he wants to do God's work in a remote and simple monastery, who am I to stop him?" She nibbled a little bread, but refused any other food. "I will be left here alone, but I will manage."

I tried to eat as much as I could, without appearing greedy.

"It would be nice for Nicholas," said his mother, "to have a

friend. There are so many dangers and temptations, even in a wilderness. A friend would help him resist them."

I stayed with Nicholas and his mother for two weeks. I slept on the flat roof, with the servant, an old man who snored loudly. Every day, Nicholas went to the church or market place and waited, hoping to meet travellers who could tell him about suitable monasteries. Each day, he came home disappointed.

"The monasteries are corrupt," he said. "All the monks seem to think about is comfort. All I hear about is high, safe walls, rich farmland, regular meals, miraculous icons, and libraries full of books."

"That doesn't sound so bad," I said.

"How can we purify our souls while wallowing in luxury?"

"I was taught by monks. It did not seem like luxury."

"We must go somewhere simpler and more remote than your school," Nicholas said. His mother gave me a look that implied that I was hopelessly worldly, perhaps too much so to be of use to her son. I realised that, without really thinking about it, I had become involved in their plans. Even their disapproval seemed flattering. No one had paid me much attention before.

While Nicholas gathered information, his mother made me stay and read to her from the lives of saints. We sat, I on a stool, she on a hard, upright chair, her small smile tightening at each extreme of self-denial, suffering or martyrdom. Her particular favourites were Polyeuctos and Nearchos, a pair of soldiers who had formed bonds stronger than those of brotherhood. They were martyred for their friendship, which the hagiographer described as a 'passionate union of souls'.

I had not had any close friends at school, as anything but a generalised brotherly love was discouraged by the monks. But there were older boys at the monastery, on whom the younger ones depended. They could be wrong, and were sometimes unfair, but we longed for their favour. Just as those boys came to replace the families we had been taken from, I felt that, for me, Nicholas could replace them. The sense of freedom I had

felt at the start of my failed journey to Athens had gone. I wanted to belong, and to follow.

Eventually Nicholas's questioning produced a promising lead. A monk, who was attempting to reach Antioch, had visited, and recommended, several of the more luxurious type of monasteries. Reluctantly he told Nicholas about an ascetic community in Cappadocia, north of the Taurus Mountains. It seemed that, under the leadership of the saintly, or fanatical, Simon, a small group of monks led a life of poverty, contemplation and improving work. That was enough for Nicholas who proposed that we set off there as soon as possible.

"It has everything we have been searching for," he said. "Simplicity, contemplation, God's work to be done. We are sure to find ourselves there."

As I listened to him, he seemed so full of certainty that I wanted to believe him. But even then I had my doubts. It was the first of many occasions on which I have been misled by the promptings of lust.

3
CAPPADOCIA
A.D. 618–619

Cappadocia was a parched land, where a shower of rain would disappear instantly into the dry earth, and where men and beasts might easily die of thirst in the cruel heat of summer. White dust lay deep on the road, as bright as salt or snow. It came from white hills and cliffs that stretched to the horizon, crumpled and folded like linen. There were valleys full of huge rocks, humped and moulded in a way that was oddly familiar.

"What does this remind you of?" I asked.

"Nothing," Nicholas said.

"Nothing at all?"

"No."

When we had walked a little further, I realised that the scene was like my father's shop, which I had not thought of for years. It looked as though a gigantic baker had rolled and kneaded the land, leaving it strewn with flour and misshapen loaves. In some valleys the rocky mounds were layered like pastries, or coloured like cakes. The valley floors were scattered with white mounds and ridges like piles of windblown flour. Whole hillsides were gnarled and lumpy, like loaves that had risen too high and collapsed. Oddest of all were the valleys full of rocky cones and columns, pointed and polished, topped with boulders balanced like hats.

"I can't see a monastery," Nicholas said.

"Neither can I."

"Perhaps we have come the wrong way."

"It must be here somewhere."

"But I can't see any buildings. Just rocks."

"They remind me of loaves," I said.

"They look more like skulls."

Nicholas was right. Some of the mounds, white, knobbly and deeply shadowed, were skull-like. It was hard to believe that rock could be formed into such shapes without demonic intervention. I began to think Cappadocia an unlikely place to be doing God's work. Yet, as we neared our destination, we began to see patches of green. There were clumps of trees, and plots of what might once have been cultivated land, sheltered by folds in the rock and watered by unseen springs.

We continued along the valley until we saw two young men idly working in a field. They gladly laid down their hoes to talk. When Nicholas asked about the monastery, one of them said:

"Look around you."

He pointed at a nearby mound, and I saw that what we had taken for shadows were crudely cut doors and windows. Other mounds were pierced in the same way. It seemed that the monastery was underground, more like a burrow than a human habitation. They directed us to the end of the valley, where an arched doorway led into one of the larger mounds.

I expected to find a straw-strewn cave, little better than an animal's lair, but we stepped into a large and elaborate room. Its floor was level and clean. The walls were carved with columns and alcoves. Biblical scenes and images of saints were painted on its vaulted ceiling. We stood for a moment, marvelling at what we saw. Then a voice summoned us from beyond an archway at the end of the chamber. We followed the voice and found Simon, the community's leader, in a smaller room, which seemed to be a study or library. He sat at a large table cut from solid stone. Under a skullcap his hair was shaved, except at the back, where it hung limply over his shoulders. His beard, which he rubbed regularly with his right hand, was grey and bushy.

"We wish to do God's work," Nicholas said. "And be part of your community."

Simon studied us for a while, frowning, wondering what sort of people we were and whether we would be any use to him. "Of course you can do God's work," he said, smiling at last. "If you are willing."

"We are willing," Nicolas said.

Simon went to the doorway and called: "Daniel!" An elderly monk entered.

"Daniel, here are two young men who wish to become Brothers. Look after them and show them what they must do. When they are ready, bring them back to me for instruction."

Daniel showed us some of the nearer mounds. There was a refectory, a church and a few other communal buildings, all carved out of the rock. But it seemed that the monks lived mostly alone, only meeting for prayers and meals.

"Your first task is to build yourselves a cell each. All the Brothers have their own cells. It aids contemplation. After that you will join the work of the community, according to your abilities. You will sleep in the guest room tonight. Tomorrow I will give you picks and shovels."

It was evening. We were taken to the guest room and given food and water. There was no communal meal that day.

"Do you realise," I said, as we tried to make ourselves comfortable on the stone shelves that served as beds, "that they expect us to dig our own cells."

"It will be God's work. We will find ourselves through honest labour."

"Have you ever done any digging?"

"Not exactly."

"You haven't, have you?"

"No."

"I have. At school we had to grow all our own vegetables."

"It has obviously made you what you are," he replied, ambiguously. I wondered, as I drifted off to sleep, what Nicholas meant, what he thought of me, and how, now that we were free from the influence of his mother, our friendship would develop.

The next morning we surveyed our new home. The monastery was scattered, with no plan or boundaries. Generations of monks seemed to have dug cells or storerooms wherever they liked. We looked for some suitable unclaimed mounds and started to dig. The rock, when tested, was surprisingly soft

and porous, rather like a dry sponge. We chose a place for a door and started hacking. By midday we had an alcove which could shelter us both. I had imagined each Brother spending years on his cell, and the church looked like a century's work, but our task was going to be easier than we had thought, and perhaps, for Nicholas, insufficiently mortifying. After a couple of weeks we had excavated an irregular but adequate cell. We chose another mound, began a second cell, and soon finished that. I found a maul and chisel and began to refine the insides of the cells. I smoothed the walls, and pierced small windows. With growing enthusiasm, I cut shelves and alcoves, and added a prayer niche flanked by false columns. I began a geometric frieze at shoulder height, and planned an elaborate scheme of decoration for both cells. I cannot claim the work was particularly well done, but it pleased me.

Nicholas seemed to lose interest in the work once we had hollowed out the cells. While I worked on embellishments, he wandered among the other mounds, or sat outside, perched on a pile of debris that might, had he thought of it, have been shovelled out of our way. He watched the small, spiny lizards that scuttled among the rocks, and threw chips of stone at them. The lizards dodged the chips, but kept returning to hunt for insects or dart at each other aggressively, nodding their heads and revealing bright red throats.

"Look at the lizards," he said. "They fight, eat, and flee from danger. But they have no thought for the future."

"No thoughts at all. They're lizards."

"But some people are no better. They think only of the present."

"I hope you don't mean me."

"You are not thinking, just working."

"I am not just working. These decorations took a lot of thinking out. Besides, we came here to do God's work."

"And I want to get on with it."

"Then why not help me?"

"Because it will delay our real work."

"You think this building work is just delaying? We were instructed to build our own cells."

"But not to embellish them."

"There is no harm in doing a job well."

He gave my slightly crooked frieze a critical look before he replied:

"It *may* be done well, but I'm not sure it should be done at all."

"Why not?"

"Because it's worldly. We only need shelter, not luxury. What you are doing is just pointless elaboration."

"Churches are decorated. Is that pointless elaboration?"

"A church is the house of God. We glorify Him by embellishing his house."

"I see no difference. These cells may only be our houses, but building them well is worthwhile. You want us to humble ourselves, but we are human, and are entitled to some dignity. If we lived in unembellished caves we would be no better than the lizards, creeping into their holes in the rock. It cannot be right for men to live like beasts."

"You are too much attached to the world. We came here to deny ourselves and find God. I am going to tell Daniel that we are finished, and ready for instruction."

He stood up, and walked off quickly, kicking stones from the pile and sending the lizards skittering away. I carried on with my stone-carving, but half-heartedly. I knew the scheme I had planned would not be finished.

The next day we were summoned to Simon's room for instruction.

"The great enemy is the Devil," he told us, as we stood humbly before him in his carved and embellished rock chamber. "That is why we are here, in this wilderness, far from any city. You are from Tarsus. You will know how wicked and full of temptation cities can be."

I did not disagree, though his thesis was not supported by my experience. He carried on:

"Out here, leading the simple life, it is harder for the Devil to get a grip on us. But he still tries! He knows lots of tricks! We each have our own personal demon, assigned to tempt us. Did you know that?"

47

"I know all about devils," Nicholas said.

When he mentioned devils, I could not help thinking of the little red-throated lizards.

"Are you baptised?"

"Of course I am," said Nicholas, rather smugly.

"That won't do. You'll have to be baptised properly. Not straight away, of course, but after instruction. We always start from the beginning here."

I tried to explain that I had already received a full course of instruction, and had been baptised, though without mentioning my heretical past.

"That won't do at all. There's no knowing what demons might have crept into you there, or on your journey. We must make sure that you are pure, and that you have all the necessary knowledge, then you must start a rigorous course of prayer. Not forgetting work, of course. Then we can expel the demons and begin to achieve perfection. I will talk to Daniel and arrange your training."

Daniel told us that our first work for the community would be to clear vegetable plots out of the stony ground. Then there were seeds to plant, wood to cut, and animals to tend, if we could find them. I wondered what the other Brothers would be doing, and how many of them there were, for we had not seen more than a dozen.

The Brothers' main occupation was prayer, about which they had odd ideas. They did not just pray to be saved, or for the afterlife, but for perfection here and now. It was such an urgent and arduous task that they had little time for anything else. That was why they were so pleased to receive some new recruits. It was the job of novices to do all the daily work, and free the other Brothers to become perfect. Our arrival freed two older novices almost immediately. After a short settling in period, during which we learned to do our work, these two were made full Brothers and began their phase of contemplation. We witnessed their transformation.

First there was a fast. That lasted for a whole week, during which we were only allowed water, and by the end of it I was already seeing visions, mainly of food. Then there was the

ceremony. We all gathered in the chapel, and again there were not many more than a dozen of us. Simon stood at the hewn rock altar, dressed in rich, though unconventional, vestments. I could not help noting that his person, like his room, was permitted embellishment. He leaned forward, scowling at his small congregation, waiting for the novices to be brought in. When they stood before him, robed in white linen, he inspected them carefully, making sure they had reached a suitable state of readiness. Then he adjusted his skullcap, hoisting it to the back of his head, and began the sermon.

Simon evidently knew the Scriptures. He did not recite, but summarised, illustrating with many quotations, his grey beard jutting and waggling as he spoke. His voice sometimes rose to a shout, or faded to a hoarse whisper, almost inaudible under the rustling of his stiff brocade robes. He gestured constantly, raising an arm to the painted ceiling, banging both hands on the altar, or suddenly pointing at one of the Brothers in an attempt to unnerve him. Sometimes he stopped unexpectedly and remained silent for a moment, glaring round the chapel, daring us to doubt him. Nicholas listened to him with a vacant, awestruck expression on his handsome face. I tried hard to ignore Simon's mannerisms and concentrate on what he was saying.

Simon's interpretations were often different from those of the monks who had taught me, and I began to wonder whether he was altogether orthodox. Looking back, I can see that he was not, and that he had fallen into deep heresy. He was unsound on the question of demons. It became apparent during the sermon that he believed, not only that we each have a personal demon, but that this demon lives inside our bodies, and can be driven out by prayer and ritual. He also seemed to think that, once freed of our demon, and after a period of abstinence and contemplation, we would become perfect. After that, he implied, sin would no longer be possible, and any sort of life would be permissible. He supported this with the words Saint Paul wrote to the Corinthians:

"All things are lawful for me, but not all things are expedient:

All things are lawful for me, but I will not be overwhelmed by anything."

The verse became a sort of chant, repeated alternately by Simon and the Brothers, with different emphases, until all possible meaning had been extracted from it. After that, the sermon was resumed, and went on so long that I was almost fainting from thirst and hunger. Then, without instructions the rest of the Brothers moved forward and began to lay hands on the novices. It was not a calm or passive business: they stroked and patted, pushed and pummelled. It was more like a marketplace brawl than a religious ceremony, and after a few minutes of manhandling the two novices looked quite distressed. But it was only the beginning: the other Brothers began to speak in tongues. Each in turn removed his hands from the novices and began to talk. There seemed no sense in what they said, and no words could be recognised. Each Brother tried to be more enthusiastic, and incoherent, than the last. When they had all had a turn they started to rant collectively, making less sense than they had before, but building up a brutal and terrifying rhythm.

There was a moment of silence, almost as terrible as the noise, then the Brothers began to sing. Their music was not the psalms or hymns of my schooldays, but a disturbing and overpowering sound that seemed to resonate in both mind and body. Simon threw his head back, making his beard jut even more, and sang a single note, drawing it out as long as possible, and taking breath in such a way that it seemed not to be interrupted. His eyes bulged with the effort of producing that sound, and his round mouth, fringed with ragged, bespittled hair, quivered disturbingly. One by one, the Brothers joined him, each adding a different note. When all were singing, they began to vary the pitch and volume of the notes, which, meeting each other in the air, seemed to generate new sounds, not made by man or instrument. A river of sound washed around us, carrying us along with its current. Sometimes it spread and calmed, then it would rush and deepen. I could feel it coming through my feet and echoing from the walls. The noise was terrible. It filled the small chapel and rang

in my ears. I wanted to get out, but Nicholas seemed completely absorbed.

Many years later I experienced the same terror whilst at sea in a storm. The wind blowing through masts and ropes, the sea smashing and heaving hulls, have the same inhuman power, the same chaotic rhythm, as the music the Brothers made.

The two novices were shaking and snivelling by then. They looked quite unwell, and could no longer stand without help. The ceremony ended quickly when Simon quoted from the Book of Revelation:

"Because you are lukewarm, and neither hot or cold, I will spew you out of my mouth."

The two novices were grabbed from behind and, with their arms twisted, led outside. There was a little more chanting and pummelling, then the two started to vomit. Taking turns, they each bent double, heaving and retching until their white robes were spattered and pools of vomit lapped at their feet. There were gasps of approval at each new discharge, and the Brothers glanced at each other with a peculiar intensity, as though they were experiencing an exquisite but secret pleasure.

How, after a week of fasting, the novices' stomachs could contain so much, I do not know, but the volume and frequency of the vomiting seemed to be thought a good omen. Perhaps they had been secretly fed, for it was obvious that the vomiting was a vital part of the ceremony. It was by this means that the demons were ejected. Afterwards, the two, now unconscious, were carried to their cells to begin their long preparation for perfection. The rest of us ate what was described as a feast, but could only be considered so after a week of fasting.

I knew the biblical precedents for the casting out of evil spirits, but even so, the ceremony troubled me. The assumption that we all contain a demon was surely false. There seemed nothing wrong with the two novices, before the ceremony at least, and I thought some evidence of possession should be found before exorcism was attempted. It was also quite wrong of Simon to suggest that we could become

perfect. Perhaps he had conflated demons with original sin, or imagined himself a vehicle for God's grace, though he really should have known better.

I felt uneasy, and wanted to discuss it with Nicholas, but he just looked solemn and said, "I want to be perfect."

"Do you want to go through *that*?"

"Why not? What do our bodies matter? They are only an earthly covering, to be thrown aside when we reach perfection."

"But Simon is offering perfection *before* our earthly coverings are cast aside. Didn't you hear him? He said that afterwards, all things would be lawful."

"But not expedient. Our perfect natures will not be able to desire anything wrong, if that's what concerns you."

"What concerns me is that we should not try to be too perfect too soon. We should try to live this life properly, and wait and see what is in store for us."

"You will never be saved if you keep up this doubting."

The beauty of his face was marred by an expression of smug disapproval. He looked just like his mother.

I had been puzzled by the small number of Brothers. The monastery, scattered among the rocks, was quite large, and included many empty chambers. There was no need, other than symbolic, to make us dig our own cells. Clearly the community had been larger, but how large? And how recently? It was difficult to find anyone who would talk. That was partly because of our work, which took many hours each day. We were the only novices, and it devolved on us to provide the whole community with food. That was not easy. Our predecessors had anticipated their elevation, and had not worked the vegetable gardens for some time. We made a survey, and found that only the fruit trees had produced without being tended. As autumn approached, we stored apples, and picked and dried figs and apricots. There were some vines, but unpruned, they had grown more leaves than grapes. Wine might be possible, but not yet. We were told that there were dry goods in stock, but no one knew exactly what or where

they were. The other Brothers were always vague about anything practical, and were unwilling to be drawn, even theoretically, into any form of work. After searching many cells we found a stock of beans and grain, and were able to make bread. I remembered how, from my childhood, and was comforted by the memory, though milling with a hand quern was hard work.

The beans caused unexpected problems. A passing Brother saw us soaking them, and said:

"We don't eat those!"

"Why not?" I asked. I had never heard of anyone not eating beans. At school we had eaten little else.

"Because we don't. It's against our beliefs."

"But why?"

"I can't tell you." The Brother drew back, as though Nicholas and I were contaminated by the work we did. "You're not enlightened."

"Does that mean that we can eat beans?"

Nicholas looked worried and said: "I don't want to eat beans if they are not allowed."

"Why were the beans there then, if you don't eat them?"

"We used to eat them, but that was before."

"Before what?"

"Before the others left. They ate beans, but when the Abbot announced his revelation, they couldn't accept it. They had to go away."

"This revelation of the Abbot's, are you telling me it was about beans?"

"It was about souls, but beans came into it."

"How?"

"I told you, I can't tell you. You're not enlightened."

"These others, were they novices like us?"

"No, they were initiates, but they didn't like Simon's new ideas."

"Where did they go?"

"I don't know. There are lots of other monasteries round here, and none of them have accepted Simon's revelation."

The Brother seemed to think he had said too much, and

went away. We were left with a quantity of soaked beans, and some interesting information. As with other aspects of the community, I knew there was something wrong with the prohibition on beans, but not what. I discovered later that it is an old Pythagorean belief, taken up by some Gnostic sects. The Gnostics also believed in the power of secret knowledge, and in human perfectibility.

The prohibition on beans was not the only obstacle to our attempts at catering. There was also the question of meat, which was mixed up with the confusion about fasting. Despite the small size of the community, there seemed to be no agreement about when, and for how long, we should fast. Sometimes, as in the case of the elevation of the novices, Simon would prescribe a complete fast. At other times each Brother seemed to decide for himself, though attributing his choice to some dictate of Simon's. At first we took notice of what we were told. But some Brothers would demand food when we had prepared nothing, and others would castigate us for cooking when they wanted to fast. There were different interpretations of fasting, which could be eating nothing at all, or merely giving up meat. Meat, in any case, was not easily available. There were some dovecotes, but they were mostly empty. A few goats and chickens wandered among the rocks, but they were too useful, and too scrawny, to slaughter. There was also a donkey, which we used to carry firewood.

Some of the Brothers rejected all meat, but demanded fish. We could catch fish, but it was a long walk to the river, and time spent fishing was not as productive as time spent on other work. I thought we had solved the problem when, after a heavy autumn thunderstorm, we collected several baskets of snails. These should always be kept for a while, and fed, in case they have eaten poisonous plants. We kept them in upturned pots, and fed them on beans, until they were so fat they could hardly withdraw into their shells. Then, after strewing them with ashes to draw out the slime, boiling them and removing them from their shells, we stewed them with herbs until they were soft and fragrant. As I watched the black, coiled tails, simmering in green, glutinous sauce, I thought the dish a

triumph of ingenuity. The snails cost nothing, used up the beans, and, being neither meat nor fish, could be eaten by everyone, provided they did not know about the beans.

They were served on a day that was generally agreed not to be a fast-day. Most of the Brothers were gathered in the refectory, and sat on the benches which, like the table, were carved from solid rock. We had laid out bread, cheese, fruit and water. The Abbot said a prayer, then we brought in the snails.

For a moment there was no comment, just puzzled probing. Then one of the Brothers said: "We don't eat those."

Another, who had eaten one, said: "Yes we do!"

A third, who had looked quite enthusiastic as he began to eat, became quite angry:

"Why do you have to make yourself seem more holy than the rest of us? Why can't you eat good food when it's put in front of you? Do you think pride will make you perfect?"

"I am not proud, but humble. I abstain to abase myself. Luxury leads to pride, as you should know."

Quickly, the whole table became involved, with pro and anti snail factions, as well as advocates of humility or abstention, quoting scripture, shouting insults, appealing to Simon, or remembering recipes. Simon, despite the noise, ignored everything. He was eating. If he had ever pronounced against snails he had forgotten, or reversed the ruling. As the others noticed Simon, they too began to dip their bread into the slippery sauce, and soon all of them, even the most hostile, were eating.

Though, in a sense, the snails were a success, I thought it best not to serve them again. We settled on a mainly vegetarian diet consisting mostly of porridge, which, if it did not please everyone, offended nobody.

We spent much of the next few weeks collecting wood, which was mainly to be found near the river. That had the advantage of keeping us out of the way, and whilst there I experimented with fish traps and lines, that could be left in the river while we worked. They were not a success, and I did not catch much. I found that I enjoyed the work, which was hard, but satisfying. The winter would be cold, problems had

to be anticipated, and solutions planned. Working was, in some ways, better than thinking.

In October we picked the last of the figs, clambering among the gnarled branches of the low, spreading trees. Most of the leaves had fallen, and lay like dead hands, yellow and mottled. As we plucked the soft, purple-skinned figs, white sap oozed from the stems, streaking our arms and hands. Nicholas looked dejected. Instead of picking the figs gently, he tore them from the branches, throwing them half-crushed into his basket. Warily, remembering his doubts about my stone-carving, I asked whether he was now happy doing God's work.

"God's work is prayer, not this," he said.

"But you said we would find God in work."

"I was wrong. This work is worldly. We are storing up worldly things."

"Of course we are, we have to get through the winter, and the others won't do it."

"They are doing the real work, storing up virtue. We should be praying and preparing like them."

"How can we survive if we all pray all the time?"

"God will provide," he said, dropping a mangled fig into the sodden mess in his basket. His harvest would only be fit for stewing.

"He has provided these figs," I said. "Perhaps He has provided us to pick them."

"This isn't the Garden of Eden. Look!"

He held out his arms, which were blotched and blistered with red weals. Fig sap, which is usually harmless, stings some people like nettles.

"If you wash your arms the marks will soon fade," I said.

"It's a warning. I shouldn't be doing this work. I should be praying."

He said *I*, not *we*.

I found the conversation dispiriting. I knew that Nicholas was keen to be saved, and was impatient of worldly things. He had thought my decoration of the cells unnecessary, and an obstacle to our training. But now he was questioning work

that clearly had to be done if we were to survive the winter. After that, he worked, but not well. He clearly thought that even the minimum was a bit too much.

Lustful thoughts, the Abbot told us, are the rock on which most vessels bound for salvation founder. Our demons, wishing to tempt us away from the chosen path, have our memories and imagination readily at hand. As part of our instruction, which began when the winter reduced our work, the Abbot warned us of these dangers.

"Fornicate in the mind, and you cannot be made perfect," he said. "No one who does so is worthy to be a full Brother."

He implied that if anything of that kind happened, the offender would find himself stuck permanently in the material world, deprived of the chance of salvation. I wondered whether lustful thoughts were a particular worry among the Brothers, or whether, like beans, they had been the subject of a revelation. Some of the other Brothers, who, after the snail incident, were beginning to take an interest in us, were a little more hopeful, particularly Gordian, who said:

"Don't give in to your imagination, and don't try to battle alone. Share your thoughts with me. There is nothing the Devil likes more than secrets. I will be your confessor any time you need me."

Gordian was one of the new initiates, only a few years older than we were, and I thought his offer presumptuous. Nicholas evidently did not, for one morning as we met between our cells, he confided in me.

"I have been tormented by evil thoughts."

"What kind?"

"The kind Simon warned us against."

"Lustful ones?"

"Exactly."

"Were they memories or imaginings?"

"Surely you don't expect me to do the Devil's work for him by describing my thoughts?"

"There is nothing the Devil likes more than secrets," I

quoted hopefully. I too was being tormented by lustful thoughts, though they were confused and fragmented.

I had thought of Nicholas as a friend, and had admired his certainty and sense of purpose. As his longing for perfection intensified, I found that I admired him less. But as work made me more at ease with my body and its needs, I desired him instead. I remembered the time he had watched me bathe. He had found my unwashed body distasteful, or so I thought. Even so, I had found the attention he gave me oddly pleasurable. And I had wondered since whether his disapproving expression had masked a passion he was trying to suppress. Had he secretly shared my pleasure? Was his talk of Origen's castration an attempt to drive off unwelcome desires? I hoped his thoughts were about me.

"You are quite right," he said. "As it happens, I have shared my thoughts,"

"Who with?"

"Brother Gordian."

"You confessed your thoughts to him? Was he shocked?"

"Not at all, in fact he said that he too had lustful thoughts, and that if I knew them, I would be the one who was shocked."

"He didn't describe them?"

"No. But he hinted that if I am troubled again he will comfort me by revealing his own imperfections."

"These thoughts of yours, you still haven't shared them with me."

"I couldn't possibly. I've already shared them. To spread them would be doing the Devil's work."

"Don't you trust me?"

"I don't want to contribute to your downfall."

"What downfall? Surely we are both following the same path?"

"You still seem attached to worldly things. Your unhealthy interest in the details of my temptation proves it. I will discuss the problem with Gordian next time."

"You are expecting to be tempted again?"

"Of course. The Devil is unlikely to leave me alone for long."

I was disappointed that Nicholas was keener to share his thoughts with Gordian than he was to share them with me. He had obviously lost interest in our friendship, as well as in our work, and seemed to think himself more worthy of being made perfect than I was.

Each night, as I lay in my cell, its decoration invisible in the dark, I dreamed that Nicholas might overcome his objection to work and share my pleasure in physical activity. I imagined him stripped and sweating in the sun. We would work together, his muscles firming, his skin darkening. Nearby was the river. It ran through the dry land, bringing with it hopes of succour. It splashed and gurgled while we worked, reminding us of its soothing coolness. Under its influence, Nicholas would not be aloof. Perhaps, after our work, he would take me to the river. We would bathe together, dipping and ducking each other, taking pleasure in our nakedness. There would be no need to explain: he would understand everything. He would wash me down, his hands soft and gentle. He would hold me, support me, letting the river caress my body. All my longings would be washed away. All obstacles to our happiness would be dissolved. We would be borne away by the current, carried downstream until we floated in an ocean of love.

But when I woke, I knew that we would do none of those things. For Nicholas, to be aware of his body was to be reminded of mortality and imperfection. My thirst for him would never be quenched. He would never join me in the river.

Instead, he dodged work as often as possible, spending time with Gordian, hardly speaking to me. Sometimes they shared a cell and kept nightly vigils. That was necessary, Nicholas said, to keep lustful thoughts away. I felt betrayed. I could not help wishing that he had asked me to share his vigils. My own nightly visitations did not diminish, though I tried to drive them away with work. I woke early and cut wood, stacking it in empty caves. I spent days clearing ground and piling stones, and cutting channels that would let the spring floods irrigate the crops. I avoided, as much as possible, the Abbot's course of

instruction. But the work only made things worse. Far from exhausting me, or driving out unwanted thoughts, each blow of the axe or pick seemed to strengthen, and make more urgent, my desires.

I resolved to tell Nicholas exactly how I felt. Surely, if he knew, he could not treat me so badly. One evening, at a time reserved for contemplation, I went to his cell, and, finding him alone, confessed that my feelings for him were, like those of the saints whose lives I had read to his mother, more than brotherly. Though initially annoyed at being disturbed, he was gratified by what I said.

"It is quite understandable," he said. "I am a little older than you, and, if I may say so, more serious. It is quite natural that you should admire one who sets you such a good example."

"Of course, I do respect the example you have set," I said, insincerely, "but . . . "

"But?"

"You don't understand. The feelings I have for you are more that just admiration."

"Yes?"

"They are lustful."

"You have lustful feelings? For me?"

For a moment, I thought he looked pleased, and perhaps he was flattered by my confession, but his habitual expression of disapproval quickly returned.

"Those feelings are unnatural," he said. "You must know that."

"They seem quite natural to me."

"They are an abomination."

"But what about your own lustful thoughts?"

"They were not my own, but sent by the Devil to tempt me. Besides, there was nothing unnatural about them."

"Then why do you spend so much time with Gordian?"

"That is entirely different. We have formed a spiritual bond."

"But you share your lustful thoughts. You told me so."

"Only so that the Devil can be defeated. Soldiers must share intelligence of the enemy."

"I don't believe you. I think you feel the same way about him as I do about you. But you are not honest about it. You are afraid of not being thought perfect."

"You are quite wrong. With Gordian's help, I will soon achieve perfection."

"You will never be perfect," I said, my desire suddenly turning to hatred. "You are too full of pride and hypocrisy."

"You are an abomination!" he shouted. "You are an indulger in unnatural lusts. The demon of lust will never be driven out of you."

I could think of nothing more to say. I went to my cell and brooded, full of conflicting emotions more disturbing than any the Devil might send. I slept fitfully, dreaming that the river had turned into a torrent. It gushed through narrow chasms, tearing me from Nicholas, dashing me against sharp rocks, tumbling me over, almost drowning me. I emerged, not in an ocean of love, but in a seething cauldron of lust. I swirled in foul water, surrounded by decomposing sinners, prodded by tridents, nibbled by loathsome sea creatures, churned and simmered until all my flesh was gone, and there was nothing left of me but bones.

The next morning I returned to my work, but without enthusiasm. I decided that in the spring I would leave the Brotherhood.

At first, I wandered. I discovered that the rocky landscape of Cappadocia was much bigger than I had suspected. It was also full of religious communities. Many were small groups of monks innocently working and worshipping, but I also found:

- A monastery full of criminals, prostitutes and actors, who were very convincing about wanting to be saved from their sins.
- Solitary hermits, who fled when approached.
- A group of deserters from the army, who had hidden their weapons, and were trying to look as monastic as possible.
- Some fanatics who practised extreme forms of self-denial,

including flagellation and the wearing of hair shirts and chains.

- What seemed to be a comfortable, though well-fortified, country house, lived in by a group of gentlemen, attended by several slaves, who insisted that they were monks.
- A mixed community in which the women dressed and worked like men, with whom they shared cells. Their leader thought it no achievement to be celibate unless nightly tested.

I stayed with some of those groups. Most offered food and shelter for a day's work. Sometimes I stayed for several days, until peculiarities of each community became oppressive. The last group was the oddest, though that was not obvious when I first saw them working their fields. I did not notice the women at first, taking them for boys or eunuchs. Not that I had seen a eunuch before, but, not having seen much of women either, that seemed the likeliest explanation for their beardless, but not particularly young, faces. After a day of hacking at the dry ground with a mattock, and piling up the unearthed stones into rough walls, I was glad to share even the thin porridge that formed their main meal. After eating, the tables were pushed aside, and, in the same large chamber, to which all the cells communicated, we had prayers. The sermon, if the leader's ramblings could be called that, was about lust, though it was hard to tell whether he was savouring or condemning the eroticism of the many verses of the Song of Solomon that he read to us. It was not a text I had been encouraged to study at school, and the richness of its imagery confused me. I listened to lists of flowers, fruit, jewels, perfumes, ointments, birds and animals, precious woods and metals. All these suggested unimaginable opulence, contrasting with the simple chamber we stood in, and were presumably teasing, riddling allusions to women's bodies. But why should a woman be like a flock of sheep or a team of horses? How could her body resemble a walled garden, a palm tree, or a sealed fountain? And why should her kisses be like wine or honey?

My puzzlement was only increased when, after a few moments of silent contemplation, the leader asked us to "assume the state of nature". The others undressed and stood about awkwardly. I was obliged to follow their example, and, for the first time, when I looked up from the floor, I saw naked women. Their bodies did not resemble any of the things they were compared with in the verses we had just heard. The leader called out names in pairs, and those called went into the cells where they would share the night, and the struggle against lust. Merely to resist lustful thoughts was not enough, the opportunity must exist for their realisation. Only if the opportunity was not taken could the candidates for virtue be said to have succeeded.

My partner was a woman, perhaps ten years older than I was, scrawny and rough-skinned. "I am Pelagia," she said, as though there was something significant about the name. She said little else that night. The sun had burned her but she was not black or comely. Her eyes did not resemble fishpools, her breasts were not like clusters of grapes, nor was her belly like a heap of wheat. She glanced at me hopefully as she led me into one of the cells, but I could not help noticing that she did not smell of apples, nor of spikenard, camphire or myrrh. I do not suppose I looked or smelled any better than she did, but that did not occur to me at the time. Instead, I wondered what was expected of me. Was I supposed to submit, or resist? I felt no desire for Pelagia, and knew that I would not be tempted. But I did not want to hurt her feelings, offend against the conventions of the community, or make a fool of myself. If she expected me to give in to lust, what would I do? If a struggle against lust was to take place, how much, and how visibly, should I struggle? Even if utterly virtuous, she might be insulted by too easy a victory.

We lay down together on a pile of loose straw, a thin blanket pulled over us. Beyond the cell I could hear the sound of rustling straw as other couples settled into their cells. Pelagia mumbled something, wriggling gently, rubbing her leg against mine. I lay still, trying not to respond, listening to the gentle murmur of prayer as other couples began their struggle

by calling on God to help or protect them. Pelagia took my hand and held it against her breast. Though flaccid, it seemed superfluously fleshy. I withdrew my hand, but she took it again, guiding it between her legs, writhing against me. But the moist, mossy hollow I felt was far from alluring. Was that the sealed fountain? It reminded me only that she lacked what I most desired. She was not Nicholas, or like him. Had she been beautiful, perfumed and bejewelled, I could not have desired her. I remembered other images from the Song of Solomon, but they were too absurd to be arousing. When she grasped my penis it did not stir or stiffen.

I lay limply, hoping she would be discouraged. But she waited only a moment before climbing on top of me. She was surprisingly strong, and pinned my arms down with hers, leaving me helpless when she straddled me, pressing her ripe flesh on mine. But whatever she wanted, I had no wish to continue the struggle.

"We must resist," I said, pushing her off me, hoping she would mistake my failure for virtue. I rolled over, pressing myself flat against the straw pile, letting the dry stalks prick my body and drive away the memory of her touch.

Outside our cell the struggle continued. I could hear sighs and groans, cries and whimpers, warnings and exhortations, and more prayers. Our Lord was called upon often, and loudly. Though used to the nocturnal noises of a dormitory full of boys, I had heard nothing like the sounds of that combat against carnality. At least Pelagia had been quiet. I lay for a long time, trying to reconcile what had happened, and what I heard going on around me, with my feelings for Nicholas.

4

BASIL

A.D. 619–622

The valley was like many others, white-cliffed and flat-floored, scattered with neglected orchards and long-abandoned gardens. At the end, where the land sloped up slightly, catching the morning sun, was a less neglected, though not well-tended, garden. Above it, halfway up the cliff, was Basil's house. Its facade was carved into the rock, with columns, blank windows and a large ornate doorway. On either side were two gigantic figures, dressed in the costume of a forgotten civilisation. It was clearly a tomb.

Basil was pruning his vines when I arrived. His grey cloak lay on the ground, and the sleeves of his tunic were rolled up. He was using a short, hooked knife to cut off most of last year's growth, leaving only a main stem and a few branches, from which the new shoots would soon begin to grow. He spoke as though he already knew me but could not quite remember who I was.

"Do you like my house? Rather sinister isn't it? It puts people off. It's just as well. If it was more welcoming I'd be pestered all the time by the sick and superstitious."

He was of medium build, broad-faced, bearded, and apparently quite cheerful, though there was something sceptical in his expression. Made wary by my monastic tour, I asked him about his way of life.

"During the day I cultivate my garden. During the night I cultivate my library." That turned out to be an exaggeration. Much of each day was devoted to study, and he only gardened when he had to.

"Are you ill?" he asked, giving me a curious look.

"No."

"Good. Sometimes I tire of ignorant monks and filthy peasants coming here to beg remedies."

He turned back to his vine, and pruned a few more shoots. Then he looked up and spoke again.

"What do you want? And while you are telling me, perhaps you might help by bundling up these prunings."

I had not prepared a speech, so I got to work, collecting the prunings and tying them into bundles with twists of dry grass. They are useful for kindling, and are good for grilling fish. While I worked I told him a muddled version of my recent life, stressing my thwarted desire for Athenian knowledge, but not mentioning Nicholas. I flattered Basil by telling him how often I had heard his knowledge and wisdom praised in the communities I had visited. He did not say much in response, so I carried on with my work until, an hour or so later, Basil stopped, and said that it was time to eat. We sat on the tomb's steps and ate bread, cheese and olives.

"So, the book-thief sent you," Basil said, when he had finished eating.

"The book-thief?"

"Your Abbot, Simon. He paid me a visit a few years ago, about a medical matter that we needn't go into. While he was here he stole a book. A very rare one, *The Key of Truth*, an old Gnostic text. Full of nonsense, of course, but interesting. It explains Porphyry's theories on the magical powers of music and diet, among other things. I hear he tried to put it into practice and half his followers left."

"I believe so."

"What does he want, another book?"

"No. He didn't send me. I came of my own accord. I want to learn. I want to become your pupil."

Basil looked me in the eyes, and I had the feeling that, for the first time, he was taking me seriously. He seemed to be judging me, comparing me to some standard that only he knew. "What can you do for me?" he asked.

"I can cook," I said, "and garden, catch fish, gather wood, repair buildings . . ."

"That's enough. If you really can do those things I can certainly find work for you here."

"Will you teach me?"

"No, but you will learn."

Basil stood, and brushed the crumbs from his tunic.

"You had better see inside," he said, and led me up the steps, into the entrance. We stood between the two huge statues and looked back, along the valley. "It was empty when I came here. Someone had lived here before, though. They must have cleared the land and planted those fruit trees and vines." He turned, and stepped into the darkness, pulling his cloak around him. The interior of the tomb was chilly. "This is the vestibule." He gestured to the winged and bearded figures cut into the walls. "Interesting carvings." He gave me no time to admire them but swept aside a tattered curtain, revealing an arched entrance. "This is the main chamber."

I followed him, expecting even greater darkness, but the chamber was lit by several small windows cut high up in its curving walls. Dust shimmered in the light, which slanted across the room, striking the floor near the far wall. The chamber was as big as a small church, and lined with alcoves that had once housed the dead.

"Where are the bodies?" I asked, my voice echoing eerily.

"They were gone when I got here. I expect someone stole the sarcophagi. Look at the quality of this carving."

The walls were divided into panels by mock-wooden beams, and decorated with carvings of animals, fruit, and everyday objects such as furniture and cooking pots. Whoever did the work obviously wanted the dead to feel at home.

"That's my room," he said, pointing through a small arch. "You can sleep here." He showed me another chamber, with two empty alcoves and a small air-shaft that let in a glimmer of light.

"You'll need a lamp," he said. "And some bedding."

We went outside, and he helped me collect some dry grass, which we bundled into a rough mattress and carried to my room. Then he wandered off, leaving me alone. Warily, I explored the tomb. There were three arches at the far end of

the main chamber. The rooms beyond them were small, dark, and littered with fragments of fallen rock. I could just make out a few dim shapes, perhaps sacks or bundles. Basil's room was larger than mine, but no more luxurious. There was little furniture in the main chamber. A couple of folding stools and a tripod table seemed to serve Basil's needs. The rest of his possessions were stacked in the alcoves that had once held sarcophagi. Some held practical items: tools, cooking pots, and a few clothes. There were urns and jars, some of which contained food or oil, while others were filled with dried herbs and spices. One alcove obviously served as a scriptorium, and was filled with bundles of papyrus, pen-reeds, pots of ink and blocks of wax. The contents of other alcoves were puzzling. I found wooden chests, carved figures, a pestle and mortar, and glass bottles of dark, viscous liquids. There were sealed flasks, jars containing crystals or coloured powders, lumps of metal, and oddly coloured rocks. Among the jars were petrified bones, shells, and rocks imprinted with the shapes of fish or sea-creatures. There was a steelyard, such as market traders use, a smaller bronze balance, and many things whose use or nature I could not guess. Scattered everywhere, apparently at random, were books.

I wandered the chamber, picking up books and opening them. There seemed to be over a hundred, though I never counted them. Basil must once have been a rich man. Most were in Greek, but some were in Latin, and a few were in other, unfamiliar languages. As I browsed, I found books of philosophy, theology, poetry, mathematics, medicine, geography and history. I realised then how limited my education had been. We had only been allowed to study the writings of the pagans in anthologies, from which anything objectionable was excluded.

I picked up Xenophon's *Persian Expedition* and carried it over to the light. I had enjoyed passages from Xenophon at school, so I sat and began to read. I was soon absorbed in the world of a thousand years ago, when the Greeks fought each other, and were hired to fight for the Persians. I read of the gathering of the Ten Thousand, and their march through Cappadocia to Tarsus. I could easily imagine their passage through the Cilician Gates, a narrow ravine I had passed with

Nicholas a year earlier. I was still reading when Basil returned, carrying a skinned rabbit.

"Are you enjoying that?" he asked.

"Yes."

"It is a good story. Some of it may even be true."

There were only two of us to feed, so the work was not hard. I helped finish the pruning, and cleared some land for vegetables. As the weather grew warmer, I spent much time reading on the steps of the tomb. From there, I could look along the valley, imagining it to be places I read about. I finished Xenophon, then read Arrian's account of Alexander's conquests. Victory over the Persians was a poignant theme. I daydreamed about victories in exotic places. I tried other historians. Thucydides was full of endless speeches, incomprehensible wars and obscure language. The stories of Herodotus were wonderful, though hard to believe. I also read a more modern historian called Procopius. His account of Justinian's war with the Persians provoked more daydreams, but when I spoke to Basil about the greatness of men like Alexander and Justinian, he showed me another book, also by Procopius. This was a secret history, full of scandal and gossip. It was impossible to believe that its depraved characters were the same people as the noble heroes of the official history. Basil implied, without revealing anything about himself, that history was like that. He did not seem old enough to remember the time of Justinian.

Though remote, the tomb was not isolated. Basil's reputation brought visitors, mostly from the monasteries, but also from cities such as Caesarea or Iconium. Patients often brought a little food: fruit, vegetables, eggs, oil or cheese. Other visitors brought news. Soon after my arrival we learned that the Avars were besieging the capital.

"Could they really capture Constantinople?" I asked, having read in Procopius of the city's impregnable walls.

"Not unless they join forces with the Persians. The Avars are nomads. They are good at skirmishing, but not sieges. You need machinery for that. Catapults, and so on."

Seeing that I was interested, Basil found books and maps,

and began to teach me geography. He showed me the shape of the world: a circle, bounded by the Ocean, with Jerusalem at its centre. Once, he explained, all the lands around the Mediterranean were Roman, and the barbarians were confined to the world's inhospitable fringes. He pointed out Gaul and Spain, now overrun by Germans, and Italy, wrecked by the Lombards. He showed me Egypt, Syria and Palestine, once the Empire's richest provinces, lost to the Persians, just as they had been a thousand years earlier, in the times Herodotus described.

Little was left of the Empire, but the Emperor Heraclius was rumoured to be hiding in his palace, struck down by melancholy, unable to do anything about the Avar siege. Could his incapacity be a punishment for his incest?

"Character and circumstances are what determine a man's actions," Basil said. "Heraclius has a peculiar character, and he is in impossible circumstances. He is what medical men call a melancholic type. His nature is out of balance. Sometimes, when circumstances are with them, men like him have fits of activity, and can achieve anything. At other times, when things are against them, they sink into melancholy and pessimism. Think about it. He was offered a great chance: depose Phocas and become Emperor. He had everything to gain, and circumstances were with him. Everyone was sick of Phocas and his tyranny. But once Heraclius was crowned everything turned against him. There was no money in the treasury, Phocas had spent most of it, and sank the rest in the Bosphorus when he tried to escape. Then the Persians scaled up their invasion. Then his wife died, and he married his niece, Martina. He is certainly guilty of incest, but it's not God's wrath he has to watch out for but the people's. They hate Martina in Constantinople, and if you remember Procopius you will know how dangerous the mob can be."

"Don't you think that God disapproves of incest?"

"I am sure He does, but would He let a pagan king destroy a Christian Empire because of that?"

"There are scriptural precedents." I remembered the smiting sermons I had heard at school.

"Probably, but I prefer to think that God, having made us as we are, leaves us to get on with things. You would have a much better understanding of human nature if you studied Galen and Hippocrates."

Basil's suggestion appealed to me. I was still hurt by Nicholas's rejection, and puzzled by his characterisation of me as an indulger in unnatural vices. He seemed to think such people a particular type, to which I belonged, though I had not actually indulged in any vice, unless mild self-pity can be so called. I was curious to explore human nature, especially if it could be done in the safety of a library.

Beginning as advised, I discovered that the two founders of medical knowledge believed that disease had natural causes that could be deduced by observation. Most illnesses, it seemed, could be cured by removing the cause, usually by correcting diet or adjusting the environment. Sometimes herbs and drugs were useful, but not as often as was thought by the ignorant. Human nature is derived from the balance, or otherwise, of the four humours, which are:

- Blood, which is hot, sweet, red and temperate
- Phlegm, which is cold and moist
- Choler, or bile, which is hot, dry and bitter
- Melancholy, which is cold, dry, thick, black and sour

There is nothing supernatural or demonic about the humours, they are just natural bodily fluids, which are affected by diet, climate, season and exercise. Chronic imbalances of the humours, which we all have to some extent, give us our moods and characters. An excess of melancholy, depending on its degree, can lead to sadness, apathy, mania, despondency or delusion.

Basil understood the humours well, and was able to diagnose the state of anyone's health just by careful observation. When he had looked at the colour of the patient's eyes or tongue, watched them walking, listened to their breathing or the rumblings of their guts, or felt the heat and texture of their skin, he knew which of the humours predominated, and

which were lacking. From that, he was able to prescribe what was necessary to restore order, which was usually a correction of the patient's diet, but could be fresh air, cold baths or exercise. A change of climate was sometimes needed, but seldom possible. For some complaints, such as those of the stomach, Basil would prescribe simple medicines, such as mint or fennel, but he preferred to give advice on how the patient's life could be brought back into harmony. Despite that, patients were seldom satisfied unless they went away with an actual remedy. Mere advice was not enough, and implied fault in the patient's life.

Considering these theories, I was reminded of fish soup. I had watched fishermen making it, several times, on my failed journey to Athens. Each soup, though beginning with roughly the same ingredients, was unique, the result of a distinct combination of circumstances. One type of fish might dominate the catch, or remain largely unsold. Others might vary with the seasons. Vegetables might be unavailable, or in poor condition. A successful crew might add costly spices, an unsuccessful one make soup with little but heads and bones. Even if a skilful cook attempted to replicate a soup admired the day before, it is unlikely that he would be able to do so.

I concluded that our imperfections are the result, not, as Nicholas seemed to believe, of insufficient firmness of purpose, but of our humours, mixed and heated in the womb, altered by circumstance, moderated by climate and diet, but essentially beyond our control. That may seem a complacent view, and perhaps it is. But, knowing that some would condemn me for my desires, I think it best to judge others, if at all, for what they do, not for what they are.

My speculations were undermined when I came across the theories of the Atomists. I sat in the main chamber, reading by lamp-light, which cast shadows among the fruit and vegetables carved around the niches. The book was a compendium of summaries and quotations from various authors, most of whom seemed out of sympathy with the theory of humours. It seemed, from the book's muddle of assertions and refuta-

tions, that there was a philosopher called Democritus, who explained everything in terms of invisible particles called atoms. These, in their different forms, arrangements and movements, make and determine everything. Following him, Asclepiades denied the existence of humours and explained illness in terms of these atoms, whose state, compressed or extended, still or moving, determined the condition of the body. As I read I felt confused and uncomfortable that what I had so recently struggled to absorb was being refuted and devalued. I asked Basil what he thought. After a moment he said:

"Can you see these atoms?"

"No."

"Then can they exist?"

I looked at the book, and replied: "There is an extract from Lucretius here. It says that, just as we feel the wind, and see its effects, without seeing the wind itself, so we can see the effects of atoms without seeing them."

"What is wind?"

"A stream of windy particles?"

"No! Wind is air, pushing as it flows, like water."

"But air is nothing, how can it push?"

"Let me show you what air is." Basil went outside, then returned with jug of water, then found a bowl and a glass beaker. He stood the bowl in a low niche, brought a lamp near it, and half filled the bowl with water.

"Observe!" he said, as he inverted the beaker and lowered it into the water. "What do you see?" he asked.

"The water rises," I said, remembering the story of Archimedes and the crown.

"Why does the water rise?"

"Because the beaker takes up space, and the water moves to make room for it."

"No! Let's try again. This time he lowered the beaker in sideways, so it filled with water, then sank. The water did not rise much. He removed the beaker and repeated the first experiment. The water rose more.

"Now what is making the water rise?"

"The air. It must take up space like the beaker."

"Precisely! Now watch." He tilted the beaker slightly so that a large bubble escaped. "Now what do you observe?"

"A bubble."

"Which is composed of what?"

"Air."

"Yes, air. We have just made some observations. Nothing new, but apparently you haven't thought about what you have seen before. You have observed air taking up space, and passing visibly through water. Normally we don't notice air, but it exists. The world is made of four elements: air, water, earth and fire. They mirror the humours in us, and, in the form of climate, season and food, they affect the humours. The practice of medicine confirms that. We don't need these invisible atoms to explain the world. Let's stick to what we can observe, and what can be deduced from that."

I felt stupid again, and no less confused. If it was all as simple as that, why did those old philosophers, also presumably beginning with observation, arrive at such different conclusions? And what of the teachings of the Church? I thought for a while and said:

"The ancient philosophers-they were all pagans weren't they? How do their ideas fit in with ours? After all, we can't see God."

"Galen and Hippocrates fit in well with Christian ideas, despite their paganism. God made us with bodies, and organs, and vital fluids, as can easily be observed. He also made the world out of elements. There is no mention of atoms in the Bible, and the Atomists tended to atheism. For them, everything was determined by atoms, and there was no need for God. And as for not being able to see God, remember the example of the air."

"You mean that we can see God through His effects."

"Something like that. But if I were you, I wouldn't mix up God and philosophy, not publicly anyway. That's why I had to leave Constantinople." It was the first time he had mentioned that, or anything much about his past, and I could not resist asking him about it.

"I used to be a professor of philosophy at the university," he said. "It seems to have closed down now, but this was before you were born. There was a lot of trouble with the students. Some were rich men's sons, preparing themselves for a career in the Imperial administration. They were not profound scholars, but they were no trouble. They just wanted to appear cultured. An elegant style and a good stock of quotations were all they needed. They came to my lectures to pick up a few names and ideas to drop into their conversation. There were no real pagans among them, but their old-fashioned style looked pagan to some. They spent more time at the races, or hanging around the brothels, than they did studying, but they were always well behaved in lectures. The trouble was caused by the poorer ones. Some of them were not much more than peasants, sponsored by their local churches. They were sent to Constantinople with a little money, and instructions to learn as much as they could. They didn't like what they found in the city, and organised themselves into various societies, secret or otherwise. Some were content to live like monks. It saved money, and they could concentrate on their studies. But others wanted to interfere. The curriculum wasn't Christian enough for them. They were Christians, living in a Christian Empire, and they didn't see why they should have to study anything that wasn't written by Christians. The fundamentalists started to get the upper hand. They would disrupt lectures by heckling, or reading out sections of the Bible. Other students, who might have preferred to get on with their work, dared not say anything, for fear of being accused of paganism or heresy. Even the richer ones had to go along with it, as they could easily be condemned for unchristian luxury. It got to the point where it was almost impossible for me to teach. My lectures would either be nearly empty or full of fundamentalists shouting 'pagan' at the mention of any philosopher."

"In the end it was the book-burning that scared me off. The fundamentalists started to pick off the professors they didn't like. They raided their houses, dragged out their books and burned them. Sometimes they found, or claimed to find,

books that were not so much philosophical as magical. A couple of professors were accused of devil-worship and badly beaten up. The authorities could not ignore the trouble, but rather than punish the fundamentalists, they took their side, and banned all mention of pagan books or writers. That made my teaching impossible, and I decided to get out while I still had my books. "

"Does that mean," I asked, "that you are not a Christian?"

"Of course I'm a Christian. What else could I be? Paganism is nonsense, just myth and superstition. At least Christianity more or less explains things."

"In that case why did you teach pagan philosophy?"

"The philosophy wasn't pagan, just as it wasn't Christian. Philosophy is a thing in itself, and has to be pursued for its own sake. It has to begin with what we observe, not with faith."

"Why couldn't they see that?"

"Perhaps they could. That may have been the trouble. There would be no theology, Christian or otherwise, without Plato. And some of the philosophers, the Stoics or the Cynics for example, were quite puritanical. Christianity has revived their morality, especially in sexual matters. Epictetus, the Stoic who taught Arrian, whose histories you admire so much, is a perfect example. He believed in celibacy, especially for teachers, and his ideas could guide any monk, but were derived from reason. Perhaps some Christians are uncomfortable with that, and prefer to think morality can only come through revelation."

That conversation was the nearest we got to any sort of personal revelation. I never mentioned my feelings for Nicholas, and Basil made no further disclosures about his past. As far as I could tell, he had long been celibate, and had overcome, or hidden, that part of human nature that had made me so unhappy. Though Basil advocated the study of human nature, we only discussed its sexual element in the most philosophical of terms, and I remained confused about my own nature and desires. I had no choice but to be celibate, and, in an effort to reconcile myself with that state, considered the

justifications for it. There were many, but some seemed paradoxical.

The Church teaches that the sexual act is shameful, but that parenthood, its result, is not, though both are irrelevant in view of the imminence of the Kingdom of God. Heretics like the Abbot Simon forbid even thoughts of lust, but only in order to achieve an earthly perfection in which sin is impossible, and anything permitted. The Stoics valued the calm celibacy brings, and preferred to avoid excess, but also taught that we should accept what nature decrees. Both monks and Stoics try to diminish desire, by contemplation, prayer or diet, but nature usually triumphs. Despite my momentary doubts over atomism, I had come to believe that our natures are fixed at conception, by the mixture of our parent's humours. If we are unbalanced by an excess of hot humours, that is bound to be expressed later in sexual desire. But what determines who we desire, and how? Is that, too, determined at birth, or by circumstances?

Though my desire for Nicholas had faded, I still felt desire, and knew the nightly visitations of lustful thoughts.

I stayed with Basil for three years, during which I continued my reading, and learned some of the practicalities of medicine. He was, I suppose, like a father to me, as well as a teacher, though my own father was never as tolerant or encouraging as Basil. I feel guilty when I remember how I abandoned him. Now that I am old and infirm I know how good it is to be attended by one's friends and pupils. I should not have left Basil, but I was young, and the outside world, from which I had been so sheltered, began to seem more interesting than that isolated Cappadocian valley. In the spring of 622, the warming weather brought visitors and rumours. We heard that a fleet was being assembled in Constantinople, and that the Khan of the Avars, after accepting enormous bribes, had signed a peace treaty, and withdrawn his hordes from the city's walls. Shortly after Easter, an old man arrived at the tomb asking for treatment. He was simply dressed in a dusty tunic and brown cloak, and was obviously poor. Though Basil

77

sometimes sounded as though he disliked his patients, or at least resented the time they took up, I never knew him to be anything but polite, or to refuse treatment, when one arrived. He asked the old man what was wrong.

"It's my stomach. I keep feeling sick, and getting pains."

"What do you eat?"

"The same as everyone else. Bread, porridge, fruit and vegetables. A bit of cheese when I can afford it." It was frugal, but healthy enough.

"How are your bowels?"

We were given a lengthy description of their state.

"Lift your tunic."

Basil listened to the man's stomach and heart, then pressed and rubbed his abdomen, feeling for heat or lumps. Then he examined the patient's eyes, mouth and tongue.

"I can't see much wrong. Perhaps you should eat a bit more fruit. I know Galen is against it, but I've always found it helpful myself. Providing the fruit is ripe of course."

"I eat plenty of fruit. There's nothing wrong with my diet that a bit of money wouldn't cure. It would be good to eat meat now and again."

"I can't prescribe money. And more meat might not be an improvement."

"Can't you give me anything?"

"You could try ginger. Or cardamom. Both are good for settling the stomach."

"How can I afford them? I'm a poor man."

"Wait there," said Basil, and went into the tomb.

I was left with the old man, who was restoring order to his clothes.

"Where have you come from?" I asked him.

"Caesarea."

"What's it like there?"

"Better, since the Persians left."

"What's the news?"

"They say the Emperor has left Constantinople."

"Where's he gone?"

"Cilicia, they say. He's calling up an army."

"Do you know where?"

"Issus, I think." It was at Issus that Alexander had defeated the Persians nearly a thousand years before. And Issus was further east than Tarsus. The Persians must have withdrawn from my birthplace.

Basil came out of the tomb with a small bag, which he gave to the old man.

"Ginger and cardamom, freshly pounded. Take a pinch when you need it."

The old man took the bag, muttered a few inaudible words, and began the trudge back to Caesarea.

I told Basil the old man's news, but he seemed unmoved. He had heard enough of what he regarded as the follies of the age. But I became so restless that I could think of nothing else. The world was waking up. I was twenty, and had done little except study. Not far away, an army was assembling to invade the East, and young men like me would soon be doing all the things I had read, and dreamed about. My nightly thoughts became more martial than lustful, though sometimes they were interestingly confused. I spent the sleepless parts of many nights debating with myself. Should I stay with Basil, sharing his exile, or should I go out into the world and do something? He seemed sure that the world had little to offer, and that there was nothing worth doing. But he, as I was beginning to realise, had been embittered by his experiences in Constantinople. He had retreated to a world of books. I had shared that world, but my reading had fed my dreams. I decided to leave Basil's valley and find out whether what I had read of the world was true.

Basil accepted my departure in a manner that I suppose is appropriate to call philosophical. He gave me the *Persian Expedition* and the *Campaigns of Alexander*.

"You might need them," he said. "They'll make good guide books if you get that far." He also gave me some food and money for the journey.

5

WAR

A.D. 622

I was not, as I had so confidently expected, enrolled as a soldier. When the recruiting sergeant discovered that I could read and write, and knew Latin as well as Greek, he sent to me to the Intelligence section, where I was set to work copying and translating reports. As well as the tedium of my work, I had to endure the hostility of my ill-educated fellows, and the nagging of the chief clerk, a small thin man, who, like me, seemed bitter not to be a soldier. It was such a disappointment that I considered running away and rejoining Basil in his safe and distant valley. But the army, constantly drilling in the dusty plain around the camp, and swelled by daily drafts of new recruits, made that impossible.

It was a relief when, several months after my arrival, the camp was put on alert, and the Emperor announced that the war against the Persians would at last begin. But my relief was short lived. Once the army set off, the misery of marching was added to the drudgery of clerking.

We marched for weeks, sometimes chasing the Persians, sometimes trying to avoid them. Each night we dragged the document chests from the wagons, set up our portable office, and worked by lamplight on the day's reports. When we reached the mountains of Pontus there was a battle, and the Persians were defeated, though not decisively. But I saw nothing of the fighting, being confined to camp. It was not war as I had imagined it. For me, the only notable result of all that first campaign was that I met the man who was to become my patron, and, if I do not flatter myself too much, my friend.

It happened towards the end of that autumn, as we set up camp in a stony plain near a tributary of the Halys. While we

unpacked, a messenger told us to stand by for a visit from George the Pisidian, who wanted some information.

"George the Pisidian!" said the chief clerk. "He's the Emperor's chaplain. We don't normally see his sort here. We'd better make ourselves look busy." He fussed and worried while we arranged everything, then made us stand in line, as though on parade.

George was rather fat, and dressed, much more grandly than anyone we usually met, in tailored and embroidered silk. His manner was neither military nor clerical. He seemed almost to bounce into the tent.

"Good evening boys, I'm told you can help me."

"Certainly Sir," the chief clerk said. "Just tell us what you want."

"As I expect you all know, I am a poet. In fact *the* poet of this expedition." He did not seem particularly poetic. I suppose I thought that poets should be grave or noble in manner, saying little that was not perfectly composed. George had a cheerful expression. Both his dark eyes and his bald head seemed to shine, and he beamed at the clerks as he waited for a response. There was no reply, so he carried on.

"I'm composing a poem at this moment. The *Heracliad*, all about our heroic Emperor and his great victory." He began to declaim:

> "When the army was filled with dread of the Persian,
> When their manner of battle was flight from danger
> And this had become second nature by use:
> Who turned their hearts to war and clad them in the armour of his eloquence?
> Who changed their craven souls,
> And from their cowardice brought out courage?"

The clerks stared at their feet, not understanding this quasi-antique style, or able to guess how long the recitation would go on. I thought the verse not entirely fair to the army, who seemed quite keen to fight, though it might have referred to an earlier period. In spite of these doubts, I saw my opportunity, and took it. I quoted:

"So high his brazen voice the Hero reared:
Hosts dropped their arms, and trembled as they heard;
And back the chariots roll, and coursers bound,
And steeds and men lie mingled on the ground."

"Very good!" George said, though he looked puzzled. "Very apt, comparing our illustrious Emperor to Achilles. I must remember that. Do you know the whole of the *Iliad*?"

"Most of it, Sir."

"What about you other boys? Do any of you know Homer?" They stared at their feet again, but said nothing. He looked at me and said:

"You'll do. You can help me with my poem. Come to my tent in an hour with all the papers relating to our march. I want to know routes, places, times and any other useful facts."

Then he went, leaving me to face the rest of the clerks.

They accused me of creeping, snobbery, showing off and thinking I was superior to the rest of them. Though I denied it, I knew that I was guilty of every charge. Only the chief clerk seemed pleased that someone else would have to find the required information and waste time explaining it to the chaplain. Poetry did not seem to fit in with his orderly approach to work. We quickly found some relevant documents, and I set off for the chaplain's tent, followed by obscene taunts about what I might be expected to do there. When I found the tent, guards let me in, and I found George sitting at a small tripod table, at which he was writing. His tent was much richer than any other I had seen, and was furnished with rugs and a folding bed. I offered him the papers, but he did not take them, so I stood awkwardly for a while, not daring to look him in the eye, gazing down at his soft, embroidered boots and the rich pattern on the hem of his tunic. I had never seen such luxurious clothes.

"You seem very educated for a clerk," he said, when he looked up from his writing. "What else do you know, apart from Homer?"

"I know Latin, some history, some philosophy, and a little

about medicine, and, of course," I said, remembering who he was, "the Holy Scriptures."

"And where did you learn all this?"

I told him about my education.

"I think I could use someone like you. You can help me with my poem."

"It would be a great honour Sir." There seemed little point in not creeping.

"I need to know the details," he said. "This poem is historical. It must describe the campaign, but poetically. I need to know the facts so I can construct the poem around them, though of course they will all be concealed in the epic style. But I'm a busy man. What I need is someone to construct a basic narrative: who, what, when, where and for how long. That sort of thing. A chronicle. Do you think you could do that?"

"I would be very willing to try, Sir."

"Good. Start as soon as you like. Bring me the outline of the campaign so far, when you have finished it."

A week later, I returned to George with the information he had requested. He was pleased with my work, and arranged with the Intelligence section that, in addition to my regular duties, I would act as his assistant. For the rest of the war, I followed George, helping him turn a bare outline of events into courtly verse.

Sometimes, when we marched, I wandered from my usual place and walked among the artillery wagons. They were loaded with beams, slings, ropes and windlasses, or mounted with catapults: huge crossbows for shooting rocks or javelins. I was fascinated by the power of the siege engines, and by the strength of the men who operated them. They strolled beside their wagons with a muscular swagger that implied, for them, the impossibility of mere marching. They seemed as strong as the oxen that pulled their wagons. I did not dare to speak to them. I had still seen nothing of battle, and had resolved that, next time there was an opportunity, I would try to play a more active part. Obviously, without weapons or training it

would be impossible for me to fight, nor did I want to. But I wanted, at least, to see the fighting. Studying the siege engines and their operators, I decided that next time they were in action I would volunteer to help.

At the Armenian city of Dvin we found the gates shut against us, and the walls guarded by Persians and Armenians. Our column was long, and the defenders cannot at first have known the size of the army that approached. As each section arrived, it was deployed, and by nightfall the city was surrounded. Its walls, though impressive, were not nearly as strong as those of Constantinople. I slept uneasily that night, not fearing defeat, the Imperial army was too big for that, but afraid that I would not dare to carry out my plan.

Throughout the next morning, while archers kept the walls of Dvin clear of defenders, the army prepared to attack the city. I slipped away from my fellow clerks and wandered among the waiting troops, watching their preparations. I could always claim to be gathering information for George. All around the city, wherever high ground gave an advantage, or suitable rocks could be found, artillery men were unloading wagons and assembling siege engines. Some were dangerously close to the walls. If our archers faltered they would be vulnerable to attack from the city. I kept looking, until I found a team that had dragged a catapult up a low mound that seemed a safer distance from the arrows of the city's defenders. The leader, a gigantic man wearing a loose red tunic and tight barbarian trousers, was supervising the mounting of the bow. I watched his men as they climbed on the timber frame, tightening the skeins of rope that pulled the great bow's arms forward. They had taken off their tunics, and their backs looked like carved wood, their muscles as tense and twisted as the cords they tightened. Aware that I was likely to be rejected, but keen to take part in the attack, I approached the leader. He turned from the catapult and glared at me.

"What do you want? Not more orders I hope. I'm not moving this thing again."

"I bring no orders."

"Well? What do you want?"

"I would like to help."

"You? Help? Don't make me laugh!" The artillery men laughed obligingly.

"Please. I would like to help."

He reached out and gripped my upper arm, encircling it with his huge hand. "You're not strong enough," he said. "This is what it takes." He flexed his arm, his red sleeve falling back to reveal bulging, knotted muscles.

"I may not be strong, but I am willing," I said. The men laughed again.

"You should be careful what you say. You might give my boys the wrong idea."

I stood silently, looking beyond the catapult, to the massive bulk of Mount Ararat to the south, still snowy at its summit. He thought for a moment. Volunteers ought never to be turned away.

"Can you lift rocks?" he said. I thought of all the stones I had piled in Cappadocia while trying to forget Nicholas.

"Yes."

"Then you can help find missiles. Nilus! Show him what to do."

Nilus had unusually fair hair, and an amiable face, which, though he was as brawny as the rest of the team, made him seem gentler. He led me down the slope to a wide hollow, where rocks of all sizes were strewn.

"This is the size we want," he said, easily lifting a rounded boulder almost as big as my head. "And the smoother the better. We need them up there, and in a pile."

For the rest of the morning we worked, bent double, searching for suitable rocks, lifting them, then carrying them cradled in both arms, up the slope to the catapult. I felt at first that I should talk to Nilus, but he did not share my need for conversation. After he had answered my few, pointless questions, we worked in silence. Others joined us, and the rock pile grew steadily. The sun climbed higher in the clear sky, burning our backs. Sweat trickled down dusty skin, joining to form little rivers, flowing and spreading, making muscles shine like bronze breastplates. An unseasonable sweat, according to

85

Galen, is a symptom of melancholy. But sweat born of hard labour is a sign of health, of the body's ability to achieve harmony by balancing the humours. I kept near Nilus, breathing in his sharp smell, a sign of his vitality, so unlike the ripe reek of Pelagia, the woman with whom my virtue had supposedly been tested. Even caked with dust and sweat, his hair stuck limply to his forehead, Nilus seemed clean, wholesome and desirable.

At midday the leader called a break. We ate dry bread and goat's cheese, and drank eagerly from skins of tepid water. Afterwards I lay among the others, on the soft grass of the newly cleared hollow, watching small clouds drift across the sky. My back ached and my arms were bruised and scratched, but I had enjoyed the work, and the feeling of shared endeavour with other men. It was what I had hoped for when I worked, alone, in Cappadocia. Then, when Nicholas would not join me, I had used work to drive away my desire for him, but had discovered that physical exercise made me more aware of my bodily needs. Surrounded by the naked, sweating torsos of the resting artillery men, I was reminded again of what I had so inopportunely desired. They were so strong, and so at ease with their bodies, and with what they could do with their strong backs and muscular limbs. They were everything Nicholas was not, and I could hardly believe I had found him so attractive. My dreams of bathing with him in the river seemed absurd, though I would happily have bathed with Nilus. But a siege was hardly the right occasion to even hint at what I felt. Afterwards, perhaps, if all went well, there might be an opportunity.

When I had rested I climbed back up the slope and looked across at Dvin. Its occupants, who must by then have realised that shutting the gates against us was a mistake, were doing little to defend themselves. Perhaps the Persians and Armenians could not agree. The town looked like any other town, sleepy in the midday sun. A slinger appeared for moment and flung a stone in what seemed to be my direction, though I did not see it fall. If he was aiming at me, it was the only time the enemy thought me worth attacking.

In the afternoon, when the sun was behind us, we were given the order to begin bombarding the walls. Two of the men heaved on the windlass, fresh sweat pouring down their backs, tightening the rope that tensioned the bow. When the bow-arms were drawn back far enough, the first stone was dropped gently into the holder. At a shout from the leader, we stood clear, he knocked a catch with a mallet, then the sling shot forward, hurling the stone and jolting the back wheels of the wagon off the ground. I felt a surge of savage and inexplicable pleasure as the missile flew through the air. I willed it to fly strong and true, to hit its target, to smash into the walls of Dvin, breaching the hard masonry, opening a gap through which our men could rush. But it fell short, tumbling limply into a beanfield.

We took turns to wind the windlass and load stones. After a few more trial shots, we found our range, and the missiles began to hit the walls, dislodging facing stones and loosening rubble filling. We worked for hours, each shot a climax of our steady rhythm of winding and piling. The savage pleasure I had felt earlier rose in me again, buoying me up, filling me with energy. We yelled as the sling swung forward, sending every missile on its way with wild and bloodthirsty boasts. We forgot that we were Christians fighting a holy war against pagans and heretics. We did not think about the True Cross, or the fate of the churches and monasteries of the East. We just wanted to see the city burst open, yielding its soft secrets. And all around us were others, wanting the same thing. Wherever there was high ground, artillery teams shouted and shot, aiming at weak spots, repeatedly pounding the walls, bringing down great heaps of rubble until there were gaps big enough to drive wagons through.

But the defenders did not surrender, and we had almost run out of missiles. We slowed down, adjusting our rhythm, shooting just often enough to drive off anyone attempting to repair the walls. Then, late in the afternoon, the order to advance was given. I lay back on a patch of soft grass, utterly exhausted. But the rest of the team seemed strangely agitated. They watched anxiously, eagerly anticipating the rapid end of what

they had made possible. When the trumpet sounded, tight formations of heavily shielded infantry came from somewhere behind us and moved slowly forward, preceded by their long shadows. They were quickly followed by light cavalry, who cantered towards the walls, ready to rush into any gap. Archers covered them, driving back the few Armenians and Persians who appeared at the walls, and the gaps we had made were quickly forced. The defenders fell back, and our infantry rushed in. Some Persians tried to escape through one of the gates, but the cavalry soon caught them. It was over very quickly, and was almost an anti-climax. I had expected acts of heroism, dramatic incidents, or at least clever tactics, that I could record for George, but instead the city was taken by a combination of efficiency and brute force.

The rapid end of the attack was not an anti-climax for the artillery men. They abandoned their catapults and rushed towards the city, following the last of the infantry through the walls. Looking around, and seeing that I was almost alone as the sun set behind me, I decided to follow them. I ran down the grassy slope and then across the trampled vegetable plots that surrounded the walls, then clambered over the debris of our demolition, through the wall and into the city, where for the first time I saw the aftermath of battle.

The narrow streets were full of soldiers, shouting and jostling, smashing down doors and looking for loot. The inhabitants tried to hide, but were dragged out and robbed or beaten. I saw old men knocked to the ground for not understanding what they were asked. Their wives clung to the legs of marauding soldiers, begging for mercy, but were kicked aside. Younger women were dragged into alleys and raped. Enemy soldiers lay everywhere, dead or wounded. I was sickened by their mutilated bodies, their guts, organs that I knew only as names in Basil's medical books, spewed on the ground. The soldiers were not deterred. They turned the corpses, searching for valuables among blood-soaked clothes. Some fought each other for what they had found. Red flickering light from burning buildings made the plundering soldiers seem demonic. Smoke drove me back, and I wandered, lost.

Abandoned children screamed, reminding me of the night when I was taken away from my parents, when houses had burned in Tarsus, and the streets were full of milling, aimless crowds. But the self-conscious barbarism of the Blues and Greens seemed tame compared with the casual cruelties of the Imperial army. I wanted to find Nilus. He had seemed gentler than the others, though he had followed them readily enough.

I kept on, pressing unsteadily through the crowded streets, not looking anyone in the eye, not knowing where I was going. I had seen nothing that could be described in George's epic verse. Screams came from a doorway that was blocked by the broad, red back of the leader of the artillery men. He turned, smiled down at me, and pulled me in.

"Come and get it," he said. "You've worked for it."

Inside the room, hidden at first by the backs of the soldiers who crowded, leering around him, was Nilus, his trousers round his ankles, his naked buttocks thrusting between the splayed, writhing legs of a woman, who was being held down by his crouching comrades.

The alley outside, despite the horrors I had seen there, suddenly seemed inviting. I tried to back out of the room, hoping to disappear into the crowd and make my way, somehow, to the camp. But the leader was behind me, blocking the doorway. He grabbed me, easily encircling my chest with his huge arms, forcing me to watch while Nilus finished his turn. I am ashamed to admit that I had no sympathy for the woman: I watched her squirming with disgust, thinking only of myself. It was clear from the attitudes of the artillery men, crouched, intent, expectant, that they were involved in a savage ceremony in which I, too, would have to play a part. I knew I had no choice. Merely walking away would not be possible. But what would I be required to do? What would happen if I was pushed forward to take Nilus's place? I knew I could not emulate his enthusiastic performance. What would the others think of me? And how dangerous would it be to fail?

Nilus stopped thrusting and lay still for a moment. Then, to the half-hearted cheers of his comrades, he rose to his feet,

briefly displaying his semi-tumescent penis before stuffing it back into his trousers and readjusting his tunic. A few of the men still held the woman down. The others stood back, glancing at each other expectantly, waiting for a signal. I readied myself, thinking I might just slip free if the leader loosened his grip. But my legs were shaking so badly that I doubted whether I could do anything except fall to the ground. And his grip did not loosen. He pulled me back against his hard body, pressing himself against me, and I could feel that he was aroused by what he had been watching. The woman lay before us, her arms pinned down, her legs spread wide. She struggled feebly, her chest heaving in a way her captors obviously found provocative. They stared down at her, entranced by every movement of her soft breasts. I found her as unalluring as I had found Pelagia.

The leader loosened his grip slightly, but not enough to let me struggle free. He fumbled under my tunic, untying my trousers, allowing them to slip down, exposing my lack of arousal. I was terrified. I imagined myself shoved into the arms of the waiting artillery men. If I did not show enough enthusiasm, they would force me onto the woman, holding me down, as well as her. If I could not do what they did, they would regard me as an outsider, an enemy, someone as contemptible as the inhabitants of Dvin. And they, all around us, were being deprived of their goods, virtue, dignity and lives. I would be mocked, kicked, pummelled, perhaps killed.

The leader called out a name, another man took Nilus's place, the woman cried out in fear, and the rape began again. For a moment, I felt hope. The others would all go before me. Perhaps the leader would take his turn soon, unless he had done so already. I might just escape before I was humiliated. But he pulled me tighter against him.

"Are you ready?" he said, but I could not answer. His huge hand released my arm, but jerked up to grip my throat. I feared that he would strangle me, but the hand slipped slowly round until it held the back of my neck. He kicked my legs apart, then pushed my head down, hoisting my tunic with the other hand. He reached under his tunic, readjusting his

erection, slotting it between my buttocks. There was no escape. While his men were distracted, he thrust himself into me.

It was painful but quick: a few strokes and he was finished. He froze for a moment, gripping me even tighter, then pushed me away. I fell forward, tripping and tumbling, hitting knees and elbows as I rolled over on the hard stone floor. I did not stop to inspect my injuries, or to look back at what the others were doing. As soon as I had got my breath back, and recovered the use of my shaking limbs, I dashed through the doorway and out into the dark night. Then, ignoring the cries and suffering around me, I made my way out of the city and back to the camp.

I suppose I should not have been surprised by what happened in Dvin. I knew from what I had read that war is not all heroism and bravery. Homer is full enough of impalings, cloven heads, spouting blood and spewed guts. But I had listened to Heraclius's speeches and George's sermons, and imagined that the Imperial army was engaged in something noble and Christian. It was a shock to find that they were no better than the gangsters that persecuted my family. I felt stupid. I had admired the soldiers, imagining them as epic heroes, and been brutally humiliated as a result. I had lost something, and not just my dignity or my illusions. What I had hoped and longed for, what I had imagined a source of pleasure and happiness, had been revealed to me as shameful and painful.

Yet, when I recovered from the pain, I realised that there had been a sort of pleasure in it, and that alarmed me. How could I have enjoyed something so degrading? I was like a starving man feeding on rotten food, repelled and satisfied at the same time. Did Adam feel the same confusion, as the flesh of the forbidden fruit softened in his mouth? I knew that I had been defiled by my experience, which seemed a just punishment for giving in to the demons of lust. Perhaps the Dualists were right in thinking all fleshly things tainted.

For the rest of the war I was content to observe and record. When, a few weeks later, the army pillaged Tabriz, I kept out

of their way, and did not see the inside of King Chosroes' palace until it was already badly damaged. Despite that, and empty of everything moveable, it was still magnificent. Each of its many great halls was supported by hundreds of massive columns, all carved with writhing plants and animals. The walls were painted with battles, hunting scenes or views of gardens, and lined with statues of kings and gods. Carpets and tapestries had hung there, but now decorated our officers' tents. Suns, stars and moons, which are as significant to the Persians as the Cross is to us, were carved or painted on the ceilings. The treasury, which had not been completely emptied by Chosroes, was rumoured to have contained riches hoarded for centuries, including the treasure of King Croesus.

George, who had salvaged a silver statuette of a bearded king or god, said:

"Do you know the story of Cyrus and Croesus?"

"No."

"You must have read it. It's in Herodotus." We often consulted the *Histories*, looking for poetic parallels between the Persian wars of the past and those of the present. "Remember," George said. "Croesus was King of Lydia. Sardis, his capital, was one of the richest cities in the world. He might have enjoyed his wealth, but instead he went to war with the Persians. When Sardis was captured, and Croesus taken prisoner, Cyrus showed him the Persian soldiers sacking the city. Croesus asked what they were doing. Cyrus said: 'They are ransacking your city and plundering your treasure.' Croesus replied: 'It is no longer my city or my treasure. It is yours now, and it is you they are robbing.' After that, Cyrus called off his troops."

"But we are destroying this palace."

"And we will have to go on destroying until the Persians surrender. This is war, not conquest."

Near the palace was a Zoroastrian fire temple. It was square, and built of enormous blocks of stone, carefully cut and fitted together. Next to it was a tower that tapered up to a small platform some sixty feet above the ground. The temple had been abandoned by its keepers, and contained nothing of

interest to looters, so I was able to enter it unmolested. I pushed past a heavy bronze door into a narrow, dark passage. I could see nothing at first, and blundered into a wall when the passage turned a corner. Then I saw a light. It came from a large copper bowl that seemed to float in the centre of the darkness. I went towards it, but stumbled against a step, falling forward and grazing my shins. The bowl was supported by a wide stone platform. I stood, and looked down into the bowl, staring at the flickering, bluish flames. It was the eternal sacred flame, which the magi, or Zoroastrian priests, carried to the top of the tower for religious ceremonies. The bowl was half full of an oily liquid, and the flame burned without a wick. I stooped, and dipped a finger into the edge of the oil. It had a pungent, unfamiliar smell. I looked around, and when my eyes adjusted to the gloom, saw that I was in a high, square chamber. Unlike most churches, it was completely undecorated. The walls were of plain stone, and it contained no relics or holy images. I could not help being slightly awed by the temple. Its elemental simplicity contrasted with the worldly decoration of some churches, and I knew that the beliefs of the Zoroastrians were something like those of my parents.

Heraclius did not share my awe. He remembered the fate of Jerusalem and its relics, and decided to desecrate and destroy this temple. The magi were assembled and made to watch, while relays of soldiers urinated on the sacred fire. They had some difficulty with the oil, which threatened to overflow while still alight, and the job was finished with sand. But the fire was extinguished, and the temple was demolished, its stones spread as widely as possible. Many of the soldiers who took part in this desecration were later afflicted by unpleasant urinary diseases. They attributed their condition to a magian curse, but I suspect it may have been due to other uses to which their penises were put. Heraclius later suffered from the same complaint, but it was generally regarded as God's punishment for his incestuous marriage.

For several years Heraclius campaigned inconclusively against the Persians. Sometimes the army marched east, deep into

enemy territory, sacking towns and burning farms. Sometimes we marched west, pursuing, or pursued by, the Persians. The two empires were like exhausted wrestlers, locked together, lumbering round the ring, trampling everything in their path, but unable to bring the fight to a conclusion. Far more was destroyed by the war than by the Persian invasion that had provoked it. Tarsus was wrecked and abandoned, as I saw myself on one of our westward marches. Despite unhappy memories of my hometown, I was appalled. More than anything I had seen, its destruction made clear to me the futility of war. When we passed through Cappadocia, I thought of deserting. Basil's valley was nearby, and it would have been easy to slip away from the camp. But it was unlikely that Basil and his books had been left unmolested by brigands and deserters. I stayed on, consoled by my growing friendship with George, who protected me and gave me status. I read intelligence reports, summarised events, and helped him turn them into epic verse.

Only a few events stand out from that period of endless marching and skirmishing, and they tended to undermine my faith in the orthodoxy and civilisation that we were supposed to be defending. But I learned something, about myself, and about what it is possible to believe in.

6
DOUBTS
A.D. 623–625

One winter, while we were camped among the wild tribes of the Caucasus Mountains, from whom Heraclius hoped to recruit much-needed allies, I had the chance to interview a magus. The Persian priest was caught by a hunting party, while wandering alone in the mountains. He claimed to be searching for wisdom, but it was more probable that he was a spy trying to make contact with our Persian prisoners, some of whom were magi from the fire temple at Tabriz. In order to find out what the magus was doing, George suggested that I talk to him about Persian religion. I was already curious. The fire temple had reminded me of my heretical childhood, and I have always been interested in what others believe.

This magus had travelled widely, not just in Persia, but as far as Arabia and India. He had studied what men have believed, and, as he soon let me know, came from a religious tradition much older than Christianity. He seemed to look upon my beliefs as derivative and faddish, a curiosity to a philosopher, but unworthy of serious consideration. He explained Christianity, not as a product of divine revelation, but as a historical development of other religions. This was disconcerting, like being led up a high mountain and finding, not an improved view, but a place from which one might easily fall.

"All religions begin as polytheism," he said. He sat on a small stool, his dark robes gathered around his legs to keep out the cold wind that blew through the tent. "All peoples, like children, begin by fearing the night, and shadows, and the forces of nature. In their primitive state they know that the things they need: food, shelter, warmth and security, are hard to get and easily lost. They personify their fears and needs, and try to placate the former in order to gain the latter. As they

progress to a more civilised state, and learn the arts, such as poetry, these personifications of nature become gods, and their deeds are told in epics and sagas. Have you studied Homer?" He leaned forward to emphasise his question. His dark eyes were deeply set in a narrow face, and I found his gaze unnerving.

"Of course," I replied.

"Then you know the stories of your old gods."

"Not my old gods."

"You are Greek?"

"I am Roman, but Greek is my language."

"Then the gods of your ancestors. But not just your ancestors, all peoples have similar traditions. The Aryans, who were the ancestors of the Indians as well as the Persians, brought the stories of these gods with them as they left the steppes in their chariots. The Rig-Veda is the oldest book in the world, and all the world's gods are derived from those of my ancestors. The Aryans worshipped a father-god called Dyaus. Even the name is similar to Zeus, his Greek version. There was also Varuna, a god of the underworld, like Uranus, and Indra, a hero like Hercules. You will be pleased to hear that now the Indians worship a trinity: Brahma, Vishnu and Siva, of whom their lesser gods are incarnations. On the whole, they have the same characteristics as the Greek gods, who, in turn, are the same as the Roman ones. The Germans too, those that are not yet Christians, are polytheists on the same pattern. They worship Thor, god of thunder, but are ruled by Odin, whose wife is Frejya, goddess of love and fertility. Who do they remind you of?"

"Thor and Odin both sound like Zeus, and Frejya seems to be Aphrodite."

"Exactly. They are the same, though under other names, and with attributes rearranged. You can find the same pattern in the old religions of all peoples, from the Western Ocean to India. And you can see the same process of reform, though progressing at different rates. Spirits of places or things become personifications of those things. Then they become tribes of gods whose attributes and actions symbolise human

qualities and needs. But do you think that philosophical Greeks or Romans actually worshipped those old gods?"

"Not worshipped. Respected, perhaps. They certainly used the names in prayers and dedications."

"They may have used the names, but they were just conventions by then. The paganism of your ancestors had been reformed by philosophy, long before it was modified by Christianity."

"Christianity did not modify paganism, it refuted it."

"That's where you are mistaken. Christianity took advantage of what was already happening. Polytheism always reforms itself. In its simple form it is good enough for a simple society, and in its heroic form it is suitable for a heroic society, such as Homer described. But when people settle down into civilised city life, and organise themselves into kingdoms and empires, nature-worship or hero-worship are not enough. People need a moral element in their lives, and that can't come from squabbling gods who are little better than they are. For such a religion to become ethical it must be reformed. The names of the old gods may be retained, but they become fewer in number and more abstract. One of them, let us call him Zeus, Jupiter, Ahuramazda or Brahma, must become supreme. This supreme god must be a creator, a legislator, and should offer something beyond earthly life: redemption or salvation, though this is sometimes deputed to a lesser being such as Mithra. Even the Germans, who have not otherwise reformed their religion, have an innocent redeemer-god called Balder. Can you see any resemblances?"

"I can see that you are comparing God to Zeus, and Christ to Mithra, but you are mistaken. Christianity does not descend from Greek or Roman paganism any more than it reformed it. Nor do these coincidences undermine the uniqueness of Christianity. Its truths are newly revealed."

"By a Jew. A reforming rabbi in fact. The Jews, too, have reformed their beliefs, and many times. You know your Old Testament?"

"Of course."

"Then you must remember the stories of Moses and his

97

reforms. He insisted that the Jews worship one god, and do so without idolatry. He also introduced a strong ethical element into Judaism, embodied by the Ten Commandments. Virtue was defined ritually, by adherence to complex sets of rules. Do you remember Leviticus?"

"Yes." Leviticus is certainly full of rules, some of which I had pondered when I considered my own tastes and nature.

"Then you will know what I mean. Judaism after the time of Moses could be described as a constant struggle between two tendencies: one eclectic and polytheistic, the other monotheistic and reforming. The Israelites were surrounded by pagan neighbours, and had to struggle constantly to keep their faith pure, as the Book of Kings records. After the Babylonian exile, and conquest by the Persians, the Jews felt that their God had deserted them, and their struggle to come to terms with this led them to introduce new ideas to their faith. Many of those ideas came from us Persians. Later they were heavily influenced by your ancestors, the pagan Greeks, who stole their civilisation from the Persians."

"I dispute that. The Greeks have always resisted the Persians. Remember Alexander!"

"He conquered our land, but we conquered his heart. He became more Persian than the Persians."

"Even if you are right, this has no bearing on Christianity. Jesus was only a Jew by geographical chance. His divine element made him universal."

"He was only one of many reforming rabbis, preaching a reformed Judaism in which actions are judged by intent rather than legality."

"He did more than that. He offered salvation."

"You may think so, but salvation was an idea that was grafted on to Christianity by the Greeks. The reformed version of Greek and Roman paganism was expressed in mystery cults, in which the name of a god stood for some philosophical ideal. When a rich Roman was inducted into the Eleusinian mysteries, or a soldier joined the cult of Mithra, he did so to be redeemed. As soon as Greeks started to be converted, Christianity stopped being a reformed branch of Judaism, and

became a blend of debased Platonism and eastern mysticism."

"If you mean Plotinus and Porphyry, you are wrong. Their ideas are not part of Christianity."

"They are, but mostly they go unnoticed. There are more explicit Christian borrowings from Plato. Remember Dionysius the Areopagite? He is a perfect example of what I mean. After he was converted by Saint Paul, he set about writing books that explain Christianity in Platonic terms. Many of your theologians have borrowed from him. The fact is, as you surely must see by now, that your religion is not new, and not a revelation. It is a development of what went before, and borrows most of its ideas, via the Jews and Greeks, from my people, the Persians."

"But your people are fire-worshippers."

"Do you worship icons?"

"No."

"But you pray to them."

"Not to them. Through them, perhaps. The icon is a symbol or representation. We pray to what is represented by the icon."

"Then you can surely see that if we Persians appear to revere the elements, we are actually revering their creator."

"Or creators," I answered. A gust of wind filled the tent, tightening its leather sides, rocking its poles. The magus smiled, perhaps taking pleasure in this display of elemental power.

"My people began by worshipping several gods, or personifications of elements, but, as in other religions, our attitudes have changed. Over a thousand years ago Zoroaster subordinated the lesser gods, and introduced morality. He taught that Ahuramazda, the creator, is supreme, and that his evil rival Ahriman is limited in power. Man can choose to follow one or the other, and can be redeemed, but only if he follows the path of Good. Zoroaster saw that gods cannot be placated with sacrifices, but only with virtue. He was the first to understand this, and his ideas have fed all other religions. The Jewish prophet Isaiah was influenced. Do you remember this verse:

"To what purpose is the multitude of your sacrifices unto me? Said the Lord: I am full of the burnt offerings of rams, and the fat of fed beasts; and I delight not in the blood of bullocks, or of lambs, or of goats."

It was disconcerting, being lectured by a pagan who seemed to know the books of the Old Testament better than many Christians, but I could think of no answer, and he carried on.

"The Buddha and Mahavira, who introduced morality and salvation into Indian religion, both borrowed from Zoroaster's ideas. So did Mani, who also borrowed from Buddhism and Christianity. The Christians have been influenced by the Manichees, however much you may deny it, and they got their ascetic tendencies from Buddhism, though mixed with Greek philosophy. The only difference between Christian monks and Buddhist monks is that the former reject the material world, while the latter deny its existence. The Buddha, incidentally, was immaculately conceived, taught his elders and was tempted by the devil, centuries before Christ. All these ideas are a consequence of Zoroaster's insight into morality and redemption, and derive from his teachings."

"No Christian would dispute that there have been earlier revelations. They were necessary to prepare the way for Christ and His message, which must be the ultimate revelation."

"You seem to be contradicting yourself. You denied other revelations earlier."

"I denied the completeness of earlier revelations," I said, trying to remember what I had said, or meant.

"There will always be new prophets and would-be messiahs. Many of your people have followed Mani."

"The Manichees have caused much misunderstanding among Christians, but Mani's teachings were not a genuine revelation. There can be no successors to Christ."

"Not everyone would agree with you on that point. In fact, a new Prophet has recently proclaimed himself in Arabia. He claims to be the successor to the Jewish prophets, and to Jesus, whom he calls a prophet but not the Son of God."

"He sounds like an Arian. They deny the divinity of Christ, or at least, diminish it."

"He is more than that. He is calling on all the Arabs to follow him and adopt this new faith."

"Have they answered his call?"

"Only a few, so far."

From my point of view, the conversation was rather unsatisfactory. I had expected a simple explanation of Persian beliefs, which I hoped easily to refute. I had been drilled in orthodoxy by the monks at Tarsus, and had discussed with George the theological disputes that had split the Empire. I knew, from what Basil had taught me, that the Church had inherited some ideas from the pagan philosophers. Yet the magus had skilfully undermined my faith. His claim that Zoroaster discovered morality might be dismissed as exaggerated, but his other ideas were worrying. I imagined religious ideas constantly circulating the world like gold coins, or being stirred together like the ingredients of a fish soup. Surely there must be more to faith than the unsold portion of the day's catch?

What the magus said made me doubt that Christianity was inevitable as well as true, and left open the possibility that the heretics might be just as right as the orthodox. I also failed to find out much about the magus's purpose, though his hints about Arabia suggested that he probably was a spy. Perhaps he had been sent round the fringes of Persia to discover how trouble might be stirred up among the Emperor's enemies. He clearly knew enough to be able to sow doubts among the Christians of the Caucasus. To cover my confusion I quickly wrote a report about our conversation. I summarised it so that I did not appear too incompetent, and described the magus as a Zoroastrian fanatic, determined to undermine Christianity. I concluded that he was clearly a spy, who had already attempted to subvert our Arab allies. Afterwards I felt rather ashamed of what I had written, as he was clearly no fanatic, but, in his way, a philosopher like Basil. Considering what we had done to the temple at Tabriz, he was also quite restrained.

"You know what I think of the locals," George said, as we

marched, yet again, into Armenia. His round face, once pale from a life spent in churches and palaces, was burnt brown by the sun.

"That they are half Persian?"

"Yes, and only half Christian, too."

"More than half, surely? From what you have told me, there is not much difference between us and the monophysites."

"You sound like the Emperor. He thinks we are all the same, at heart. He wants me to debate with them."

"The Armenians? Why?"

"To unite the Empire! He wants to win back the loyalty of the monophysites. You have seen how little help the Armenians give us. It's the same with the Egyptians and Syrians. They all seem to prefer the Persians."

"Surely they would rather be ruled by fellow Christians than by pagans."

"They don't think of us as fellow Christians. They think of us as heretics. And they have done well out of the Persian conquest. Chosroes has given them privileges. He has handed over all the orthodox churches to them, at least, those he has not destroyed. But the Emperor seems to think that if we assemble some monophysite bishops and debate with them, the Syrians and Egyptians will eject the Persians and return to the Empire with no need for further fighting."

"Does he really think so?"

"Perhaps not, but having summoned all these heretic bishops he wants me to present the orthodox point of view to them."

"You should have no difficulty."

"I can explain what I believe, though I am no theologian. What worries me is that there is more behind this. I may be set up, only to be knocked down. The Emperor has been discussing something with Patriarch Sergius. He must have proposed some sort of compromise."

"A compromise with orthodoxy?"

"I am afraid so. But the whole point of orthodoxy is that it is orthodox. People believe in it because it is what everyone

believes in. Tampering with doctrine can only make it less universal."

The meeting took place at Ani, a well-fortified town a hundred miles north of Lake Van. It was the seat of an Armenian clan who had decided to ally themselves with the Empire. That was just as well, as the town was a natural fortress, and could never be taken by force. The bishops had already been summoned from Armenia and the Caucasus, and were installed in the town's many monasteries before we arrived. The meeting was quickly convened, in a dark, domed octagonal church, just outside the citadel. Even though they were mostly heretics, the bishops would not appear before the Emperor unless dressed in their finest vestments. The dim light, filtering down from the ring of windows above us, picked out their heavy dalmatics, richly embroidered pallia, and chasubles stiff with gold thread. Hanging down over these silks and satins were a variety of beards, forked or straight, trimmed or shaggy, according to taste. One or two of the bishops wore simple linen robes, ostentatiously white, but they were no less proud than their finely dressed rivals.

I sat in a half-round niche, near George, but outside the circle of bishops. I was there as his secretary, with instructions to stay in the background and write everything down. I was far too unimportant to be noticed by the bishops or the Emperor. Heraclius was opposite me, on the far side of the circle, seated on a borrowed throne, which was carefully placed so that a shaft of light fell on him. Not yet fifty, his hair was full, and still fair, and his face, though lined, was handsome. His coat was of the finest crimson silk, and decorated with mythical beasts. On his head was the imperial diadem, decked with precious stones, and on his feet were the pearl-studded purple boots that signified his rank. Despite the magnificence of his dress, he managed to look both thoughtful and military, and I could see why he had been so admired when he arrived at Constantinople to usurp the throne.

George was asked to begin the debate, which he did with a nervousness that was rather too apparent:

"The orthodox position was fixed, once and for all, by the

Council of Chalcedon in the year of Our Lord 451. We believe that Our Lord is one Person, that He has two natures, and that He is both human and divine. These two natures are fused but separate, indivisible but each perfect in itself. He is both perfect man and perfect God. All other views, and there were many, were condemned at Chalcedon, and must be regarded as heretical." He sat down, sweating slightly. He had stated the orthodox position as asked, and as briefly and forcibly as he could.

One of the white-clad Armenian bishops stood up and said:

"That's nothing but Nestorianism. And you talk of heresy! How can you claim that He has two natures when that is precisely what the Nestorians were condemned for at Ephesus in the year of Our Lord 431?"

George spoke again. "Nestorius believed that the two natures were quite separate, manifested in two Persons, and that Mary was mother only of the human Christ, who was adopted by God as His Son."

"Well in that case," scoffed the Armenian, "how do you explain the co-existence of your supposed two natures before His birth. Surely God cannot be constrained in a human womb?"

"If you doubt that, then how do you think that He could suffer on the Cross?"

"All His earthly acts were illusory!" the Armenian said. "He only has one nature, which is divine. All this talk of Him mingling with earthly matter is blasphemous!"

The other Armenians told him to be quiet, then one of the richly dressed ones said: "You are wrong. His nature, though single, cannot be wholly divine. In Him, human and divine elements are fused, as body and soul are in man."

"Did this fusing happen before or after His incarnation?"

Heraclius was listening, thoughtfully stroking his beard. He looked up at the last speaker, and the discussion halted. The Emperor tried out a proposition:

"Are we all agreed that He is one Person?" No one disagreed. "Could it not be said then, that His human nature was

subsumed by his divine nature after His adoption?" Everyone looked embarrassed at this. After a pause, someone, braver than the others, spoke: "With respect, your Majesty, that is the Eutychian heresy. Christ's two natures are eternal as well as perfect and indivisible."

"Thank you, I had forgotten." Heraclius did not seem embarrassed by his mistake. Perhaps emperors are forbidden by protocol to feel or show embarrassment. Possibly his mistake was deliberate, designed to test the knowledge or tolerance of the heretics. After looking around the circle of bishops, Heraclius continued. "But we are all agreed that He is one Person?" Neither the orthodox or monophysite bishops could object to that, and the Emperor continued: "Then let us consider the question of His motivation." He looked around. The bishops waited. That must have been the issue he had already discussed with Patriarch Sergius in Constantinople. He looked towards the orthodox bishops and said: "Is it conceivable that He could be motivated by anything but a single energy?" They had not considered the matter before, but after a moment one of them asked: "This single energy. It would have to be that of His divine nature?"

"There is no other!" shouted one of the Armenians.

"It sounds Eutychian to me," muttered an orthodox bishop.

"What I am proposing," said Heraclius, "is that we emphasise what we can agree on. And that is a single Person motivated by a single, divine Energy. Is there anyone here who cannot accept that?"

There was a lot more argument. The single energy was easily acceptable to the monophysites, but they were suspicious of compromise and kept pressing the orthodox to abandon the two natures. The orthodox would not do so, but could find no real objection to the single energy. Heraclius allowed the debate to wear itself out, then secured an agreement to his compromise formula from all present. He concluded with what must have been a premeditated sentiment: "I feel that, in monoenergism, we have reached a historic compromise. Church and state must work together, motivated

like our Saviour, by a single energy. If we can do this we are sure to prevail over our enemies."

Afterwards George was doubtful. He shook his head sadly and said: "All this compromise may seem like a good thing, but it will do nothing to unify the Church. Just the opposite in fact. The Emperor has created a third doctrine, not unified the other two."

"Why does that matter?" I asked. "Why do we not leave these questions as a matter of individual faith?" The bishops' arguments seemed trivial compared to the criticisms of Christianity I had heard from the magus.

"Because the Church is not about individual faith, but revealed truth." George replied. "It is also an institution, and an arm of the state. If we left people to believe what they liked, then they would end up believing so many different things that there would be no unity, no Church, and no Empire. We can see it happening already. Egypt and Syria have drifted away, and I don't think they will be brought back by compromise. Civilisation depends on orthodoxy, and we must defend one to defend the other."

7

THE KHAZARS

A.D. 626

We waited at Tiflis for several weeks, enduring unseasonable rain and cold, until the Khazars arrived. George was not impressed by our prospective allies. "How can we defend civilisation with the aid of savages?" he said. "The Khazars are just like the Huns and Avars. All these nomads are the same. If their warlords are successful they attract other tribes and form huge coalitions. They swarm like locusts, multiplying until Asia is too small for them. Then they spill into Europe, destroying everything they touch."

"According to the reports, the Khazars are no longer nomads," I said. "They have abandoned wandering and have settled around the northern shore of the Caspian Sea."

"What is settling when you live in tents?" George said, gesturing at his own tent, the sides of which ran with water. "You can't trust nomads."

Their Khan, Ziebel, was a small man, perched on a small horse, but his flat, expressionless face, thin moustache and narrow eyes made him look cruel, if not fierce. He was wrapped in a dark red Chinese coat that was much too big for him, and his sword belt was hung with gold coins and silk tassels, as well as a gleaming silver dagger. His followers looked more military, though many of them wore Chinese or Persian silk over their armour. Their faces were a mixture of types, some narrow and sharp, others round and fleshy. All had blue-black hair, which they greased with something rancid, perhaps butter, making the whole party smell like cheesemongers. On horseback they looked as impassive as their Khan, like men who ruled the world and expected no trouble. But dismounted, they were ill at ease. They were the more presentable part of the Khazar horde, the rest of which stayed out of

sight, starting rumours among our men that they were centaurs, wolf-men or blood-drinkers.

The Emperor's tents were decorated with the most expensive hangings and carpets. Items looted from the Persians were prominently displayed. Heraclius appeared, dressed in an appropriately Imperial manner, surrounded by generals and courtiers. Empress Martina was with him, and wore a purple robe that, though her right, did not look well with her bright red hair. Ziebel and his followers prostrated themselves, and Heraclius, in a carefully calculated spontaneous gesture, took off his crown, gave it to the Khan, and greeted him in terms that might be interpreted as implying some form of adoption. If he was repelled by Ziebel's smell, he did not show it. The Khan's followers were then given all sorts of gifts, some valuable, others not, and a long and elaborate banquet. It was not possible to do things quite in the style of Constantinople, but enough robes, dishes, food and wine were found to put on a good show. Many toasts were drunk, and many boasts and promises made. After much ceremony, the Khan confirmed that he would send a contingent to join our army in its next advance against the Persians.

Later, George told me that the Emperor had secretly offered his fifteen-year-old daughter Eudocia to the Khan.

"It's not right to make a young Christian girl marry a pagan savage," George said. "Ziebel will never become a Christian. Whatever they may say to us, these barbarian chiefs never abandon their old ways. If they did, their tribes would desert them. And mixed marriages never work. The result is always the same: a princess roasts or freezes at the ends of the earth, and the barbarians carry on just as before. But I know what's behind this. It's Martina. Eudocia is the daughter of the Emperor's first wife. Martina wants her out of the way."

I was surprised to hear George criticise the Imperial family so directly. I knew his private doubts about Imperial policy, but his sermons, and his courtly verse, contained nothing but praise for Heraclius and his deeds.

Despite George's reservations, I found the arrival of the

Khazar horde interesting, even exciting. Nomads seem to us to be primitive. George had compared them to locusts, swarming unpredictably, descending on the civilised world to strip it bare. But that is misleading. Nomads could not lead their lives without specialised knowledge and equipment. Their horses and sheep are bred for endurance, and can travel for hundreds of miles without tiring. Their tents are light and portable, but much more comfortable than ours. Everything they carry with them is light, durable and does its job reliably. The Khazars could make or strike camp in a fraction of the time it took us, and be eating a cooked meal before our fires were lit. They laughed at the quantity of heavy and unsuitable equipment we carried, though they never objected to it as a gift. We tried to carry with us everything the countryside could not provide, but the Khazar horde was a city on the move. It is true that they did not wash much, but neither did we when on the march.

It was washing that brought me into contact with them.

We had reached a river, and were to camp by its banks. It was hot, and I was dusty, so I went to the river to cool down. The Khazars, having arrived first, had already set up camp, and were busy watering their horses in the shallows before their place was taken by the Imperial cavalry. There was a great crowd of men and horses, and the banks were trampled and strewn with dung. I was obliged to walk upstream, to where the water was cleaner but less approachable. As I scrambled along steep slopes, looking for a place to climb down, I could hear the water below me, invisible beyond a screen of bushes, tantalising me with its promise of refreshment. I could hear voices, too, calling out in an unfamiliar language, mingling with the sounds of the river.

At last I found a place where the water seemed accessible. I hopped and scrambled over loose stones, sending showers of pebbles ahead of me, steadying myself by grabbing the branches of stunted shrubs. Small lizards scuttled for cover as I passed their basking places. Halfway down I reached a clump of bushes where I rested for a moment. The sun seemed hotter on that sheltered slope. My mouth was dry with dust and

effort. I heard the voices grow louder. Pushing on through the thicket, I saw a group of young Khazars swimming in the river. They were naked, and splashed about in the water like children. The sight of their bodies revived a confusion of feelings. I held back, balancing on a boulder, remembering how, in Cappadocia, I had dreamed of the river, and of bathing with Nicholas. But my humiliation at Dvin had taught me to be wary of soldiers. Would these savage Khazars be any different? They seemed so pagan and free. It is true that our soldiers sometimes washed naked when they got the chance, but they showed no signs of enjoying it. Nakedness was necessary in the circumstances, but was otherwise a matter of shame. Those nomad horsemen clearly knew no shame.

I was still watching them when one of the Khazars saw me, and signalled that I should join them. I wanted to, but I was alarmed as much as I was attracted by their nakedness. He signalled again, standing up in the water and beckoning me with a sweep of his arm. I slipped off my boulder and clambered down the bank, working my way cautiously over the unstable ground. When I reached the water's edge, he called and beckoned again, pointing to a smooth rock from which I might slip into the water. But I was aroused, and dared not undress. Instead, I waited and watched, amazed at their vitality as they splashed and wrestled. What, I wondered, did they do when troubled by lustful thoughts? There were no women in the Khazar horde. Did they exhaust themselves, driving away temptation with boisterous games and antics? Or were they were complete in themselves, made whole by male friendship?

After a while they climbed out and sat around me on the rocks. Their bodies were sinewy rather than muscular, and most of them were slightly bow-legged from spending their lives on horseback. Where they were not tanned by the sun, their skin was as pale as blue-veined marble. Their hair was long and black, and they were clean-shaven, though one or two had moustaches. They wore earrings in the shape of writhing animals, such as I had seen decorating the palace at Tabriz. Wherever I looked I could see what I had often

desired, but had tried to forget. They seemed to have no idea of the effect they were having on me, and carried on their chatter as they reclined on the rocks. While they dried off in the sun, they plaited each other's hair. They pointed at themselves and told me their names, but I could hardly make out what they were saying. Their language sounded as strange as birdsong, and just as incomprehensible. I pointed to myself and said my name, but they were no more successful at reproducing it than I was at theirs. Only one of them got close. He, I eventually worked out, was called Kurt, which means *wolf*. He seemed to want to learn some Greek, and started pointing at objects and saying their names in Khazar. I told him their Greek names, and after much repetition we both learned a few words.

After their swim, most of the Khazars put on their bright shirts, black, baggy trousers and felt riding boots, picked up their bows and quivers, and set off to search the countryside for food. I washed discreetly, while Kurt stayed and continued our language lesson. Kurt kept up his linguistic enthusiasm for most of the time I knew him, and was eventually able to communicate quite well, though never elegantly. I never did grasp much Khazar. Though some of the words were simple enough once I learned to listen for them, the grammar was impossible, and totally unlike Greek or Latin. Each simple word for a thing or person seemed to grow by acquiring other elements signifying direction, position, relation or tense. New words were created as the speaker needed them, and were so complex that their meaning could only be conveyed by half a sentence of a civilised language.

After a while, the other Khazars returned with some pheasants they had shot. I watched while they were prepared. They were too tough for grilling, so a large metal bowl was found, and the birds stewed with water and herbs. There were no vegetables, and the stew was thickened with hard-tack. Some older men joined us, and, as dusk fell, they asked one of them, called Ozan, to entertain us. Much older than the others, he had a narrow, leathery face and a wispy grey beard. He moved nearer the fire, and began a performance, part song, and part

111

recitation, sometimes accompanied by a lute. His music was strange to my ears. Both notes and rhythms were quite unlike any I had heard, but I could see the power he had over his audience. It was obvious from his actions that the story involved frequent deeds of heroic violence, but I could understand nothing else. The others knew the epic well, and were hushed or enthusiastic, as the story required. It was my first experience of bards, though I was to come across them again in England. While the others followed the story, I remembered my conversation with the magus. The Khazars seemed to be at the most primitive of the stages he described, and I wondered about their religion.

After the epic was the feast. They passed round jugs of kumis, a revolting drink of fermented mare's milk, which I had to share. The stew was probed by greasy fingers, the tenderest portion was found and offered to me. I took it gratefully, and we all dipped in with hands or lumps of bread. Though it was not the best meal I had eaten, it was obvious that my participation was considered symbolic. I had shared their food, and was their friend.

After that I spent much time with Kurt and his friends. That summer's campaign was not eventful, and it did not take long to write my daily notes. Because of my status as George's secretary, my intelligence duties were vague, and I could account for my time by supplying information about the Khazars. Almost the first thing they did was to teach me to ride. They could not believe that I had never ridden before. They had all done so since early childhood, and if I was to be their friend, I must ride with them. They laughed at my first attempts, and at my soreness, but I was soon able to stay on the horse, provided it went slowly over level ground. That was enough to keep up, as their actual progress was not fast, but interrupted by wild antics and dashing in all directions whenever game was sighted. They were excellent archers, and could shoot just as accurately from horseback as on foot. I found all this unsettling, like the swimming. To me, the horse was hostile and uncomfortable, and could only be controlled with

difficulty. The young Khazars were so much at ease with their horses that they seemed almost animals themselves. They communicated with their mounts without words, and almost without gestures. A group of Khazar riders could change direction instantly and unanimously, like a flock of birds. In battle, it was this silent unity that made them seem both more and less than human. To them there was no mystery. They were in communion with their horse-god, and riding was a form of worship. I envied their bravery and dexterity, and wanted to be like them and share their pleasures. Yet I was slightly repelled by the feeling that they were compromising their humanity. And there was always an element of violence in their antics, which scared me, though I was never threatened. I let them laugh and play, while I plodded to the next halt.

As he learned more Greek, Kurt was able to tell me more about his people. He confirmed that the Khazars were no longer completely nomadic, and described the towns they had built, with stone and wood houses. They only lived in them during the winter. In the summer they travelled with their flocks or cultivated their crops. They even grew vines and made wine. Their life, as he described it, sounded almost civilised. Then he undermined that impression by telling me about the Khans. Ziebel was not the only Khan. There was another, greater Khan, back in Khazaria. This Great Khan was as much priest as king, was never seen by the public, and never left his own house. He had many wives, like the Persian kings. His commands had to be followed exactly, but all the actual government was carried out by the lesser Khan, who might be chosen from any of the Khazars, even the poorest. Kurt explained that, though the Great Khan was considered almost a god, he was killed after a fixed time, and replaced by a younger relative. When I objected that this was barbaric, Kurt replied:

"You killed your God."

"We did not. But He was killed, and resurrected, He lives on."

"Our Khan lives on. In new Khan. Is the same thing."

"A man, even a king, cannot be a god."

"Your Christ is man and God."

"He is, but it's not that simple."

"We have many gods. Sometimes they die. Sometimes men or animals are gods. Sometimes things are gods."

"Animals can't be gods."

"How you think we tame horses, if no horse-god?"

I could not answer that. Instead, I asked him to tell me more. There was a chief god, he explained, who ruled the sky, but not absolutely. Other gods, representing elements, seasons, death, night and day, as well as men and horses, all shared his rule. They seemed to argue like the Olympians. Men could hope to influence the gods by various means, including human sacrifice. That seemed to confirm the magus's theory of heroic peoples having heroic gods, whose epic deeds are told by bards. Perhaps the Greeks were like the Khazars, before Homer's time.

I felt that it was my duty to at least try to explain Christianity, but, with the limited language we had, Kurt could not understand its subtleties. Once he grew angry with me, when I insisted on repeating a point in the hope that he would understand.

"We kill people like you," he said.

"Do you mean you kill Christians?"

"No. Big-heads. Clever people."

"You kill people for being clever?"

"For making trouble."

"But how do clever people make trouble?"

"With new ideas."

"What's wrong with that?"

"My people are all the same. We all think the same. Always do the same. We are happy. New ideas make us unhappy."

I suppose conformity was necessary for the Khazars. Without it they could not have achieved their silent and terrible discipline in battle. Obedience is necessary in any army, but a horde that never thinks of disobeying is unstoppable. But I was so obsessed with my own desires that it did not occur to

me then that Kurt had taken a risk by befriending me. "But why kill?" I asked.

"Someone must die. For the gods. If not, the gods do bad things."

"Your gods are devils. No one should die for them."

"Christ died for your God."

I tried again to explain that he had misunderstood, but he interrupted and said:

"I will show you a god."

It seemed unlikely, but I did not object. I was afraid that I had offended him. I longed to be like him, and to be at ease with myself. And I wanted his friendship more than I wanted him to share my beliefs. I was also becoming less sure of what I believed. My faith, drilled into me by the monks at Tarsus, had been gradually weakened by the brutality of the army, which fought in the name of Christianity. I had been confused by the persuasive arguments of the magus, and by the bickering bishops at Ani. And George's pragmatic defence of orthodoxy, which he had equated with civilisation, had just been undermined by Kurt's strikingly similar justification of barbarian conformity. Much of what I had been taught at school now seemed open to debate and compromise. And the previous year, when the army marched through Cilicia, I had seen the monastery where I was taught, the church where I was made a Christian, and Tarsus, whose citizens had persecuted heretic families like mine, all ruined. Despite my attempts to explain Christianity to Kurt, I had begun to wonder whether God really was on the side of the orthodox, and to speculate about His nature. After all, if God is everywhere, it is pointless to argue that He could not be constrained, or would be corrupted, by matter. If He is not everywhere, then parts of the world must be filled with something else, which, not being God, must be evil. In that case, Dualists like my parents were right. I even thought, considering what Kurt had told me, that an omnipresent God might legitimately be worshipped in things or people. I can see now that I was foolish to dabble in paganism, but I was misled by real doubt, as well as by curiosity and desire.

A few days later, Kurt told me that it was time to see the god. He led me away from the domed Khazar tents, up the dusty slopes of the shallow valley where we were camped, towards the rock-strewn plateau above. The sun was setting behind us, and our shadows stretched ahead, twisting and jerking as we stumbled on loose stones or floundered in soft sand. At the top we kept walking, over firmer ground, until we reached a flat-topped mound that rose, catching the last of the sunlight, above the plateau. As the sky went dark, we scrambled up, and found that it was occupied by a dozen of Kurt's friends, and an older, bearded man I had not seen before. We sat in a circle, round a small fire, and I was glad to rest my aching legs, despite the hardness of the ground. The Khazars talked quietly, apparently agreeing something between them, then the older man stood up, and walked round the circle, giving each of us a small bundle of leaves. Like the others, I put the leaves in my mouth and began to chew. The taste was very sour, like sorrel. The leaves broke up, and I found that they contained a wad of something fibrous and sticky. As the mixture softened, other flavours, sweet and spicy, filled my mouth and competed with the sourness. The old man returned to his place and unwrapped a length of carved wood from a bundle of sheepskin. He set it up, supporting its base with three or four stones. When he sat down, giving me a clearer view, I saw that the object was a carved phallus, about two feet high.

I turned to Kurt, and whispered: "You worship that?"

"Why not? I came from one. So did you."

Nothing seemed to happen for some time. The old man muttered occasionally to the phallus, stroking it gently. The others watched, but not intently. I looked to Kurt for an explanation, but he ignored me, his eyes vacant. The wad of leaves turned to a soft mush, and released yet another flavour, the unbearable bitterness of unripe fruit. I pushed it into my cheek and stopped chewing. The bitterness did not diminish, and I did not think I could keep the mixture in my mouth any longer. I needed somewhere to hide it. I felt the ground by my legs, pressing my fingers against the cold rock, unsuccessfully

exploring its irregularities. A shooting star flashed overhead. The old man spoke again. The Khazars were all staring at the phallus, and I thought I might be able to throw the bitter mixture behind me. I tried to raise a hand to my mouth, but my arms felt so heavy that they would not move. I felt cold. Bitter saliva ran down my chin. More shooting stars appeared, swarming round me like mosquitoes. I was dizzy, and my whole body felt as though it was being pulled or pressed into the hard ground. I could see the fire and the phallus, but everything else was black.

Then I began to see visions.

The phallus grew and swelled until it was the size and shape of a barrel. It changed from wood to soft, pink flesh. From its lower rim sprouted four lobes that quivered and lengthened into the shape of human legs. The legs pushed against the ground, and, like a foal taking its first unsteady steps, the barrel stood, its fleshy staves heaving with the effort. The heaving turned to writhing, as new shapes emerged from its upper half. Fingers pushed through its skin, clustering in fives, followed by arms, that extended outwards like the four handles of a windlass. My own limbs were completely numb, and I could do nothing but watch while the phallus completed its wobbly metamorphosis. It staggered blindly while its upper surface bulged and shuddered. A knobbly, quince-like lump emerged and formed itself into a head. But it was a head with two faces, pointing in opposite directions.

I knew then what I was seeing.

The creature looked around, then stamped its feet, as though trying them out. It stretched its arms, then began a slow, lumbering dance, like two bears tied back to back. I looked away, and saw that the hill-top had grown bigger. It stretched as far as I could see, and was full of four-armed, four-legged, two-faced creatures, all clumsily hopping and capering. At first their faces were twisted into expressions of grim concentration, but gradually, as their movements became more fluid, their faces grew more human. They quickened, and seemed to spin in front of me, like leaves driven by the wind. As they turned I could see from their faces and genitals

117

that some were composed of male and female halves, whilst others were entirely male or female. As they twirled faster they lost balance and fell, rolling rapidly along the ground, propelled by their eight whirling limbs. They dashed in every direction, like frightened spiders, colliding and collapsing until all were heaped up into a squirming mass of trunks, arms and legs. There was a brief calm, then vague, ill-formed beings appeared at the edge of the heap, and began to grope among the exhausted bodies. They pulled, dragging out struggling creatures which, with the ease of fishermen gutting mullet, they split into two. Reduced to two arms, two legs and one face, their flayed flesh red and weeping, men and women limped, whimpering into the darkness.

When I woke up I was back at the camp. I do not know how I got there. I had obviously vomited, my head ached, and I was extremely thirsty. While I searched for water, I thought about what I had seen. The penis-god was a disappointment. I had learned nothing about the Khazars' beliefs, though the fact that Kurt had shown me the phallus was a sign that I had not offended him as much as I had thought. But the Khazars had other gods, and doubtless worshipped them, too. Kurt might just as well have shown me a ceremony dedicated to horses, or the sky. Was his choice significant? I hoped so, as my experience that night had confirmed for me something about my own nature.

In that vision I had seen the myth of the origin of sexual desire, described by Aristophanes in Plato's *Symposium*. I had read the book in Basil's library, and thought it rhetorical and ambiguous. The ambiguity, I later discovered, was due to censorship of certain passages by an over-zealous scribe.

According to Aristophanes, there were originally three genders, and humans were round-bodied, four-legged, four-armed and two-faced. Those composed of male and female halves were known as androgynes, while others were double males, or double females, just as I had seen in my vision. The double people had rebelled against the gods, and been split in

half as a punishment. Ever since, according to Aristophanes, we have sought our missing other half, and found pleasure, as well as becoming whole, through both friendship and the sexual act. Most of the original humans were androgynes, so most men and women are content to marry and have children. But the descendants of the double men or double women love and seek their own sex.

I found a jug of water, drank half, and poured the rest over my head.

I was troubled by what I had seen. The myth, like the rather perfunctory ceremony that invoked it, was pagan. I ought to have rejected it. But I knew that, somehow, my own nature had been revealed to me. And I knew, too, or thought I did, that Kurt was the other half I sought.

Though I wanted to let Kurt know how I felt, there was, at first, no opportunity. The army resumed its march, and we were soon penetrating deeper into the green valleys and bleak mountains of Armenia. Kurt was always surrounded by his friends, inseparable from the horde. As we rode, I remembered what the *Symposium* said about the love of a man for a man, which Plato thought the noblest of loves. The Church did not share that view, though it revered some saints whose love for each other was more than brotherly. I had read their lives to Nicholas's mother. Surely it could not be wrong to love one's fellow men?

I kept thinking about the time I had first seen Kurt, and hoped that we might soon halt by a river. Bathing would be an occasion for innocent contact that would enable me to judge his reaction before I committed myself. I convinced myself that I had aroused a secret longing in him, just as he had in me. But I had seen no evidence that Kurt's relations with the other Khazars were anything more than comradely. It might be difficult for him to admit his feelings, or to express them, unless we could be alone together. His friends, I thought, were the chief obstacle to our happiness. I continued to ride with them, but still could not bring myself to try anything dangerous. Though Plato had thought lovers of men the most manly,

and military of men, I could not think of the Khazars' antics as anything but oafish.

At last we reached a river, and it seemed likely that we would stay for a few days. The Khazars bathed their horses, then themselves. I joined them, and while the others were splashing about in their childlike way, I stayed close to Kurt. I wanted to share the Khazars' ease with their bodies, and, like them, had taken off my clothes. I tried to keep close to Kurt. He was my other half, and would make me whole. He would allow me to express my true nature, if only he could express his. I knew what I wanted to do: I wanted to touch him, and for him to touch me. And I wanted to go on from touching, to do other things—things I had seen men do with women, violently, in the aftermath of battle. But I feared violence, and could not forget my shame and confusion after the man-handling I had had at Dvin. I did not want to be hurt again. How could I be sure he would be gentle?

Kurt did not respond to my attempts at conversation. He seemed bored, and anxious to get away. That, I imagined, was because he did not want his friends to know how he felt. He washed himself, sluicing his body with water, ducking under the surface, bobbing up again and throwing back his streaming head. His naked body, sinewy and strong, glistening with river water, seemed more desirable than ever. I kept talking, babbling nonsense about nothing, keeping close to him in the hope that we might, by accident, touch. But he stood aloof, stretching his arms, and admiring his muscles in the sun. I ran out of words, and he turned away and began to wade towards the others.

"Kurt," I called.

He turned back, his face twisting into what I took to be a smile, and I waded towards him. We stood facing each other near the bank, in water up to our knees. The others were out of sight. I could not help staring at his fat, pale penis. I imagined the pleasure it might give, if aroused, but it lolled limply against his muscular thighs. Not knowing what else to do, I reached out and touched it.

It was a mistake.

He pushed me back and shouted: "No! Is forbidden. Is holy place. Not for man to touch!"

"Your penis, holy?" I feebly replied from my resting place in the mud.

"Is a thing of creation. You saw the god."

"That was a piece of wood, not a god." It was not the moment for pedantry, but I felt impelled to object. He looked even angrier.

"Now I must make sacrifice. To make holy again."

I might have asked what sort of sacrifice, but I did not really want to know. All my interest in the Khazars vanished instantly, and was replaced by a growing feeling of humiliation. I climbed out of the river, dressed, and quickly walked away. I did not take my horse.

I reviewed the justifications for celibacy, and added to them the wish to avoid embarrassment. Fortunately I did not have to endure the presence of our Khazar allies for long, as Ziebel died, and his followers rode back to Khazaria to witness the selection of his successor.

During my time with Kurt I had neglected my intelligence work, as well as George's narrative. I resumed this work, and spent hours reading reports in an attempt to dispel my feelings of humiliation. Unfortunately, most of the reports were about the Avars, another nomad tribe, who were thought to be converging on Constantinople again, ready to begin a new siege. They were said to have built some huge mangonels, perhaps copied from the Chinese, against whom they had once fought. Even worse, the Persians were sending an army to help them. If the two enemies joined forces, there was a real risk that the greatest city in the world might be lost to pagans and barbarians.

I imagined the Avars bombarding the triple walls of Constantinople, just as we had bombarded the walls of Dvin. When the walls were reduced to rubble, savage nomads would ride into the city on their rugged steppe ponies, just as the Khazars had galloped into the Persian towns they helped us capture. The Persians would follow them, looting houses and

monasteries, burning libraries, and desecrating churches. All the learning of a thousand years would be destroyed. The city's inhabitants, and all the refugees who had gathered there, would be killed, raped, or enslaved. There was no reason to believe the enemy would be any less bloodthirsty than we had been when sacking their cities.

Heraclius sent a few troops back to Constantinople, but not enough to make a difference. He was relying on the navy, which controlled the Bosphorus, to keep the two enemy forces apart. But something more was needed, to divert their attention from the capital. I spent so long sitting in the Intelligence tent, wondering how Constantinople might be saved, that my chief complained, and told me to get on with something useful. He threw me a bundle of reports that no one had had time to look at. When I opened them I was dismayed, as they were about France, an unimportant barbarian kingdom in the West. I felt affronted that he had given me such pointless work. But once I began to read, I saw what no one else had noticed.

As Basil had once explained to me, when the Roman province of Gaul was invaded by the Franks, it was lost to the Empire for ever. Not even Justinian was able to reconquer it. The Franks were Germans, who still ruled their original homeland beyond the Rhine, and had conquered some of their German neighbours, as well as Gaul. Their kingdom was the largest in Europe, stretching from the Western Ocean to the dark forests of Bavaria, and from the Pyrenees to the wild North Sea. Had the Franks been united, they might have been a serious threat or a valuable ally, but they seldom were united, and it seemed that no one had thought recently to enlist their help.

Reports about the Franks came from two sources: Ravenna, which was the capital of the Empire's Italian province, and Marseille, where, despite the Persian occupation of their homeland, some Syrian merchants continued to trade. They described the enfeebled state of the country under King Chlothar, who, though unusual in ruling the whole kingdom, had only achieved that position by appeasing his nobles, who

held the real power. These nobles tended to support rulers who were too young, or weak, to rule effectively, and were happiest when there were several kings who could be dominated easily. The reports from Ravenna gave hints that this situation might soon change. Some of the nobles, pursuing their policy of division, had urged Chlothar to make his son, Dagobert, King of the eastern, German part of the country. Chlothar had given in to the nobles, but Dagobert had proved much more able than expected, and was governing his part of the kingdom well. Chlothar was old and ill, and would soon die, probably to be succeeded by Dagobert. It seemed to me that if we could secure Dagobert's friendship, he might be useful.

I tried to remember the geography Basil had taught me. Dagobert's eastern frontier was close to the western limits of the Avars' empire. If the Franks were to attack the Avars, that might distract them from their attacks on Constantinople and the Balkans. I wrote a report suggesting that an alliance with Dagobert be bought, and an attack encouraged. He was given a subsidy, and offered one of the Emperor's daughters, but it turned out that, despite being an orthodox Christian, he already had several wives. Dagobert later became King of all the Franks, and continued to be useful to the Empire.

The Avars, when they arrived at Constantinople, must have terrified the inhabitants. They brought with them a huge horde of savage tribesmen gathered from all over Eastern Europe, including Slavs, Bulgars, Goths, Gepids, and several varieties of Hun. They made camp along the land walls, assembled their siege engines, and waited for the Persians.

In the city, the Green and Blue militias manned the walls, and the Patriarch mobilised the holiest icons and organised vigils and prayers. A delegation was sent to buy off the Avar Khan, but he refused to withdraw, thinking the city already his. He began the attack, bombarding the walls with powerful mangonels. But the Persians, though they watched the attack from across the Bosphorus, did little to help. The walls proved too strong, and were not significantly damaged. The Khan launched an improvised naval attack, but the dugouts of

his Slav subjects were all sunk. After some ineffectual skirmishing beneath the walls, the Avars withdrew, hastily and mysteriously.

It was claimed afterwards that the city was saved by a miracle, visions of the Virgin having been seen hovering above the walls. Some said that the siege failed because of treachery, and that someone in the Persian camp had informed the city's defenders of the enemy plans. But I believe that the Avars withdrew because Dagobert and his Frankish army were attacking them from the rear. However, had I known then what difficulties King Dagobert's heirs and enemies would one day cause me, and what lies would be told about my involvement with that troublesome dynasty, I might have torn up my report and let Constantinople take its chances with the barbarians.

8

NINEVEH

A.D. 627–628

I do not recommend Edessa. It lies beyond the Euphrates, on
the northern edge of the Syrian Desert, among low, sand-
coloured hills from which the hot wind brings a plentiful
supply of dust and biting insects. Its architecture is dull and
functional, its amenities are few, and its heretical population
was not keen to rejoin the Empire. It was just the place to
drive an army mad with heat and boredom, yet we stayed
there for many weeks. We arrived in the stiflingly hot summer
of 627, after passing the winter in Armenia, where Heraclius
had received pledges of loyalty from mountain chiefs, and
organised the repair and manning of captured strongholds. It
was a shock to descend from the cool, green highlands of
Armenia into the heat and dust of Syria. Edessa had been
captured by Theodore, the Emperor's brother, while we were
with the Khazars, and he was waiting for us with his part of
the army. They paraded in polished armour while we, tired
and thirsty, trudged into the city, watched by its sullen
inhabitants. After we had settled into our quarters in the
citadel, George said:

"The army are impatient. They don't want to stay here,
they want to see some action."

"Surely we will attack the Persians soon?" I remembered
what Basil had told me of the tendency of melancholy men to
sink into inaction. "There is nothing to stop us now."

"The Emperor won't move until everything is in order
here. This is our last chance, and nothing must go wrong."

"I've seen the reports. There are only a few Persian troops
left in Syria and Mesopotamia. They can't stop us marching
east."

"No, but they would be behind us if we did, and they may

have support among the monophysites. The Emperor will stay here until he is sure that the population is loyal and all the cities have trustworthy governors."

The Edessans were neither loyal nor trustworthy. Most were monophysites, and had not been much inconvenienced by the Persian occupation. Some were said to be heretics of the same kind as my parents, though many of the sect were rumoured to have fled east with the retreating Persians, whose faith theirs resembled. I did not dare to look for the heretics, if any remained. Whatever their beliefs, the Edessans resented the troops billeted in their houses. They stole from army stores, swindled quartermasters in the markets, and made life in their city as difficult as possible. I stayed away from the narrow streets, where unarmed men sometimes disappeared, preferring to work in the safety of the citadel. George was busy attending Heraclius, and I was not obliged to write any notes for him. Neither the Emperor nor the army had recently achieved anything that might form the basis of an epic poem, and I had almost forgotten my work for George when he came to see me.

The room in which I worked was small, and its high windows let in more dust than light. The documents on my table were covered with a thin layer of gritty particles, the fineness of which provoked me to speculate again on the atomic theories I had once discussed with Basil. Some of the books I had read in his library implied that elements could be transmuted, though by what means, I did not know. I idly crushed dust grains with a stylus, wondering whether they still retained their essential stoniness, or had been transformed by division into a new substance. I was trying to reconcile what I could remember of atomic and elemental theories when George arrived, sweating and anxious. He sat down heavily on a stool given to him by one of the clerks, and dabbed the top of his bald head with a brightly coloured silk scarf.

"I'd like to know what you make of this letter," he said, giving me a roll of papyrus. My work, at that stage of the war, required me to read many letters. Some were from town governors or petty chiefs pledging their loyalty to the Empire.

Others came from their subjects alleging the treachery or unreliability of their rulers while under Persian occupation. George's letter seemed no different, except for a rather grand seal. It was written in a thick, heavy script, which I could not read, but there was a Greek translation. It was signed with the name Mohammed, Apostle of God.

"Where did it come from?" I asked.

"Some Arabs brought it. They are waiting for a reply."

"Is it urgent?"

"You tell me." He wiped his head again, and asked a clerk to bring him some water. While he waited, I read the letter. It was not a pledge of loyalty, but a request for it. It described a series of revelations, which, in the opinion of the writer, superseded those of Christianity. All who read the letter were required to acknowledge the truth of the new faith, and submit to the authority of its Prophet.

"I think I've heard of this Mohammed before," I said. "The magus told me about him."

"I thought so," said George. "What did he tell you?"

"No more than is in this letter."

"I was hoping you might know more."

"I don't. Has the Emperor seen this?"

"He has, and he's furious. He asked me to find out about this new faith, and I remembered that you had said something about it."

"The magus was vague. He only mentioned the subject to confuse me."

"We need to know more. Perhaps you could have a word with the messengers. I seem to remember that you like barbarian horsemen." He gave me an odd look as he put down his empty cup, but I did not reply. I had imagined that my interest in the Khazars had not been noticed, and could think of nothing to say that would not make me seem more foolish than I evidently appeared.

I collected a Syrian clerk who spoke Arabic, and, carrying the letter, set off to find the Arab horsemen who had delivered it. I discovered them near the south gate, reclining in the shade of some palms, their horses tethered nearby. Had I been given

their task, I would have waited anxiously, but they seemed completely calm. They lay on striped saddle-blankets, their faces covered by head-cloths, in attitudes that suggested repose rather than exhaustion. I was about to walk up to them, but the clerk gripped my elbow and held me back.

"Don't startle them," he said. "Look at their hands."

Each Arab, though apparently asleep, had his hand on a dagger. The clerk coughed loudly to warn of our approach. They woke, or pretended to, and stood, brushing the dust from their loose, white clothes. Most of them were dressed in little more than sheets, wound round their hard, thin bodies. Their leader, distinguished by his tunic and wide trousers, took a step towards us, pulling a yellow head cloth over his long black hair. He wore it like the Khazars, oiled, and in plaits. In other circumstances, he might, as George had hinted, have been desirable. But his eyes were full of the same hard certainty that I had seen in Nicholas. It is curious that those who seem most sure of themselves are often eager to follow new leaders, while those who are most doubtful usually find their own way.

I explained who I was, and discovered that he spoke some Greek. I pointed to the letter, and asked him:

"Do you follow this new faith?"

"It is not new. It is the true faith, that has always been. But, yes, I follow it."

"How many others do?"

"Many."

"How many is that?"

"You will see." I could not tell whether he was making a threat, or recalling a prophecy. To him, the outcome of either would have been equally certain. I thought it pointless to dispute with him, so I asked him about the letter.

"How many others have received this?"

"The Kings of Persia and Abyssinia, the Governors of Egypt and Yemen, and the Princes of Arabia."

"And what was their reply?"

"They have all submitted to the authority of the Prophet Mohammed. Except for the King of Persia." It seemed un-

likely. Whatever Arab princes and African kings might do, provincial governors were hardly likely to commit treason on behalf of an obscure Arab chieftain, even if he did have mantic pretensions.

"What was Chosroes' response?" I asked.

"He tore up the letter and had the messenger killed."

"You are very calm. Do you not fear the same fate?" I wanted to undermine his confidence, and see the certainty in his eyes replaced by doubt or fear.

"Not at all." His expression did not change. "God is with us. Mohammed has prophesied that God will tear up Chosroes' kingdom, just as Chosroes tore up the Prophet's letter."

"And the Persians are your enemies now?"

"Their King is our enemy. The Persians are welcome to adopt the true faith, just as you are." He stared at me, in the way that I have seen practised seducers stare at an intended victim.

"I have my faith." I said, but I was not sure that I had. I realised then how much of faith is sensuality denied. My faith had faltered while I desired Kurt, and had returned now that I did not. But I was not sure what it was I had faith in. Perhaps, after my encounters with savagery and paganism, I had put my faith in civilisation. And civilisation, as George maintained, meant orthodoxy.

"That may be," the messenger said. He paused, and looked back at his men, showing, for the first time, a hint of anxiety. "How will your Emperor reply?"

I knew very well that Heraclius would not submit to Mohammed's demands, and that he might well be angry enough to have the messengers imprisoned, if not killed. But I did not say so. Arab allies had often been useful in the past, and it might be possible to encourage their hostility to Chosroes without accepting any of Mohammed's extravagant claims. When I returned to George, I explained what I had learned, and recommended that Heraclius send a polite, but ambiguous reply, emphasising our common cause against the Persians. The reply, when it was sent, may have bought the

Empire a little time, but it did not, as things turned out, secure the friendship of the Arabian prophet.

In September, all the available troops were assembled on the dusty plain outside Edessa. There were almost 70,000 of them, mostly veterans of previous campaigns. The Empire was exhausted, it was the last army that could be raised for some time, and it was essential that it was not wasted. We marched north-east, passing through bare steppes, then crossed a bleak, rocky plateau occupied only by shepherds. At Amida we crossed the Tigris, then continued, slowly, following the east bank as the river descended into Assyria. We marched in short stages with long stops, and I had plenty of time to read the two books that Basil had given me. Xenophon had passed that way, though in the opposite direction. I found him rather vague about the geography, as he seemed to forget several large rivers, tributaries of the Tigris, which we were obliged to cross.

We were entering the country where Alexander had finally defeated the Persians, and made himself Great King. Reading about Alexander's campaigns in Arrian's history reminded me of what I had hoped for when I joined the army, but also of what I had failed to achieve. George thought my admiration for Alexander foolish.

"He was a tyrant," he said, finding me reading instead of attending to my work. "And a pagan. Just like Chosroes."

"He could not help being a pagan," I replied, trying, rather pointlessly, to push the book under a pile of documents, as though it was part of my research. "He lived before Our Lord, but he tried to acquire what wisdom he could. He studied philosophy with Aristotle. He was interested in medicine, geography and natural history. He learned about Plato, and loved Homer."

"That didn't make him a philosopher-king, if that's what you are thinking."

"But he was great man. How can you compare him to Chosroes?"

"He tried to conquer the world, like Chosroes. He

murdered his opponents, and even his own generals, like Chosroes. He declared himself a god. Whatever ideals he may have started with, he became an oriental despot."

"Because he made the Greeks prostrate themselves to a man? We are still doing that!"

"Be careful what you say," George said, looking around uneasily. But there was no one within earshot. The other clerks were away on errands. "We can safely compare Alexander with Chosroes, but it is dangerous to compare either of them with our Emperor. We prostrate ourselves to Heraclius because he is God's representative on earth."

"Even when he meddles with theology?"

"We revere his person," George said. "Even if his opinions are wrong."

"And praise him in verse?"

George gave me a warning glare. His bald scalp flushed with anger.

"Do you think me a hypocrite?" he asked.

"No." I did not think it wise to provoke him further.

"A sycophant?"

"No."

"But you think me a flatterer. You can't deny that."

"You have said yourself that flattery was advisable at court."

"It is," he said, sadly. "But you must not think badly of me. Heraclius may not quite be the hero I make him seem, but he is the best Emperor we have. And he has succeeded, even though the war has gone very slowly. We have to support him, despite his theological compromises. The alternative is civil war or Persian conquest, and we have had enough of those. With luck, we will beat the Persians this winter, and the Empire will return to peace and prosperity. If so, Heraclius will be hero enough."

"I still think Alexander a greater hero. He was inspired by genius, and acted quickly to carry out his ideas. His will was not sapped by melancholy."

"Is there not some other reason why you admire Alexander?" George's anger had faded, but his smile was not altogether friendly. I hesitated before answering.

"I envy his friendship."

"Friendship?"

"With Hephaestion."

"You call that friendship? Some would call it more."

"Love, then."

"Alexander's love for Hephaestion was excessive."

"It was noble. They fought side by side, like Achilles and Patroclus."

"It was not noble love. It was unnatural lust, and it led to his downfall. You know very well that when Hephaestion died, Alexander's greatness died. He went mad with grief and drank himself to death."

"That proves the strength of their love."

"That sort of thing is dangerous and wrong. You should be careful." George paused, apparently considering whether he should say more. He had obviously noticed my interest in the Khazars. Perhaps he knew about Kurt. If he intended to give me more personal advice, he changed his mind and said:

"It is the myth we remember, not the man. If we are lucky we will be remembered for the good we have done, not for our faults."

Perhaps George was right. He surely hoped to be remembered for his verse rather than his doubts. Perhaps Alexander was no more to be admired for his genius than Heraclius was to be condemned for his melancholy. But George's arguments could not prevent me from envying Alexander. Whatever his ultimate fate, he had at least known love. My meeting with the Arab messenger had reminded me that I had not. His beauty, certainty, and barbarian swagger had unsettled me.

The next day we continued our advance along the east bank of the Tigris. I thought, as I marched, of Nicholas and Kurt, of my solitary condition, and of the unassuaged demands of lust.

If King Chosroes had as many wives as was rumoured, his lusts can seldom have gone unassuaged. But in other respects he may have considered himself thwarted. Far from ruling the world, as he had once boasted, he was in his palace at Dastagerd,

preparing to defend what was left of his kingdom against the advancing Imperial army. Many of his troops were still camped by the Bosphorus, as reluctant to return to Persia as they had been to join the Avar's siege of Constantinople. But Chosroes assembled as many soldiers as he could, gathering men from all over the East. To me, the most interesting thing about this new army was that it included elephants. Arrian's account of Alexander's battle against the Indian king Porus suggested that elephants, though terrifying, were not invincible. It seemed that they frightened horses, and, if their drivers were shot, the elephants would panic, and trample anything in their path uncontrollably. Alexander used that method to cause chaos in the Indian ranks, then drove the confused enemy into an ambush. Much of the Persian army was newly recruited, and it was likely that neither they nor their horses would be any more used to elephants than we were. I wrote a report, suggesting that a group of archers be given the task of shooting the elephant's drivers, choosing moments when the animals were surrounded by Persian troops or cavalry. The report was acted on, and though I do not think it affected the outcome of the battle, it did have consequences, which I will tell later.

In December, the Persians, who tried to avoid battle at first, halted by the ruins of the ancient city of Nineveh. That seemed an omen, for it was near there, at Gaugemela, that Alexander fought his greatest battle, defeated Darius, and made himself ruler of the East.

I did not sleep much in the night before the battle. I had seen enough of war to feed my imagination with many unpleasant possibilities. My fears were increased by the knowledge that I would spend the day with the baggage train and the non-combatants. That may seem like a safe place, but as soon as a battle is over, the winning side makes straight for the defeated enemy's baggage. Sometimes, in the middle of a battle, deserting auxiliaries will raid their erstwhile enemy's camp before retreating. It could be dangerous to be caught near an entire army's portable wealth. Shortly before dawn I abandoned my attempts to sleep, left the tent, and climbed up a

rocky mound from which, with luck, I would be able to observe the battle.

All around me, below the mound, were the medical tents, where orderlies were already setting up tables and preparing bandages and dressings. Further off, the troops were forming up, the noise of shouted orders and clanking equipment muffled by the swirling winter mist. The rising sun, feeble and yellow, lit their preparations and slowly drove off the mist. I sat shivering among the rocks, waiting and watching.

The troops did not look much like those I had seen when I first joined the army. Their uniforms were patched and dirty, or replaced by miscellaneous garments obtained in the East. Many, defying regulations, wore Persian armour or weapons, booty from previous campaigns. They were reluctant to leave those prizes in the camp, just in case. Horses, too, were dressed in Persian fashion, with brightly woven blankets under ornamented saddles. Some wore padded leggings to protect them against arrows. The equipment of the more experienced units was so ill assorted that they looked more like brigands than soldiers.

After what seemed hours, when all was ready, and I was almost frozen, the purple flag was raised, and the army set off. They advanced in rigid formation, hoping that the formal tactics they had learned on the parade ground, and practised often enough in battle, might settle the issue without any actual fighting. They knew that if they could survive that battle they would survive the war. The infantry made a lot of noise as they advanced, shouting, clashing shields and spears. In my perch among the rocks I could feel the shaking of the earth under their combined step, and the steady rumble of the heavy cavalry in the centre. When the two armies drew close to each other there was a great clamour as war cries in half-a-dozen languages rose above the general din, but there was no great eagerness to make contact. Instead, the front ranks of both sides began to shout and feint, taunting their opponents into fighting or fleeing, while officers moved among them urging them to advance.

The mist had cleared by then, and I looked eagerly towards

the eastern horizon, hoping to make out the elephants before the dust raised by the two armies blocked the view again. I could not see them at first. Was our information wrong? Were there no elephants, or too few to be significant? If so, my scheme would fail. Then I realised that what I had taken to be some sort of crenellated wall, winding sinuously beyond the main mass of Persian troops, perhaps a temporary stockade, was in fact the elephants. There must have been a couple of hundred of them, far more than I had imagined, evidently disciplined and patient, their backs topped by wooden castles. I could see no sign that the Persians were afraid of their elephants, but if the animals managed to advance in a solid mass they would surely terrify our men, and might even drive them into the Tigris. The report I had so confidently written, based on ancient and possibly unreliable sources, no longer seemed such a good idea.

The feinting and grappling I had witnessed earlier began to turn into real fighting. The Persians were disciplined, and their armour was good. They held their positions at first, though some of their auxiliaries deserted. Our infantry parted to allow the heavy cavalry to charge through them, but the Persian horse archers suddenly turned and retreated, shooting backwards at their pursuers. I had read about this tactic often, in ancient histories, but never seen it. Persian bows are strong enough to drive arrows through chain mail at close range, and many of our men and horses were killed or injured. That stopped the charge, and made it hard for the survivors to regroup, which is always difficult after a failed attack. As a result, and because the newer troops on both sides failed to hold their positions, it became harder to carry out the formal tactics that had begun the battle. The Persian rearguard, who were conscript peasant spearmen, milled about uselessly, unwilling to fight, but unable to disengage safely.

By then the elephants had advanced, their solid rank dividing into groups of a dozen or so. They were a magnificent sight, towering above the men and horses, like islands rising from the sea. The wooden castles on their backs were manned by archers and spearmen, and their tusks were sheathed with

bronze. At last, now that they were within range, some of our archers began to carry out my plan, aiming arrows at the elephants' drivers. I watched, willing the arrows to reach their targets, hoping that my scheme would work. At first, nothing seemed to happen, but when enough of their drivers had been killed or wounded, the elephants' advance faltered. Driverless beasts tossed their domed, lumpy heads and made strange trumpeting sounds with their trunks. Some of them were injured, and lashed out tusks and feet, causing chaos as I hoped they would. But the surviving drivers seemed to realise that they were being targeted. Without obviously retreating, they steered their animals away from the dangers of battle, leaving gaps in the Persian front. Being Indian, the drivers had no particular loyalty to the Persian King.

After hours of fighting, which gradually became more disordered, the Persian general challenged Heraclius to single combat. He knew that, one way or another, he would die if he lost the battle, and must have calculated that only by killing Heraclius could he save his own life. I saw nothing of their contest from my mound, but those who were close said that, despite receiving a wound to the face, the Emperor cut off the general's head with one blow of his sword. They also say that he killed several other Persian officers in the same way. After that, the morale of the Persians steadily declined, and by nightfall most of the Persian army had either been killed or had run away.

I climbed down from the mound and returned to my tent. Most of the troops slept on the battlefield that night, too tired to find the camp. They lay among the mutilated bodies of comrades and enemies, shivering with exhaustion and cold. Many who survived the battle died in the night. Early next morning we were woken by wild animals and scavenging birds that had assembled to feed on the corpses. Some of the dead were buried, but not many. Most of the survivors were keen to search the battlefield for valuables. They walked, stooping, through the morning mist like silent spirits in Homer's Hades. Odysseus had made the spirits speak by sacrificing sheep. We had sacrificed men, and so many had died

that all our soldiers found something worth taking. Heraclius took the Persian general's showy armour. The general's head was stuck on a spear and carried at the head of the army as we quickly continued our march.

The battle of Nineveh was the nearest thing I saw to the battles I had read about in books, and it ought to have ended the war. But it was not quite the end. Chosroes was still in his palace at Dastagerd, about seventy miles further along the Tigris. We marched for a few days, and then, as it was Christmas, halted to celebrate. Messages were sent to the King inviting him to surrender, but he refused, promising 'the greatest of all battles' if we continued to Dastagerd. We continued, but there was no battle. Instead, Chosroes ran away. He climbed through a hole in the palace wall, taking only a few of his wives. When they realised what had happened, his courtiers and army followed him, leaving the palace undefended.

Before the palace was sacked, Heraclius had it carefully searched. He was hoping to find the True Cross and other relics taken from Jerusalem, but if they had ever been kept there they had been removed. After that the Emperor and his followers had their servants remove the most precious items, then, in descending order of rank, the rest of the army was allowed to take what it could. There was no disappointment, even in the lowest ranks. There was enough to go round, and many valuable things were trampled in the search for something portable. As I wandered its echoing chambers, I could see that this palace was greater and more luxurious than the one at Tabriz. Chosroes had assembled, or inherited, a museum of treasures and curiosities from Europe, Africa, India and China. Storehouses were filled with traded goods brought from all over the world. There were enough spices, silks and carpets to supply the markets of several cities. The carvings, paintings, statues and mosaics could not be removed, and seemed full of pagan significance, so they were first casually defaced, then systematically destroyed. Several temples were found and burned, and the flames soon destroyed the whole palace.

Around the palace were gardens, some artfully wild, with exotic plants, birds and animals, others tiled and paved, with fishponds and fountains. I walked through them, watching the palace burn. Soldiers, loaded with loot, were drinking round fires made of costly furniture and the trunks of rare trees. Slave girls danced, for as long as possible, knowing what would come next. Drunken songs boasted of what the singers would soon be incapable of doing. Some soldiers, more epicurean than lustful, had killed some of the King's animals and were roasting them. I was offered a charred chunk of meat.

"What is it?" I asked.

"Unicorn."

"Really? Are there any others?"

"No. Just the one."

I looked at the mangled carcass. It might have been anything.

After clearing the palace at Dastagerd we marched towards Ctesiphon, where Chosroes was thought to be hiding. But the winter had been unusually mild, and rain had fallen on the mountains instead of snow causing the Tigris to flood. We could only go slowly through the spreading swamp, were exhausted, and were encumbered with loot. Before reaching the city, Heraclius gave the order to turn back. Perhaps he was discouraged by the floods, or was sinking into winter melancholy. He had always avoided fighting through the winter. Possibly he guessed, or had secretly influenced, what would happen next. It was clear that we had won the war, and destroyed so much of the Persian army that Chosroes could do little against us now. As we began the retreat, I thought of Alexander, who had reached India before giving up and turning back. But he had been younger than Heraclius, and thought himself favoured by the gods. It was difficult to see that inconclusive end to the war, or anything that followed from it, as a mark of God's favour.

We marched north, and, though there was some complaining among the troops that they had been denied the chance to finish off the Persians, most were glad enough to be heading

for home. The mild weather was in our favour, and we were able to cross the Zagros Mountains easily. But as we approached Armenia, an icy wind sprang up, and we were soon enveloped by a blizzard. We struggled on, through woods and orchards thick with snow, and reached Tabriz. We could go no further, and had to halt until the weather cleared. It was as well that, five years earlier, though we had destroyed the temple and sacked the palace, we had only pillaged the town. The inhabitants were obliged to give up their houses and shelter where they could from the bitter cold, while we moved in, slaughtered their flocks and ate their winter stores of food.

George settled into a comfortable merchant's house, which he furnished with looted Dastagerd carpets and warmed with oak cut from the surrounding hills. While we waited, we worked, going over my notes, trying to devise a climax for the *Heracliad*. George had already turned much of the war, and the siege of Constantinople, into verse, but the last two years had been so uneventful that it was difficult to make them sound heroic. We considered the sack of Dastagerd and the battle of Nineveh, looking for Homeric parallels. But George seemed sadder than before, and his occasional scepticism had become more permanent. He was disappointed by the length of the war, and by the price the Empire had paid for victory. Despite defending Heraclius as enough of a hero to be praised in verse, he found it difficult to see anything heroic in the Emperor's recent actions. We spent a month pondering fruitlessly while the snow fell, drifted, then began to thaw.

We were trying to decide how many Persians Heraclius might plausibly be said to have killed with single sword-blows, when we were interrupted by a messenger.

"King Chosroes is dead!" he announced, his wet boots dripping over George's finest carpet. "And the war is over."

George, remembering his position, said a short prayer of thanks, then asked for more details.

"He ran away again," said the messenger. "But they caught him."

"Who did? The people?"

"No, the King's son, Siroes. He killed the King, and his wife, and nineteen of his sons."

"Siroes killed his own father and brothers?"

"Yes, Sir."

"And is this monster, Siroes, the new King of Persia?"

"That's right!"

The messenger, realising perhaps that his manner in telling this grim story was a little too enthusiastic, looked down and noticed the spreading puddle at his feet.

Heraclius returned to Constantinople as soon as the weather cleared. He was accompanied by some of the elephants captured at Nineveh, which took part in his triumphal procession, towing him through the Golden Gate in a gigantic chariot. The populace, surprised by the premature infirmity of their once heroic Emperor, and by the gaudy eastern loot that decked his chariot, greeted him with laughter as well as cheers. I am glad I was not there to see it.

George, too, went back to Constantinople, taking my outline history of the war, and what he had completed of the *Heracliad*. He left so hastily that I hardly had time to say goodbye. But I knew that I would miss his cheerful public manner, and his gloomy confidences.

I stayed on in the East, working for Theodore, the Emperor's brother, whose job it was to negotiate peace with the rapidly collapsing Persian Empire. Later, we toured the reconquered provinces, restoring their administration and persuading their peoples, sects and factions to live peaceably together.

9

ANTIOCH

A.D. 631–636

Antioch became my home for a while, as I worked on a commission given to me by the Emperor. When I was summoned to an interview with Heraclius, I was surprised and uneasy. I had never spoken to the Emperor, and had only once seen him close up, when I had taken notes during the meeting of Armenian bishops. Then I had been so unimportant that we had not acknowledged each other's existence. Now he wanted to speak to me in person. Some of Theodore's staff found suitable clothes, and explained the protocol I should observe. A few days later I crossed the bridge to the palace, which was set in a walled park that occupied most of a large island in the Orontes. When I reached the waiting room of the Emperor's audience chamber, I found that I was not, as I had foolishly imagined, alone. Instead I was part of a large crowd of local notables, who had bribed or persuaded their way past the lower levels of administration, and hoped to present their petitions to the Emperor. In the confusion of the preceding years many genuine grievances had arisen, as well as the usual vexatious ones. Properties had been destroyed, title deeds lost, heirs died, wills disputed and debts repudiated. The visit of the Emperor seemed a good opportunity to claim or dispute title to these properties. I stood among the petitioners, staring at the hunting and fishing scenes on the floor, and listening to them rehearsing their cases. A man who stood on a mosaic wild boar seemed to be reciting his entire family tree. Another, by a stag at bay, described the dishonesty of his brother, while the man next to him explained how his neighbour had moved some boundary stones. An abbot stood among writhing fishes on a tessellated sea, practising unfurling a scroll.

Soon the double doors to the audience chamber were swung open, and all the muttering stopped. An attendant called out some names, and the first group went in, prostrated themselves in front of the Emperor, and attempted to repeat what they had rehearsed. The rest of us waited silently, trying to look noble, honest or long-suffering, as the case required. I expect I looked baffled. I had no idea why I was there.

I was called forward with a group of grain merchants who were trying to collect money owed to them for goods supplied to the army. It seemed that either their goods or their money had been diverted by a dishonest official, though no definite proof was produced. When they were dealt with, I was left alone. An attendant asked my name.

I told him, and looked at Heraclius directly for the first time. His sparse hair was now completely white, and his blue eyes watered. The wound he had received during the battle of Nineveh made his mouth sag unevenly. His hands gripped the arms of his throne rhythmically, and he seemed to be trying to force his stooped body upright. He turned to the attendant, who looked at his list and whispered to the Emperor. Heraclius then spoke to me, wheezing as he did so.

"You seem very young."

"I am twenty eight years old, your Majesty."

"George the Psidian has told me about you. It seems that you have assisted him in some way in composing his great poem the *Heracliad*."

"Yes, your Majesty."

"George tells me that you composed an outline history of my wars, and that you are well acquainted with the great historians of the past. Is that so?"

"Yes, your Majesty." I had been warned to agree with everything.

"And it was your intelligence work that led to the alliance with King Dagobert?"

"Yes, your Majesty." I had not expected to be given the credit for that. Presumably George had told him. I hoped he had not mentioned the elephants.

"And you assisted my brother at the peace negotiations?"

"Yes, your Majesty."

"Good. I would like you to be my historian. You are familiar with Procopius's history of the Persian wars of my predecessor Justinian?"

"Yes, your Majesty, I know it well." I wondered whether he had read, or knew about, the scandals and exposures of the same writer's *Secret History*.

"Do you think you could write something similar about my own wars?"

"If your Majesty wishes, I will be glad to attempt it."

"Begin straight away. All the facilities you need will be made available."

"Thank you, your Majesty."

It was all over in a few moments.

Back in the waiting room I was met by another attendant, and taken into a side-room. He gave me a packet containing all the notes I had made for George, and told me that any extra information I needed would be made available in the palace archives.

I crossed the bridge back to the city in a daze, astonished that I had been given such an important commission. I hardly noticed the sluggish waters of the Orontes running beneath me, or the ridge of Mount Silpius, rising above the suburbs and villas on the far bank. George and Theodore must both have praised me highly to make the Heraclius think me worthy of being his historian. But what a story the Emperor's wars would make! A pagan king, seeing dissent among the Christians, and a feeble tyrant in the palace, had challenged the Roman Empire. The East was overrun, and Constantinople, the greatest city in the world, had almost fallen. But Heraclius, the handsome hero, had sailed to the city and deposed the tyrant. Then, despite his own melancholy and the Empire's breakdown, he had fought back, marching to the East to turn near defeat into total victory. It was a story worthy of Herodotus or Thucydides, yet I had been chosen to write it. Was it possible that my name would live on like theirs, that I, too, would be a great historian?

I worked in the city's archives, where many of the materials I needed were stored. I began to plan my history, ordering events, selecting incidents and episodes, making notes for chapters. Reviewing what I had written for George, I found that events seemed more purposeful, men more heroic, and battles less squalid than I remembered them. But that, I knew, was an illusion. I began to wonder how Xenophon, a participant in the events he described, had composed his histories, where Arrian, who wrote centuries after Alexander's death, had found his information, and how Procopius knew about the private depravities of his illustrious contemporaries. My task ought to have been easy. I was present at many of the events I would have to describe. However, when writing notes for George, I had often found it difficult to establish exactly what had happened. Eyewitnesses gave contrary accounts, and even things I saw myself were open to different interpretations. My own narrative was often made up of the most plausible or creditable version of events, rather than what I knew to be certainly true. That seemed acceptable as the basis for an epic poem. George had been pleased enough with my work, and only needed an outline that could be dressed up in antique verse, though even he found that difficult towards the end. When I read my notes again, I knew that they would not do for me. To be a real historian, it was not enough to be an eyewitness. I would have to enquire into the origins of the war, consider its consequences, and collect evidence from every possible source. I began the long business of searching the archives, talking to veterans, and writing letters to anyone who might be able to help.

I was not, as I had first assumed, free of my administrative duties. As well as writing the history, I was required to make abstracts of intelligence reports and translate documents from Latin. Usually they were passed on, never to be heard of again, but sometimes I was summoned to meetings to explain what I had found out. I would like to pretend that I made some contribution to the government of the Empire during that time, but, in the confused and contradictory reports that poured into Antioch, I failed to find

anything as potentially useful as the alliance with King Dagobert.

Sometimes intelligence work was a welcome distraction from the difficulties of writing history, but often the complexities of the situation described in the reports reinforced my feelings of frustration as I tried to find a coherent pattern in the past. As I read of events on the eastern frontier, which was crumbling away under pressure from Arab raids before it had been fully recovered from the Persians, or heard of the consequences of the Emperor's theological policy, it seemed increasingly hard to make sense of the present.

I found that I disliked Antioch. It was a city that, having little else, lived on pride. It had been great, but after a century of misfortunes, most of what made it so was gone. Ruined buildings had been rebuilt so often that antique columns or the heads of statues could be seen embedded in walls like common bricks. Commerce had been so interrupted that tradesmen had forgotten their skills, and merchants had lost their markets. The citizens could only be diverted from attempting to restore their fortunes by arguments about religion, and were keen to blame each other for the city's troubles. They watched sceptically when Heraclius gave the city a monoenergist Patriarch, but did not deviate from their habitual beliefs, whether orthodox, monophysite, or, as was rumoured, secretly pagan. The Emperor's attempts at theological compromise were of no interest to them.

When I wanted to avoid my work, which was increasingly often, I found little to divert me in Antioch. I preferred the suburb of Daphne, a few miles south of the city. Its name means *laurel*, and among the many laurels is the one into which the nymph Daphne was changed, to avoid the attentions of Apollo. In pagan times Daphne's groves contained many temples of the old gods, as well as the country houses of Antioch's rich, and the pavilions and summerhouses of its lesser citizens. They liked to escape from the city's heat, and indulge themselves among the orchards, olive groves, streams and waterfalls. It was still a cool and pleasant place, though

during the recent upheavals most of its houses had been abandoned and looted. Life, of an improvised sort, still went on, and many of the buildings were habitable again, though not luxurious. Refugees from the city, or further away, had moved in, and ran its various enterprises, which included, taverns, food shops, brothels and boarding houses. It became a place where those with a taste for cheap luxury came to pass the time aimlessly, strolling, sitting, eating or drinking. Artists and performers gathered there, hoping that the citizens of Antioch might soon acquire enough wealth to feel secure, and start employing them. I found it far more congenial than the city.

The first time I went there, I just looked around, enjoying the cool greenery, and observing the strollers and the drinkers in the taverns. Cooks and wine-sellers had set up their stalls among the fallen masonry of a long-abandoned temple, using its broken columns for counters and tables. I wandered among the laurels, enjoying the sights and smells of the food. I watched while a huge tuna was sliced, then slowly grilled and served with stewed leeks. Sardines and red mullet were cooked, wrapped in scorched, green parcels of vine leaves. Small spicy sausages were grilled on sticks, while larger ones were boiled and sold sliced. Split and flattened quails, smeared with honey and spices, sizzled over smoky fires of rosemary branches, their small limbs charred and crumbling. Whole sheep were rubbed with thyme and garlic, then spit-roasted and served with spiced and sweetened sauces. Some stalls offered sheep's heads, boiled or baked, piled in grinning pyramids. The cooks noisily sharpened knives, banged spits or clattered saucepans, drawing attention to their food. Everywhere, dashing between the stalls and strollers, were boys with jugs or baskets, selling wine, bread, cheese, olives or fruit, and calling out the names and virtues of their wares. Other boys seemed to offer nothing but themselves.

Shafts of sunlight struck through the canopy of leaves, illuminating clouds of scented smoke. Drinkers and diners sat talking in the dappled shade. Most of the men were dressed in the Syrian style, wearing short, belted tunics over narrow trousers. Their clothes were mostly white, but the rich

colours of their flimsy shawls brightened the shade like the aconites and cyclamens that grew in the less trampled parts of Daphne. I had observed in Antioch that eastern women were not so secluded as those in Constantinople, but I was surprised by the freedom they seemed to have in Daphne. They went unveiled, and even drank publicly with men, something I had only seen prostitutes doing before. Perhaps they were prostitutes. All pleasures seemed easily available in Daphne, and that troubled me. I knew that, if we are to avoid the heresy of Dualism, the world should not be rejected, but I found it difficult to embrace. I was reminded of my feelings about the Khazars. Like them, the people I watched seemed at ease with themselves, happy to waste time with drinking and talking, and untroubled by thoughts of work. I found the bright aimlessness of these people disturbing, but I wanted to join them, though without knowing how.

I went to Daphne several times before I spoke to anyone, and when I did it was by accident. One group, louder and more confident than the rest, had attracted the attention of a small crowd. They sat among the ruins, in the shade of a laurel grove, by tables made of Ionic capitals, drinking and talking loudly. A boy was pouring from a jug of wine, while another served bowls of chick peas and olives. A tall, well-dressed man had stood up and, to the accompaniment of cheers and satirical comments from his friends, was reciting a long poem. I was transfixed, not by the quality of the poem, which was one of the worst I have ever heard, but by the enthusiasm of the group. I joined the bystanders, trying to work out, from its exaggerated imagery, what the poem was about. When the poem ended there was applause, but not from me. Then I noticed that I was being spoken to.

"You! You there, with the miserable expression! Did you not enjoy my poem?"

"It was a very interesting poem," I replied, "But I don't think I have come across that metre before."

"Perhaps you have written something better?" the poet asked.

"Not me, but many have."

"Such as?"

I thought for a moment, then recited part of George's *Heracliad*. My audience was mostly silent, though a few laughed towards the end, despite George's heroic manner.

"Very military!" the poet said, smirking. "And patriotic. Rather like a bronze statue: hollow and ringing."

It had not occurred to me before that George might not be a good poet, but it occurred to me then. I stood awkwardly under the laurels, wondering how much of a fool I had made of myself.

"Come and have a drink," the poet said. "And listen to the rest of our work." I sat down on a fluted fragment of column, was given a beaker of wine, and found myself, though drab and dusty, surrounded by colour and chatter.

As I sat, drinking more wine than I was used to, I considered the question of poetry and taste. I realised that I had hardly thought about the subject since my schooldays, but had simply accepted what I had been taught as good. George's poems, like Homer's, might impress courtiers, but these people obviously had very different ideas. I resolved to think critically about poetry, and perhaps even to write some myself. When I emerged from these thoughts I noticed that I was being observed. The watcher was a small man, dressed like the others in Syrian trousers and a white tunic. Draped over his shoulders was a long length of blue silk, which he had arranged very carefully in loose folds and gathers. His long hair was slicked back with perfumed oil, but shaved at the sides in the barbarian fashion. He swaggered, if you can swagger whilst sitting down. He might have been a Blue. I had forgotten about the factions, and found his presence disturbing. One of the others noticed that he was staring at me and said:

"Michael seems very interested in our new friend!"

"I am just wondering who he is, and what he does. He looks very monk-like, but he can hardly be a monk, not here!"

"I am not a monk."

"Then what are you?"

"I am the Emperor's official historian." I though it best not to mention my intelligence work, as it might provoke suspicion.

"Really?" They looked sceptically at my untidy clothes.

"Yes, really."

"And how did you get that job?"

I found myself telling an unlikely story involving monks, soldiers, Frankish kings, epic poems and elephants. They listened politely, and gave me more wine.

"What a fascinating story. You must tell us more."

I could not quite tell whether they were laughing at me. They moved on to what I later found was a favourite topic, the possibility of reviving Antioch's theatre. There were two theatres, both just outside the built-up part of the city, on the lower slopes of mount Silpius. One had been ruined and the other fortified during the recent wars, and the citizens had shown little sign of wanting to spend their money on restoring them. Some of the group had written dramatic verse in the manner, they thought, of Euripides, which they hoped to have performed, or at least publicly recited. They must have known that the Church disapproves of drama, and that the theatres, before they were ruined, were used only for pantomimes, circuses and wild-beast shows. But their dreams were harmless, their conversation seemed sophisticated, and I was content just to listen. When the group broke up I walked, slightly unsteadily, back through the smoke-scented night to Antioch, full of unfamiliar thoughts and feelings.

After that I drank with them often. I looked at intelligence reports in the mornings, worked on the history in the afternoons, then walked out to Daphne when the day started to cool. The membership of the group was fluid, but there was always a quorum, ready to talk away the evening. Often, Michael was there, observing the others with a self-assured aloofness that I continued to find unsettling. When the subjects of poetry and theatre palled, I was sometimes asked about my life. I described what I had seen of war, savage tribes, Persian palaces, pagan temples, and the foibles of the Imperial family. They seemed to enjoy my stories, though I am not

149

sure that they entirely believed me, and that made me even more uncertain of the value of history.

As I passed more evenings drinking and talking, I found that I was spending more than my salary. To resolve this crisis, I took another job, and became tutor to Ephraem, the son of a rich Syrian family. He was a fat, studious boy, who took pleasure in learning, though he was destined to be a merchant. His family had connections in Aleppo and Damascus, and had kept their business going during the Persian occupation, though it was best not to ask how such things were done. They spoke Syriac, and wanted their son to learn Greek. Actually, they spoke perfectly good Greek, as I was surprised to find out when they interviewed me, but many parents think that what they can pay for is better than what they can do themselves. I enjoyed the teaching, but, even though it obliged me to spend more time in Antioch, I still spent more than I earned. I could hardly take on more work. Three jobs were quite enough, so it was necessary to reduce my expenditure.

Michael resolved my difficulty. Breaking his habitual silence, he said that there was space in his house, and that I could save money by lodging with him. I was surprised at his offer, and reluctant to accept it. I found his manner disturbing, and was not sure that I could share a house with him. But there seemed to be no alternative, so I went with him to see the place where he lived. It was hardly a house, more a sum-merhouse, small, rickety and dilapidated. But there was room, so I moved in, and began a new routine, walking to Antioch in the cool early morning, working and teaching during the day, and returning to Daphne in the evenings. Soon afterwards, as a celebration, I was taken, very reluctantly, to a brothel.

It was in the courtyard of a once grand, but now decayed summer villa. My new friends had pushed me through the arched doorway, guessing, though I had not admitted it, my inexperience. The sun was in my eyes, and I had drunk too much wine. The courtyard was large, but not so large that aimless wandering was possible. It was colonnaded on all four sides, but the columns were damaged and the paving tufted

with weeds. There was a powerful smell, suggesting that something had gone wrong with the drains. The fountain was dry, reminding me of the cryptic imagery of the Song of Solomon.

I tried to look purposeful without rushing, and attempted to look around without catching anyone's eye. Rugs and curtains had been rigged up between the columns, to make improvised cells. The women lay on couches, waiting for customers. A few of the cells had their curtains drawn. Some of the women noticed me, and tried to make themselves look more alluring, opening their robes to show what they had to offer. Others did not bother. The superfluousness of their flesh, obvious even under their loose robes, reminded me of my night with the Cappadocian sect, where chastity had been tested by nakedness and proximity. I had not been tempted then, and, as I looked around again, could see nothing to tempt me there. What could be done with all that soft flesh, with all those bulges and declivities?

My friends were still at the doorway, watching.

Fortifying myself with lustful thoughts, I walked in what I hoped was a purposeful manner to one of the cells. The woman in it was neither more nor less attractive than the others. She was plump, and dark-haired, dressed in a loose silky garment. She looked slightly vacant, but sat up and welcomed me with a professional smile.

"Are you a monk?" she asked.

"No." I was dressed simply, and, in comparison to the gaudy dress of the Antiochenes, that may have made me look monk-like.

"I don't mind if you are. We all need a bit of love, don't we?"

"I expect so, but I am not a monk."

"All right, I don't mind either way. I won't tell the abbot."

I could think of nothing to say, so I looked round and saw that my friends were still watching.

"Can we go in?"

"Of course," she said, closing the curtain behind me. "How much money have you got."

She looked disappointed when I showed her some coins.

"Is that all you've got."

"I'm afraid so."

"It'll have to do then. Let's get on with it."

She undid her robe and lay on the couch, revealing cascading mounds of creased dark flesh. I pulled off my tunic.

"You have done this before, haven't you?"

"Of course."

"Not much of you, is there?" she said, when I was naked.

As I moved towards her I thought of those I had desired in the past. There were some older boys at school, the would-be saintly Nicholas, Nilus the artillery man, and Kurt. But the memory of those humiliations was the opposite of arousing. I concentrated on the other memories in the hope of being able to perform. It was no good. The moment she put her arms around me and pulled me towards her soft and ample body, older memories came rushing back. The last time I had been held like that, gently, in the arms of a woman, I was six years old. It was just before the priests took me away. I remembered my terror as I was led away from my home and parents. I burst into tears, and could not be stopped. I think the woman was genuinely sorry for me, but the more she reassured me, the more I was reminded of my long-forgotten mother. Eventually I stopped crying, and the woman brought a jug of water and washed my face. She did not ask me to explain, and nor could I. When I left, my friends must have seen something in my expression, because they did not tease me or ask any questions.

That night there was a storm. I lay in the flimsy wooden summerhouse, listening to the timbers creaking and the wind whistling through the laurels, remembering, in an attempt to forget my embarrassment, the philosophy I had studied with Basil. Was my nature, and the nature of my desires, really explained by elements and humours? I imagined elemental air flowing across the land like an invisible river, racing and slowing, parting and rejoining, carrying away leaves and branches, losing its force as it met the mountains, rocky outcrops of earth. Did the two elements combine when the violence of

the wind forced them together? Were they transformed into new substances? Or did they remain separate, sharing only movement and struggle? As Basil had taught me, we can only know the nature of a thing by testing it. Only then can we be sure that what we see is what we think it is. But Basil had taught me nothing about desire.

Through the rising howl I heard a voice, calling my name. It was Michael, and he was kneeling beside my bed.

"You didn't do anything did you?" His voice was soft and reassuring, barely audible above the wind.

"No."

"Did you want to?"

"No."

"You wanted something else, didn't you?"

"Yes." I reached out for him, and found that he was naked.

Knowing that lust leads mostly to shame, I feared him at first. But he was gentle, and crouched beside me, holding my hand, crooning a fragmented song, making his words mingle with the wind. He calmed me as a rider calms a nervous horse, with sounds that mean nothing but dispel all fear. He was unexpectedly strong. I felt his power when he pulled off my tunic and held me in his arms. His touch on my skin stirred dormant desires and drove away my reticence. We lay together for a while, entwining our limbs, becoming complete, like the beings Aristophanes described in the *Symposium*. He kissed and stroked and fondled, showing me what to do, not rushing, but leading me step, by step. I knew that what followed would bring pleasure, not pain.

Outside, the wind grew stronger, and the summerhouse began to rock like a boat. It started to rain, large drops drumming loudly on the thin roof. While the elements competed, we explored each other's bodies, mingling our flesh, winning pleasure from exertion.

Afterwards, as we lay on my bed, slippery with sweat, I did not know whether to feel triumphant or remorseful. Michael had driven out the memory of what the artillery man had done to me at Dvin. That pain and humiliation was wiped away by his touch, just as old parchment is scrubbed clean

with pumice, ready to be written on again. I felt renewed. Yet the intensity of Michael's desire had startled me. He had lost himself entirely in lust. And I had experienced a pleasure that I had only dreamed of before. I was not disappointed. Was that pleasure a spark of divinity? Did we, for a moment, free the spirit from its bodily prison? Or did we further enslave it?

Michael was a singer, did not come from a rich family, and depended on visitors to Daphne for much of his work. He was a favourite of the Blue faction and often worked in Antioch. Sometimes he travelled to other cities, such as Aleppo or Damascus, where the Blues were also powerful. In the first few weeks of our friendship, while I neglected work and thought of little but the pleasures we shared, I often went with him to the houses of the rich, and watched him perform. His songs were mostly about love, though he would praise or lament to a paying audience. His words were ambiguous. The love he sang of might have been any sort. He used words and music to manipulate the passions. He was able to leave the listener in the state portrayed by the song. I knew that was possible. I had been indoctrinated by music in Tarsus, and had felt its demonic force in Cappadocia. Later, I experienced its spiritual power in Constantinople. Even the rough marching songs of soldiers stir martial passions. Michael used his voice and lyre to provoke the anticipations, uncertainties, pleasures and agonies of whatever sort of love the listener had in mind. He himself did not agonise much, preferring pleasure to thinking.

Some of the books I had read in Basil's library suggested that music affects the humours. Each note has qualities of heat, cold, dampness or dryness. Singly, or in combination, they resonate with our inner selves, provoking or moderating our moods and passions. As Plato said, in the *Republic*:

"Rhythm and harmony enter most powerfully into the innermost part of the soul, laying forcible hands on it."

I tried to make Michael explain the theory behind his music. He said:

"There is no theory, it's all emotion."

"Then how did you learn it?"

"I didn't learn it, I lived it."

He seemed too young to have experienced all that he sang of, but perhaps he had experienced nothing else. I learned little of his past. Like most Syrians, he preferred not to discuss the Persian occupation. "We did what we had to," was all they would say.

Michael performed for public events or private gatherings, and whatever pleasures were available, he would take. He was not deterred by fears or scruples. If rich, he might have been a gastronome or oenophile, but charm was his main asset, and his pleasures were of another sort. In the dark, Syrian way, he was beautiful, and at ease with his body, just as the Khazars had been. But he had none of their inhibitions, and no part of his body, or anyone else's, seemed to be sacred or forbidden. He had a way of staring directly at people, unsmiling and intense, that worked like his music on the passions. He knew that what he wanted, they would want soon.

Despite his apparent assurance, I think he knew his limitations. The ephemeral life of pleasure and emotion that gave his singing such power, may also have prevented its development. If his art was to mature, it could only do so by becoming more thoughtful. That was why he spent so much time listening to the talk of would-be poets and dramatists. I came to see that his silence at such talk was caused by a suspicion that there was something he could not understand, but should. He was right, but wrong to search for it among that group of dilettantes. They would achieve nothing before their world was swept away by forces we all failed to notice. I think Michael saw in me an outsider like himself, but one who might be able to act as a bridge to the world of ideas he secretly desired.

Michael taught me two things: that our desires can be a source of pleasure, and that pleasure is not enough. He also caused me to reassess my faith, which I lost, for a time, while I lived with him. I do not mean that I reverted to the heresy of my parents, or followed the new prophet, Mohammed, or practised the supposed paganism of the Antiochenes, or

155

emulated the philosophical detachment of Basil. Nor did I become more doubtful than I already was. I simply forgot either to believe or to doubt.

Those who attempt celibacy, as I had done, often think of little else but lust. Whether lustful thoughts really are sent by demons, as I was taught in Cappadocia, I do not know. But attributing too much power to the Devil, like rejecting the material world, is Dualist and heretical. I rather believe that lustful thoughts are stirred up by the humours, which are unbalanced by continence. It is possible that by prompting us to appropriate action, the humours seek to restore their own balance, like a brimming amphora that topples and empties itself. However caused, lustful thoughts are certainly torment-ing, and can overwhelm the rational parts of our minds and lead to melancholy. I had tried to be stoical, and ignored my desires, not because I thought my desires wrong, but for fear of seeming a fool. With Michael I found that desire can be mutual, and need not be left unexpressed. For a while, my needs outweighed my fears and I found contentment.

But it did not last. I soon tired of Michael's relentless sensu-ality, and discovered that lust drives out thought just as surely when it is consummated as when it is denied. Pleasure turned to indulgence, idleness became sloth, and doubts returned. I began to think again about what I believed, or should believe. When, a few weeks later, Michael left Daphne to tour the cities of southern Syria, I was quite glad of the chance to be alone, and to think.

I decided to spend more time in Antioch, and resume my neglected work. I had received some letters from participants in the siege of Constantinople, which I had not witnessed myself. Unusually, their accounts more or less agreed, and I was soon able to complete a chapter. Encouraged, I began a new topic, but information I had collected about the Mesopo-tamian campaign proved hopelessly contradictory. I struggled to produce a coherent narrative, but after a week I gave up and went back to Daphne. As I approached the tavern, for the first time for a month, they called out:

"It's the Procopius of our times!"

"Not Procopius! The Xenophon, surely?"

"How much have you written today?"

"Nothing. I've been working in the archives, shovelling facts."

"Not written anything? The Emperor won't be pleased."

"He'll have to wait. I'm sick of history. Even when you can find out what actually happened, which is impossible, it's usually so chaotic that it doesn't make any sense."

"Surely, the war that was planned and conducted by the Emperor can't have been chaotic. He is our greatest general, is he not?"

"He was great enough in the end, but it didn't always look that way at the time."

"I think we'd better all have another drink. Boy! Bring some more of your excellent wine." In fact it was the cheapest, but we pretended that it was the best. A grilled-sausage monger passed, pushing his cart. We waved him over, and bought some of his wares. Someone held a sausage suggestively and said:

"Speaking of our great Emperor, have you heard the latest? It seems that his private parts have been afflicted by a loathsome disease. It's his punishment for all those years of fucking his niece." They looked to me for a comment.

"He certainly looked ill when I last saw him," I said. "But as he was fully clothed at the time, I can't comment on the rumours."

The others liked to pretend that I had regular meetings with Heraclius, during which my work was discussed. I told them about the profanation of the fire temple at Tabriz, and its penile consequences, but they preferred to blame the Emperor's condition on his incestuous marriage. The Empress Martina was unpopular, even in the provinces.

"The Emperor's completely obsessed by theology these days," someone said. "He spends all his time discussing mono-energism with bishops and patriarchs."

"Perhaps he thinks he can avoid the punishment for incest."

"If he thinks he can persuade everyone to believe the same thing, then he doesn't know Syria."

"You know what they say. If four bishops are gathered together in one place, they'll give you five different opinions."

"Not if one of them is Sophronius. He will only allow one opinion, and that must be his own."

The excesses of the zealous patriarchs of the East were a popular topic among my friends, who, if they were anything, were monophysites. The Patriarchs of Antioch and Alexandria were seen as turncoats, who had adopted the official doctrine of monoenergism for the sake of power. They were despised, by the orthodox as well as the monophysites, but their appointment was perfectly explicable. What no one could understand was why Heraclius had made Sophronius Patriarch of Jerusalem.

At that time, I admired Sophronius. I had read about him in the *Spiritual Pastures,* written by his friend, John Moschus. I had found a copy of the book in Antioch, and read it often, hoping for enlightenment. It portrays John Moschus and Sophronius as gentle, scholarly monks, wandering round the monasteries of the Mediterranean. They pursued miracles, saints and books, and their description of monastic life is full of reason, calm and order. I envied John and Sophronius for their apparently untroubled orthodoxy, and for their friendship, seemingly ideal, full of shared pleasures and enthusiasms, but devoid of unruly passions. Reading the *Spiritual Pastures* reminded me that my attempts at friendship had mostly been undermined by lust.

I knew that before I met Michael, my life was incomplete. Since my failure with Kurt, I had tried to deny an important part of my nature, just as the monophysites deny the humanity of Christ. My sexual initiation with Michael was a sort of incarnation. For the first time, my body seemed fully inhabited, and its needs satisfied. But I was not a hedonist, any more than I was a man of action. Hedonists deny the other, spiritual side of human nature, just as some heretics deny the divinity of Christ. It seemed to me that Man must be both

body and mind, just as Christ is both man and God. That realisation seemed to lead back to orthodoxy.

I could see the value of orthodoxy. I had heard it defended often enough, and knew all the arguments in its favour. Had I remained among the monks who educated me, and encountered nothing but orthodoxy, I might have come to share their certainty. But I had wandered the world, witnessed the horrors of war, and talked to heretics and pagans. Each time my faith seemed to strengthen, it was undermined by events, doubts, clever arguments or inappropriate desires.

Abbot Simon, when he had lectured Nicholas and me in Cappadocia, many years before, had compared lustful thoughts to a rock, on which ships bound for heaven might founder. It seems to me that our passions are more like a strongly flowing river, liable to flood. It may be pleasant to immerse oneself in cool water on a hot day, but if the current rises we may be overwhelmed, carried away, washed into strange and dangerous waters. Perhaps, just as the world is encircled by a vast and unknown Ocean, we are all surrounded by Siren-haunted seas of temptation. To reach a safe harbour we must learn to navigate that Ocean of desire. But how?

Odysseus was guided by Circe's prophecy. He stopped his crew's ears against the Sirens' call, and had himself tied to the mast so that, though he could hear, he could not obey. Odysseus sailed on, past the Sirens, past the dangers of Scylla and Charybdis and the temptations of the Island of the Sun, to reach Ithaca. I could not stop my ears against the promptings of desire, but I might tie myself to the mast of orthodoxy. If I could believe fully what I had sometimes doubted, and reconcile my spiritual aspirations and physical desires, then the dilemma of lust and friendship might also be resolved. Inspired by the *Spiritual Pastures*, I began to think seriously of the monastic life, which, with its regularity and opportunities for scholarship, seemed calmer and more congenial than my life in Antioch and Daphne. But I did no more than think about it. It was many years before I withdrew from society, and my decision was influenced by events, as much as by the writings of John Moschus.

However, outside the pages of the *Spiritual Pastures*, Sophronius had another side. In reality, he was a fanatic. After John Moschus died in Rome, Sophronius wandered the Empire, arguing with Popes and Patriarchs, and anyone who, in his view, had compromised orthodoxy by failing to object to monoenergism. When he reached Syria, he confronted the Emperor, who, instead of dismissing Sophronius, appointed him as Patriarch of Jerusalem.

Sophronius's first act was to summon a council of all the orthodox bishops of Palestine. Monoenergism, he told them, was an abomination. It betrayed the achievements of the council of Chalcedon, which all good Christians had accepted. It confused the two natures of Christ, which, as every one knew, were entirely separate. It diminished Christ's human nature, which is whole and perfect, by denying its energy. It was, Sophronius said, little better than monophysitism. Bishops who had noticed nothing wrong with monoenergism, and had seen those who accepted it preferred and promoted, suddenly became embarrassed at not having noticed its obvious flaws. They went back to their churches with a renewed orthodoxy, and a determination not to be caught out in compromise again.

10

YARMUK

A.D. 636

Had I paid more attention to my official work, I might have predicted the disaster that befell the East. After all, I had a clear warning of it, years earlier, in Edessa. But I liked visiting my Syrian employers, and whatever time I did not waste in Daphne I wasted with them. They were hospitable, and respected my knowledge. As merchants, they valued what they could buy, unlike many others I have met, who, whether from wealth or poverty, despise everything with a price. If I arrived at the right time I was often given a meal, and passed time talking with Ephraem's family. Their house was built for comfort, not show, as merchants do not waste money on meaningless symbols. Its tiled courtyard was square, and shaded by four small trees, each producing a different fruit. Sitting idly by the fountain was a pleasure I found increasingly difficult to relinquish for work. Ephraem was by then sixteen, and though he had grown taller, he was no thinner than when our lessons began. He spoke Greek very well, and there was not much I could teach him, but I enjoyed his company. We often abandoned grammar and talked about the latest news.

On one occasion they were agitated because some Arab raiders had stolen a consignment of goods that was being sent to Palestine.

"Is that unusual?" I asked. Syria had always been troubled by Arab raids.

"It is for us. We pay our money to the Bedouin. They are meant to protect us."

"Why didn't they?"

"The raids are getting bigger. They don't just steal and run. They stay and look around. Also, they are coming from further away."

"The border tribes have always kept them out before. Why are they failing now?"

"The raiders are like an army. And they are driven by the new religion."

"I thought Mohammed was dead."

"He is, but Omar, the new Caliph, is just the same. He wants all the Arabs to follow him."

"Even the Christian Arabs?"

"Yes."

"Do you think they will?"

"I don't know. Some have become Moslems, but most of them are still Christians."

"They are monophysites."

"So are we."

I had forgotten that, by unspoken convention, we did not discuss the divisive topic of religion. We returned to grammar.

While I was teaching and idling, the East was descending into chaos. Inspired by Sophronius, orthodox and monophysite zealots were disputing churches, dividing communities, and turning the whole population against Heraclius's policy of theological compromise. There were more Arab raids, and it was rumoured that the border garrisons were no longer resisting, and had been bribed to let the raiders through. Then the Moslems captured Damascus and several other cities. The inhabitants were given a choice. They could become Moslems or continue in their own faith. Jews and Christians, unlike Moslems, had to pay taxes, but were free to worship as they pleased. Only those who declined both taxes and conversion were killed, but there were not many of them. As news of this policy reached the monophysites, they became even more restive.

My teaching work ended then, as the family's main warehouse was in Damascus, and Ephraem had to take his place in the business while the crisis was resolved. They may, perhaps, have realised that Greek was not going to be so useful to them as they had thought. It was fortunate, as my official duties suddenly increased when Heraclius returned to Antioch and began to assemble an army to recapture the lost cities. The

Emperor was by then too ill to do anything except give advice, so when, in May 636, the army set off for Damascus, it was commanded by his brother, Theodore. None of us knew it then but they were to fight the most important battle of Heraclius's reign.

That summer in Antioch is one of the worst times I can remember. The Emperor's melancholy was turning into something worse. He brooded helplessly, waiting for news, surrounded by his family, who tried to disguise his illness. No one dared tell him anything, and everyone feared his orders, which were becoming arbitrary. I was kept busy with a constant demand for information about the Moslems and their army.

I was only occasionally able to get to Daphne, but I was not entirely sorry. The market for Michael's songs had dried up, and he had no money and no one to charm. Had he been more reflective, the change in our circumstances might have inaugurated a new maturity in his work. He knew well enough the mood of fatalism and uncertainty that had spread throughout the cities of Syria. Most of our friends had disappeared, having run out of money, or returned to their families. It was obvious to me that many Syrians were already preparing themselves for the possibility of Moslem rule. But Michael did not prepare. When his singing stopped, he brooded, or spent his days sleeping or idling. It is possible that, if he ever really needed me, he needed me more then. But he did not say so, I was often away, and our friendship, having already faltered, died.

Later, when Theodore was disgraced and imprisoned, I asked him about his campaign against the Moslems.

"It was hopeless from the start," he said. "But I didn't know that then. We cleared the Moslems out of Damascus and Emesa easily enough. But they did a very odd thing. Did you know that they returned the taxes they raised from the citizens of Emesa? They said that they were giving back the money as they were unable to fulfil their promise to defend the city. It made the Emesans much less friendly to us when

163

we arrived. They wouldn't supply us with food. But we didn't stay there, we chased the Moslems south to the Golan Heights. I thought we might not have to fight them at first. They clashed with the local Arabs over pasturage, and retreated from their first camp. But they settled further south, by the River Yarmuk."

"So what did you do?"

"We waited. I'd been promised more men. And by the time I realised that they were not coming, it was too late. I'd been given a rabble instead of an army. I didn't trust them, and they didn't trust each other. They were always quarrelling. I wasn't sure our Arabs would fight the Moslems. And you know what the Armenians are like. They say one thing then do the opposite."

Theodore told me how he waited for weeks, hoping for reinforcements or orders, while his auxiliaries quarrelled or deserted. Eventually, in August, an unauthorised sortie by the Armenians provoked the Moslems to attack. After six days of disorganised skirmishing, the Moslems, helped by an opportune sandstorm, drove Theodore's men into a narrow neck of land between two rivers. Most were killed, but those who survived fled north, spreading panic, pursued by the Moslems.

"Do you know the worst of it?" Theodore said, wearily. "It was only half their army that beat us! The rest of them were in Mesopotamia, fighting the Persians. They chased King Yezdegerd and his followers into the Zagros Mountains, just as quickly as they chased us out of Palestine."

When the news of the defeat at Yarmuk reached Antioch, Heraclius seemed to go into an even worse decline. He attended a final service in the cathedral, but he was visibly upset by the open criticism he heard there. Shouts from the congregation blamed the disaster on the Emperor's incest, his tampering with orthodoxy, and on the general discord among the Christians of the East. Heraclius began what sounded like a public confession, but Martina stopped him. After that she kept him hidden, but the damage was done. The rumour quickly spread through Antioch that he had gone mad, and

was unfit to defend the Empire. The citizens panicked. Heraclius, or Martina, must have realised that everything he had fought for would now be lost. It was decided that we would withdraw from the East, and return to Constantinople. I just managed a brief visit to Daphne.

Michael was there, lying on his bed in the summerhouse. His once-fashionable hairstyle had grown into an untidy tangle. He sat up, and looked at me sadly.

"You're leaving, aren't you?" he said.

"Yes, I have to." I found a bag, and started to collect my belongings.

"You could stay," he said.

"I don't think so."

"Why not? People are saying that the Caliph is more tolerant than the Emperor."

"It's not the Moslems. It's the Syrians."

"Like me?"

"Not like you. Syrians who would rather argue than defend themselves."

"But I am a Syrian."

"I've never heard you argue about theology."

"It didn't seem important."

"Perhaps it isn't, now."

I found my two books: *The Persian Expedition* and the *Campaigns of Alexander*. They had travelled with me for years, but their subject now seemed obsolete. Instead of conquering the East, we were abandoning it. I put them in the bag anyway.

"You only came for those books, didn't you?" Michael said. "You didn't come to see me."

"No, of course not," I said. But he was right. I had hoped to collect my belongings without meeting him. He stood up, and smoothed his rumpled tunic. Sensing anger behind his sadness, I stepped back, but he grabbed my arm and held onto it firmly.

"You think those books make you better than me," he said. "You think all your reading, all your scholarship, makes you superior."

"No I don't. I may be a scholar, but I lack your talent."

"My talent? What use is that? I haven't sung for weeks."

"Perhaps you should. Music affects the humours."

"It affects our moods, but whether that has anything to do with humours, I don't know. But it is so like you to have a theory about it. You see life through books and theories, but you hold back from life itself. You are like the audience for my songs, when I had an audience. You want others to have your feelings for you."

"I must go," I said, trying to pull my arm from his grip.

"So, you've had your pleasure, and now you're leaving?"

"Pleasure?" That summer had not been particularly pleasurable.

"The pleasure I gave you. The pleasure I introduced you to. The pleasure you took, without giving anything back." He let go of my arm and looked at me imploringly. "If you had any real blood in your veins, you wouldn't leave me here, you'd take me with you."

"I can't. I'll be travelling in the Emperor's fleet."

"So I must stay here with nothing to live on?"

"I have no choice."

"You will never change," he said. "As long as you hold yourself aloof from life, you will learn nothing."

I did not think it likely that Michael would change, either. But, not wishing to prolong an uncomfortable encounter, I did not say so. I gave him what little money I had, took my belongings, and left.

As time was short, I did not return to Antioch, but went straight to the harbour at Seleucia. It took several hours, and, as I walked, I brooded on what Michael had said. He was right, in a way, though it is easier for me to admit that now than it was at the time. I did not think myself selfish. I thought Michael unreflective for not understanding what I had to offer. But I had already tired of the pleasures he had offered me. I had realised that a life devoted only to sensuality was unbalanced. Though the circumstances of my departure were unsettling, I was glad to be leaving him. I remembered the *Spiritual Pastures*, and the life of contemplation that was possible if lustful thoughts could be overcome. I felt like one of

Odysseus's men, released from Circe's magic, made human again, ready for the next stage of the voyage.

As I got nearer the coast, I found myself among crowds of refugees, who were trudging through the dust, loaded with baggage. In the harbour, everything was confused. It was full of priests carrying icons and crosses, soldiers with their families, clerks and officials with bundles of papers, piles of luggage, and crowds of servants and hangers-on. Everyone connected with the Imperial administration, or the orthodox Church, was trying to get out. The crews of freighters, even of fishing boats, were being offered large sums to ditch their cargoes and load up with refugees. The rich were buying places in boats already filled by the less rich, whose luggage was being thrown in the water. Silver chalices, saved from the Moslems, were immediately sacrificed for the safety of the clergy. Syrian merchants, not entirely displeased that the Greeks were leaving, produced scales, and weighed church plate like bullion.

I looked for the Emperor's ships, and found that they had been prepared, but that Heraclius had refused to sail. It seemed that he would only travel by land. That suited me, as I was sick at sea, but it meant that I had to return to the city as quickly as possible. There was no food available in Seleucia for those who could not pay with gold, so I set off, tired and hungry, for Antioch. I arrived in the small hours, and went to the palace, which was as chaotic as the harbour. It was being stripped of everything valuable or useful, and not all of its portable wealth was going into the Imperial baggage. As I wandered, looking for someone to report to, I thought of the looted palaces of Tabriz and Dastagerd, and of the cowardice of Chosroes.

That morning, soon after dawn, Heraclius, with his family, servants and bodyguard, began the retreat to Constantinople. I was assigned a place near the rear of the column, among the clerks. I walked beside a wagon full of documents from the archives, just as I did when I first joined the army.

11

THE SINGLE WILL

A.D. 636–638

When, two months after leaving Antioch, we reached Chalcedon, Heraclius would not go on. It was only a short distance across the Bosphorus to Constantinople, but he would not cross it. He moved into the old palace, the court and family assembled around him, and he ruled the Empire from his bed. Or rather, Martina relayed his purported instructions from his well-guarded bedroom. He spent some months there, and for those of us who had travelled with him, it was an uncomfortable time. The palace had been neglected since the Emperor's last stay, eight years before, when he had waited there before entering Constantinople in triumph, bearing the True Cross. Some of the damage caused during the Persian occupation of Chalcedon had been repaired then, but little had been done since, and the building was decayed, damp and draughty. Most of the Imperial staff seemed to know what was expected of them. As soon as we arrived, they unloaded the wagons, and tried to make the Emperor's quarters comfortable with rugs and hangings salvaged from Antioch. But the rest of the palace was barely habitable, and no one, however senior, dared raise the matter with Martina. As in Antioch, those who could tried to keep out of the way, and hoped to avoid being given orders. I was not sure whether the defeat at Yarmuk should form part of my history, but in the absence of any specific orders, decided that it would, and began to write an account of it, based on what I could find out from the documents we had brought with us. I settled, with some clerks and secretaries, into a disused room that was as far from the Imperial quarters as possible. The glass was gone from the windows, but we had a good view of the Bosphorus, beyond which, just out of sight, was Constantinople.

I had almost reached the greatest city in the world, and I longed to visit it. I spent much of that cold, damp winter staring out of those windows, hoping that, if the mist cleared, I might just see the city, thinking of its warmth and comforts. It was easy to imagine the palaces, the marble covered Imperial offices, the exquisite churches, the opulent mansions of the nobility, the broad avenues, hilly streets and busy markets. There would be nobles wrapped in silks and furs, perfumed eunuchs, veiled women in closed litters, soberly dressed merchants, swaggering Blues and Greens, and black-clad monks swarming everywhere.

I often gossiped with the room's other occupants, all of whom were as keen to reach Constantinople as I was. We eagerly exchanged the most insignificant rumours of events there. One February day, we had closed the half-rotten shutters against the drizzling rain, and were working, or pretending to, by lamplight. We were discussing the racing results, a subject that had not previously seemed interesting to me, when we were interrupted by a eunuch, who bustled into the room wearing full court dress.

"Here you are," he said. "You've hidden yourselves away haven't you?"

We all tried to avoid the eunuch's eye, and look as though we were engaged in work of vital importance. He looked around and said:

"Which one of you is the historian?"

"I am," I said. The others sighed with relief.

"The Empress wants to see you."

"Martina?"

"Yes."

"When?"

"Now."

"But I'm not dressed for an audience."

"Never mind that. Come with me. Now!"

I followed him through echoing, empty rooms and grey, puddled courtyards, until we reached the Imperial quarters. Then, after a surprisingly short wait, I was shown into a room where Martina sat on a large chair got up to look like a throne.

Like the room, it had been draped with silk to cover its decrepitude. As I prostrated myself, I could see ordinary wooden legs sticking out from under the crimson brocade. I rose, hesitantly, and she said:

"Are you the one who's writing the history?"

"Yes your Majesty." I looked at her close-up, for the first time. Not yet forty, she was an attractive woman, tall and slim, with reddish hair. But she wore no make-up, and was dressed simply in a plain green belted tunic. She looked worried or angry, but not knowing her, or her moods, I could not tell which.

"You were recommended by my uncle." There was a distinct sneer in her voice.

"Yes, your Majesty."

"That is not much of a recommendation."

It did not seem wise to reply, or to meet her eye, so I looked at the carpets under my feet, wondering whether they were the source of the strong musty smell that filled the room.

"He said that you know about medicine. Do you?"

I had kept up my interest in medicine, and, while serving in the East, had once cured her uncle's stomach trouble by recommending one of Basil's remedies. But I was not an expert, and thought it might be dangerous to pose as one. "A little, your Majesty," I said, trying to sound as humble as possible.

"You had better know more than that. I want to consult you about the Emperor. There is a very delicate matter that requires knowledge as well as discretion."

I hoped, urgently, that she was not going to ask me to examine the Emperor's allegedly diseased penis.

"I will do my best, your Majesty."

"You had better. The last doctor had an unfortunate accident. He poisoned himself with his own medicine."

I knew little of women, but I could see that, despite the implied threat, she was afraid. As later events proved, her position would have been uncertain, and possibly dangerous, had anything happened to Heraclius.

"I am sorry to hear it, your Majesty."

"The problem is this. His Majesty is unwell. He has developed a morbid fear of open water. His illness prevents him from crossing water, or even looking at the sea, and he will not enter a boat or cross a bridge. That is why we took the land route from Antioch. Have you come across such cases before?"

It did not seem the moment to admit my lack of knowledge.

"Hydrophobia is a well-known, though rare condition, your Majesty."

"And what is its cause and remedy?"

"Is he reluctant to drink water?"

"No!"

"I take it, your Majesty, that his Majesty the Emperor has not been bitten by a dog?"

"Of course not!"

"I beg your pardon your Majesty, I had to ask. That is the commonest cause."

"And the other causes?"

"Circumstances."

"Circumstances?"

"They conspire against a man, causing an imbalance of the humours, until one predominates, tipping him over into. . .melancholy." I almost said madness.

"And the cure?"

"The usual cure is forcible immersion," I said. She glared at me. "But of course that would be extremely inadvisable in his Majesty's case," I added, quickly. "His general infirmity, as well as the dignity due to his position, would make it inappropriate."

"Some how, he must be got across the Bosphorus. There is a conspiracy against him in the city, and he must be there to stop it. He knows he must go, but will not cross the water. What can be done?"

I knew of no cure, but could not say so. I had to find a way round the problem without admitting my ignorance. I thought about water, boats and bridges. I remembered a story from Herodotus, about Xerxes, who built a pontoon bridge to

171

transport a Persian army to Europe. But he bridged the Helle-spont, which is much narrower than the two miles from Chal-cedon to Constantinople, and Martina had said that Heraclius would not cross a bridge. Remembering how George and I had often consulted Herodotus, in search of heroic precedents for Heraclius's actions, I wondered where George was, and how he would have dealt with my dilemma. If I failed to satisfy the Empress, I might never see him again.

Martina was watching me impatiently. She was the most powerful woman in the Empire, its real ruler, perhaps, and I was nothing. The fact that she was unveiled, and was receiving me without ceremony, showed that she considered me little more than a slave. I sensed that she used her beauty, as well as fear, to unnerve men. She was like Echidna, half lovely woman, half foul serpent, who lived in a cave and ate men alive. Hundred-eyed Argus killed her, but not before she had produced a brood of monsters.

"I have an idea," I said, without being sure whether I really did. "It may be that his Majesty is not really afraid of water."

"But I have just told you that he is!"

"With respect, your Majesty, fears are often confused. We feel fear, and give a name to it, without necessarily being sure of its cause. It may be that his Majesty is afraid of something else altogether."

"Such as?"

"Open spaces."

"Open spaces?"

"Yes, your Majesty. The sea is an open space, as much as it is a body of water."

"I do not see how that gets us any nearer to a solution."

"He must not see the open space of the Bosphorus as he crosses it."

"Then how is he to be got across?"

"He could go below deck. It is only a short crossing."

"No. He would never agree to that. You must think of something else."

"If his Majesty does not see the sea, and can believe himself to be on land, he may be able to cross over."

"How can that be done? It is no good merely asking his Majesty to close his eyes. He will feel the motion."

Then I remembered a detail from the story of Xerxes. According to Herodotus, the Great King's engineers had covered their pontoon bridge with earth and brushwood, and raised a palisade high enough to stop the Persian horses being frightened by the water they were obliged to cross. "His Majesty must cross the Bosphorus in a special boat," I said. "A boat prepared to look like land."

"How?"

"With earth and rocks on the decks, and branches and trees forming a screen. Enough of them should block the view, and create the illusion of land."

"And the motion?"

"Choose the calmest of calm days."

She thought for a while, then said: "I think that may be the most stupid idea I have ever heard."

"Yes, your Majesty."

There was a long silence. I stood as still as possible, staring down at the decaying carpet. Its pattern, mythical beasts and exotic foliage, seemed to swirl in front my eyes, as though stirred by a tempest. Griffons chased basilisks, and chimeras frolicked with centaurs, mocking my confusion with a wild dance. Would I be taken away and imprisoned for wasting Martina's time? Or would my punishment be worse? I had heard that the Empress had a taste for torturing those who offended her, or for having them mutilated, deprived of hands or tongues, depending on the nature of their offence. She had mentioned a conspiracy against Heraclius. I knew that I would confess to anything, incriminate anyone, if threatened with torture. A quick death seemed preferable.

"It *might* work," she said.

I waited.

"If it does not work, then you will pay a very unpleasant price. If it does work, and you try to take the credit, you will pay an even more unpleasant price. Is that clear?"

"Yes, your Majesty."

"You may go."

My heart pounding, I backed out of Martina's lair, dodging the eunuchs who lurked outside. When I got clear of her attendants and found myself in an empty courtyard, I almost collapsed with relief, and sat for a while on a damp stone ledge recovering my composure. I tried to look calm when I went back to the room where I had been working. The clerks all wanted to know what had gone on, but I did not think it wise to tell them. I pretended that I had been consulted about my history.

Soon afterwards a boat was prepared in the way I suggested, and, on a very calm day, the Emperor was carried across the Bosphorus, shaking with fear and staring at the deck. It was, people whispered, more ludicrous and pathetic than his arrival towed by elephants, ten years before. Once Heraclius was established in Constantinople, some alleged conspirators were arrested, one of whom was his nephew. They were mutilated and exiled. After that, the Emperor's health began to improve.

Martina had made it plain that the success of my scheme would not result in gratitude, and I was uneasily aware that merely to know too much was dangerous. It was a relief, at first, to be forgotten about, and left in the decaying palace at Chalcedon. I wandered the vacated Imperial quarters, imagining what, over the centuries, must have happened there. I dreamed of history, rather than writing it. But the palace was not empty, and the other remaining staff were unhappy at being abandoned. They got in touch with colleagues or superiors, and reminded them of our plight. A few weeks later we were transferred across the Bosphorus.

Constantinople proved more squalid than I had imagined, and was full of refugees, who begged and stole and swelled the mob. Its streets were dangerous, and I kept to the official quarter as much as possible. I resumed my historical work in the archives of the Great Palace, which were large enough to get lost in, and where much time could be spent, without anyone knowing what I was doing. I went to live at George's house, which was not far from Hagia Sophia. Despite his age and declining health, and the long gap in

our friendship, he had gladly found a place for me in his household.

From the outside, there was not much to see but a high stone wall. George's house was designed to look inwards and conceal its comforts from passers-by, which was wise in a city that could be turbulent, and was plagued by inequality. It was entered through a small and unimposing doorway, which was always guarded by a servant. Inside was a large pillared courtyard with a fountain, statues and some small trees. Several rooms opened directly onto the courtyard, and many other rooms led off them. The house was large and rambling, containing a confusing mixture of family, servants and slaves. It must once have been grand, perhaps almost a palace, but it was by then rather shabby. Despite the age and condition of its contents, it had everything that one might need. With its library, baths, servants, civilised company and regular meals, it was the most pleasant and comfortable place I have lived in. I was given a curtained-off alcove to sleep in, and shared meals with the men of the family. The women were mostly confined to their own quarters, though I did sometimes see Pulcheria, George's widowed sister, who was beyond the age when segregation is thought necessary. She was the real head of the household, and controlled its finances ruthlessly. Pulcheria, though younger than George, tended to patronise him. She seemed to think him irresponsible for not having married, regarded his work in the Church as unproductive, and condemned his poetry as sycophantic.

After so many years of war, the family estates in Pisidia were not as productive as they should have been. Some of the younger men had been sent there, reluctantly leaving the city, to put the estates in order. Their absence increased Pulcheria's authority, though I think she would rather have had them at home. She was not as austere as she pretended. Her plump figure billowed like the raised loaves my father used to bake, and her silvery hair escaped from its gilded clips in soft drifts. I think I saw in her something of my lost mother. She did not welcome me at first, but her attitude softened when she saw how useful I was to her brother. George became a sort of

patron to me, and gave me an acceptable status to the many nobles and Senators who visited him. Though they had gained some political power during Heraclius's absences from the city, many of them were much poorer than they had been. Most, like George's family depended on land for their wealth, but the land had been neglected, trade disrupted, and some had lost their estates completely. They had supported the Emperor in his wars, but were regretting the price they had been obliged to pay. These men, who from their talk seemed to favour Constantine and orthodoxy, brought with them a flavour of the city's tensions.

About a year after crossing to Constantinople, Heraclius named his two sons, Constantine and Heraclonas, as his joint heirs. They were presented to the Senate, and to the army, and were acclaimed by both. Soon afterwards, I was summoned from the archives by Constantine, the Emperor's son by his first wife, Eudocia. I was required to bring with me the history of the Persian wars. It was an uncomfortable interview. Constantine was young, only in his twenties, but was a sick man. Though he sat with dignity, he was thin and hollow-chested. He had a consumptive cough, and a pallor made worse by the bright silks he wore. His condition seemed another example of the Emperor's bad luck, though, unlike Heraclonas, his half-brother, he was not the product of incest.

He asked to see the history.

"It is not finished, your Majesty."

"How long have you been working on it?"

"Eight years." I hung my head. There was no need to simulate shame: I felt it keenly.

"Why so long?"

"It was not my only work, your Majesty. I also had duties with your illustrious father's staff in Antioch."

"Even so, it is a long time."

"History is an imprecise art, your Majesty. It is often difficult to find out exactly what happened."

"In eight years?"

I thought of the hot afternoons I had spent in Daphne, the

176

cheap wine I had drunk, the words squandered in futile arguments. I could not believe that I had wasted so much time.

"I have attempted to expand the scope of the history, to include the causes of the war, your illustrious father's saving of the Empire from the tyrant Phocas, and later events in Syria."

"Don't. You were asked to write a history of the Persian war. I want it finished as soon as possible."

"Yes, your Majesty. I will do my best."

"I hope so. You have access to everything in the archives, here in the Great Palace. Is there anything that could prevent you from completing the work in, say, one year?"

"Only, your Majesty, a lack of eyewitness accounts of some important events."

"Such as?"

"Your uncle Theodore's campaign in Mesopotamia." That was risky. When Theodore arrived in Constantinople, bringing with him the holy relics he had managed to salvage from Jerusalem, he was blamed for the defeat at Yarmuk, and disgraced. He was forced to become a monk, which has always struck me as an odd punishment. I hoped that Constantine might favour Theodore, whom I knew to dislike Martina. My hope seemed to be justified.

"I will arrange for you to speak to my uncle," he said. "But you must confine your talk to military matters."

The monastery was not one of the luxurious sort, such as are endowed by rich men, ready for their retirement. It was little more than a prison, and a damp, autumnal wind blew through the barred windows. The cell's only ornament was a small icon of Saint Anastasius, shown with his sword, and chains of martyrdom. I was surprised to see it. Years earlier, I had travelled with Theodore to Sergiopolis, where devotees of the saint had been causing trouble. For reasons that we had found hard to discover, the remains of Saint Anastasius, a Persian convert to Christianity, had proved popular with those who were discontented with newly restored Imperial rule. Theodore had ordered the relics to be translated to Jerusalem, where the cult was rendered harmless. When he fled from the

disaster of Yarmuk, he brought the relics to Constantinople. That Theodore had adopted the cult, which we had discussed in utilitarian terms when we discovered it, was a sign that he had had a change of mind. He had seemed, when I worked for him, to believe in little but practicalities, but misfortune, as it often does, had made him return to faith, or hope.

Theodore was perched on a wooden shelf that served as both bed and seat. He was dressed humbly in a simple brown tunic. Though younger than his brother, he also looked old and ill. He was thin, and his hair was grey and wispy. He made an ironically expansive gesture of welcome, as I entered his bare cell.

"I had forgotten you," he said. "Was it in Jerusalem that we last met?"

"Antioch, Sir."

"You can forget the 'Sir', look at my condition." I did not know what to say.

"Who sent you?" he asked.

"Constantine. He instructed me to get on with the history."

"I've always liked my nephew. I don't blame him for this."

"He looked unwell."

"He's never been healthy. But I hope he lasts. Otherwise we'll get young Heraclonas as our next Emperor, and you know what that means?"

"No." I said, not knowing a safe answer.

"It means that bitch Martina running things."

"But your niece . . ."

"Is a power mad schemer. And the people hate her."

The conversation was becoming treasonous, and remembering Constantine's restrictions on what we could discuss, I asked him about Mesopotamia. He told me more than I really wanted to know, but I wrote it all down. Generals are always keen to give their version of events. Encouraged by his loquacity, I asked him about Yarmuk, and he gave me a full account of the battle.

"Why were you left without reinforcements?" I asked him, when he had finished.

"It was Martina. She made sure I didn't get the men I needed."

"But why?"

"To make sure I did not succeed."

"Does she hate you that much?"

"She hates anyone who stands in the way of her son becoming Emperor. And the public know that if they get Heraclonas, they get Martina. She's no fool. She knows she's hated, and she won't leave anyone alive who might be more popular than her son." He did not look like a potential popular hero, as he sat hunched against the cold.

"Would she have risked losing the battle, just to make you less popular?"

"Why not? What does she care about Palestine or Syria? The throne is here in Constantinople."

"Was there really a conspiracy?" He looked pained, and did not speak for a few moments.

"Of course not," he said, recovering his composure. "My son was no traitor, it was all invented by Martina. It got another possible rival out of the way. And do you know what Martina had done to him? She had his nose and hands cut off! Then exiled him, as though mutilation wasn't enough."

I could think of nothing to say. I felt that I had contributed to his suffering by devising the plan that had got Heraclius across the Bosphorus. But I could hardly mention that.

"I haven't got long," he said. "I don't know when, but she'll finish me off."

I waited.

"Are you orthodox?" he asked. That was difficult. Officially we were all supposed to believe in monoenergism.

"Yes," I said.

"I thought so. The single energy. That's her too."

"I thought it was the Patriarch."

"Possibly. He may have worked out the details. But it was her idea."

It seemed unlikely.

"I haven't got long," he said again.

I do not know how long he lasted. Though I liked him, it

179

struck me that he was a dangerous person to know. Whether his opinions were right or wrong, I decided to hear no more of them.

I returned to the archives, and wrote up my notes, but I cannot say that the history was much nearer to completion. There was so much information available in the capital that the problems of selection and interpretation became even worse. It seemed that Constantine wanted an account of his father's heroism, but I felt unable to produce it. The Emperor had had his heroic moments, but it was hard not to think of his recent madness, the disaster of Yarmuk, and the folly of monoenergism.

It was obvious to everyone that the policy of theological compromise had failed, pleasing neither orthodox Christians nor monophysites. Even the Patriarch seemed to think that he might have been mistaken. He spent much time in the Palace, engaged in theological discussions with Heraclius and Martina. He concluded that, as Sophronius had noticed, there were logical flaws in the idea of the single energy, as well as its major disadvantage of unpopularity. But the Patriarch thought he had the answer. He proposed a new compromise called monotheletism, which preserved the two natures of Christ, motivated them with a single will, and forgot about the single energy. When the details had been agreed, this new policy was set out in a document called the Ecthesis, which was sent to all the bishops, and displayed in Hagia Sophia.

12

THE SUCCESSION

A.D. 639–641

At that time, I used often to visit the church of Saints Sergius and Bacchus, in the palace grounds. It was built by Justinian, like Hagia Sophia, which it resembles in miniature. Squashed between two other buildings, and rather irregular as a result, it was a quiet church, unfrequented by the crowds who filled the cathedral. I was still troubled by lustful thoughts, which the gloom of the palace did not dispel. I often thought about the nature of desire, and of the soldier-saints to whom the church was dedicated. The life of Sergius and Bacchus was one of those I had read to Nicholas's mother while we were preparing to set off for Cappadocia. They were officers in the army of the pagan Emperor Maximian. When they refused to recant their Christianity and sacrifice to Jupiter they were demoted and horribly martyred. Before they died, their military clothes and signs of rank were removed, and they were publicly paraded in women's clothing. Their hagiographer made it clear that they were lovers.

The two saints were popular in Syria, where they died, and I had heard, in Antioch, of men solemnising friendships in their name. My Syrian friendship had proved unsatisfactory. Michael was too sensual and unreflective. His attitude to pleasure seemed, like the Khazar's attitude to their horses, slightly to compromise his humanity. Though I had been glad to discover what he offered me, I was not entirely unwilling to relinquish it, and had been celibate since. I was not sure that I wished to remain so. I hoped, as I mused in the church of Saints Sergius and Bacchus, for a friendship that would bring pleasure, but not preclude thought.

In January 639 I saw the elevation of Constantine and

Heraclonas, who were made co-Emperors with Heraclius. The first Roman Emperors had been proclaimed by soldiers, who raised their candidate on a shield as a sign of approval, and the custom was maintained in succeeding centuries. The two princes were to be raised on shields, but by the Patriarch and a selection of Senators and officials. As these were mostly rather elderly, the actual lifting was done by soldiers, but the others had at least to place a hand on the shield while it was raised. That was easy enough for Heraclonas, who was lifted above his bearer's heads, but difficult for Constantine, who was delicate, clearly disliked being handled, and was only raised off the ground for a moment. Both had to be raised at the same time, and the ceremonial part of the lifting party scuffled clumsily to make sure each had a hand on both shields.

I followed the crowd into the great cathedral of Hagia Sophia, determined to see the rest of the ceremony. I was carried through the doors by a torrent of people, all keen to be at the front of the aisles or galleries. I glimpsed green marble, red porphyry, gold mosaic, carved foliage, all jumbled together like the flowers in a spring meadow. Women filled the galleries, jostling for the best view and peering down at the men. I had never seen so many beautiful women, who were wearing their best clothes and jewellery in honour of the occasion. They were fifty yards away, the church was so big. I stared about me, over the heads of the other men and through the massive pillars that supported the galleries.

At the far end of the cathedral, four gilded thrones were set on a raised platform, which, like the Imperial enclosure, was draped with purple silk. When the Imperial doors opened, light flooded in, reflected from the gilded ceilings, and lit our faces with a shimmering glow. As the procession entered all chattering stopped. Heraclius was carried in on a litter, and helped onto his throne. His wife and two sons sat by him, all wearing the brightest and most ceremonial of silk robes. Shining with gold and precious stones, they looked as flat and stiff as mosaics, and tried to keep as still as statues. The effect was undermined by the bearing of the four. The Emperor was by then seriously ill. His body was bloated, and his eyes bulged.

His melancholy had reached the terminal stage, when the humours lose all balance and swell the body. He could hardly sit up, and was supported by two eunuchs. Martina's mask-like make-up could not conceal the way her mouth twisted into a smug smile. She was getting what she wanted, and did not disguise her pleasure.

Martina's son, Heraclonas, seemed ill at ease. He was thirteen, awkward in his body, and found it hard to keep still. He kept gazing round the cathedral as though he had never seen it before. At first Constantine had no trouble looking like a statue, as his face was marble white, though tinged with reflected purple from the silk drapery. He was almost slumped in his throne, and had attendants standing by, though they did not actually hold him up. When the deacons began to swing their censers, the resulting clouds of incense smoke made Constantine writhe on his throne, and though he managed not to cough, the statue effect was soon ruined.

Patriarch Sergius had just died, punished, some said, for his tampering with orthodox doctrine, so the service was taken by his successor. After the two princes had been crowned and anointed, they appeared with Heraclius and Martina in the Hippodrome, and as is usual, were acclaimed by the people.

I sat among 40,000 spectators in the great banks of seats that surrounded the race-track. I was in the Green seats, not because I had joined, or approved of, that faction, but because their seats gave the best view of the Imperial box. While we waited for the ceremony to start, I looked at the statues and monuments that line the centre of the track.

When Heraclius and his family appeared in the Imperial box, the crowd cheered, then sat quietly, waiting for the acclamation. When they were ready, the choirs of the Blues and Greens rose and sang an antiphonal greeting to the Emperor and his associates.

Long life to our Emperor

 Heraclius, son of Heraclius

Defender of the Faith

 Restorer of the Cross

And to the Emperor

his son Constantine

And to the Emperor

his son Heraclonas

And to our Empress

Martina, wife of Heraclius

There was some heckling when Martina was acclaimed, but it was not so loud that it could not be ignored from the Imperial enclosure. Most of the crowd seemed relieved, as it was obvious that Heraclius would soon die, and that the succession must be secured. Afterwards people joked that the Empire would soon be ruled by two Persons, and asked whether they would be motivated by a single will. If so, it seemed clear that that will would be Martina's.

Like most people in Constantinople, George disapproved of monotheletism just as much as he had disapproved of monoenergism. He could see little difference between the single will and the single energy, and, with most of the monophysite provinces already lost to the Moslems, thought further compromise pointless. George's orthodoxy, once pragmatic, had become a matter of conviction. He had discovered a new interest in theology, and he spent his last years composing poems condemning heresy in all its forms. I used to write for him, while he dictated from a couch. He lay back, propped up by cushions and wrapped in rugs. I sat beside him scratching his words into wax tablets before transcribing them onto precious papyrus.

Sometimes his verse was hard to understand. On one occasion I was so puzzled by his opaque archaism that I stopped to think about his words and failed to record them.

"That verse is rather ambiguous," I said, to cover my omission.

"Not at all. It is in favour of orthodoxy."

"Our orthodoxy, or the Emperor's?"

"Ours, of course. You know that very well."

"But anyone reading it would not know. They might think you meant monotheletism."

"They might."

"Could you not be more explicit?"

"No. It is too dangerous. Not until true orthodoxy is restored."

"Do you think there is any real hope of that?"

"Not yet. The new Patriarch is very careful not to commit himself, but his silence says everything. In practice he is a monothelite. The orthodox party is powerless."

"But the followers of Constantine . . ."

"They say he is orthodox, but I don't know. He hates his father now. I know that. For making him share the throne with Heraclonas."

"Would he restore orthodoxy?"

"Not if Martina keeps her grip on things. Did you know she's named as co-ruler in his will?"

"Along with Constantine and Heraclonas?"

"Instead of, in practice."

"But the Empire has never been ruled by a woman."

"Not officially. But she'll hide behind Heraclonas."

"And Constantine?"

"Have you seen him?"

"He doesn't look well."

"He isn't well, and never has been. It won't be difficult to get him out of the way."

"But the people seem to support him."

"We can't rely on them. It would be most inadvisable. But most of the Senate is orthodox. And the Army."

"But will they do anything?"

"Not while Heraclius is alive."

Heraclius lingered on for two more years, obsessed by his failure in the East. He ignored events in Constantinople, and thought only of Egypt. On 11 February 641, soon after the Moslems reached Alexandria, and the new Pope condemned monotheletism as heretical, Heraclius died. Palace rumour said that he claimed orthodoxy on his deathbed, blaming Martina for monotheletism. His bloated body was put on display, crowned with gold, draped with jewels and clothed in silk. Many who came to view him must have thought that he

185

had lived too long for his own good, though perhaps not long enough for the Empire's. Almost everything he achieved was undone in his lifetime.

Soon after he was buried, Constantine, Heraclonas and Martina appeared at the Hippodrome to receive the acclamation of the people. The will was read out, and the people were asked to accept her as Empress. The choirs of the Blues and Greens began their ceremonial response:

Long life to our Emperor
> Constantine III, son of Heraclius

Defender of the Faith
> Hope of the Empire

And to the Emperor
> Heraclonas, son of Heraclius

And to our Empress
> Martina, widow of Heraclius

But when Martina's name was sung, hecklers interrupted, and sang the rest of the acclamation with their own words:

Down with Martina
> Who was fucked by her uncle

And has fucked up the Empire
> Down with the Patriarch

Who is a heretic
> And will fuck up the Church

Let Constantine rule
> And let Heraclonas assist him

But only when he is old enough

There was no ignoring this, as it was sung by a sizeable section of the crowd, who must have rehearsed their performance. Martina stood up, shouted something at the crowd, and rushed furiously out of the Imperial box. Heraclonas, after confirming the crowd's low opinion of him by dithering,

followed her awkwardly. Constantine stayed, and was cheered by the mob. They could see that he was ill, but he was the eldest of Heraclius's sons. He was orthodox, not a product of incest, and had played a part in defending the city during the Avar siege. They were happy to acclaim him as their sole ruler.

Martina's anger had no effect on the mob, but she still dominated the palace, and she quickly set about sacking or exiling any official or minister who showed any sign of favouring Constantine.

In April I received a second summons from Constantine. He had by then retired to the palace at Chalcedon, driven across the Bosphorus by Martina's campaign against all his supporters. I gathered up some papers, and tried to make them look like an unformed, but substantial, work of history.

The palace was in no better condition than when I had last seen it, but to Constantine it must have seemed more comfortable than the Great Palace. He received me in bed. It was a very grand bed, and it was covered in the most expensive silks, but he was indisputably in bed and unwell. The smell of the sickroom was not quite masked by smouldering herbs and resins. Their fumes were doubtless intended as a remedy for the Emperor's weak chest. Having seen him overcome by incense at his coronation I wondered who his doctor was, and looked to see if the bed had been hung with magic stones or mummified lizards.

"It is more than a year," he said.

"My humblest apologies your Majesty. It has proved more difficult to do justice to your illustrious father than I anticipated."

"Has Martina got at you too?"

"I can assure you, your Majesty, I have had no dealings with your illustrious step-mother." It was not true, but I could not tell him that I had advised her how to bring Heraclius across to Constantinople in a disguised boat. She had, in any case, not mentioned the history on that occasion.

"You must be the only one then. She's got at everyone else."

"I am sure, your Majesty, that I am beneath her notice."

"Don't count on it. She notices everything."

There was a long pause, while he recovered his strength, and I wondered what the least dangerous course of action was. His attendants watched silently, and would remember everything.

"This history," he said, "will it ever be finished?"

"I think . . ."

"Perhaps it might be just as well. It can only show my father as a fool."

I did not think it wise to agree.

"I have tried to show your father's best intentions in everything he did."

"Including his theological policy?"

"The wish to unite the Empire is a noble one."

"But not if it divides the Church."

"That is an unintended consequence . . ."

"Perhaps. But it is a consequence, nevertheless. And the division of the Church has cost us the East. In your history, which must be finished very soon, I want you to make it clear that monoenergism and monotheletism were the work of Martina and the Patriarch. My father said as much on his deathbed."

"Then I will make it clear, your Majesty."

As I backed out of the room he twitched his bedsheet, and I am sure I saw, knotted into a corner, a dried sea horse. He was being treated by a magician, not a doctor.

I felt rather ashamed of myself as I was rowed back across the Bosphorus. Though I had come to think Heraclius foolish in some respects, I did not think him completely so. Nor did I believe that monoenergism was not his idea. I was there when he proposed it to the Armenian bishops. It was possible that monotheletism was forced on him by Martina, but compromise with the East was very much his policy. It was difficult to know what Constantine would do if I did not finish the history. He had power, but his retreat to Chalcedon suggested

that he did not have much. Though he was assumed to be in favour of the restoration of orthodoxy, he had not proposed it, and, given the state of his health, might be in no position to achieve it.

Soon after that, my confusion was increased by a summons from Martina. She made no reference to our previous meeting a few years earlier, and I did not remind her of it. This time, her face was heavily painted, and her hair was redder than I remembered. In contrast to her step-son Constantine, she was obviously quite healthy. It seemed likely that she would be in power for some time.

I can hardly bear to describe my cowardice during that interview. The first time we met, she was worried, and needed help. This time she was confident and completely in control. She did not ask my advice but issued commands. Her requirements were the opposite of Constantine's, and I agreed to them all. My history was to stress the late Emperor's saintly devotion to the unification of the Church, and would make it clear that all who opposed him were heretics and traitors. I was completely unnerved by her, and knew that, if I did not obey, something bad would happen to me. I crept back to the archives, and spent several hours staring hopelessly at the disordered pages of my manuscript.

I spent that spring mastering the art of ambiguity. It seemed the best solution.

Visitors to George's house brought rumours from the city. They hinted at what the orthodox faction might do, but all its hopes depended on the health and survival of Constantine. It was said that he had gone to Chalcedon because Martina was trying to poison him. The Senators, for all their talk, were clearly terrified of Martina, and would do nothing openly against her.

Then, only three months after Heraclius, Constantine died. I cannot tell whether he died of his disease, of Martina's poison, or of the ministrations of his doctor. He was not quite thirty.

Martina pushed Heraclonas into the background, and, with

189

the help of the Patriarch, started persecuting the orthodox as well as those who had supported Constantine. The Senators did nothing, even though many of them were punished and exiled. They shut their doors and hid, afraid even to conspire. Only the mob were brave enough to protest. Led by the Blues and Greens they demonstrated sporadically throughout the summer. They were sure that Constantine had been poisoned by Martina, and demanded the restoration of orthodoxy. We could often hear them shouting in the streets near the palace, and I was uneasily reminded of the way the factions had behaved in Tarsus.

By the autumn the protests had become so frequent that it seemed to me that the moment for action had arrived, but the Senators and nobles feared the mob even more than they feared Martina. They could not bring themselves to seize power with the help of the people. We waited for several days and nights, not daring to leave the house, while the noise in the streets grew worse. Then, just as the enthusiasm of the mob seemed to be waning, we were woken in the middle of the night by furious banging on the outer door. George was in bed, Pulcheria was locked in the women's quarters, and the young men of the family were all away. I wrapped myself in a cloak and went to the courtyard, where some of the servants stood, wondering what to do. If it was the Blues or Greens, I did not think I could face them. I remembered how, one night nearly forty years earlier, the Blues had taken away my parents and sent me to be indoctrinated by the monks.

"Who is there?" I asked the servants.

"Soldiers," said the gatekeeper. "About ten of them, from what I could see through the spy-hole."

Soldiers suggested order, rather than disorder. But whose order? Martina might have sent them, to arrest those she thought favoured orthodoxy. The door shuddered as it was shoved and hammered again. The men outside called:

"Is this George the Pisidian's house?"

"Who wants to know?" I answered.

"General Valentinus."

"Who?"

"Commander of the army in the East. We have been sent for George the Pisidian. Are you going to let us in? Or shall we break the door down?"

"I think we had better let them in," I said to the gatekeeper. He slid back the bar and opened the door. Two officers stepped through the doorway, their long red cloaks covering any marks of rank or origin. Behind them were a dozen soldiers, their faces lit by flickering torchlight. They pushed into the courtyard with their swords drawn. Despite their fierce appearance, they carefully shut and barred the door after them.

"Who are you?" asked one of the officers. He was holding what looked like a list of names.

"I am George's secretary." It was not quite true, but I did not want to annoy him with long explanations.

"Take us to him."

"But Sir," I thought it wise to be polite, "he is unwell. We should not wake him."

"I'll be the judge of that."

We were obliged to take the officers to George's room, though the men stayed in the courtyard. George had been woken by the noise, and a servant propped him up with cushions.

"What do you want?" he asked.

"Your support."

"What for?"

"General Valentinus is waiting at Chalcedon. We have orders to take you to him."

"As you can see, I am not fit to travel."

"This is hopeless!" the second officer said. "Everyone on the list is either sick or absent. Are the Senators and nobles all gutless? Will you stand by and watch Martina wreck the Empire?"

"I am not fit even to stand by, but I would help you if I could."

"That's what the others said."

"How does Valentinus propose to stop Martina?"

"He led us to Chalcedon to support Constantine. We were

191

going to make him sole Emperor, and depose Martina. But we arrived too late."

"Then there is nothing to be done," George said, sinking beneath his bedclothes. The servant propped him up again.

"Constantine left a son," the officer said.

"Constans? But he is only a boy."

"He is eleven years old, he is the grandson of Heraclius, and he is not tainted by incest." The officer sounded as though he was reciting a religious formula. "With the help of the Senate, Valentinus will make him Emperor."

Valentinus's men must have found some Senators willing to go to Chalcedon. With their backing, he brought Constans across to Constantinople and forced Heraclonas to proclaim him as his co-Emperor. When Martina refused to accept him, she and Heraclonas were deposed, mutilated and exiled.

With a boy-emperor on the throne, the Senators looked forward to some real power, something they had not had for centuries. They exiled those who had supported Martina, and brought back those who had been exiled by her. But exchanging one set of exiles for another was not a coherent policy, and did not address any of the Empire's problems. The Senators were unused to government, and, because there were so many of them, could never agree on a single policy. Most of their actions cancelled each other out, and nothing effective was done to prevent the loss of Egypt to the Moslems.

13

THE MONASTERY

A.D. 642–649

During that time George died. He had been ill ever since I had returned to Constantinople, and had at last moved from his couch to his bed. He had once been plump and fleshy, but unlike Heraclius, had suffered from a draining away of the humours, which left him thin and wasted. His energy also drained away, and for his last few weeks he was almost unable to move. His household kept a constant watch. There were always three or four people in his room, sometimes more. Relatives and servants were supplemented by Senators, soldiers or monks, but no one came from the cathedral of Hagia Sophia. Neither the Patriarch nor his staff would risk visiting him while the issue of monotheletism was unresolved. As death approached, George became even more convinced of the need to avoid heterodox theology. He called me to him, and whispered:

"When I was young, I used to go to the circus. God forgive me, it seemed a harmless pursuit at the time. But perhaps He was watching, guiding me even then. I remember one performer. A beautiful girl." He paused to get his breath back, and perhaps to savour, or regret, the memory. "Her speciality was rope-walking. Have you ever seen it?"

"No."

"She walked across a rope. Her attendants stretched it between two tall poles. She climbed up. Just like that. No ladder. I've seen sailors doing that." He paused again, recovering the thread of his story. "At the top of the pole, she put one foot on the rope, then another, and standing upright, walked right across. Once she found her balance, she went across quickly." He was sweating now, and a servant cooled his face with a wet cloth. "God must have been watching over us then. That girl and her act, they were a parable. We are like her.

Orthodoxy is a narrow path leading to heaven. If we take one step away from the path of orthodoxy, we will fall." After another pause, he quoted from the Sermon on the Mount:

"Straight is the gate, and narrow is the way, which leads to life, and there are few that will find it."

He slept afterwards. When he woke, he did not recognise anyone, and his speech was meaningless babble. A doctor examined him, and proposed to bleed him to restore the balance of his humours. I wished that I had taken more notice of Basil's treatments, though none of his patients were as near death as George. It seemed to me that his humours had deserted him, and there was nothing left to balance. A little blood was taken, but it made no difference. The number of watchers round his bed increased, and when he died there were more than twenty of us. Pulcheria, who had seemed to hold him in ridicule when he was well, and tended him better than a slave when he was ill, collapsed in tears and was taken away by her servants. The rest of us stood around, making the sort of reassuring comments that people make when someone has just died.

I had thought George slightly ridiculous when, twenty years earlier, he had appeared in the clerk's tent searching for information. In public he was usually cheerful. He knew the value of a brisk manner. When he preached to the troops about their duty to the Empire and orthodoxy, they believed him and fought well. However, as I got to know him, I saw that he was full of doubts. Some of those doubts were about himself. Though proud of his antique verse, he feared that the flattering tone of his poems made him seem a hypocrite. Perhaps that fear fed his opposition to the Emperor's policies, though he never dared to express his views openly. His unwilling exposition of orthodoxy to the Armenian bishops at Ani was the nearest he came to open opposition, and that was at the Emperor's request. Heraclius's compromises with heresy had provoked George to consider his own position. He had always linked orthodoxy with civilisation, but came to value orthodoxy for its own sake. From his doubts came real faith. He had influenced my own religious thought, as well as

encouraging my interest in history. He had been my mentor and patron. Without seeming to, he had taught me more than Basil. I owed him a lot.

After George's body was covered I went to my alcove and considered my life and achievements. I was forty. That was an achievement of sorts, for many die younger in this age of war and plague. In my melancholy state, it seemed to me that my life had been a series of failures. I had tried to become a monk, but had fallen among heretics. I had tried to become a soldier, but had been made a clerk. I had been appointed the Emperor's historian, but could not discover the truth. I had earned a little money, but owned no more than I could carry. I had been plagued by lustful thoughts, but had neither satisfied nor resisted them. I had not married, nor wished to. I had lived in Constantinople, which most provincials could only dream of, but was oppressed by the pointlessness of life at court. I was sick of pretending to write what no one wanted finished, and of listening to rumours of what no one would dare to do. In addition to all that, my salary had stopped with the death of Constantine. It was time to enter a monastery.

I had enquired of George's friends, and of the monks who sometimes visited, many of whom recommended the monastery of Saint Pachomius, just beyond the city walls, near Blachernae. After George's funeral, I collected my few belongings and made my way to the monastery. It was in a compound, enclosed by high walls, made of alternating courses of white stone and red brick. The entrance was an arched doorway, blocked by iron-studded oak. I knocked, was ignored, and knocked again, louder. A small hatch opened, and the face of the gatekeeper peered out.

"What is it?"

"I would like to join the monastery."

"You are not ready. Go away."

The hatch snapped shut. I walked away. I had not expected to be rejected. I went back to Blachernae, and wandered for a while, but the only thing I could think of was to return and try the door again.

"Yes?"

"I want to join."

"You are not ready." The gatekeeper stared at me for a moment. "Come back tomorrow." He spoke in a loud whisper, indicating by winks and twitches, that I was not to take his refusal seriously. I returned the next day, and was again ritually turned away. On the third day the door was opened and I was admitted. I was questioned to make sure I was not a lunatic, debtor or criminal, all types who find monasteries congenial. Then I was asked why I had chosen to become a monk.

"I felt a calling."

"Have you read a book called the *Spiritual Pastures*?"

"Yes I have. Why do you ask?"

"It's a very popular book. All our postulants seem to have read it."

"Is there something wrong with it?"

"No. Nothing at all."

Then my orthodoxy was tested. I gave satisfactory answers and was accepted. The doors closed behind me, and I began a new life, leaving the earthly and trivial behind. Straightaway I was plunged into the orderly world of the novice. Instead of wasting time, all my time was regulated, accounted for and purposeful. We woke in the small hours to sing the first of many daily offices. At dawn, and again throughout the day, we returned to the chapel to sing, pray and hear readings and sermons. When we ate our simple meals of bread and stewed vegetables, we listened to readings. There was no doubt about our purpose. Unlike those outside, who argued about Christ's nature, we followed His example. When not in chapel I joined the other novices in menial work around the monastery. There was no allowing for skills or specialisms, we all did whatever was necessary, and learned humility and obedience. I found that I did not mind this at all. My life in the city had become pointless and repugnant to me, and I was glad to stop thinking and lose myself in work. Only one thing seemed odd in the monastery's rules: we were forbidden to feel sad. Melancholy was regarded as a sin, and wilful, not as an involuntary

imbalance of the humours. I did not feel melancholy, on the contrary, but had I done so I would have been given a penance of daily prayer and genuflections.

After a year I was ready to take the vows. In front of the whole community, I confessed my sins, prostrated myself and promised obedience to the Abbot. In return I was given the new name of Theodore, after a soldier-martyr who was tortured horribly when he refused to worship at a pagan temple. At first I was not entirely pleased by the Abbot's choice, which reminded me of the gruesome stories I had read to Nicholas's mother, and of the Emperor's brother, whom I had served in the East. But, when I remembered Theodore's stoicism in adversity and unfanatical orthodoxy, I was reconciled to the name.

As I had renounced possessions, my belongings were handed over, and the *Persian Expedition* and the *Campaigns of Alexander*, though scorned as secular, were given to the library. I wondered what Basil would have thought about these books, which he had rescued from fundamentalists, being given to a monastery. Then my head was shaved. The tonsure is a symbolic castration, indicating that one has become sexless. I was not sure that I had indeed become sexless, but, under the influence of work and contemplation, had been much less troubled by lustful thoughts, and hoped that I would free myself from desire.

Full members of the community were encouraged to make use of their skills. As a scholar, I was sent to the scriptorium, where the monastery of Saint Pachomius generated income by copying and selling books. The scriptorium was a large, light room, where a dozen monks sat at desks that were scattered with pens, knives, ink-pots, and sheets of parchment. More parchment was piled on a table at the back of the room, where two novices worked, smoothing and polishing. Parchment was expensive, but, as conditions worsened in Egypt, papyrus had become scarce. I was given a desk and equipment, and a book to copy. I balanced the book on the carved wooden stand that was fixed to my desk, and opened it. It was

the *Spiritual Pastures*. I ruled a sheet of parchment, prepared a pen, and began to copy. I had to concentrate at first, as I had not written the large uncial script for some time. My administrative and historical work had been written in the minuscule script used by clerks and tradesmen. I did not have to worry about leaving space for decorations and illuminations. As a beginner I was not expected to produce a fancy edition, though carelessness, like melancholy, was rewarded with penances. Fifty genuflections were the price of an untidy copy, and a hundred and fifty for incorrect punctuation. A five-day fast was the punishment for missing out any of the text. I was so careful to avoid such penalties that at first I hardly read what I was copying. As my skills returned, I was able to concentrate less on forming the letters, and began to read as I copied. I was surprised to find the book not as I remembered it. The stories of wandering scholars, of books and miracles, and of the contemplative life, seemed outweighed by fables of faithful dogs and obedient donkeys. Sophronius had been the author's fellow traveller, and it was hard to imagine the Patriarch who had divided the East with his obstinacy sharing his friend's taste for sentimental animal stories. Perhaps sentimentality is an outlet for the melancholy that must result from diverting all passion and desire into orthodox enthusiasm. Or it may be that sentimental people, often otherwise ruthless, attribute to animals those feelings that they dare not acknowledge in themselves. After I had copied yet another episode involving a miraculously tame lion, I asked some of my neighbours what they were copying. We were not supposed to converse, but most of the others could only read aloud, and under cover of their combined mumbling, I managed to establish by whispers that at least half of the copyists were working on the *Spiritual Pastures*.

I suppose the copying was another sort of probation, though it was never described as such. After I had worked in the scriptorium for a couple of years, I was given other, more varied duties. At first I worked in the archives, dutifully sorting piles of dusty documents. I also taught. Some of the novices, and even the brothers, were not fully literate, and I

prepared them to read, so that they could study the Scriptures and the lives of saints. I hoped to teach them to read silently, as I have always found the mutterings of other readers distracting, but I was not successful. Most people cannot believe that words can exist independently of speech, and those who have learned to read late are so proud of their achievement that they insist on declaiming loudly any words they see. I might, perhaps, have been allowed to teach more than just reading, but the Abbot seemed to think that we should not be given work that is too congenial. He demonstrated that by interrupting my teaching and telling me that I was to go out of the monastery and attend a deathbed.

"What, Father, is my purpose at the deathbed?"

"You are to ease the passing of a good Christian, who, incidentally, is a rich man and one of our patrons."

"How am I to do that?"

"You are to provide support, and act as a sign of grace to the dying man's family."

"But, with respect, Father, I do not feel full of grace."

"That is for the Lord to decide, not you."

I had taken a vow, so I obeyed.

I was reminded of George's death when I arrived at the house. There was the same mixture of family, friends and servants waiting for the end. I did not know what to do at first, so, as a monk's prayers are considered more than usually effective, I prayed. I read from the Scriptures, choosing hopeful verses, and kept a vigil through the night. I observed the doctor and doubted his wisdom. The rapid death of the patient confirmed my doubts. If death was inevitable the doctor should have said so, not promised an impossible cure. I quoted reassuring verses to the bereaved. Soon after the death, the monastery received a useful endowment of land near Adrianople. The donor had died happy, knowing that his generosity would be repaid in heaven.

After that, I attended deathbeds regularly, and I often had to leave my pupils for days and nights spent in the crowded bedrooms of the dying. Sometimes I was not expected to do anything, and my presence was considered enough. I waited

solemnly, while a dozen lives slipped away, and a dozen donations enriched the monastery. I found that, when I had run out of hopeful verses from the Bible, Homer was well received. The speech by the ghost of Patroclus was popular, despite its pagan views of the afterlife and the disposal of the dead. Another favourite was the visit by Odysseus to Hades, where he talks to the spirits of the dead. The rich like to be reassured about the afterlife, and their families are flattered by the obscurity of a learned language.

Soon I found that I was becoming known among the city's rich, and I was requested, not just for deaths, but for dinners. I consulted the Abbot, and was told that my presence at these events was both a duty and an economic necessity.

"The monastery cannot survive on book selling," he said. "Books get a good price, but they take a long time to produce, and in the meantime we must all be fed and clothed, however humbly."

"Yes Father."

"Remember, just as it is wrong for the rich to store up worldly goods, it is wrong for monks to keep all their virtue to themselves. It is your duty to go out into the city and exchange one for the other."

I suppose I should have noticed, but it seemed that monks had become fashionable, and were considered ideal additions to any social occasion. Hermits and stylites had had their vogue, but monks, not requiring picturesque cells or lofty columns, and being obliged to return regularly to their monasteries, were less permanent, and cheaper to maintain. I resigned myself to a career as a pious ornament. It was odd attending dinner parties under those circumstances. Sometimes, while the rest of the party dined on luxuries, I was given a bowl of porridge. "I am sure it's what you prefer," the host would say, as the wooden bowl was banged down by a servant. At other times, I would be offered luxuries, but in such a way that it was quite clear that I was expected to refuse. Porridge was always held in reserve. Whatever food was offered, there was always a moment of suspense, while the

other diners waited to see what I had chosen. I asked the Abbot what I should do, and he said:

"Do not draw attention to yourself, either by refusing good food if offered, or by demanding better than you are given. Do what is expected of you. Above all, do not give offence."

That was sensible, but unhelpful, and I was rarely able to get a good meal. My inhibitions about asking for better food must have been interpreted as a sign of sanctity, and I found myself invited to more and more social gatherings. I became very popular with elderly ladies, who could invite a monk into their quarters with no risk of scandal, and whose reputations for piety were thereby increased. My teaching was so interrupted that it was assigned to someone else, leaving me with nothing to do but socialise. I ate porridge and drank water, contributing, where appropriate, a few words, which, whether attributed to me or the writers I had borrowed them from, increased my reputation for wisdom.

During that time, while the Emperor was young and the Senate dithered, it was possible to discuss religion more or less openly, and I was often asked to explain abstruse theological points, which I did, to the best of my ability. It was my namesake, Pope Theodore, who, indirectly, ended that freedom, by condemning monotheletism and demanding that Constans declare the Empire officially orthodox. Constans, who was by then seventeen, refused, and issued a decree that banned all discussion of the question of the single will, from whatever point of view. It stated that anyone, of whatever opinion, who broke this law, would be deposed, exiled, mutilated or flogged, according to status. Dinner party conversations were rather limited after that.

My mission to the rich ended then, and I returned to the peace and quiet of the monastery and resumed my teaching. I showed novices how to form their letters, heard brothers read the Scriptures, and hoped that in time the Abbot might allow me to do something more satisfying. A year or so later the Abbot summoned me to his room and said some surprising yet familiar words.

"I have decided," he said, staring at the book that lay open on his table rather than looking me in the eye, "to send you away from the monastery."

"But why, Father Abbot? Have I failed in my duties, or offended against my vows."

"No, you have not failed." He closed the book and looked up at me. "It is I who have failed," he said, rather surprisingly. "I have failed to find an outlet for your scholarly skills. But now there is an opportunity."

"An opportunity?"

"I have had a letter from Abbot Hilarion, of the monastery of Saint Anastasius. He says he needs a teacher, one who can set up a school, and devise a curriculum, as well as teach. I have decided to send you."

"Where is this monastery, Father Abbot?"

"In Italy, near Naples. There are many refugees in that region, people displaced from Greece by the Slavs. There are monks among them, but not many scholars. There is a need for teachers to help them keep our Greek language and learning alive. I think you would be well fitted for that work."

I tried to think what Italy would be like. I remembered Procopius's account of the Gothic wars that had ruined the country. I thought of the subsequent invasion by the heretical Lombards, and pictured the wrecked churches and looted monasteries. I imagined myself teaching Greek grammar and literature to barefoot refugees, squatting in roofless schools. The prospect was unappealing, but I had promised obedience, so I agreed.

A few months later, when everything was arranged, I was summoned again by the Abbot. He said a few encouraging words, gave me some money and advice for the journey, then produced a bundle from the carved chest that sat beside his table. It was about a foot long, narrow, and wrapped in sheepskin. He unrolled it, reminding me uncomfortably of the wooden phallus the Khazars had shown me. Inside was another package, wrapped in purple leather, sealed with wax and gold.

"Keep this safe," he said. "Do not open it. Give it to your new abbot when you arrive."

14

HADRIAN

A.D. 650–655

The monastery sat on the top of a low hill, a day's walk inland from Naples. Above its walls of grey stone, I could see red tiled roofs. Below it was a small village inhabited by refugees from Greece, and beyond were fields where some of them worked. I climbed the hill, presented myself to the gatekeeper, and was taken to Hilarion, the Abbot. He was a stocky, vigorous-looking man, with a wide face and short neck. He took the package I gave him, placing it absent-mindedly on his table, as he began an enthusiastic explanation of the work of the community. To illustrate this, he took my arm and led me round the monastery, showing its various parts and explaining how they were organised. He was the kind of man who can explain a thing best when he is looking at it.

"This is where you will be working," he said, as he led me into a colonnaded courtyard. On one side were the library and a small scriptorium, both obviously neglected. On the other were several empty schoolrooms. As we toured the rooms, Hilarion told me of his plans and hopes, and of my duties. Beyond the courtyard was a terrace that overlooked the hillside. Hilarion led me to it, and we looked down at the vineyards, where villagers, monks and oblates were at work picking the first of the season's grapes. The vines were not pruned low, like those I had tended with Basil, but were trained among the branches of trees, which had to be climbed by the lightest or most agile of the pickers, while others stood below with baskets. The late afternoon sun gilded the scene and cast long shadows. I looked around, and, as I considered the task ahead of me, the first useful work since my noviciate, I thought that I could be happy there. Hilarion must have seen that in my expression.

"It looks like Paradise, doesn't it?" he said.

"Yes."

"Do you see those hills, over there to the north?"

"Yes."

"They mark the edge of the Duke of Benevento's lands."

"Are the Lombards really so dangerous? The captain who brought me to Naples was afraid of them. He wouldn't land at any Lombard towns."

Hilarion removed his skullcap, and ran a hand over the top of his shaven head. He thought for a while, looking at the hills, before replacing the cap.

"They are savages and heretics. Since I have been Abbot here, the Lombards have captured Liguria and Salerno. They will take these lands if they get the chance. And if they do, we will be refugees again. Their King, Rothari, persecutes orthodox Christians wherever he can get his hands on them."

"He is Arian?"

"Yes. Most of them are. They think that Christ wasn't a man, but a sort of lesser God. Or is it the other way round? Whichever it is, their priests think His earthly presence was just an illusion. And they say the Father and Son are 'distinct and separate.' But that's just polytheism, isn't it?" His tone suggested real doubt. Evidently, theology puzzled him.

"It is certainly heresy."

We resumed the tour of the monastery, then Hilarion led me back to his room. There, on his desk was the sheepskin bundle I had brought from Constantinople. He unrolled it, broke the seals on the inner package and opened that, extracting a roll of papyrus. Lying on the unfolded purple leather was a bone.

"Ah, yes!" he said, reading the papyrus. "I hoped so. Your Abbot promised. And here it is!" he said, grasping the bone and holding it up.

"What is it?" I asked.

"The arm of Saint Anastasius of course! Didn't you know?"

As he touched the bone, stroking it gently, just as the Khazar witch-doctor had stroked his wooden phallus, Hilarion's face

204

filled with happiness and pleasure. He seemed transformed, perhaps imagining himself, through the intercession of the saint, in communion with heaven.

"I didn't know," I said. "But I have seen the relic before." As I spoke, I realised that I could not possibly have seen the bone before. It was a humerus, no longer than mine, but the bones I had seen in Sergiopolis were those of a gigantic warrior.

"Where?" asked Hilarion. I explained how I had been with the Emperor's brother when he investigated the cult of Anastasius, and how the relics had been transferred to Jerusalem and then Constantinople. I did not think it wise to mention the huge size of the original saint.

"That is remarkable!" he said. "You have obviously been sent. And now that we have this relic, we no longer need feel inferior to our rivals in Rome. They claim to have his head, but I doubt it. It is so easy to be mistaken in the matter of bones. But with you as witness, no one can doubt that we have the real thing."

That evening there was a solemn ceremony in the chapel, during which the bone was placed in a gilded casket and installed in a niche by the altar.

I found contentment in the monastery of Saint Anastasius. I had by then lived in several communities, and I found it by far the best. Governed by a practical, though sometimes anxious, Abbot, it was free from the heresy, excess or hypocrisy that had marred the other monasteries I had known. The day began early, and was divided into regular intervals by prayer and work. The work, in my case, was what I enjoyed. I was the teacher from Constantinople, and my knowledge and scholarship were respected. With a village attached to the monastery, none of the monks had to do manual work unless they wanted to. It suited some to potter in the kitchen garden, tend the vines, keep bees, or supervise the villagers in the fields. Sometimes Abbot Hilarion would proclaim a day of agricultural work for all, but it was always something satisfying, like bringing in the harvest, or picking fruit, that reminded us of the

dignity and usefulness of labour without tying us to it. We would go out with sacks, baskets, scythes, ladders, knives, or whatever the job required, and, at a safe distance from the female villagers, work virtuously until our backs ached. Hilarion always supervised in person, rushing about checking everything, and, if necessary, giving practical demonstrations of how things should be done. He was not resented, as his love of the monastery and its inhabitants was obvious.

After such days we would eat a special meal, often including the results of the work, like the honey-sweetened grape-bread we ate after the vintage. All our food was good, though not luxurious, and whenever it was not a fast day we drank a little wine. There was no excess in any of this. Our food was not so good, or bad, that we were distracted by it. Its seasonal variety, emphasised by our part in its production, and by regular, but not too arduous, fasts, reminded us of our place in nature and of God's bounty.

However, aware that bucolic happiness may drive out thought, I tried to spread a taste for scholarship throughout the monastery. I organised the school, first teaching the oblates myself, then recruiting assistants from among the more intelligent brothers. I planned a more advanced curriculum, so that we might attract pupils from all over the region. And I encouraged my fellow monks to borrow books and study them. To ensure that they understood what they read, and were not just trying to accumulate virtue by mumbling as they ran a finger over the words, I started a discussion period after Vespers. I borrowed that idea from Isidore of Seville's *Monastic Rule*, which, unlike most of his other books, is full of good sense. Hilarion often joined those discussions, and, though he was not bookish, he was good at elucidating theological problems with practical examples.

I also resumed my own studies, turning to theology, a subject I had considered from time to time, but not seriously or intensively. My youthful enthusiasm for theological theorems had been discouraged by my teachers, and embarrasses me now. But the question of the Incarnation continued to interest me, though not in the way that it had gripped the zealots of

the East. The monoenergists, monothelites and monophysites disputed the nature of Christ for reasons of State, or to further factional interests. I had heard their arguments often enough. For me, Christology had taken on a personal significance. I had become a monk, if I am honest about it, more to find peace of mind and to give my life a purpose, than out of orthodox enthusiasm. I had convinced myself that I was orthodox, partly because of my admiration for George, but also as a result of my struggle to reconcile the conflicting demands of the body and mind. I was consoled by the orthodox view that Christ is both man and God, motivated by two wills, but I was aware that Christology was only one branch of theology, and that I knew little of the others.

Partly to explore other aspects of theology, and partly to improve my Latin, I began to read Saint Augustine's *City of God*. I am not an admirer of Saint Augustine. In his *Confessions*, he confesses to no crime worse than scrumping, yet boasts, as though of a virtue, of abandoning his mistress and child. His denunciations of lust are so detailed that he seems to savour what he purports to condemn. Yet he is a saint, no one accuses him of hypocrisy, and he is regarded in the West as the greatest of theologians. I found much of the *City of God* tedious. Augustine's laboured attempts to prove the pagan gods false or powerless, or to demonstrate the immorality of the old Romans, belonged to a vanished age. History has either proved his point, or made it irrelevant. But, in the chapters that discussed the nature of God, I found a surprising reliance on what I thought of, despite Basil's opposite view, as pagan philosophy. Both Basil and the magus had alerted me to Christianity's debt to the ancient philosophers, but I had imagined it to be small, or restricted to details. In the *City of God* I discovered a deep and persistent dependence on the philosophy of Plato, whom Saint Augustine seemed to think almost a proto-christian. I read other theologians, and found that many of them also relied on Plato, both for ideas and for the words with which to express them, just as a host with no cook will entertain his guests with dishes bought ready-made from a baker or cook-shop.

I remembered what the magus had said about Dionysius the Areopagite, one of the earliest Christians and a Platonist. He was an Athenian who, after being converted by Saint Paul, was keen to reconcile his new faith with the philosophy of his ancestors. I read some of Dionysius's works, and commentaries on them, and was surprised to find that some scholars regarded them as forgeries, perhaps only a century old. I studied the Dionysiac books carefully, and concluded that both the arguments put forward and the style in which they were expressed belonged to the time in which Dionysius lived. I also found his description of man's ascent through love to union with God, though perhaps a little mystical, more inspiring than the petty quibbling of some other theologians. I wrote a short book, asserting the genuineness of Dionysius's writings, and refuting the arguments of those who thought them forgeries. I was unable to take it with me when I left the monastery, and considering what happened later, it is unlikely that my manuscript has survived. Even so, writing that book gave me great satisfaction.

I was reading in the shade of the colonnade, when a dark, dusty young man crossed the courtyard. His face was shaded by a broad-brimmed straw hat, such as peasants wear while working in the fields. He walked towards me, and took off the hat, which he held, rolling the brim in both hands. He wore the round tonsure of a Latin monk, and his clean-shaven face was as brown as a chestnut, and as smooth.

"Theodore?" he said.

"Yes."

"I am Hadrian."

"Hadrian?"

"I wrote to you. You replied."

There was something odd about his manner. He stood diffidently, but spoke abruptly, almost rudely. He looked at me directly, with eyes as black as olives. I found myself staring back, trying to remember what he had written to me about, distracted by his dark beauty. He was, as the Song of Solomon

says, black and comely, but not, I thought, because the sun had looked upon him.

"Where are you from?" I asked. His darkness seemed to need an explanation.

"Niridano. A few miles from here. I explained in my letter."

"But where were you born?"

"Africa," he snapped.

"But where?"

"Near Carthage."

"Like Saint Augustine."

"Yes. But unlike him I would like to learn Greek."

"Do you know any Greek."

"I have made a start."

I tested him, and found that, despite his manner, he was being modest.

"Will you teach me?" he asked.

I had asked Basil that question when I was perhaps a few years younger than Hadrian. He had replied, "No, but you will learn." That answer was typical of Basil, who affected to be much less interested in other people than he really was. While I thought I was aimlessly browsing through Basil's library, he was gently guiding me towards the subjects he thought important. His secret was detachment, which enabled him to encourage without hope or disappointment. As I looked into Hadrian's dark eyes, I did not feel at all detached, but was uneasily reminded of unresolved desires. He had the same combination of beauty and certainty that had proved so troublesome in Nicholas. Yet I knew that he was not like Nicholas. He was clearly intelligent, and I thought I saw in him a hint of Basil's scholarly scepticism. Hadrian reminded me of things I had long renounced. I studied his face, trying to guess what it revealed of his inner self, his true nature. What combination of humours, what chance events and circumstances, had created the person who stood before me? I longed to know him, yet I knew that it would probably not be a good idea to accept him as a pupil.

"Well?" he asked.

"Yes," I said.

He spent most of that summer at the monastery, though he was obliged to return to Niridano occasionally. We worked in the library, which was cool, and within earshot of the classrooms where my assistants taught. I broke off my own studies to teach him, though he learned so quickly, as we progressed from grammar to literature, and conversed about what we read, that my teaching became a continuation of my studies.

"You are learning Greek very quickly, for a native Latin speaker," I said, soon after we began our lessons.

"I am not a native Latin speaker," he said. "My first language was Punic. I only learned Latin at school."

"In that case, you must have a natural aptitude for languages."

"Perhaps," he said, apparently taking no pleasure in my praise. "We have good schools in Africa. We have not been so afflicted by disaster as the rest of the Empire."

"Yet you came to Italy."

"I had learned what I could there. And the Moslems are advancing. They have captured Egypt and Libya. It will not be long before they reach Carthage. Then Africa will be ruined, like the East."

"I saw the loss of the East."

"Then you know what I fear."

Nothing in his manner suggested fear, yet, like many others, he had fled the turmoil of the outside world for the peace and order of a monastery.

"Why did you become a monk?" I asked.

"Civilisation will survive in the monasteries."

"Nowhere else?"

"You have seen more of the world than I have. What do you think?"

"Civilisation will survive in Constantinople, I think."

"Yet you left the capital and came here."

"True. Perhaps it depends on what you mean by civilisation. In Constantinople they eat fancy food from silver dishes. They dress in silk and have perfect manners. They quote

Homer, and before Constans stopped them, they debated theology. But they don't read much, and they are forgetting what everyone once knew."

"Civilisation is not silk and silver," Hadrian said. "It is books and ideas. Those things will only survive in monasteries. That is why we are here."

I did not disagree. Though much younger than me, Hadrian seemed to have thought about his life far more carefully than I ever had. I saw in him an echo of my own youthful self, but his more formal education, as well as his character, had given him something I lacked. He had a sense of purpose that enabled him to pursue his studies without distraction, and might almost have been described as ruthless, if his object was not so worthy.

By the autumn, his Greek was so fluent that he was able to join the discussions after Vespers. I was proud, and also a little envious, of the ease with which he mastered Greek theological terms, and deployed them in subtle arguments. But I was aware, sadly, that his proficiency was a sign that our lessons would soon have to stop. He had been sent to learn the language, and had learned it well. It was unlikely that his abbot would allow him to remain with me much longer. The prospect of his departure made me realise just how much I admired him, but my admiration was tinged with desire, and I was troubled by lustful thoughts. I remembered Kurt, whom I had imagined to be my Platonic other half, and Michael, about whom I had no such illusion, but who had given me what Kurt withheld. Neither of them shared, or was capable of sharing, my scholarly tastes, though Michael had imagined that he might. I had come to believe that, though one should embrace, rather than reject, the world, the life of the mind was incompatible with that of the senses. Hadrian, being both beautiful and intelligent, had undermined that belief. Despite my vows, I desired him more than I had desired anything or anyone before.

There was no copy of Plato's *Symposium* in the monastery library, but I remembered its arguments. Despite being the source of much Christian thought, Plato seemed to think

human love, and its physical expression, a way to find God. And Socrates had thought it an honour for a youth to be loved by an older man, who would teach him virtue, and implant in him the seed of wisdom. Hadrian was already my pupil, but monastic rules do not encourage individual friendships, and forbid absolutely the love that Plato and Socrates thought the noblest of all.

I meditated on the reasons for celibacy, but resolved, as soon as possible, to obtain a copy of the *Symposium*.

To re-read the books that influenced one's youth can be disappointing. Often, returning to a book after many years, one finds that much of what seemed so important is no longer there. It is not that the book has changed, though with standards being what they are in some scriptoria, that is not impossible. It is rather that young readers are keen to make sense of the world, and like to equip themselves with ideas, which they choose, much as the rich young men of Constantinople choose their clothes, to augment their own opinion of themselves. Searching for ideas that meet a particular need, they often miss a writer's real meaning. Many who imagine that they have understood a book, actually understand an imaginary version of it, largely of their own devising. Nicholas, with whom I went to Cappadocia, was an example of that. He read saint's lives rather as an aspiring general might read military manuals, searching for tactics that might bring a quick victory, but ignoring the dull chapters on logistics. I had been inspired to become a monk after reading the *Spiritual Pastures*, which seemed, in the confused conditions in which I read it, to be an account of the reflective, scholarly aspects of monasticism. Some years later, when I was obliged to copy the book, I could hardly believe that I had been influenced by such sentimentality. But it was not like that with the *Symposium*, which was everything I remembered, and more.

Hadrian brought me the book, which his abbot had borrowed for him from a monastery in Syracuse. He showed it to me when he returned from one of his visits to Niridano, but we were not able to study it until later, when we had finished

the day's work, and had attended the evening discussion period. I was eager to begin reading it, but one of the keener young monks, encouraged by Hilarion, prolonged the debate with more than usually persistent questions about the Incarnation. Hadrian shamed me by patiently explaining what I declined to discuss.

Eventually, we got away and went to my cell. As an officer of the monastery, I did not have to share the dormitory, but my cell, when I was not sleeping in it, was intended for work or contemplation, not for receiving guests.

"You were very short with him," said Hadrian.

"Was I?"

"Yes. You gave the impression that the Incarnation is not worth discussing."

"The orthodox position is quite simple."

"Not for everyone. Some cannot understand its subtleties."

"Like the monophysites?"

"He is not a monophysite, just puzzled."

"Perhaps you are right. I should be more patient. But I wanted to read the *Symposium*."

He pulled the book from his leather bag, and gave it to me. It was small, without decoration, and written on limp, worn papyrus in faded brown ink. I looked at its pages, hoping, as I had when young, that they might reveal something significant. I had been puzzled then by Plato's method. As Saint Augustine observed, Plato disguised his opinions by attributing them to the characters who appear in his dialogues. The *Symposium* begins with Apollodorus telling a story about Socrates attending a banquet at Agathon's house in Athens, which happened some years before, and which he heard from someone else. The teller is so far from the story that we know we cannot rely on him, yet he seems convincing. Apollodorus describes how, after the feast, seven of the guests deliver speeches on aspects of love. Each speaker has a different point of view, and a distinctive style. Socrates disagrees with much of what the other speakers say, and complicates matters further by attributing all his knowledge to Diotima, a wise woman he once knew. It is difficult to know what Socrates really

213

believed, and in other dialogues Plato ascribes to him beliefs that seem to contradict what he says in the *Symposium*.

I offered the book to Hadrian.

"Will you read, or shall I?"

"I should really go to the dormitory," he said, without sounding as though he wanted to.

"Stay and read to me," I said, grasping his arm.

"If you are sure . . ."

Hadrian sat on a stool, and, by the dim lamplight, prepared to read.

I lay on my thin straw mattress, stretching out like a symposiast on a couch, closed my eyes, and listened to Hadrian. The ability to read aloud well is as rare as the ability to read silently. Hadrian could do both. Though his Greek was newly acquired, he read fluently, reflecting the style and character of each of the guests at Agathon's banquet. After the prologue, the first of the speakers is Phaedrus. Hadrian gave his simple words on the divine origins and moral power of love the sincerity they deserved. His conclusion, on Achilles and Patroclus, reminded me of my youthful dreams of martial friendship and heroism. Pausanius, the next speaker, develops Phaedrus's moral theme, distinguishing between noble and ignoble love, claiming that, while love can lead to folly, love between a man and a youth leads to virtue. Hadrian read the speech almost without characterisation, sounding much like himself.

He made Eryximachus, a doctor, sound precise, almost pedantic, as he expounded his medical theories, explaining love in terms of the humours, which, like music, should ideally be in harmony. I was reminded of Basil, though he had not been particularly interested in either love or music. I had not thought that odd at the time, but I wondered then whether there was more than philosophy and fundamentalism behind his flight from Constantinople. Then I realised that Hadrian's rather pompous style was intended as a parody of me. I tried not to react, but lay still, wondering what he meant by it. In comparing me to Eryximachus, was he implying that I was too rational? Or that love was best not anatomised? Perhaps he

just wanted me to know that he had studied my character. Whatever he intended, his facility suggested that he had studied the book thoroughly before showing it to me, and that his performance was premeditated.

He then began Aristophanes' story of the origins of gender and desire, abandoning mock pedantry, and assuming the sprightly manner of a teller of comic tales. But, despite his attempt at characterisation, the story did not seem at all comic to me. My right hand was resting on the cool stone of the cell's floor, but for a moment it might have been touching the hard rock of an Armenian hill-top, as I saw again a monstrous vision of primeval double men, whirling and tumbling, then split as a punishment by the gods. I opened my eyes and sat up.

"Shall I stop?" said Hadrian, resuming his normal manner.

"No, go on. I was just remembering something."

"Do you want to tell me what it was?"

"Later, perhaps," I said, lying down again. The day had been mild but the night air, blowing through the high, narrow window, brought a damp, autumnal chill.

He continued, but though he read well, my attention wandered for a while, and I thought of Kurt, rather than the old gods that were the subject of Agathon's rather empty and rhetorical speech. I listened again when Hadrian mentioned Socrates, to whom Plato often attributes his most important ideas. Socrates, or Diotima, tells us that animals are motivated by a desire to reproduce, that they will struggle, and even give up their lives to make sure that their offspring survive. Most people do the same, and achieve a sort of immortality through their children. But some men, he says, are more creative in their souls than in their bodies. They are drawn to poetry or philosophy, and seek immortality in ideas, or to war or politics, and find immortality in fame. But the noblest of men seek immortality through knowledge of eternal beauty, which grows from the appreciation of individual beauty. Those who seek such knowledge will best find it through the love of an older, wiser man, who will teach the younger, and be inspired by his beauty. This speech, like some of the others, had been censored in the text I had read in Basil's library.

Hadrian stopped, and cleared his throat. Nothing in his expression showed what he thought of what he had been reading.

"Shall we stop?" I asked.

"No, but would you read the rest? I am hoarse."

"Do you not think it too pagan?"

"Not at all," he said. "What could be more Christian than seeking God through love?"

"Nothing. If what Plato called Good or Beauty is what we mean by God."

"Saint Augustine seemed to think so."

I started to read, knowing very well what came next. Plato ended the *Symposium* with the arrival of the drunken and dissolute Alcibiades, who, after praising Socrates, describes his attempts to win his love and share his wisdom. Because of the rhetorical style of the earlier speakers, it is possible to imagine that the love they describe is spiritual or brotherly. But Alcibiades' story of drinking, wrestling and shared beds makes everything clear.

When I finished reading I looked up at Hadrian. He seemed unshocked, but I still could not tell what he was thinking. I was filled with sadness at the thought that, having found him, he would soon be gone. Anything I might have said to him seemed to have been anticipated by Plato.

"What were you remembering earlier?" he asked, after a thoughtful silence.

I decided to trust him, and told the story of my desire for Kurt, the phallus-ceremony, the vision, and my embarrassment in the river. The cell was chilly, and when I finished I sat shivering, as cold as I had been when I saw the vision on the hill-top. Hadrian slid from the stool and crawled onto my mattress.

"Socrates, are you asleep?" he said, quoting Alcibiades' account of attempted seduction.

Unlike Socrates, I did not resist. Silently, or as quietly as my straw mattress would permit, we undressed and lay together, our chests heaving as we breathed in unison. At first, I was overwhelmed by his proximity. He was young,

and his flesh was firm and smooth. I had not touched a man for years, and had found comfort in my vow of chastity, thinking that I would never have to face temptation again. I remembered the Cappadocian sect I had visited as a youth, and how puzzled I had been by their struggle against lust. But I felt the power of lust that night, and could not resist. It tugged at me like a river, sucking me in, threatening to carry me away. It washed away my doubts, flooding me with warm hope, making me forget that we had both renounced fleshly pleasures. The ghosts of ancient symposiasts seemed to hover above us, urging us on, telling us that what we wanted was not wrong.

Despite the lateness of the hour, we did not rush. We moved slowly, stalking pleasure like stealthy huntsmen. We knew what we wanted. Michael had taught me how to satisfy my natural inclinations. Hadrian, too, seemed experienced. But he was gentler than Michael, and not so concerned with his own pleasure. Yet he was not passive, as Pausanius prescribes. He gave me no reason to reproach myself, as Michael had reproached me, with selfishness.

In the morning Hadrian returned to Niridano, leaving me confused. I attended to my duties, but absent-mindedly, distracted by thoughts of what had happened the night before. I was happy, having found, and consummated, the friendship I had long sought. Yet I knew that I had broken a vow, and by doing so had risked my equilibrium. Surely, those who give in to pleasure are changed by it?

Later that day, Hilarion summoned me to his room.

"I understand that Hadrian spent the night in your cell," he said.

"Yes, Father."

"What were you doing there?"

"Studying, Father."

"Studying what?"

"A book by Plato."

"Plato? You have told us about him. Wasn't he a philosopher?

"Yes, Father, a very great one, approved by Saint Augustine."

"I suppose that's all right. Study is a good thing. But you should not spend all night at it, and it would be better not to invite Hadrian into your cell again. Perhaps next time you might include some of the other monks in your studies. I am sure they would benefit."

Next time Hadrian visited the monastery, I told him about Hilarion's warning, and about my qualms at having broken the vow of celibacy. Hadrian showed no signs of remorse.

"Are you a good person?" he asked.

"I don't know. Probably not."

"Of course you are."

"I don't think I can be."

"I know that I am a good person," he said. "I know that I am good, and that my thoughts and desires are good. God made us what we are. He gave us appetites, and the means to satisfy them. If we ignore hunger or thirst, we die. He cannot have intended us to deny our desires. I think that what I want to do cannot be bad."

"But what if your thoughts and desires are not good. Suppose you felt like killing someone. Would that be good if you desired it?"

"It is not in my nature. I would not have such thoughts."

"And those who do?"

"Are not good people."

"But our vows. We have broken them, and that must be wrong."

"I don't think I have broken a vow."

"Did you not promise celibacy?"

"Of course. And I promised poverty, but I did not expect to starve or go naked."

"Some have."

"Madmen in the desert. They must have spent all their time thinking about food or sex."

"But they were celibate."

"In their bodies, perhaps. But their minds were filled with

lustful thoughts and demonic visions. How can anyone hope to find God in that condition?"

"Some did. They came out of the desert having fought the demons and won. They achieved sainthood."

"They fought, but they weakened their minds in the process. Their victory was Pyrrhic. Have you seen Rome?"

"No."

"You should, it's an instructive sight. Rome was so precious that it had to be defended at all costs. Each time it was lost to the barbarians it had to be recaptured, whatever the cost. The result was that the city was ruined. There is so little left that even the Lombards don't seem to want it, though they could take it easily. The mind of an ascetic is like that, turned into a wasteland by the struggle against temptation."

"But we have lost our battle."

"We have made a tactical retreat, to avoid a destructive struggle."

"Perhaps you are right."

"Remember what Socrates said: 'he who knows what is right will do right.'"

As I feared, soon after bringing me the *Symposium*, Hadrian was told by his abbot that he should return to Niridano permanently. Neither of us wanted that, and we tried to think of justifications for extending his visits.

"I could teach you philosophy," I suggested.

"I doubt that my abbot would agree. I can just as well study philosophy at Niridano, especially now that you have improved my Greek."

"Theology?"

"No. The same objection applies. And Greek theology is rather suspect until the Empire is officially orthodox."

"You can't think me a heretic?"

"I am just anticipating what my abbot will say."

"Why did he want you to learn Greek?"

"So I could teach it."

"That's the answer! You must teach here."

"What?"

"Latin, of course."

"It is possible, but you will have to get Hilarion to write to my abbot."

I went to Hilarion and tried to persuade him that we needed Hadrian to help teach Latin.

"I don't know," he said, rubbing the top of his head anxiously. "Can't you teach Latin yourself?"

"I could, but Hadrian would do it better."

"Do we really need Latin? We do everything in Greek here."

"Of course we do! With respect, Father, we are in Italy, and surrounded by Latin speakers. Even the Lombards speak Latin, when it suits them." I hoped that mentioning the Lombards would divert his anxiety, but he only thought for a moment before replying.

"But do we really need Hadrian? If he goes back to Niridano you will have more time, and you may be able to concentrate on some of your other duties." That was a rebuke, but not an unkind one. I persisted.

"It is not just the Latin, Father. You have seen what he is like in our discussions. I have tried to encourage scholarship among the younger monks, and have succeeded to some extent, but I can't claim to have inspired them. Hadrian has. He is so enthusiastic that the others all want to share his knowledge. He is a natural teacher."

"Perhaps you are right. The discussions have certainly improved. I have trouble understanding them sometimes."

"Will you write to the Abbot of Niridano?"

"You prepare the letter. I will sign it."

It took more than one letter to convince the Abbot of Niridano, but eventually, about a year after we first met, Hadrian was given permission to visit us regularly. He was an excellent teacher. Despite his own linguistic ability, he understood that some had to be brought to a new language slowly, and was never impatient with his pupils. And he was able to encourage debate and stimulate scholarship far more effectively than I could. Depending on the occurrence of feasts, fasts and holy days, he came to us two or three times a month, usually staying

overnight. He always brought with him a book or an idea that would provoke discussion. I found happiness with Hadrian, and in the work we shared, and always regretted his regular departures for Niridano.

When my duties permitted, I went with him, leaving the toiling monks and villagers behind, crossing the empty land that separated the two monasteries. Hilarion thought that land dangerous, imagining brigands or Lombards behind every bush. But we were too absorbed in each other to see any danger. We talked and debated, planning the work we would do, imagining a revival of Greek culture among the refugees of southern Italy, hardly noticing the abandoned fields and orchards we walked through, or the ruined houses that stood among them.

Halfway to his monastery was a grove of cypress trees where we would stop and rest. If Hadrian had brought food, we ate it. Otherwise we sat in the shade, talking of trivialities, postponing the moment of our parting. Sometimes, when the trickle of talk dried up, we obeyed the silent prompting of our bodily needs. Then, away from eavesdropping monks and the censure of abbots, surrounded by the lawless emptiness of the countryside, our love expressed itself in physical form. We felt like beings from the pagan past, when nymphs, fauns and satyrs took their pleasures in a timeless Arcadia, untroubled by yet-to-be-revealed morality. We often lingered for hours at that neutral place, unobserved and unaccountable. But we always parted, and Hadrian went back to share the knowledge I had helped him acquire with the Latin monks of Niridano.

Hadrian was, and is, I think, my Platonic other half. The men I desired before him were unlike me. They offered me something other than a reflection of myself. Had my desire been reciprocated, it would still have been imperfect, and not love. But Hadrian, though unlike me in body, was like me in spirit. He might have been a younger brother, sharing my interest in things other men were forgetting. Yet there was an aspect of Hadrian's character that troubled me. He had a way of withdrawing into himself, like a lamp whose wick has dipped into the oil, dimming or extinguishing its flame. He

would contemplate, considering a problem, searching for a solution. He would be there, and yet not there, seemingly oblivious to the needs, or even existence, of others. During those silences I sensed disapproval, and dared not interrupt him. But it did not usually last long: the flame of his old self flared up again, and he would awake from his reverie, ready to share his thoughts with me or his pupils.

Hadrian was a young man, and I was his teacher. I knew well enough that my knowledge was exhaustible, and that the time would come when I could teach him no more. I wondered what would happen then. Would he move on and seek another teacher? When he was older and wiser, would some young monk look up to him, and become his friend and admirer, replacing me? Perhaps, despite the dangers he saw there, he would return to Africa, taking his knowledge with him. Whatever happened, I feared that I would lose him, and I would have to return to scholarly solitude.

Was I right to love Hadrian? If Plato is right, we sought eternal beauty through the noblest form of love. Despite much study of Plato and his theories of love, I cannot say for certain that love for another man is consistent with the universal and unconditional love preached by Our Lord. Perhaps it is not. If so, I cannot believe it is any worse than the love of a man for his wife, which the Church approves and celebrates. Brotherly love is a good thing, for, as Saint John pointed out, if we cannot love our brother men, how can we love God? It is true that in pursuing our friendship we have broken at least one of our vows, but it has given us the strength to do the Church's work. However, many years, and a period of estrangement, were to pass before I knew where friendship with Hadrian would lead me, and what our work would be.

It was autumn. Most of the grapes were picked and pressed, and the villagers were already preparing the rustic feast that would mark the end of the harvest and of their labours. Hilarion was wise enough to overlook any pagan elements in the villagers' festivities, knowing that we monks would give thanks for the harvest more decorously. I was out in the after-

noon sun with some of the other monks, who were gathering the last of the grapes. Others collected our brimming baskets and carried them up the hill to the monastery, where the grapes would be tipped into tubs and trampled by barefoot novices. Even then, I was too old to be sent up a ladder to cut ripe bunches with a hooked knife. Instead, I stood in the shade of a vine-tangled tree, sorting what others had picked, rejecting leaves and mouldy grapes, enjoying the gentle bustle around me, and the golden light glinting through green leaves, and the sharp scent of sap and grape juice.

While we worked, thinking of the meal we would later enjoy, a group of six men rode up, circled us and dismounted. Their long, straw-coloured hair, sun-reddened faces and wide, striped trousers, showed that they were Lombards. As they walked towards us they talked loudly in a rough, Germanic dialect. One of them, his long moustaches plaited, spoke to us in Latin:

"Who is the chief eunuch?"

The other Lombards laughed loudly. No one replied, until I realised that I was the only Latin speaker among the group of monks.

"There are no eunuchs here," I said.

"No eunuchs? Do you call yourselves men, then?" He turned to the other Lombards and translated, just in case they had missed the joke. They laughed loudly, bellowing like cattle. He turned to a young novice who was carrying a basket of grapes and addressed him:

"Are you not going to offer us some of those grapes? Among my people no real man would refuse a guest anything."

The novice looked uncertain, so I told him, in Greek, to offer them some grapes. The spokesman took a bunch, and crammed it into his mouth, but immediately spat the grapes into the novice's face.

"They are sour! You have offered a guest sour fruit!"

The novice had jumped back, dropping the basket, and I could tell from his expression that he was likely to do something stupid.

"Turn the other cheek," I said, gripping his arm. "And remember they are armed. If you haven't seen what a sword can do, I have, and I don't recommend annoying them."

"Take us to the chief eunuch," said the Lombard spokesman. There was something disturbing about his wide mouth, and the lock of fair hair that flopped over his blue eyes.

"I will take you to the Abbot," I said, wondering whether it was a good idea. I started to lead them towards the monastery gates, but Hilarion had been warned, and met us half-way down the sloping path. I looked back, down the hill, and saw that the villagers, who had also been grape-picking, had disappeared. Hilarion was trying to look calm, and asked me to ask the Lombards how he could help them.

"You could offer us some good food," said the moustachioed man. "Nothing sour or stale. And some wine. But only the best. No man would offer anything but the best."

Wine meant trouble, but we had trouble anyway. Hilarion gave orders for a trestle table to be set under a tree, and for food and wine to be brought. If we had to entertain the Lombards, it would be best not to let them into the monastery. Soon they were eating our bread and cheese, with more of the grapes, which they no longer found sour. They demanded meat, so a party was sent to the village to bring whatever had been prepared for the harvest feast. While we waited, the Lombards started on the wine.

"This is no good!" The moustachioed Lombard threw his cup on the ground. The others copied him.

"But it is our best wine," said the Abbot. "Tell them it's last year's, kept in jars to mature."

"Last year's!" said the Lombard, when I had translated. He turned to the others. They looked puzzled or angry, but only as children do when they are pretending. "Bring us this year's wine. We don't want your old wine!"

"But this year's wine is not ready. The first pickings have only just been pressed," I said.

"Bring us the new wine!" They began to look genuinely angry, and Hilarion sent for a jug of the new wine. It was foaming and full of floating stems and skins. It did not look at

all drinkable, but they swigged it down with pleasure, passing the jug between them.

"Bring us more! And bring us meat!"

For the next few hours we acted as servants to the drunken Lombards. The sun set, and lamps were brought, while they ate, drank, sang, made more demands, and tried to rouse us to anger. The young novice who had been spat at was keen to be revenged.

"Father," he muttered to Hilarion, "I've been thinking, and some of the others agree. If we could take their weapons . . ."

"Take their weapons!" Hilarion said, too loudly. "How will you manage that?"

"When they are drunk. They will fall asleep eventually. We could do it then."

"And then what?"

"Well, we could . . ."

"Kill them? Is that what you mean? You are a fool! Quite apart from our vows, what do you think would happen? Do you think the Duke of Benevento would allow us to kill his men without protest? Or do you propose to take the captured weapons and lead an expedition to his castle, and kill him too."

"I am sorry Father, I did not think." I could not see the young man's face clearly, but his hunched posture looked suitably contrite.

"Obviously!" said Hilarion. "We should not provoke them, or be provoked by them. If we give them what they want, with any luck they will go away and not bother us again. And, you, young man, had better go to the kitchens, where you can do no harm."

The novice slunk away into the darkness.

Late that night, when they had run out of insults, could think of no more unreasonable demands, and were thoroughly drunk, they fell asleep, slumped over the table or collapsed on the ground. No one touched their weapons. We crept away and, aware that we could do nothing to protect the villagers, barred the monastery gates. But even that was a provocation. The next morning, ashamed of our impotence,

we hid inside while they banged on the gates, cursed us in both Latin and Lombard, promised revenge, and, frustrated, rode away. Later, when we dared open the gates, we found several of the villagers dead, with their throats cut. Most of the others returned later in the day, when they were sure the Lombards had really gone, but a few of the younger women were never seen again.

15

ROME

A.D. 655–667

When Hadrian returned from Rome, where he had been
buying books for his abbot, he listened, without surprise, to
my account of the Lombards' visit.

"That's what we can expect from barbarians and heretics,"
he said.

He was much more interested in the new Pope, Eugenius,
who was being pressed by the Emperor to adopt monothe-
letism, and by the people of Rome to defend orthodoxy. His
predecessor, Martin, who had condemned the Emperor's
theological policy, had been arrested, and was awaiting trial in
Constantinople. Constans was becoming more fanatical.
Other leading supporters of orthodoxy had been mutilated,
tortured and exiled. Disappointingly, but understandably,
Eugenius had made no public theological statement since his
election.

"What are they saying about him," I asked.

"Not much. They are all talking about Gregory the Great,"
said Hadrian.

"Why him?"

"He was a Roman. And was chosen by the Romans."

"Like Eugenius."

"True, but unlike him, Pope Gregory actually did some-
thing. He stood up to the Emperor's men, and did a deal with
the Lombards. He protected Rome when it was abandoned
by the Empire."

"But that was over fifty years ago."

"He is the last successful Pope anyone can remember. And
he almost made the Church independent of the Empire."

"Well, if he did, the Empire has made it subservient again."

"That's what the Romans are saying. I think all their talk of

Gregory is meant to provoke Eugenius into doing something."

"But what?"

"Defying the Emperor, I suppose."

Some of what Hadrian said was, perhaps, exaggerated, but it reinforced what I was already thinking. Until the Lombards' visit, I had not shared Hilarion's anxieties about them, but considered the Empire's abandonment of orthodoxy a greater threat. Now I knew that both were equally dangerous. Just as in Gregory's time, we needed a strong Papacy to deal with the double threat to the Church. None of the recent Popes, however well meaning, had been strong enough to defend orthodoxy against the Emperor's theological meddling. But how could the Papacy be made strong?

Pope Gregory had favoured a sort of Christian Republic, and, as the power of the Empire waned, he tried to extend the power of the Church, by spreading orthodoxy to the Germans who had conquered the West. He believed the Church to be the rightful successor to the universal Empire that had ended with the fall of Rome, and his dealings with the Lombards were a sign that he aimed for secular as well as spiritual authority. He had been inspired by Saint Augustine's *City of God*, and in order to try to reconstruct his ideas, I resumed my reading of that book. I read alone, in the cell I had sometimes shared with Hadrian.

I found little in Augustine's long-winded disquisition on God, philosophy, the Empire, and our ultimate end, that supported Gregory's supposed views. At best Augustine seemed in favour of rendering unto Caesar what is Caesar's, in the hope that Caesar might not be too much of a tyrant. History does not support that hope. Since Augustine's time the Empire has been ruled by many tyrants, some of whom were also fools or heretics, and only a few emperors who were both able and orthodox.

I spent much time thinking about the problem of Church and State. As well as the *City of God,* I read Plato's, and Cicero's, *Republic*, and their *Laws*, but found little that was pertinent. I tried to discuss my reading with Hadrian, but he did not

share my enthusiasm, and was spending more time at Niridano, where his abbot had put him in charge of the monastery's school. I was left to consider the subject on my own. With hindsight, I can see that I became so interested in political theory precisely because my friendship with Hadrian appeared to be cooling. He was becoming a scholar and teacher in his own right, no longer my pupil. I missed him, and, like a lovesick youth, turned to philosophy for consolation. I did not misunderstand what I read, as such youths often do, but, in the gaps between ancient theory and present reality, I began to construct my own ideas. Eventually, my head full of theories that I could not share with Hadrian, I wrote to Pope Eugenius, offering justifications for papal independence. I argued that the old idea that the Emperor is God's representative on Earth was thoroughly discredited. I noted that there were now, perhaps, more Christians outside the Empire than in it. I quoted the authorities I had studied, though selectively. I ended my letter by describing, rather incoherently, I fear, a world in which the Papacy would become the guardian of knowledge, wisdom and civilisation, and in which kings and emperors would apply to the pope for their titles as well as theological guidance.

Almost a year after I wrote to the Pope, I received a reply. I had not seen Hadrian for several weeks, as he had gone to Rome again, to buy books for his school. Few libraries had survived the depredations of the city's many conquerors, but booksellers, disposing of the contents of looted villas and monasteries throughout the country, had settled where the Church would provide them with a good market. If a book could not be found in Rome, a dealer could usually locate it elsewhere, and arrange to have it copied. If an ancient text was lost, it was not unknown for unscrupulous scribes to reinvent it from surviving scraps, quotations and their own imaginings. Scholarship is so far declined in the West that there are many ignorant enough to buy such forgeries, and display them proudly in their meagre libraries. There is also a market in hagiographies, which can be discovered or written to order.

The materials of almost any life can be reordered, interpolated with standard miracles, and presented as the life of a saint.

When Hadrian returned, he brought with him a letter from Pope Eugenius, summoning me to see him in Rome. I was surprised. My letter had seemed foolish as soon as I had sent it, and I hardly expected it to reach Eugenius, still less to receive an answer. I wondered whether I was to receive a Papal rebuke for my folly, or be asked to expound my ideas. I showed the letter to Abbot Hilarion, who was not pleased.

"What made you write such a letter? Don't you realise how dangerous our position is? We are an outpost of the Empire, but a very precarious one. If the Duke of Naples, or the Governor in Ravenna, were to hear that a member of this community was advocating Papal independence, our position could be very difficult."

"I am sorry, Father. I was carried away by Saint Augustine's ideas. I did not think of the consequences."

"And think of the Lombards. What would they do if they thought us disloyal to the Empire?"

"I am sorry Father. What should I do?"

"I think you had better go. You can hardly ignore a Papal summons. But whatever you do, don't encourage his Holiness with any more of this nonsense."

"No, Father."

"If, rather than giving the reprimand you deserve, he asks your opinions, make sure he knows how loyal we are, and how close, and dangerous, the Lombards are."

For the third time in my life, I was sent on my way by an abbot, and there was a suggestion in Hilarion's manner that he would be happy if I did not return. As before, I was given a little money, some food, and the names of some places where I might stay, on the journey, and in Rome. As well as leaving the monastery of Saint Anastasius, I was also leaving Hadrian. We had, by then, known each other for six years, and I had found in him everything that I had ever hoped for. But he was becoming increasingly independent, and did not seem disturbed by the prospect of life without me.

"I don't think you will be back," he said.

"Hilarion does seem angry."

"Yes, but quite apart from that, his Holiness would not summon you, an obscure monk, to receive a reprimand. He would instruct Hilarion to administer that. Hilarion knows that very well, and that's why he is so worried. The Pope wants to hear more of your ideas."

"But Hilarion has instructed me not to encourage him."

"If the Pope asks you for advice, you can hardly refuse it."

"And if I give it, I can hardly come back here."

"No, I don't think you can."

"Will I see you again?"

"Of course. I am sure to need more books, and I will soon be in Rome again. Write to me and tell me where you are staying."

As I trudged to Rome, I felt like one of Aristophanes' primeval men, ripped as a punishment from his Platonic other half for rebelling against the gods. I had not rebelled against Hilarion, but I had failed to follow his instructions. I had been led, by my weakness, and by Hadrian's plausible justifications, into gratifying desires that I had supposedly abjured. Hilarion had warned me against the danger, though without defining it, but I had ignored him. Even though it was not for that that I was leaving the monastery, the letter that provoked the Papal summons was an indirect result of my folly with Hadrian. Yet I still desired him.

Hadrian, possibly for rhetorical effect, had exaggerated the condition of Rome. It had certainly been conquered many times, and was no longer the great city it had been, but it was not completely destroyed. Perhaps four fifths of the area within its walls was uninhabited, and much of its vacant land was strewn with the debris of collapsed or demolished buildings. But, clustered around the old centre, and scattered randomly elsewhere, were the great buildings of antiquity, many of them almost intact. I recognised the Baths of Caracalla, the Colosseum and the Circus Maximus. Monks, knowing that pilgrims were the city's main source of income had taken possession of most of the ancient monuments and swarmed over them like

ants. As I walked towards the Capitol, I was constantly pestered by the guardians of these sites, who shouted the wonders that could be seen by those prepared to pay the entrance fee. I fended them off with my faltering Latin, and managed to get directions to the Lateran Palace.

The Palace guards were huge, handsome men, who looked splendid in their embroidered tunics. They carried richly decorated shields, and wore ornate swords hung from their broad shoulders on leather baldricks. But they were intent on the ceremonial aspects of guarding, would not speak, and would not even acknowledge the letter I waved at them, despite the Papal seal. Some other visitors, who seemed to be there to admire the guards as much as the Pope's Palace, started to stare at me. I realised then that the main entrance might be a little too grand for me, and that there might be some side entrance through which non-ceremonial visitors were admitted. I explored the other approaches to the Palace, getting lost in side-streets, and tripping over piles of rubbish. Eventually I found a sleepy door-keeper who, after seeing the seal on my letter, sent me to a room full of clerks. I explained to one of them that I had been summoned by the Pope.

"What for?" the clerk asked.

"I am not sure."

"You must have some idea."

"I think his Holiness wants to ask my advice."

The clerk looked at me, my simple clothes stained and dusty from the journey, with obvious disbelief.

"What makes you think that?"

"This letter." He took it, and read it, and had to agree that it did appear that his Holiness wanted to see me, though his reasons were not made clear. He asked my name, and wrote it down.

"We'll let you know," he said.

"When?"

"When his Holiness is ready to see you."

I suppose I had imagined that I would be conducted into the Pope's presence, if not straight away, then fairly quickly. But it seemed that my name was to be added to a list, pro-

cessed by clerks, and brought to the Pope's attention when they felt like it. There was no knowing how long that would take. I needed to find somewhere to stay, so I made my way to the area near the Palatine Hill, where I had been told that the Greek churches and monasteries were. I found a pilgrim's hostel where, for the first few weeks, I stayed.

I presented myself as an ordinary pilgrim. There was no point in drawing attention to myself by mentioning my Papal summons. I joined the hostel's other guests in wandering the city and seeing its sights, both ancient and modern. We saw pagan temples, ruined, or disguised as churches. There were mausoleums, baths, columns, triumphal arches, theatres, and, encrusted with shops and houses like swallows' nests on a cliff, the great bulk of the Colosseum. We admired statues, and deciphered inscriptions, often finding that ostensible saints or martyrs were actually emperors, gods, or charioteers. Whenever we saw a church, which was often, we went in and said a prayer to any saint whose relics were displayed. Sometimes my fellow pilgrims paid to inspect these relics more closely, handing over a few coins to see a jewelled reliquary briefly opened, or, if the saint was less important, watch his bones tumbled out of a leather sack.

I preferred ancient buildings to saints' bones. Under the great dome of the Pantheon, its gloom pierced by a shaft of light from the open apex, we said a prayer to all those who have suffered for their faith, to whom the once-pagan temple is now dedicated. I thought of the Emperor Hadrian, who had the Pantheon built, and of his namesake, whom I had left behind. Crossing the Tiber, passing through an area of stinking and unhealthy swamps, we saw Hadrian's Mausoleum, now used as a fort. The Emperor Hadrian had had a close friend, Antinous, who drowned while still a young man. The Emperor, tormented by grief, deified Antinous, whose statues can still be seen, often wrongly identified as saints. Their friendship, which in lesser men would have been regarded as folly or weakness, became a legendary example of manly devotion. Like Sergius and Bacchus, Alexander and

Hephaestion, or Achilles and Patroclus, their love for each other was a proof of their greatness. Power, like saintliness can make anything acceptable.

We visited Saint Peter's Basilica in the Vatican, following crowds of other pilgrims up the road from the river, struggling through gangs of beggars, touts, and souvenir sellers. We ignored them, and climbed the steps to the forecourt, a high-walled colonnaded square, filled with gardens and fountains. The Romans call those gardens Paradise, but, though they were pleasant enough, and cool, they only reminded me of the place I had been expelled from, and the happiness I had almost certainly left behind. We pushed our way up the wide steps and jostled past the guides who attempted to block all the doors into the Basilica. It was huge, far bigger than Hagia Sophia, its nave lined with massive antique pillars of green serpentine and red and grey granite. We pressed forward, glimpsing shrines and altars in the lamp-lit aisles, craning our necks to see the frescoes and mosaics on the walls above. Beneath our feet were the worn gravestones of Rome's rich or pious dead. The crowd grew quiet as we neared the great triumphal arch at the far end of the nave. Beyond it was the broad transept, where we admired the mosaic of Constantine, and venerated the shrine of Saint Peter. I was moved and humbled as I thought of Peter, a fisherman, chosen by Christ, whom he betrayed. He was weak, vacillating, doubtful, and unlearned, yet he atoned for his betrayal by founding the Church of Rome. I was aware that, despite my learning I had achieved little.

Unless the Pope summoned me soon, listened to my advice and acted on it, I was likely to achieve nothing at all. My only contribution the work of the Church was my little book on the philosophy of Dionysius the Areopagite, which, I realised, I had left behind at the monastery.

At the end of each day we returned to the bustling area round the Palatine Hill, where our hostel was crowded in with many others, each dedicated to visitors from a different country. There were also monasteries that housed monks from the most distant places, from Ireland to Egypt, as well as Italians,

Franks and Greeks. Rome seemed also to be filling up with Syrians, driven from their homeland by the Moslems. I noticed that the narrow lanes among the monasteries were full of prostitutes, accosting pilgrims in many languages. Perhaps the women were stranded travellers, or were merely adept at assuming whatever identity might most please a man far from home. It seemed that as much virtue was lost as was gained by visitors to Rome.

After three weeks, I felt that I had seen enough, and having neither means nor inclination to buy any holy souvenirs, I let my fellow guests complete their pilgrimage without me.

It was on the first day of June, when the pilgrims were preparing to return, and were packing their books, icons and relics, ready for the journey, that the hostel was visited by a messenger from the Pope. He was only a young boy, but he was richly dressed, and puffed himself up when he declaimed his message:

"His Holiness, Pope Eugenius, requires the presence of Theodore the monk, at his residence."

"When?"

"Now. Come with me."

I followed him, watched by the startled pilgrims. As we walked the mile to the Lateran Palace, past the Colosseum and across a rubble-strewn waste puddled with stagnant water, I wondered, yet again, what Eugenius wanted of me, and what it would be prudent to say. This time, when we reached the Palace, the guards acknowledged me, and I was allowed through the columns and arches of the main entrance. Inside, I was greeted by a richly dressed servant, and shown into a large, frescoed reception chamber.

There were about thirty people in the room, clustered together in groups, talking, but not so loudly as to create a general conversation. There were bishops, mostly Italian by their robes, though a couple might have been Greek. The Germans were marked out by their clothes or hair. The Franks dressed in plain linen tunics of sage green or dull red, over trousers and boots, but wore their hair long as a mark of

rank. Gold torques and clasps also showed their status. The Lombards wore the long beards that gave them their name, forked or pointed, and hair shaved at the neck, but long and droopy at the front. Their clothes, too, were extravagant: silk brocade coats, fastened with gold clips, worn over wide, striped trousers. They reminded me uncomfortably of the Blues and Greens, and of the boorish drunkards who had visited the monastery. It was surprising to see Lombards as guests of the Pope, but I had heard rumours that their new king, Aripert, was orthodox, or at least not so fanatically Arian as his predecessors.

Some Syrians, seemingly merchants, their shoulders draped with brightly coloured shawls, a fashion familiar from my years in Antioch, were engaged in an animated, but incomprehensible, discussion. They seemed more at ease than the other guests, among whom Papal officials, ranked by the ornateness of their tunics, mingled dutifully.

I could only see two other monks, who stood awkwardly together, attempting to match their different brands of Latin. One, dressed in elegant approximations of an ordinary monk's clothes, was an Abbot of a wealthy monastery near Lyon. The other, as unkempt as me, was an Irishman, also an Abbot, though in a place whose name was as hard to pronounce as it was far away. He was in Rome to buy books, which, he told me, were highly prized in his homeland. His Latin was quite comprehensible, though oddly accented, and he knew a few words of Greek. He told me that it was common for Irish monks to travel all over Europe, even though they came from its remotest region. I was talking to those two, or rather to the Irishman while the Burgundian looked on, when the double doors at the end of the chamber were suddenly, and noisily, thrown open. After a warning announcement from a herald, Pope Eugenius entered.

It would not be entirely correct to say that Eugenius was a disappointment, but he was certainly a surprise. He was about seventy, little over five feet tall, and very fat. He was helped onto a low platform, where he sat on a gilded chair, suggestive of a throne. As he sat, his red robes stretched

tightly over his bulging paunch, their colour only slightly diminishing that of his flushed face. Sudden changes of expression suggested intermittent pain, perhaps indigestion or gout. We stood silently while, in order of rank, myself last, we were taken by attendants to kneel and kiss his hand. As I looked up at him, I was reminded of the audiences I had had with emperors in Constantinople. Eugenius apparently considered himself to be something of an Emperor in the West, and I wondered whether my theorising about Church and State was superfluous as well as foolish. He asked who I was.

"Theodore, your Holiness."

"Yes?"

"I wrote to you. About the *City of God*. You asked me to come."

"Of course. I remember now. You must tell me about your very interesting ideas. Later."

While I backed away, his attendants helped him up, and led him through the doors into the next room, where a long table was laid out for a banquet. His gilded chair was carried to the head of the table, and after his stiff, gold-embroidered cape was removed, he sat, with obvious relief. We were led in, and given our places. Most of the Palace staff did not join us, but even so, we were about twenty at table, far more than at any dinner I had attended in Constantinople. I was as far from Eugenius as it was possible to be, though not, of course, at the opposite end of the table, which was occupied by the Pope's chaplain, who said a prayer before the meal began. I had a Syrian beside me, Germans opposite, and the chaplain to my left. The other monks were well beyond the range of polite conversation.

"I was in Syria," I said to my neighbour, while the first dishes were being served. "I lived in Antioch for several years."

"When?" He replied in Latin, though I had spoken to him in Greek.

"Over twenty years ago."

"I was only a boy then," he said, coolly, "and I come from

237

Damascus. But I remember very well how you Greeks abandoned us."

"We had no choice," I said, realising that I had not been tactful. "How are conditions in Syria now?"

"Some would say we are better off than when you Greeks ruled us. The Governor, Mu'awiyah, is tolerant. He does not discriminate between the different forms of Christianity, and he is well disposed towards merchants, providing that we pay our taxes."

"I am glad to hear it."

"We are much better off now. We can trade anywhere. Arab rule stretches from Africa to India."

"India? Are the Persians completely defeated?"

"A few of their nobles hide in the mountains like brigands. But their king is dead. And so is their religion. The Moslems will not tolerate Zoroastrianism as they tolerate Christianity."

We began the meal with many small dishes that were scattered about the table by a constant succession of servants. There were several sorts of pickled fish, fresh pike from the Tiber, sea urchins, peahen eggs, dishes of green herbs, beans, cardoons, radishes, and pastries filled with fruit and honey. But they were put down anywhere, so that one part of the table got all the fish, another got all the eggs, and so on. Only the radishes were ubiquitous. With these dishes we were given a light, sweetish red wine from the Papal estates.

The Lombard opposite me shoved whole eggs and large lumps of bread through the curtains of his hair, biting off chunks and chewing noisily. As he did so, he leaned towards me and said:

"What are you running away from, monk?"

"Nothing," I replied, surprised both by the question and his passable Latin.

"I don't believe you. All monks are on the run. What did you do? Was it debt? A crime? Or a woman?"

"None of them."

"Was it a boy, then?"

"Certainly not." Hadrian could not be described as a boy, but I was unnerved by the accuracy of his guess.

"I know what you Greeks are like. I've fought you. Always running away."

"I became a monk to escape from the folly of worldliness."

He laughed loudly, showering the table with fragments of egg and bread.

"Well you've come to the wrong place. Look around you!"

I did, observing the hall's mosaics, marbles and hangings. The Pope's palace was certainly worldly. I picked silently at the dishes I could reach, getting a pastry and some radishes. When these dishes had been eaten, or scattered carelessly over the fine linen cloths that covered the table, all were taken away, and more wine was served. There were so many servants that no cup stayed empty for more than a moment. Before we had time to digest what we had just eaten, a huge cauldron was brought in, carried by four men. It was placed on the floor near the head of the table, and from it we were served bowls of broth. It was thick with glutinous lumps of long-boiled pig's trotter, and glistened with drops of fat that caught the reflections of the room's many flickering oil lamps. The Lombard picked up his bowl, and drank from it as though it was a cup, but most of us ate with long silver spoons, which were inscribed with philosophical texts. Mine quoted Pittacus of Mytilene, who said, "Nothing in excess".

While we drank, servants pulled meat from the cauldron and laid it on boards. There were shins of beef, ox-tongues, capons, a pig's head, fat sausages, and, dredged from the cauldron's depths, the quivering debris of the trotters. Most of this, having been boiled for hours, was so tender that it could be pulled apart with fingers, but the Germans could not see meat without drawing their daggers, and were soon stabbing and slashing as though at war. Other servants brought dishes of cabbage leaves, stuffed with forcemeat and simmered in broth, bowls of fruit pickled in mustard sauce, and thick sauces, spiced and sweetened. Conversation flagged while the meats were eaten, and I noticed that neither the Pope nor his chaplain drew attention to themselves by eating less than their guests. Not wishing to seem more holy than the Pope, though bearing in mind the slogan on my spoon, I followed their example.

While the debris was being cleared, and replaced with bowls of fruit and honey cakes, the Lombard spoke again:

"To my people, a shaved head like yours is a mark of slavery."

I was tempted to comment on his own outlandish hairstyle, but thought it best not to provoke him.

"To me it is the opposite," I said. "It is a mark that one has renounced bodily lusts, which enslave the weak," I said, more pompously than I intended.

"Just as I said, you're running away!"

As my spoon was taken away I saw that the back of it, which I had not noticed before, was inscribed: "Love those who mock you."

I turned to the chaplain, who was pausing before beginning on the cakes, asked him about Roman plainchant, and enjoyed a long and technical discussion of church music. While we drank sweet wine and considered the question of vocal ornamentation, I heard the Lombard accusing the Syrian of running away from the Moslems. After a while, the chaplain, perhaps tiring of the topic, began to look frequently towards Eugenius. Then, when he saw a signal, or judged the moment suitable, he stood and said another prayer. The Pope was led, almost carried, away, his face contorted with the effects of over indulgence. The banquet was over.

The other guests were quickly conducted away by torch-bearing servants, leaving me alone outside the Palace. Even the Irish monk had vanished. Once the doors closed, the night was black, and I could hardly see as I walked, unsteadily, in what I hoped was the right direction. I splashed through puddles and tripped on lumps of fallen masonry, scaring off animals whose rustling I could hear in the dry undergrowth. After a while my eyes adjusted to the night, and I could just see the dark shape of the Colosseum rising above the horizon, blocking out the stars. When I reached the hostel it was late, the door was barred, and I had to bang loudly before the doorkeeper, complaining that the hostel was for honest pilgrims, would let me in.

I slept late the next morning, and missed not only

Nocturns, but Matins, and even Prime. My guilt was diminished by the thought that even the Pope was unlikely to have attended all of the morning's prayers. Then I remembered that I had not had a chance to talk to Eugenius about the Church and the Empire. But after a moment's thought, I realised that that was probably a good thing. I had seen his worldly ways, and how he conducted himself with the Franks, Lombards and Syrians. He seemed well able to spread his influence beyond the Empire. However cautious he might be over the question of monotheletism, he did not need my advice on how to govern the Church. With luck, he would forget my letter, and I might be able to return to the monastery of Saint Anastasius. My head swirling with contradictory thoughts, I went to the fountain to wash, and found the courtyard full of my fellow pilgrims who were gathering their bags and preparing to leave. They looked at me even more oddly than they had the previous evening. One of them asked:

"Did you really visit the Pope last evening?"

"Yes, I dined with him."

"With the Pope himself?"

"And a few others."

"Have you heard the news this morning?"

"What news?"

"What they are saying in the street."

"Which is?"

"That the Pope is dead."

When the other pilgrims left, to return to their homes, I was left alone in the hostel. It had become obvious that I was not a pilgrim, yet it was not obvious to me what I was, or what I was to do. By volunteering to do some of his work, which was not onerous, I persuaded the hostel-keeper to let me stay on. I wrote to Hadrian, asking him to find out whether Hilarion would have me back, or whether I had in fact been expelled from the monastery that, of all the communities I had lived in, I had found the most congenial. Nearly a month after Eugenius's death I received, not a letter, but a visit from Hadrian. In an echo of our first meeting, he entered the courtyard of the

hostel, dusty and carrying his hat. But I was sweeping, not reading. My relief and happiness at seeing him again were undermined by the sadness of his expression, which suggested that we were not to be reunited.

"Is it bad news?" I asked.

"Yes."

"I can't go back."

"No."

"Would Hilarion not forgive me?"

"He can't."

"Why not?"

"He's dead. And you have nowhere to return to."

I felt unsteady. I let the broom fall to the ground, and sat on one of the stone blocks that served as seats. Hadrian sat beside me.

"Hilarion dead? But how?"

"It's the Lombards," he said.

"Do they know about my letter?"

"No, of course not. It's nothing to do with that. They were sent by their new Duke, Grimoald. He gave the monastery to one of his followers, a brigand called Arculf. He came and took the monastery and land. It wasn't difficult. A couple of dozen armed men were enough. The villagers ran away, and so did the monks."

"And Hilarion?"

"He refused to go, so Arculf had him killed."

"How can a Christian, even an Arian, behave like that?"

"I expect he persuaded himself that it was his duty. The Arians think that we are the heretics. If they take our property and kill a few of us, our error is diminished and their souls are surer of salvation. Greed and piety are a dangerous combination."

I had been surprised by the Pope's death, but Hilarion's death shocked me. It was the last thing I expected. It was only a few weeks since he had angrily sent me away from the monastery. I knew that he had trusted me, and that I had let him down. I had only belatedly come to share his anxiety about the Lombards, and, even then, had exacerbated it with

my letter to the Pope. The vague guilt I had felt since my departure started to attach itself to specific actions.

"He was a good man," I said.

"Yes." Hadrian gently gripped my arm. His touch reminded me of how long it was since we had lain together, and regret fought with remorse to dominate my thoughts.

"Hilarion always feared the Lombards," I said, hoping to drive away the inappropriate feelings Hadrian had provoked.

"Yes."

"I ought to have listened to him—to have paid more attention. Not to have made things worse by meddling in politics."

"You couldn't have done anything. And if you had stayed, the Lombards might have killed you, too."

We sat silently for a while, Hadrian watching me while I brooded.

"And Niridano?" I asked, when I had recovered my composure.

"My monastery is safe for the present. Grimoald has rewarded all his supporters."

"What will you do?"

"I am to stay here until a new pope is appointed, then go to France."

"Why France?"

"To buy more books."

"Are there not enough in Rome?"

"Yes, and enough dealers, too. But it seems that books are plentiful, and cheaper, in France, so my abbot has given me permission to go."

"There is no news about the new pope."

"Then I will have to wait."

We waited for a month while bishops assembled, candidates were put forward, and messages were sent between Rome, Ravenna and Constantinople. I avoided making a decision about my future until Hadrian went to France. There were several Greek monasteries in Rome, including the one my hostel was attached to, and the rival monastery of Saint Anastasius, which lay just outside the city, and, according to Hilarion, claimed to possess the saint's head. Considering

their merits provided an excuse to delay entry, and spend time with Hadrian. When he was not busy on errands for his abbot, we wandered Rome, both seeing things we had seen before, using the city's sights, and its desolation, as an excuse to be together. But I did not find much pleasure in his company. He did not seem to understand guilt. Hadrian and I were seldom truly alone, and when we were, anxiety made us awkward. Little that we had talked of before seemed relevant to our new circumstances, and I found myself wishing away our remaining time together.

Then it was announced from the Lateran Palace that Vitalian was to be the new Pope. No one we asked seemed to know much about him.

"At least," Hadrian said, "he is young man."

"Young? But he is older than me. He must be nearly sixty."

"He is young for a Pope. Think of it. How many popes have there been in your lifetime?"

"I don't know."

"You were born in the reign of Gregory the Great?"

"Yes."

"Then there must have been a dozen since then."

"Most of their reigns have been so short that it is hard to remember their names, let alone their achievements."

"Because they were all so old when they were chosen."

"That is understandable," I said. "Wisdom is a product of age and experience."

"Of course it is," said Hadrian, smiling. "But there may be another reason. Emperors either choose or confirm the pope, and they may think that if they have made the wrong choice, an old pope will be less of a mistake than a young one."

"Perhaps Constans thinks that Vitalian will accept monotheletism."

"The Romans won't let him, any more than they would let the others."

On July 30 657, Vitalian was installed. His procession began at the Lateran Palace, outside which Hadrian and I waited among a large crowd, not just of priests and monks, but also of

Rome's common people, who seemed to regard the Pope as their sovereign. Extra guards kept us away from the entrance, and admitted those important enough to take part in the ceremony. The morning was already warm, but at least the season's heat had dried up the many pools of stagnant water that had filled the city's empty spaces. When the doors were opened, and Vitalian came out, he was dressed simply in white, not vested for Mass. The people cheered when they saw him, and the guards moved forward to clear a path. The new Pope, the Governor of Italy, and a gaudy throng of bishops, abbots and ambassadors processed out of the gates, and began the journey to the Vatican, which lay over two miles away, on the far side of the city. There was a good road across the open space between the Lateran and the centre, but it was only wide enough for the procession. The crowd struggled along on either side of the road, scrambling through the scrub and stones that littered the ground. The buildings in the centre had been decorated with rugs, hangings and green branches, and people climbed onto the ruins to cheer. The Pope threw handfuls of coins at the crowds who waited near the Capitol, then, after passing slowly through narrow and winding streets, the procession reached the Bridge of Nero, and crossed the Tiber. More crowds waited on the far side of the river, and they too had to be placated with coins before Vitalian could reach Saint Peter's in the Vatican. We did not see the actual ceremony, as we were not allowed in the Basilica. Those places not reserved for dignitaries seemed to have been sold. We could not even get into the forecourt where we might have kept cool among the fountains. With hundreds of others, we waited outside the walls while Vitalian was vested and installed, and the Mass was celebrated.

I was struck then by the burden of ceremony that all dignitaries have to bear. However humble they may be in person, all who reach high office, in either Church or State, are obliged to spend much of their time enacting meaningless rituals designed to impress the ignorant and powerless. If they are vain, they soon come to believe that they are as important as the ceremonies imply, if not, they are frustrated by the time

they waste. Now that I am an Archbishop, even though in England, where there is no long tradition that defines the form such ceremonies should take, I too, however much I resist it, am encumbered with formality. But, as I stood with Hadrian, watching the Papal procession, the burden I felt was of guilt and failure.

The next day, Hadrian joined a group of pilgrims who were returning to France. I went to the Monastery of Saint Demetrius, near the Palatine Hill, and asked to be admitted.

I lived in Rome for eleven years. The monastery was not as idyllic as the one the Lombards had taken, and the Abbot's rule was stricter than Hilarion's. But it had its advantages. The hostel of Saint Demetrius, as well as its more luxurious guest-house, attracted visitors from throughout the Empire. There was a good library, and after a couple of years I was put in charge of it, and made sure that it was improved. Many of the richer guests liked to endow the monastery with a sign of their gratitude, and I made sure that they were aware that a book signified culture as well as piety.

Pope Vitalian, though able enough, proved a disappointment. He compromised over monotheletism, grovelled to the Emperor, and allowed Rome to sink into provincial obscurity. My idea that the Church should make itself independent of the Empire seemed increasing irrelevant, and dangerous. However, Vitalian did two things that affected me. One was the reform of Church music, the other I will describe later. As an Italian, the Pope was keen to diminish the Greek influence on the Roman church, and knew that there were many forms of chant in the West, as well as that of Constantinople. He gathered experts and examples, selected the best, clarified melodic lines, reformed notation, and added subtle but elaborate ornamentation. He also introduced the organ, to assist the singing of congregations, who were not as skilled as the choirs who pioneered the new technique. One of the few pleasures of my years in Rome was attending the city's many churches, and comparing the emerging new style with the many regional variants that could still be heard.

I did see Hadrian again, perhaps once or twice a year, when he returned to Rome, or passed through on his way to or from France. He sometimes found books for me, as knowledge of Greek is dying out in the West, and Greek books are not much valued. There was an autumnal sadness about our meetings, which reminded me of what we had lost. But I could not forget him, and though his departure always left me melancholy, his impending arrival always filled me with anticipatory pleasure. I wrote him many letters, but he often seemed too busy to reply. I spent much time thinking of him. In some ways, friendship at a distance is more intense, and poignant, than constant companionship.

After several years, my melancholy was increased when Hadrian wrote, explaining that his Abbot had died, and that he had been elected as his successor. His new responsibilities would not permit him to visit Rome. I read the letter many times, trying to decide whether it meant more than it said. Our friendship had been threatened before, but by circumstance rather than choice. It had been weakened, but not broken. Though Hadrian might not have chosen his abbacy, he had accepted it, and must have known that, by doing so, he was ending our friendship. I felt betrayed.

16

THE PLAGUE

A.D. 667

Rome is an unhealthy city. Its swamps breed fevers, its many
visitors bring infections, and the lack of sea breezes or moun-
tain air, combined with the stifling heat of summer, ensure
that diseases, once established, are not easily eradicated. Dur-
ing the years when I saw little of Hadrian, I lost interest in
Plato and his theories of love, but I continued my medical
studies. However, despite having made the occasional success-
ful cure, my interest in medicine was mainly philosophical.
Influenced by Basil, who had been my mentor, I was con-
cerned with the maintenance of good health, rather than with
infectious diseases, which cause, but are not caused by, dis-
harmony of the humours. When the plague arrived, in the
spring of 667, I was unprepared, and realised that I knew as
little as a Khazar witch-doctor, or those charlatans who pur-
port to cure with spells and talismans.

When more practical students of medicine began to ask me
for advice, I read what I could of medical books and antique
histories, searching for the causes of the plague, and a means
to cure it. Perhaps the best description is that given by
Thucydides in his *Peloponnesian War*. Though he had the dis-
ease himself and survived, he made it clear that not many did,
and that the doctors died first and most frequently. That con-
firmed my feeling that theoretical medicine is safest. I read
much, but found that, though there are many theories about
the causes of plagues, almost nothing is known of cures or
treatments. If infections really are sent by evil spirits, as some
believe, then there is little to be done but pray. But we must
not attribute too much power to the Devil and his minions. It
seems more probable to me that Hippocrates was right, and
that such diseases are caused by bad air and water. The old

Romans had drained the swamps and built aqueducts to bring clean water, but the Tiber had silted up, the swamps reappeared, and the aqueducts were nearly all ruined. The diminished population of Rome had mostly abandoned the hills, and gathered around the river, where air and water are at their worst. The weather, which was unusually cool and rainy that spring, increased the spread of the swamps, and left many parts of the city covered with mud and stagnant puddles. Not much could be done about those factors, at least in the short term, and I could find no convincing evidence of a cure. It seemed to me that the best course was to isolate the victims, and stop them spreading the disease to the healthy. As I had read in Procopius's histories, that method had been tried in Constantinople during Justinian's reign. It had contained the outbreak, though thousands had still died. I recommended a similar system of quarantine to anyone who asked my advice, and to many who did not. It was impossible to persuade the people of Rome, many of whom depended on the sale of miraculous trinkets, to disrupt their trade, or cast doubt on it, by isolating the city. But Pope Vitalian was persuaded, and guards were posted to prevent anyone from entering or leaving the city, and isolated buildings were prepared to accommodate those citizens or visitors already infected.

Before the city was closed, I just had time to write to Hadrian. I tried to congratulate him, but I fear that, in enumerating the virtues that made him worthy of his new office, I may have seemed to be taking the credit for them. I tried to describe Rome's predicament, but described my own. My letter was full of the cold, black humour of melancholy, and of my feelings of betrayal. I did not expect a reply.

The next few months were possibly the most miserable I have ever lived through. The deaths continued, and at first most people tried to keep off the streets and avoid any public gatherings. Despite the empty spaces within its walls, Rome had little agriculture, so, as food stocks ran out people began to starve. In the monastery we lived almost entirely on lentils, of which we had a stock, and we fasted often, as much to make the food last as to invoke divine intervention. The Abbot was

convinced that God had judged the city, and found it corrupted by greed and vice. Though the churches mostly stayed empty, there was much praying, and those who had icons or relics deployed them in the hope of a miracle. We spent many hours each day in protracted and punctilious worship, unenlivened by music, which the Abbot discovered to be frivolous, and a contributory cause of our predicament.

In their desperation, the poorer people left their houses, and scoured the city for anything edible. Many poisoned themselves by eating leaves and twigs, and grass was harvested eagerly. Fish were caught in the Tiber, frogs and snails were gathered from the marshes, birds were trapped and eaten, and the city's dogs and cats disappeared, which led to an increase in the number of rats and other vermin. There were even rumours of cannibalism, though I cannot believe that, in the middle of an epidemic, even the most stupid could have thought it a good idea to eat human flesh.

As is usual in adverse circumstances, there were attempts to fix the blame on outsiders, and some Jews and Syrians were killed, after being dragged out of their houses and accused of spreading the disease. Needless to say, their houses were robbed afterwards. There were also riots, when bands of starving people tried to force their way out of the gates to find food in the countryside. It might have been simplest to let them go, but they would only have been rejected by the country dwellers, died anyway, or climbed back into the city, bringing fresh infections. The guards kept them in, killing a few in the process, but not improving the mood of the city.

Gradually, as the weather grew warmer and drier, making the city healthier, the number of deaths decreased. Though it did not result in a miraculous cure, the quarantine system was successful, and by August the epidemic was declared over. The gates were opened, and the survivors tried to restore their disrupted and impoverished lives.

I spent much of that summer attempting to write a long, narrative poem, describing the condition of Rome during the plague. While working with George I had absorbed some of the elements of his style, which was judged by his con-

temporaries to be original. But my attempt to adapt his heroic Greek rhythms to the demands of Latin, and to the mood of the subject, was not a success.

Towards the end of November, while working, rather aimlessly, in the library, I was interrupted by a young monk, who said that an Abbot had come to see me. I followed him, across the small courtyard to the doorway where, in the shade of the arch, sat Hadrian. He stood up when he saw me and, rather uneasily, we hugged.

"What are you doing here?" I asked, more coldly than I intended.

"Are you not pleased to see me?"

"Of course I am," I said, but I was not sure that I was. His expression was uncharacteristically anxious. He had not replied to my last letter. I wondered how reproachful it must have seemed to him. "You said you would not come to Rome again."

"I know." He looked warily at the gatekeeper. "Can we talk?"

"Come to the library."

"Is it not full of toiling scholars?"

"No. We can talk there."

I led him to the library. We sat at my table, drafts of my unsuccessful poem lying between us. Hadrian picked up one of the pages.

"The style is rather gloomy," he said.

"The subject is rather gloomy."

"Does no one share your work?" He gestured at the empty desks.

"Rome is a worldly place, as you know well. Books are valued for their price, not their contents."

"You have a good library here."

"The Abbot's guests are generous."

He looked at my poem again. I watched his expression, wondering whether he saw the same defects in my verse that I did.

"Why are you here?" I asked.

Hadrian put down my poem, reached into his bag and pulled out a rolled document. It bore a Papal seal. He unrolled it and pushed it across the table.

"What is it?"

"A summons."

"From Pope Vitalian?"

"Yes."

"What does he want?"

"He wants to make me an Archbishop."

"You! An Archbishop?" I was aware that I sounded too surprised. "What an honour. And for me too. For one of my pupils."

"It is a long time since I was your pupil."

"Yes." He was nearly forty, yet, because he had been my pupil, and my friend, I felt that his achievements were, in part, mine. "Where is your province to be?"

"His Holiness wants to make me Archbishop of Canterbury."

"Canterbury?" The name was unfamiliar.

"It is a town in England. Or Britain, as I expect you would prefer to call it."

"But England is at the edge of the world, practically in the Ocean."

"I know."

"Why England? Why does his Holiness want you to go there?"

"It seems that I am the last resort. There was an English candidate. A man called Wighard. He was sent here to be consecrated, but died of the plague as soon as he arrived."

"Couldn't the Pope find another Englishman?"

"Apparently not. Wighard's fellow travellers all died, and the plague made it difficult to communicate with England. Vitalian was keen to appoint quickly, so he chose me."

"So you are to leave Italy?" I could not think of anything else to say. I found it difficult to imagine him as an Archbishop.

"I don't want to go."

"Why not?"

"I have not been happy as an Abbot." He paused, and absent-mindedly picked up my poem again.

"I can understand that," I said. "You are a teacher, not an administrator. I was surprised that you accepted the abbacy."

"I had no choice. They elected me."

"It has changed you. I can see it in your face."

He seemed troubled by my comment. He tried to look more cheerful, and spoke briskly:

"I came to Italy to become a monk because I thought that civilisation would survive in the monasteries. I was partly right. Life has become less civilised outside the monasteries."

"Partly right? Do you mean that monastic life is less civilised than you thought?"

"Perhaps."

"Then why not accept the Pope's request?"

"I don't want to live among savages."

"Savages? Surely the English aren't that bad?"

"I don't know anything about the English, but if they are like the Lombards they are best avoided."

He paused for a moment, and we looked at each other.

"Would they welcome an African like me as their Archbishop?"

"I don't know."

"They might reject me."

"Is that the only reason?" I asked.

"If I went, I would never see you again." He tried to smile.

I was not convinced. It seemed an afterthought, and, even when our friendship was closest, he had never admitted that his need for me was as great as mine for him. I had grown used to the idea of life without him, and had almost achieved the scholarly calm I had always imagined I wanted.

"But you were not going to see me anyway," I said.

"We are only a hundred miles apart. I'm sure we would have found ways to meet. I mean *will*. I'm not going."

"But how can you refuse?"

"I will say that I am not worthy."

He saw the Pope the next day, and came back to tell me that he had successfully declined the archbishopric, and had

nominated instead a monk called Andrew, who was chaplain of a nunnery near Niridano. My mood of melancholy, which had grown during the plague, had been modified rather than abolished by Hadrian's sudden reappearance. I was sure that, without the Pope's summons, we would not have met again, and I was not convinced that our friendship really was to be revived. There seemed every chance that, after a short reconciliation, he would return to Niridano and forget me again. But his muddled reasons for refusing the archbishopric suggested an uncharacteristic loss of self-confidence. He had always seemed sure of himself, and of what he wanted. He had lacked guilt. His abilities had always been more than adequate for the tasks he attempted, or was allocated. But becoming an Abbot had apparently changed him. I have observed that sometimes the ablest of men dislike collective endeavour. They prefer to work alone, avoiding the consequences of other people's failings. Basil was an example of that. Had Hadrian discovered in himself a fear of responsibility? Perhaps his profession of unworthiness was not just an excuse.

He remained in the city for a fortnight, searching for books and attending to monastic business. I was not as free to leave the monastery as I had been, but I spent a little time with him. He brought the books he had found to my library, and we discussed them, just as we had in the past. I suspected that he was trying to win back my friendship by reminding me of the time when he was my pupil.

Just as he was about to return to Niridano, he was summoned again by the Pope. When he came back he looked worried.

"Andrew has refused," he said.

"Why?"

"He's too ill."

"And what did his Holiness want of you?" I knew the answer.

"He asked me again to go to England."

"And what did you say?"

"The same as before, that I am unworthy."

"And did he accept that this time?"

"He was not pleased. He made it plain that unless I can come up with a suitable candidate he will send me, worthy or not."

"Well, we had better think of someone."

Before Hadrian's next meeting with Vitalian, we ran through the names of the worthiest abbots, chaplains, priests, theologians and scholars that we could think of. Most, when we considered them, were unsuitable or unavailable. Some turned out to have died of the plague, others lived too far away, or were now stranded in enemy territory. A few, though able, lacked important skills, or had minor, but significant flaws, making them unsuitable for high office. Hadrian seemed reassured to find that so many were unworthy of the office he had declined. I began to think that he would accept it after all. He went to his meeting cheerfully, though he had no names to offer.

When he returned, he was smiling.

"You don't look like a man condemned to exile among the savage English."

"No?"

"I take it that his Holiness has not obliged you to accept."

"That's right," he said.

"Did you propose someone else?"

"Yes."

"Who?"

"You."

"Me?" It was the last answer I expected. "But why?"

"You are the obvious candidate: experienced, scholarly, modest and wise."

"You flatter me. But you didn't ask me. And how will it help? If I go, we will never meet again, just as surely as if you go."

"I've thought of that. I'm going with you."

"But how? Why?"

"I've persuaded Vitalian that you will need an assistant."

"What for?"

"Partly to help with the teaching. I gather that that will be an important part of the job. But mainly because you are a Greek."

255

"I am just as much a Roman as you are. And as orthodox."

"Yes, but you are Greek by origin, and there are differences between the Greek and Latin churches. Vitalian is anxious that the English Church should adopt Latin customs, and I am to go with you and make sure it does."

"Only a few months ago, during the plague, I thought our friendship was over. Now you tell me that it isn't. And you want me to go with you to the edge of the world and convert a lot of German barbarians."

"Some of them are Christian already." He avoided the question of our friendship.

"Even so, it's a job for a younger man. I'm sixty-five."

"There's nothing wrong with your health. You survived the plague. And if you stay in Rome, what will you do that you haven't done before?"

"I don't know."

"How long have you lived in Rome?"

"Over ten years."

"Have you ever lived anywhere else for so long?"

"Constantinople, perhaps."

"Were you happy there?"

"Sometimes."

"And yet you moved on. You have always moved on. It is not in your nature to settle down. You have often talked of spreading the influence of the Church, to counteract that of the Empire. England is the place for that. And if you go, we can be together."

I had not been particularly happy in Rome. And though I was old, I was healthy, and the prospect of a new adventure was invigorating. My doubts about our friendship seemed disproved by Hadrian's willingness to go with me into what he obviously thought of as exile. It was gratifying that he thought me more suitable than him, though it was odd that, having refused to go to England as Archbishop, he was willing to relinquish his abbacy and go as my assistant. That seemed to confirm my suspicion that he had come to dislike responsibility. I remembered Michael, the Syrian, who had become irksome when he began to depend on me.

But Hadrian was right. I agreed, and was taken to the Lateran Palace, where I met Pope Vitalian. He remembered the advice I had given during the plague, seemed to think me competent, and confirmed my appointment. In confirmation of what Hadrian had said about his views on Greek customs, he objected to my tonsure. There are various forms of the tonsure used by Greek monks, and I had chosen the simplest, having my head shaved all over. It saves trouble, and is comfortable in hot weather, but the Pope said that it would not do. I was instructed that before the spring, when the weather would allow us to travel, I was to grow my hair, then receive the circular Latin tonsure. It was necessary for me to be ordained before I could become an Archbishop, so I was then made a subdeacon.

Hadrian went back to Niridano to put his monastery in order before handing it over to a successor. I spent that winter learning as much as I could about England and its history, and the duties of an Archbishop. I studied the government and discipline of the Church, cannon and secular law, and the history of previous missions to England. When I had time, I read of Julius Caesar's two invasions, of Claudius's conquest, and of the four obscure but largely peaceful centuries that followed. Britain did not seem to have been one of Rome's more interesting colonies. Of the two hundred years or so since Britain was abandoned by Rome, then invaded by the pagan and uncivilised English, I learned nothing. The whole period, as far as the Papal library is concerned, is a blank, until Pope Gregory the Great sent Saint Augustine to convert the English, at about the time of my birth. I went to the archives and read copies of Pope Gregory's letters to Augustine, and Augustine's feeble replies. It was clear that the English mission was Gregory's idea, that had he not been chosen as Pope he would have gone to England himself, and that Augustine was a very poor substitute. Augustine went unwillingly, travelled slowly, turned back twice, and penetrated no further into England than Canterbury. His work of conversion was so superficial that sixty years later it had to be done again. Pope

Gregory must have regretted sending him. Augustine is not to be confused with his African namesake, the author of the *Confessions* and *City of God*, though both saints have been overrated by posterity. Their faults have been disguised by hagiographers, who call weakness humility and confuse sanctimony with virtue.

However, I was aware as I prepared for my mission that, like Augustine, I was not the Pope's first choice. I hoped that I would not be overwhelmed by fear or circumstances.

On March 26 668, at the age of sixty-six, I was consecrated as Archbishop of Canterbury, a place that still seemed remote and unknown, despite a winter of preparation. After waking I washed thoroughly, and put on a new linen tunic. Then, my hair having grown, the crown of my head was shaved, giving me the circular tonsure familiar in the West and favoured by the Pope. Wearing a plain cloak, I was conducted by my Abbot, and an escort of chanting monks, across the familiar waste-land to the Lateran. In the Pope's palace I was dressed in a chasuble, richly embroidered like the coats worn by noblemen in Constantinople. It seemed inappropriate, as after consecration I would still be a monk, but, dressed like a lord, I was led out of the palace and into the Basilica. This church, which lies next to the palace, is almost as big as Saint Peter's in the Vatican, and of similar design, though it is not so crowded with visitors. As I entered, and walked up the nave, light poured in through the rows of windows above the aisles, picking out the red, yellow and green markings on the huge marble pillars. Beyond those were other, smaller pillars supporting the double aisles, and reminding me of the thickets of stone that supported the domes of Chosroes' palace at Tabriz. But unlike that palace, or Hagia Sophia in Constantinople, the Basilica was not domed. Its flat, panelled ceiling, high above me, gleamed with gold. The length of the nave, emphasised by the receding ranks of columns, drew me towards the apse, where, by the altar, surrounded by silver statues and gilded ornaments, lit by the glimmering of dozens of lamps, sat Pope Vitalian.

I was overwhelmed. I felt dizzy, and my legs shook as I completed what seemed like an endless journey to the apse. Hadrian was there, with some monks who had come from Niridano, and my Abbot with all his monks, as well as a crowd of Papal officials, miscellaneous priests, and a few Englishmen who happened to be present in Rome. But I saw none of them, not even Hadrian, as everything not directly in front of me seemed to merge into a shapeless mass swirling with light and colour. I was hardly aware of what Vitalian said as I knelt before him, but, when he draped the pallium over my shoulders, I knew that it would change me. It was the symbol of my office, entitling me to perform the Mass and to consecrate bishops, and it made me the equal of any secular lord. I had come to realise that for much of my life I had been a follower, of events, or of men, or of the promptings of desire. It seemed to me that, though only a strip of embroidered cloth, the pallium transformed me. It showed that God had chosen me, a heretic by birth, a sinner and a doubter, to spread His Word. Despite my failings I had been thought worthy to carry faith, learning, and perhaps civilisation itself, to a distant and primitive England.

17

ENGLAND

A.D. 669–675

For a while, we were out of sight of land. The sea lay all around us, grey and glinting, its surface agitated by the wind that carried us north. I remembered Homer's lines:

> All day long we sailed, holding our course over the sea, until we reached the deep-flowing River of Ocean. There, on the edge of the world, lies the mist-shrouded city of the Cimmerians, where poor wretches live in perpetual darkness, never knowing the sun's rays.

It was in those misty northern margins of the known world that Odysseus summoned up the spirits of the dead, and heard prophecies in return for the blood of sacrificed sheep. I felt a chill at the prospect of life in a zone of endless damp twilight.

Hadrian was not there to share my gloom. Instead, Benedict sat beside me, looking eagerly ahead, hoping to see land beyond the carved prow. For the first time in a long and arduous journey, I felt I needed him. He had been assigned to me by the Pope, who did not consider Hadrian's knowledge of France sufficient to get us to England. But Benedict, an English nobleman turned monk, and a self-appointed expert on all things, was an irritating man. Being born in the raw north of semi-savage Britain was no setback to him. He had travelled repeatedly to Rome, lingering in France on the way, and made himself familiar with liturgy, ecclesiastical architecture, book production, monastic rule, and all other matters conducive to the spread of civilisation. But he had not been able to prevent the difficulties that delayed us for almost a year in France.

A streak of grey appeared on the horizon.

"A fine sight," Benedict said, rising from the bench to greet

his homeland. As he stood, the boat lurched into a wave, and he gripped my shoulder to steady himself. "A wonderful country," he said, before collapsing back on the bench. He sat for a while, uncharacteristically silent, perhaps sickened by the ship's heaving.

We passed white cliffs, then a long, low coast where the sea sucked at banks of shingle, then a shore so flat that the land was almost invisible between the sea and the sky. At the Isle of Thanet, on the eastern tip of Kent, the crew lowered the sail and rowed into the mouth of the Stour. Ahead, little more than a collection of huts on a mud flat, was the port of Richborough. I could see smoke rising from some of the huts, and the wind carried its sweet smell out to us. But the scent of wood-smoke, pleasant and evocative of comfort, was mixed with the pungent stink of rotting fish. The crew landed the boat among fishing boats and nets, then helped me over the side and up the shallow beach. The shore was strewn with shells, seaweed, fish bones and splintered wood, among which crabs scuttled and shrieking gulls fought for food. The fishermen's huts were roughly made of logs and branches, and roofed with loosely bundled reeds. Though Benedict tried to divert me, I was determined to look inside. In the first shed, which was low and open-sided, women and children worked, gutting and splitting herrings, barefoot among a foul slurry of guts and scales. In other sheds, men packed the split and flattened fish into tubs of brine, or hung them on wooden frames ready for smoking. I wandered the huts, appalled by the stench and filth, and by the squalid condition of the people. Their hair was matted, their clothes stiff and stinking, their skin red with cuts and sores, their eyes half closed by salt or smoke. They seemed as savage as the cannibal Laestrygonians or the men turned to beasts by Circe's magic. They were the wretches I had come to convert.

Benedict, tugging anxiously at my arm, led me to a small wooden church, where I said a prayer of thanksgiving for my safe arrival, and another for the success of my mission. Afterwards I was given a meal of fresh herrings, and a bed in the harbour-master's house. The house was better built than the

fishermen's huts, though of the same materials, and did not smell quite so strongly of fish. I lay miserably on a pile of reeds, wondering why I had agreed to come to this remote island, and how, without Hadrian, I could hope to civilise its primitive inhabitants.

"What fine countryside," Benedict said as we rode away from Richborough the next morning, leaving the marshes and the stink of herrings behind us. "There is no land as fertile as this in Italy," he said, easily managing to control his horse, look at the view, and talk to me at the same time. Benedict had got himself shaved before we left, and the lower half of his round face was pale, his chin nicked by the razor. He had also put on a white linen tunic, finer that the itchy stuff I wore. "In the South," he said, "the sun parches the land, drying everything to dust. But here in England, everything grows, even vines."

I did not ask why Benedict had spent so much time in Italy and Provence. I knew by then that he would have answered sanctimoniously, claiming that only duty, not the pleasures of the South, kept him away from his beloved homeland. But England was green and fresh in the May sunshine, though the wind that had brought us north still blew, and trees bucked and twisted, as if trying to throw off their new leaves.

"Look at those walls," Benedict said, as we approached Canterbury. "Not, perhaps, quite as strong as those of Rome, but strong enough. And I believe King Egbert has had them repaired. I see signs of new work."

Benedict waved an arm at the walls, where gaps had been filled crudely with loose rubble, then pointed at a building that stood just beyond them. "The Monastery of Saints Peter and Paul," he said. "You may recall, my Lord, what I told you about the monastery, how it was founded by your saintly predecessor Saint Augustine, and how it is in need of an abbot." He adopted a meek expression, trying to imply silently the modesty that forbade him to propose a suitable candidate.

Pope Vitalian had instructed me to give Hadrian, who had relinquished an abbacy to come with me, a suitable monastery

in or near Canterbury. I did not know whether Hadrian wanted another abbacy, whether he would be fit for office, or whether he would even reach England. I ignored Benedict's hints, and took the opportunity to inspect the monastery as we rode past. Though outside the town, it was surrounded by strong walls of its own. I was glad of that. Walls offer more than safety. By shutting out worldly distractions, they mark the limits of temptation and leave us free to contemplate. I know that I am subject to temptation, and not just the grosser sort. I have idled away my time, distracted by ephemeral pleasures, in the greatest cities of the world. Despite Benedict's claims, I knew that Canterbury, could not rival Antioch, Constantinople or Rome, but I was reassured to find that I could, if I wished, live in seclusion. Saint Augustine, whether wise or weak, had chosen his site well

We entered the town by an old Roman gate on the East side, and I saw that, inside its ring of walls, Canterbury was little more than a village, scattered among the ruins of a town. There were small groups of thatched wooden houses, gardens, orchards, and even small fields where goats and cattle foraged. There were few stone buildings. The remains of an old theatre, a huge semi-circle of crumbling masonry dominated the town, dwarfing the houses, and even the cathedral.

"This is the church your predecessor built," Benedict said, pulling up his horse. "A noble structure, is it not?" It was actually a rather small and ordinary church, with fat brick columns from which the plaster had long ago fallen. It was obvious that Saint Augustine had not built the church, which must have been already old, and abandoned, when he reached Canterbury. But I did not argue. A crowd waited outside the church, curious, not wholly committed, but willing, I hoped, to be impressed. They were cleaner and healthier than the people I had seen at the coast. They were peasants, not savages. The brisk wind tugged at their clothes, fluttering cloaks and tunics, making the women clutch at their scarves, pulling them tightly over their plaited hair.

I was helped off my horse, and conducted into the church, where, for the first time in my life, I prepared to celebrate the

Mass. Only a few deacons and clerks were there to greet us, and while some of them helped me put on the vestments I had brought from Rome, Benedict questioned the others.

"The church seems to have been neglected," he said, admitting, for the first time, that conditions in England might be less than perfect. "I've asked about the rest of the cathedral staff, but this is all of them." He looked, frowning, at the handful of old men and boys that stood before us. "And they don't seem to have celebrated a proper Mass for years. In fact, I'm not sure they know how to."

"Then we will have to show them," I said, relieved that my audience would not be too critical.

"With respect, my Lord, you look unwell. Perhaps the journey has exhausted you? It is, I think, almost exactly a year since we set out from Rome. And travel is very tiring for a man of your age. I would be very willing to take your place and conduct the service."

Benedict was twenty years younger than me, and liked to remind me of it. "I may be tired," I said. "But I think I can manage."

"Are you sure, my Lord? Remember what we discussed in Paris? You were so anxious that your first Mass should go well. Pope Vitalian charged you with introducing and maintaining Roman practices to England. Yet you, if I may say so, have spent much of your life in the East."

"And much of it in Rome."

"In a Greek monastery, I think you said? And you are more familiar with the Greek liturgy than with the Latin."

"That is why Hadrian was sent with me."

"An African!" Benedict said, his eyebrows arching. "So imaginative of his Holiness! And such a pity that Hadrian was unable to continue the journey with us. In his absence, let me at least make a few suggestions. I know what the English are used to, as well as what is done in Rome."

Benedict consulted with the deacons again, then suggested various hymns, psalms and chants which, with a little help, we might be able to perform successfully. I took my place in the cathedral and began. But Benedict was right. I was weak after

the long journey, perhaps worn down by his arguments, and after the first prayer my voice failed. Benedict had to take over. He sang psalms and chanted readings enthusiastically, richly ornamenting the vocal line, as he had learned in Rome. We had to perform without antiphony. The best I could manage was an accompanying drone. I do not know what the congregation made of it. Perhaps they thought that Benedict was their new Archbishop. If so, he cannot have been displeased.

Afterwards we were escorted to the King's hall, not far from the cathedral, and received by Egbert. The hall was large, and supported by carved oak beams. Inside it was dark and windowless, as all such halls are, though it was hung with bright cloths and embellished with painted carvings. We sat on long benches, at tables ranged round a central hearth. I was glad of the fire, as May can be cold in England. Servants brought us oysters, some grilled shad, rich with roe, and a pale stew of tender kid, thick with dumplings. I was impressed, but misled, as most English food is much plainer than what we ate then. King Egbert knew something of how things are done in France and Italy, and was anxious that I should be made comfortable. While we ate, he spoke to me slowly in English, nodding and gesticulating as though to a child, and like a child I did not understand. Egbert knew no more that a few words of Latin, so Benedict had to translate.

"Where will you live?" Egbert asked, waving a hand vaguely towards the roof.

"I am used to the collective life. The monastery of Saints Peter and Paul will suit me very well."

"Who will you appoint as abbot?"

"I will appoint Hadrian. But he is detained in France. His Holiness the Pope sent him to assist with my mission, and asked me to install him in a suitable monastery. I hope he can be got out of France quickly." Benedict looked anxious as he translated that, but I went on to tell to the King why we had taken a year to reach England.

Soon after arriving in France, we had been detained on the orders of King Chlothar, who seemed to think us Imperial spies. Ebroin, the king's representative, later gave us

permission to continue our journey, but arrested Hadrian and imprisoned him in Meaux. After waiting for the winter in Paris, Benedict and I were allowed to leave for England, but without Hadrian. The King nodded sympathetically, but I did not attempt to explain to him how our setbacks, combined with Benedict's invulnerable self-confidence, had undermined Hadrian's health, reducing him to a state of helpless melancholy.

"I will send a letter to France immediately, and remind Ebroin of the Pope's intentions," Egbert said, when I had finished my story.

After the meal we sat for a while, drinking mead and attempting, awkwardly, and without controversy, to discuss conditions in France and England. When we had accepted enough of Egbert's hospitality, some of his men escorted us out of the town. It was late in the afternoon, and the sun, before it dropped below the city walls, lit the grey, weathered oak of the monastery gates. Benedict knocked loudly. The gates shuddered and creaked, opened a little, then stuck. Hands appeared through the gap and attempted, unsuccessfully, to open the gates wider. Then a few monks emerged from a nearby postern and began to push from the outside. I suggested to Benedict that we went through the postern, but the monks, if they heard or understood, ignored me. They continued to shove the heavy timbers until the gap widened a little. We slipped through, into a wide grassy enclosure planted with apple trees, among which a few pigs and geese wandered. The monks, only a few dozen, lined up to greet us, tugging and tucking in their disordered clothes, while one of them, not much more than a boy, his face flushed red, stood forward and delivered a short welcoming speech in defective Latin. I thanked the speaker, who was called Titillus, and made an appropriate reply. Then, to end Benedict's anxiety, I appointed him as temporary Abbot, making it plain that he would have to relinquish the position when Hadrian arrived. He did not seem at all put out by those terms, which made me think that he was sure Hadrian would not reach England. He seemed to have enough contacts in France to know that, if not

to have arranged it. Perhaps he had not translated my conversation with Egbert accurately. Straightaway, Benedict took charge. He examined the monks and gave them instructions, then began an inspection of the buildings, rushing to see everything before dark.

The monastery was built solidly of stone, and incorporated earlier structures. Some of the walls had embedded in them gravestones and parts of sarcophagi. They were carved with representations of old Romans, or their British subjects, pagan but prosperous, surrounded by the tools of their trade, or the attributes of their rank. Clearly the monastery was built on what had been a graveyard. It had been added to and embellished since Augustine's time, and, though it was still not an elegant building by the standards of Rome or Constantinople, it was rather Italian in style. Squeezed in among its other buildings was a colonnaded courtyard, something I have not seen anywhere else in England. When Benedict finished his inspection he allocated a room for me, and sent monks to find suitable furnishings. He took the Abbot's quarters for himself. I did not object. It is best to let people like Benedict have what they think is important. After a year of travel and uncertainty, I would gladly have accepted the simplest of cells, and the room he gave me was large enough and opened onto the courtyard. I have lived in it for nearly twenty years, without feeling the need for change. The view of the courtyard, an enclosure within an enclosure, changing with the seasons but always remaining the same, has been as consoling as the other regularities of monastic life.

I had no time to think about Hadrian, as I was immediately plunged into my new duties, which seemed at first to be largely administrative. Fortunately, June is rather a pleasant month in England, being green and flowery at a time when the South is parched and brown, and I enjoyed the short walk between the cathedral and monastery. It made up for the gloom and confusion of the cathedral archives, where the clerks had done nothing for five years. When I arrived the clerks dragged rolls of parchment out of rows of wooden

pigeon-holes, then stood about waiting for me to give them instructions. My years of army clerking had taught me how to bring order to chaos. I had them set up trestle tables and lay out the documents in chronological order, grouped according to the kingdoms they came from. I had everything translated that was in English or incomprehensibly defective Latin. I insisted that minor matters were dealt with by the deacons, to whose number I added. Only then did I begin the task of reading those documents that seemed to be important.

As I worked through those letters, reports and petitions, I began to form an impression of my new province. But it was not a very favourable impression.

"The Kings of England are always at war," Benedict said, when I asked his advice. "It is a sign of their strength and independence. They obey no emperor, and accept no authority but their own."

"But they must obey me, in ecclesiastical matters, at least. Pope Vitalian made it clear that I am to establish my authority over the whole of England, regardless of the shifting frontiers of petty kingdoms."

"His Holiness has never visited England," Benedict said, shaking his head sadly. "Though a fine country, it has been troubled in recent years. The wars have caused certain difficulties, I admit. And there was the plague. But you would not be Archbishop if it were not for the plague. Wighard would be Archbishop in your place." Benedict smiled oddly at the thought. "Perhaps it was the work of God."

"But the plague has made my work impossible. Much of the country has reverted to paganism. There are not enough priests or bishops. The sees of Rochester, East Anglia, Mercia and Wessex are all empty. Filling them won't be easy."

"It's just a matter of picking the right man and sending him," Benedict said, implying by his manner that he would not have found that task difficult.

"Take Wessex, for example," I said, picking a document from the pile and offering it to Benedict. "According to this report, Bishop Wini has abandoned his see and fled to London."

"He seems to have argued with King Cenwalh," Benedict said. "It is never wise to argue with kings."

"The report says he has bought the bishopric of London from King Wulfhere."

"Mercia is a powerful kingdom, my Lord, it is best to give King Wulfhere what he wants."

"But it is a clear case of simony. I can't tolerate that. It would be seen as weakness. How can I establish my authority if I leave a simoniacal bishop in place?"

"With respect, my Lord, I think you should be careful. Simony is not the worst of sins, and London must have a bishop. It might be best to leave Bishop Wini in place. And it would certainly not be wise to begin your mission by provoking King Wulfhere. Things will change. Perhaps Wini will argue with Wulfhere."

"It is just as bad in Northumbria," I said, showing Benedict another report. "There seem to be two rival bishops, Chad and Wilfrid."

"Chad is a very good man, a saint, some say."

"But not properly consecrated. It was done by Wini, and some Irish bishops."

"You could overlook Wini's simony, but the heresy of the Irish does make Chad's consecration invalid." Benedict thought for a moment. "You could re-consecrate him."

"Wilfrid seems much better qualified. He has sent me a letter." I searched for it among the documents on the table. "He says that he was consecrated in France, by twelve bishops, including Agilbert, with whom we lodged in Paris. Unfortunately, Wilfrid was delayed in France, and found that Chad had been installed during his absence. "

After my experiences in France, I had some sympathy with Wilfrid. His letter was well written, and showed that he was concerned with orthodoxy and correct procedure. He seemed preferable to the Celtophile Chad. But Benedict was not so sympathetic.

"You should be very careful with Wilfrid," he said. "He is the proudest and most argumentative man I know."

"He says in his letter that he is an old friend of yours."

"He was a friend, once. Nearly twenty years ago, we went on a pilgrimage to Rome. He was eighteen, and I was twenty-five. I was supposed to guide and protect him, but he wouldn't listen to a word I said. He always knew best. We got as far as Lyon, then we fell out, and he refused to go on."

"Why was that?"

"He fell in love. With the niece of the Archbishop. He imagined that if he married her he would be set up nicely in Lyon, and wouldn't have to come back to England. He rather liked life in France."

"But he did come back?"

"Yes. But first he went on to Rome, and decided to devote his life to religion."

"So he didn't marry the niece?"

"No. I suspect he never really loved her. He loved the power she would have brought. But in the monasteries of Rome, he saw another sort of power. He went back to Lyon, and lived there for three years. He became a monk there, and I think he had hopes of a monastery of his own. Some French monasteries are very rich. But his plans were upset when Queen Balthild decided to have several French bishops killed, including the Bishop of Lyon. Wilfrid survived, but it was a near thing. His followers put it about that he was spared because of his beauty. After that he decided that England was safer. And you know the dangers of France, my Lord, for those who are unwise enough to provoke its rulers."

When I had finished reading all the documents the clerks had found, it seemed to me that I was the only bishop in England who was correctly consecrated and installed. I realised that I would probably have to tour the country and put things right. But, as Benedict kept reminding me, I was old, had been ill, and had not recovered from my journey through France. The prospect of a prolonged tour of England, which seemed a strange and primitive place, filled me with dread. Without admitting my fears, I asked Benedict again for advice. He confidently suggested names for the unfilled dioceses, and gave useful advice on how to travel and where to stay. Clearly Benedict knew his own country better than I could ever hope

to, and I was on the point of asking him to come with me, if not actually to go in my place, when Hadrian arrived from France.

The clerks looked up from their work and stared at Hadrian's dark and unfamiliar face. They had clearly never seen an African before. He was thinner than I remembered, and greyer. There was something about his eyes that suggested that his detention in Meaux had not been pleasant. Yet he was more composed than when I left him in France, and seemed to have recovered from the acute phase of his illness. I stood up, he stepped towards me, and we hugged. I could not help crying, and neither, I noticed through my tears, could he. Those young clerks must have thought us an odd sight: two foreigners, one old, one middle-aged, neither much more than skin and bones, both crying and babbling in incoherent Greek.

I took his arm and led him out of the cathedral, along the grassy streets where children stopped to stare. I led him out of the gates, across the open space beyond the walls and into the monastery. I took him to my room and shut the door. There we hugged again, and cried, comforting each other, not saying anything, not knowing what needed to be said. On my bed, with Hadrian in my arms, I felt the same uncertainty that I had felt years before, when our reading of the *Symposium* had led so quickly from pleasure to remorse.

I had only just handed over the monastery to Benedict, and did not feel that I could take it away quite so soon, nor was I sure that Hadrian was fit to assume the responsibility. A delay seemed appropriate. I decided to leave Benedict in place, and set off on a tour of my new province, taking Hadrian with me. I had often relied on his advice in the past, and by asking it again I could assess, and perhaps improve, his condition. It would be as well if we got to know England together.

At the beginning of July we set off, riding good horses, accompanied by priests, monks, clerks, servants, pack-horses and baggage-wagons. We were protected by forty Kentish soldiers, ill-dressed, but armed with spears and round shields.

They did not look much like an army to me, but they were there to uphold my dignity rather than to fight.

Hadrian seemed uncomfortable, and asked:

"Do we need to travel with so much show? You know how I hate riding."

Hadrian's poor horsemanship had been a cause of friction with Benedict, who was as confident on horseback as he was everywhere else.

"We must ride, as that befits our status," I said. "We will not be taken seriously if we walk. Our task is to establish the authority of the Roman Church throughout the whole of England. To do that we must deal with kings and nobles. Remember the installation of Pope Vitalian? He didn't indulge in all that ceremony to gratify himself, but to establish his authority."

"Perhaps. But humility might do that just as well."

"The English don't seem to think humility a virtue, except in those of lowly status. Besides, we must distinguish ourselves from the British and Irish."

"They are Christians too."

"But not orthodox. And they are influential, particularly in the North. They kept Christianity going, after they were conquered and driven west by the English."

"But they didn't convert the English?"

"No. They hated them. They would rather see the English damned than converted."

"Is their sort of Christianity so bad?"

"Not bad, perhaps. But different. Remember that Vitalian charged us with spreading Roman practices as well as Roman authority. Irish monks are extremists. They indulge in self-denial. Cities and civilisation don't suit them. They live in caves or hovels, or wander wild places like savage beasts."

"Yet they value learning," Hadrian said. "Remember the Irish monks in Rome."

"They do, but I suspect that for them, learning Latin is a sort of mental discipline. It is difficult, and sets them apart from other men. They walk to Rome for the same reason. If

our mission is to succeed, we must be more worldly than them, or seem to be."

We crossed the Thames east of London, then travelled through the forests of oak and hornbeam that covered much of Essex, until we reached the coast of East Anglia. At Dunwich, in small wooden church within earshot of crashing waves, I consecrated a young priest as Bishop of the East Angles. Afterwards we stayed with Aldwulf, King of the East Angles, who had a hall nearby. His kingdom was unimportant, and dominated by Mercia, but he seemed determined to appear the King, and received us surrounded by his thegns. He was a young man, with yellow hair and a raw, red face. His thegns looked little more than peasants, distinguished only by their swagger and their weapons. Aldwulf's house was larger than Egbert's hall in Canterbury, and had an odd humpbacked roof. Inside, curved crucks and rafters arched above us like ribs, supporting the bent, knobbly, wooden spine that ran along the roof-ridge. In the darkness, with the sound of the sea in the distance, sitting in that hall was like being inside the belly of a gigantic whale. The ends of many timbers were carved into the heads or bodies of animals: boars, stags, wolves and eagles, all in a writhing style, very like that I had seen in Persia. I remembered what the magus had told me about the common origins of the old German and Persian religions, and wondered whether the similar carving styles were proof of his theories. Further proof would be hard to find, as it was already apparent that the Christian English did not like to talk about their pagan past.

We were given stew from an iron cauldron that hung over the fire-pit on a long chain. The evening was too warm for a fire to be needed for anything but cooking, but the dark hall would have been cheerless without it. As an important guest, I ate from a silver dish, but most of the others ate from slabs of bread, that were later given to the dogs. While we ate, and drank mead from horn cups, musicians entertained us with the wailing and twanging that the English seem to enjoy, during which the King tried to converse. He knew no Latin,

and I knew very little English, but with the help of Titillus, the young monk who had greeted me in Latin on my first day in Canterbury, we managed, very laboriously, to exchange a few platitudes. The rest of the diners became quite noisy after the music. Many toasts were drunk, but what to, I have no idea. I sipped rather than quaffed, partaking in the nature, rather than the substance of the toasts, and no one seemed to notice, or to mind. Though I had long ago resolved to eat or drink whatever I was offered, I did not think it wise to get drunk.

When we had finished eating, the tables were taken away, but we remained on our benches, sitting round the dying fire. The King called for his bard, who, after a few twangs on his lyre, began to recite a heroic poem. Everyone was silent while he spoke, and sometimes sang, the words they obviously knew well. It was a long poem, and when it was over only a few embers glowed in the grey ash that filled the fire-pit. I understood nothing of the words, but felt its rhythms. I was reminded, uncomfortably, of the songs that Michael had sung in Antioch, and of the epics of the Khazar bards. Like them, this English bard had the power to hold and stir his audience.

The next day, as we rode west, I asked Titillus what the poem was about. He looked embarrassed.

"Pagan nonsense, not fit for Christians to hear."

"I would like to know its subject."

"It was about a hero who kills a sea-monster."

I was glad Benedict was not with us as we rode to York. Doubtless he would have told us what a great city it was, as good as any in Italy, and how rich the Northumbrian countryside was. York was impressive enough, at first sight, without his commentary. It stood above the confluence of two rivers, an imposing fortress, a larger version, in stone, of the army camps I had lived in while in the East. Its long walls looked largely intact, but they enclosed toppled columns, ruined storehouses, and armouries devoid of weapons. We passed the weed-covered bulk of an abandoned bath-house, and many heaps of masonry too disordered to identify. Among the ruins

rose the wood and thatch of newer structures: huts and houses built on the parade grounds where, over three centuries earlier, the Roman army had acclaimed the Emperor Constantine, and inaugurated the Christian Empire. Grass grew, green and long, grazed by the small red cattle that wandered the empty spaces, tended by barefoot and dirty children. In the centre, dwarfing everything, was the old military headquarters, its rambling halls and barrack-blocks collapsed in places, but repaired and evidently still in use. It would have been easy to wander the town, musing on past glories and the passage of time, but Hadrian, who knew neither camp-life nor nostalgia, reminded me that we had come to resolve the question of York's two rival bishops.

Chad, the irregularly consecrated bishop who had occupied the see for four years, was waiting for us outside the cathedral. He had not thought to welcome us at the city gates, or organise anyone else to do so. I might, had I been as vain as some bishops, have resented his lack of reverence. But, as he stood in the porch in his simple monkish clothes, he seemed so absent-minded, so unworldly, that it was impossible to take offence.

He led me into the cathedral, showing me its interior with something that might have been pride, had pride been in his nature. Perhaps it was wonder at having been entrusted with what must have seemed to him a fine and substantial building. But to me the cathedral was a disappointment. It had been built originally of wood, then partly rebuilt with stone and brick by inexpert masons. Parts of the roof had fallen, allowing water to leak into the nave, and the windows, lacking glass, were open to the bats and birds that find churches such attractive roosting places. Puddles of green slime, and piles of bird and bat dung lay everywhere. It was hard to see how anyone could worship or celebrate the Mass in such a building.

Chad was unable to explain the cathedral's state, though he did show me several smaller churches that were in much better condition. When I asked him about his consecration, he surprised me by admitting that it was uncanonical, confessing that he was unfit to be a bishop, and declaring that Wilfrid had

275

a much better claim on the see, both morally and legally, than he did. Chad was much younger than me, but, as he knelt on the damp floor, his head bowed humbly, he seemed old and frail. Despite, or perhaps because of, his negligence with church property, it was difficult to avoid the feeling that there was something saintly about him. I had no choice but to depose him, and, at his insistence, impose a penance, which was the mildest I could think of, a recital of the Psalter.

It felt odd to be standing in judgement over someone else, especially someone as transparently virtuous as Chad. I realised then what power, both moral and temporal, my appointment brought with it. I remembered the mistakes Heraclius had made in appointing patriarchs, and Constans' persecution of recalcitrant popes. I hoped, unrealistically, as it turned out, that all those I dealt with would accept my decisions as humbly and uncomplainingly as Chad.

A few days later, Wilfrid arrived from the monastery in Ripon to which he had retired after finding his see filled by Chad. He was about thirty-five, fair haired, blue-eyed, and very handsome. I could easily believe that Queen Balthild had spared him because of his beauty. His clothes, though suitable for an Abbot, subtly suggested nobility. I asked him about his consecration, which, he confirmed, was performed by Agilbert, Bishop of Paris.

"He didn't mention you," I said. "And I stayed with him for several months."

"Didn't he? That may be because we had a disagreement."

"About what?"

"He disagreed with my views on the legitimacy of the Frankish Kings."

"Was it wise of you to discuss that? I was detained by Agilbert's friend Ebroin, without having, let alone expressing, any opinion on the subject."

"I wasn't detained, though I did linger in France after my consecration. But who wouldn't? It's such a civilised place."

There seemed to be nothing wrong with his consecration, so, having confirmed his orthodoxy, I installed Wilfrid as Bishop of Northumbria.

Afterwards we were ferried across the wide, shallow river to the monastery where we were staying. Its tall stone buildings were rather barn-like, and had perhaps been warehouses in the past. The monks had repaired and adapted them, making the monastery more substantial than any I had so far seen in England. Wilfrid knew the Abbot, and seemed to have some influence over him. Teams of monks and lay brothers were mobilised to clean up the cathedral, and others were sent to go through what remained of the archives. I stayed at the monastery for a while, talking to Wilfrid about conditions in the North and agreeing points of policy. Despite Benedict's warning, I did not find him argumentative, though he was evidently able and confident. He was keen to tell me about his travels, and to talk of Rome and France. We discussed books, architecture and music, as well as ecclesiastical administration. Unlike Hadrian, he listened appreciatively to my reminiscences of Constantinople and the East, and was sympathetic when I described my difficulties in France. He arranged some excellent meals for us, sending his own cooks into the monastery kitchens to produce dishes reminiscent of Rome, though made with local ingredients. I found him a charming companion, and was glad to have installed him in such an important see. Hadrian did not agree.

"I don't like Benedict," he said. "But he's right about Wilfrid. In fact the two of them are just the same, noblemen first, and Christians second. These Englishmen see the Church as a path to power and wealth."

"I think you are wrong, Wilfrid is just the type of experienced, educated man we need."

"Chad is a much better man."

"He is a good man, but hardly practical. And he was incorrectly consecrated."

"That was not his fault. He accepted the bishopric as a duty, and got himself consecrated as best he could."

"I think I had better re-consecrate him and find him another see."

I consulted Wilfrid, who claimed great friendship with King Wulfhere, and suggested that we send Chad to Mercia.

He wrote to the King, and soon received a reply. With Wilfrid as witness I took Chad through all the stages of ordination, then sent him to Lichfield to be Bishop of the Mercians. He wanted to walk, but I gave him a horse and made him ride. I thought it important that the bishops I appointed did not seem too humble.

When I was sure that Hadrian had shaken off the accidie that had dogged him in France, I appointed him Abbot, in Benedict's place. Benedict returned to Rome, where he planned to acquire more books and vestments. I persuaded King Egbert that he would be remembered as a wise and civilised King if he supported the school, and he gladly gave me a fat purse of Frankish gold coins. He also added to the monastery's lands, enlarging its income, and increasing the manpower we could draw on to gather materials and begin construction. For the next year or two, the school took up much of my time, as well as Hadrian's. Though he did most of the day-to-day work, I helped with the teaching, and with planning the buildings. With the money given by King Egbert, and the revenue from our estates, we enlarged the monastery, following examples we had known in Italy, Africa or Constantinople. Builders and craftsmen came from France and Italy to do the skilled work, and some stayed to train local men. By the time the work was completed, we had already trained some teachers, who were put in charge of our first batch of oblates. The school flourished, and older pupils came to us from all the kingdoms of England, as well as Ireland and France.

Once the school was established, Hadrian took over all its responsibilities, leaving me with only a little teaching to do. I was able to give more time to ecclesiastical affairs. I was pleased by what I had achieved so far. I had appointed several orthodox and pro-Roman bishops, as well as many lesser clergy. The Irish influence on the Church had diminished, and many aspects of liturgy and Church practice had been regularised. England was at peace, paganism was waning, lingering only in the West, and the English were discovering the pleasures of literacy and learning.

I was also pleased by the work Wilfrid was doing in the North. He charmed Queen Etheldreda, just as he had charmed me. With her patronage, he founded large monasteries at Ripon and Hexham, as well as several smaller ones. His monastic and church buildings were said to be so magnificent that there was nothing like them north of Rome. That was not quite true. They were rivalled by my own constructions in Canterbury, though they were certainly impressive in a country accustomed to short-lived buildings of wood. But I did not resent the exaggeration. It seemed to me that, if I could find a few more men as able as Wilfrid, England might soon begin to resemble the more civilised parts of France, if not what was left of the Empire.

I had made a good start, but, as I learned more about England, I found that there was still some administrative work to do. Some of the dioceses were too big, and some were ill-defined. Mercia and Northumbria were both much larger than I had appreciated when I appointed their bishops, and if the Church in England was to be universal, it was arguable that dioceses should not correspond exactly to kingdoms. The two dioceses were also in dispute over Lindsey, the area around Lincoln.

I first learned of this dispute from Wynfrid, an able young priest whom I had just appointed as Chad's successor at Lichfield. He had been recommended by Wilfrid, and seemed just the type of man I was looking for. But he soon wrote to me, complaining that Wilfrid was demanding a large section of his territory. I hesitated before replying, thinking that Lindsey might form a new diocese, independent of either of its claimants. Then Wilfrid wrote, putting forward, very modestly, I thought, his reasons for thinking Lindsey his. I was pleased with Wilfrid's work, and inclined to side with him. He, if anyone, could manage a larger diocese.

But Wynfrid came to Canterbury, bringing with him a great crowd of Mercians, who supported his claims with anecdotes, ancient charters, sworn statements, and rambling accounts of visions and miracles. I even had to listen to a bard, who recited an incomprehensible epic about how King

Wulfhere had conquered Lindsey by leading his war-band to Northumbria and hacking and hewing through the enemy shield-wall. The English, I realised, have odd ideas about evidence. I sent them all away, promising a decision, but not sure what I would do. Then I began to receive complaints from other parts of my province. Wilfrid, it seemed, as well as founding his own monasteries, was expert at persuading the rulers of smaller monasteries to put themselves under his protection. The lesser clergy and abbots of Northumbria were unhappy with Wilfrid's attitude, which they described as overbearing, and his quickness to condemn any belief or practice different from his own as uncanonical. Other bishops were jealous of his growing power, and accused him of living like a prince.

As well as complaining about Wilfrid, the other bishops were troubled by relations with the monasteries in their territories, and with their minor clergy who, like the monks, were in the habit of wandering the country when dissatisfied. There were clearly many questions that needed to be resolved, so I decided to hold a synod of all the bishops.

"I have been talking to the Northumbrians," Titillus told me, soon after we arrived at Hertford, where the synod had gathered. The monastery I had chosen was little more than a collection of huts, surrounded by a wooden palisade within which fierce geese grazed. But it was considered comfortable enough by the bishops, of whom all except Wini and Wilfrid had attended. There was a thatched, oak-framed church, a large hut, not quite a hall, that served as a refectory and gathering place, and a barn, in which we billeted my escort. The monks were obliged to vacate their huts and sleep in makeshift tents to make room for us.

I had made Titillus my secretary, and he was able to collect much useful information while I dined and debated with the bishops. He sat with the other bishops' clerks, or, braving the geese, wandered the huts, talking to anyone he could find. Because he was English, and young, and did not look as intelligent as he was, they told him things that they would have

concealed from me. In the afternoons he came to my hut, and sitting by the pile of straw on which I rested, told me what he had learned.

"And have the Northumbrians told you what a fine fellow Bishop Wilfrid is?"

"Not quite. Some of them don't seem to like him much."

"I have heard the rumours. What are they saying this time?"

"That he has annoyed King Egfrid."

"How?" I sat up, the straw subsiding beneath me. Titillus helped me into a chair. Though slightly built, he had a strong grip.

"He has encouraged Queen Etheldreda to leave Egfrid and go into a nunnery."

"She wrote to me about that. I advised her not to. Christian queens are best employed by their husbands' sides."

"That's what King Egfrid thinks, and he's furious with Wilfrid for encouraging her."

"I'm not surprised. Are the Northumbrians taking Egfrid's side?"

"Yes, but they are laughing at him too."

"Why is that?" Titillus was embarrassed. He looked downwards, and his fair hair flopped over his eyes. What I could see of his thin face had turned red. "Why?" I repeated.

"It's because she's a virgin," he said, still avoiding my gaze.

"A virgin? But she's been married twice."

"Yes," said Titillus, looking at me at last. "But they say that neither marriage was consummated, and that as Etheldreda is much older than Egfrid, he's better off without her. And they say that Wilfrid doesn't dare leave Northumbria, in case Egfrid takes away his monasteries while he's gone. It was through Etheldreda that he got them all."

"Thank you Titillus. But you must not be so embarrassed. We monks choose not to marry, but marriage is a natural condition for most people, and the Church must deal with its consequences."

Despite, or perhaps because of, Wilfrid's failure to attend, the synod went well. The other bishops were annoyed by his

absence, as they felt, rightly, that most of the issues we discussed concerned Wilfrid more than anyone else. They voiced their complaints freely, and I was able to use Wilfrid's misdeeds as the basis for an agreement on how the church should be governed. The terms increased my power, but, in return for confirming them, the bishops insisted that the laws of marriage should be made stricter. I was inclined to be tolerant, and allow some flexibility, but the bishops wanted the simple certainty of the Old Testament, and, for the sake of unity, I agreed.

Titillus, despite his awkward manner, proved to be an excellent secretary. As well as translating when necessary, he summarised wandering speeches, reconciled subtle but important differences, eliminated unnecessary anecdotes, and reduced complex matters to their essentials. I knew well enough how difficult that sort of work is, having done it myself in the past. He drew up the final document, and when we had signed it, we returned to our provinces hopeful, if not entirely confident, that the Church would be free from discord and worldly rivalry.

The Church may have been more harmonious after the synod, but England was not. King Wulfhere of Mercia, who already dominated the kingdoms of southern England, invaded Northumbria. He took with him an army gathered from all over the South, and Hlothhere, who had recently succeeded Egbert as King of Kent, was obliged to send some of his men. I saw them set off, a small and under-equipped group, who would not have been called an army in the wars I had witnessed. They carried swords, spears and shields, but few had mail coats or even helmets. The thegns rode, but only to travel. They did not fight on horseback, claiming that their horses were too valuable. I suspect they were not skilled enough. They were followed by an uncoordinated crowd of peasants, who carried the baggage, and served the thegns in camp. As they set off to a mustering point in the Midlands, they did not look like potential victors, and so it proved. King Egfrid, perhaps still angry after Etheldreda's retirement,

resisted the invasion of his kingdom vigorously, and managed to defeat Wulfhere, who died shortly afterwards. When the survivors of the Kentish contingent returned, they told stories of epic battle and tragic defeat, but they had obviously only skirmished.

After the battle, Egfrid declared himself overlord of all England, and for a while, no one challenged him. I took advantage of the collapse of Mercia to create new dioceses in Worcester, Hereford and Leicester, and divide East Anglia into two. Unfortunately, Wynfrid of Lichfield refused to accept the changes, though he had agreed the principle at Hertford, and I was obliged to depose him. I was sorry to lose such an able bishop, especially one who been an ally against the growing influence of Wilfrid, but the unity and effectiveness of the Church are more important than the pride of one man.

18

WILFRID AND DAGOBERT

A.D. 676–678

Wilfrid chose to ignore the turmoil in England, and involved himself in the even greater turmoil in France. He had already told me that he had disagreed with Bishop Agilbert over some aspect of the Frankish succession. King Chlothar, in whose name I had been detained in Paris, had died, and noble factions competed to place their candidates on the throne. Aspiring kings were crowned, deposed, killed, tonsured or imprisoned, with bewildering frequency, until Theuderic, Ebroin's candidate, escaped from a monastery and managed to establish himself conclusively as King of the Franks. The losing faction remembered that Dagobert, grandson of King Dagobert with whom I had long ago suggested an alliance, was still alive and in exile in an Irish monastery. They contacted Wilfrid, whom they knew from his stay in Lyon, and asked him to send Dagobert to France. I do not know how Wilfrid arranged it, but Dagobert was brought across to Northumbria. Somehow, without provoking or alarming King Egfrid, Wilfrid sent Dagobert south with an armed escort, having arranged for him to stay at various monasteries on his journey. I received a letter from Wilfrid, reminding me of the hospitality I had enjoyed in France, and asking me to accommodate Dagobert while he prepared to cross the Channel. I showed the letter to Hadrian, who said:

"Hospitality! Is that what he calls it? It was imprisonment!"

"I think he knows that."

"Then why does he call it hospitality? Is he trying to insult us?"

"Perhaps he intends irony, to remind us of our ill-treatment, and provoke us to support his scheme."

"Why should we?"

"It seems that if Dagobert becomes King, then Ebroin's faction will lose power."

Hadrian thought for a while. He was clearly unwilling to support Wilfrid, whom he disliked, but his dislike of Ebroin was greater. He could not forget his detention in France, which was more rigorous than mine, and for which he received neither explanation nor apology.

"We should support Dagobert," he said. "We don't owe Ebroin any gratitude."

"I don't know," I said. "Frankish affairs are complicated. There are too many factions to keep track of, and we can't afford to make enemies. Our people have to go through France to reach Rome, and a hostile Frankish king could make Church business difficult."

"And a friendly one would help."

"But for how long? Frankish kings don't seem to last. It is the nobility who have the power, and meddling could upset them."

"Perhaps, but it would be a shame to help Ebroin, even by inaction."

I decided to refer the matter to King Hlothhere, as Kent had dynastic links with France. I went to see him in the hall where Egbert, his brother, had received me on my first day in Canterbury. Though my English was improving, I took Titillus with me to translate. It was only a short walk from the cathedral, but it was raining, and my cloak was soaked when I arrived. A servant took it as I entered, but no one else acknowledged me. Beyond a wicker partition I could hear the murmuring of women's voices. Some dogs slept in a corner. Rain hissed as it hit the embers in the fire-pit, falling from the smoke-hole above. More rain dripped through gaps in the thatch, making mud patches in the earth floor. Some servants, barefoot and drably dressed, scattered rushes on the puddles. A few men played a game with animal teeth. The game was more suited to boys, but they played it eagerly, snatching the teeth and throwing them on the food-strewn floor. After each throw they shouted, or groaned, and a few coins were handed over. I waited, my boots uncomfortably wet.

Hlothhere idly watched the game, fondling the bristling neck of a large boar-hound. He was a short, broad man, with thinning brown hair and long, drooping moustaches. It was some time before he noticed me. He did not rise from his chair, or offer me one, though he was half my age, but lounged lazily, waiting for me to speak. He did not look at all military, and I knew from what Titillus told me that he was suspected by his subjects of cowardice. While his troops marched to Northumbria he had lingered in Kent making final preparations, which prevented him from joining them in time for the battle. When the Mercians later raided Kent, he failed either to defend his kingdom or to die heroically. He was not the sort of king about whom bards sing.

I explained my difficulties, and he listened, but his watery grey eyes would not quite meet mine.

"With respect, Archbishop," Hlothhere replied, "this matter does not concern me."

"But I assumed, your Majesty, that you would wish to entertain Dagobert while he is in Kent."

"He is a usurper, and I want nothing to do with him."

"He may succeed, in which case it might be wise to support him."

"Or not." Though short, the King's reply puzzled me, and I asked Titillus to translate it again. But Hlothhere, who knew no Latin, cut him short.

"Don't gabble, boy!" The game-players laughed sycophantically, pausing for a moment before throwing the teeth again. Titillus's face turned red. He was evidently unnerved by his King's demeanour.

"Do I take it then, your Majesty, that you do not wish Dagobert to enter Kent."

"I don't care whether he comes or not."

"Will you receive him?"

"No." He rested his hands on his paunch, and looked up at the leaking roof.

"Should I entertain him?" I asked.

"That's for you to decide. This whole business is your responsibility."

"But your Majesty, I did not invite Dagobert."

"No? Well one of your bishops did, and you're responsible for him."

As soon as the rain stopped, Hlothhere went hunting in the forests bordering Sussex, and stayed there until Dagobert had gone.

Though managing the monastery was Hadrian's responsibility, entertaining potential kings was, apparently, mine. I asked the guest-master to prepare some of the guest rooms in a manner appropriate to a king and his retainers. I left it to him to decide what manner that was. I then considered the question of food. The cellarer was an honest and capable man, responsible for all the monastery's supplies of food and drink. He was thin, stooping, and, as the Rule of Saint Benedict advises, 'sober and no great eater'. I found him in a gloomy storeroom under the refectory, surrounded by jars, barrels and dusty sacks, which he was checking and reorganising with the help of two lay brothers. I explained that we would soon be entertaining Dagobert and his party, and asked him to provide some suitable food.

"What sort of food would that be?" he asked, wiping his dusty hands on his apron.

"The sort of food nobles eat," I said, hopefully.

"What sort is that?"

Clearly, I could not rely on his experience or his imagination. I described some of the meals I had eaten, or seen eaten, in Constantinople, Italy and France.

"Sea urchins?" he said. "Lobsters? Octopuses? Creeping things from the sea! We don't eat them."

"What about fish?"

"I can get some fish." He looked relieved.

"Eels?"

"Plenty of them in the marshes. They boil up nicely."

"In Paris I ate them stewed in red wine with bacon and leeks."

"All stewed up together?"

"Yes. I think Dagobert would like something like that."

"We've got some bacon." He gestured towards a large tub where pink lumps of pork floated in crusty brine. More bacon, dry and brown, hung from the arched ceiling.

"And red wine?"

"Oh yes! We've got some very good wine." He walked over to a barrel and thumped it, smiling. "This is more than ten years old. The merchant said we should keep it least that long before drinking it."

"Have you done much business with him."

"No. He hasn't come back. But this is the best, you can be sure of that. It was bought in Archbishop Deusdedit's time."

"Did he know his wine?"

"No, he never touched it."

I asked him to show me what else was in store, but, though there was plenty for a monastery, there was little with which even a would-be king could be entertained. I asked him to find some better ingredients and left him to his stock-taking. Then, without much optimism, I went back to my room and wrote some instructions which, if followed by a capable cook, might result in approximations of the dishes I had in mind.

Dagobert, when he arrived at the monastery, looked anything but royal. He was fat and dirty, with dark, puffy eyes staring warily from a blank, white face. He sniffed constantly, and wiped his round, snail-like nose on his sleeve. His clothes were rich, but they were stained and shabby after his journey. He did not look like a man who was in control of his own destiny, or even of his followers. Only his long black hair, hanging down his back like a woman's, marked him out as eligible for Frankish kingship. It must have been cut off when he was deposed, as is the custom among the Franks, but he had had plenty of time to re-grow it.

Dagobert's retinue were a mixture of suspicious Irish monks, reluctant nobles sent by Wilfrid, and some Northumbrian soldiers, whom we billeted in the town. There had also been some servants, but they had melted away, taking much of Dagobert's baggage, as they neared Kent. I attempted a speech of welcome, but my carefully prepared phrases, vaguely implying support, but not committing me to anything definite, died

as I tried to speak them. Dagobert and his supporters listened, detected my lack of enthusiasm, and reciprocated with a show of surliness.

Afterwards I led Dagobert up the stone steps to the Refectory, where the cellarer and guest-master had laid out everything ready for a welcome feast. Long tables had been set up, one of which, where Dagobert and I were to sit, had been covered with linen cloths and set with silver dishes. As Dagobert and I took our places, and the room filled with noise of scraping chairs and benches, I hoped that the rudeness of his followers would soon be mollified by the civilised pleasures of food and drink. But the meal was not a success. The cook had followed my instructions, but contributed nothing from his own skill or experience. He did not soak the bacon, so the stew was too salty. He undercooked the eel, which was tough, and the leeks, which were bitter and fibrous. The wine was sour, but that was not the cook's fault. The result was an inedible travesty. The other dishes were better, but not good, as the cook appeared to be confused by what must have seemed the randomness of my suggestions. Only the turnips were properly cooked and entirely edible. Dagobert did not seem to notice, and ate silently and greedily, though without apparent pleasure. Had he not been so fat I might have thought the Irish monks had starved him. Perhaps he was being philosophical, and stoically accepting whatever the moment offered. A bad meal was probably not his worst fear.

After staying with us for ten days, and eating much of the cellarer's stores, Dagobert and what remained of his retinue left for Reculver, where they had arranged for a ship to take them to Frisia.

It was a relief to be rid of Dagobert's truculent supporters and return to monastic routine. I retired to my room and began to read through the latest batch of letters complaining about Wilfrid, who was clearly attempting to make himself my rival in the North. No doubt he knew that Pope Gregory had originally intended York to be a metropolitan see, like

Canterbury. However, Pope Vitalian had entrusted the whole of England to me, and I did not intend to let my territory be divided. Wilfrid's ambition was obvious, but I could think of no way to curb it if he refused to attend synods or obey their decisions.

My thoughts were interrupted by Oswald, one of Hadrian's pupils.

"My Lord Archbishop, could you come and help us? We need some words."

"Can't Hadrian help you?"

"He is busy teaching."

"What sort of words?"

"Difficult ones."

Oswald looked blank. His round face suggested stupidity but, though he sometimes took time to understand what others grasped quickly, he was no fool. His main failing, if it was one, was an excess of seriousness. I rose, lifting myself slowly on the arms of my chair, and walked towards the door. Oswald followed, and I could tell, from his hesitant, uneven steps, that he was unsure whether he should skip ahead and open the door, or stay respectfully behind me. I stood aside and let him push open the heavy oak door that led to the courtyard. The day was bright, and I strolled across gently, savouring the sunshine. On the other side, Oswald skipped ahead of me again, and pushed open the door into the library.

Inside, wherever a patch of light fell from one of the high windows, a few pupils sat, arranged in stooped and scholarly attitudes. There were a dozen of them, diligently studying. As I stood in the doorway, looking at the scene, I was glad that Hadrian's efforts had produced such willing scholars, so hardworking and keen to learn. They were a sign that, despite its quarrelling kings and disobedient bishops, England would one day be civilised. Yet there was something about the library and its occupants that subtly implied the opposite. It was a high, gloomy room, with arching rafters and roughly interwoven roof-laths like the canopy of a forest. The dark wood of the tables, chests and lecterns was exuberantly carved with savage beasts and curling foliage. The pupils, dressed in leafy

russets and ochres, seemed to scurry stealthily among ornamented book-pages.

All this suggested, not academic endeavour, but furtive wildness.

However, as I entered they looked up from their books, then stood respectfully and waited while I chose a chair and settled myself into it. Oswald sat by Badwin at a large table where they had been working on a glossary of obscure Biblical words. Badwin's thin face, unlike Oswald's, was far from blank, and often betrayed what he must have imagined to be his secret thoughts. He was trying to compose his features into an expression of scholarly calm, but the effect was spoiled by a slight, sly smile.

"My Lord Archbishop, what, exactly, is an *ossifraga*," he asked. I thought for a moment. The word seemed to mean bone-breaker, which is the sort of name the English give their swords. Though there are many Biblical references to swords, they are not, as far as I could remember, given bloodthirsty nicknames. Badwin was looking at me expectantly.

"What is the context?" I asked.

He smiled a little and said: "It's something we shouldn't eat."

"I take it you are glossing Leviticus." He looked disappointed.

"Yes Archbishop, it is here in this list of creatures the Lord commanded the Jews not to eat. Most of the others are clear enough: eagles, ravens, owls, swans."

"Swans!" said Godric, from a more distant table. "They make good eating."

"But what is an *ossifraga*," said Badwin, not wanting to be diverted.

"It is obviously a sort of bird," I said. But what sort of bird breaks bones? Then I remembered. "It is a large bird that, while feeding on carrion, cracks open bones. A sort of vulture. I saw them on the battlefield at Nineveh, after we had defeated the Persians. "

"Write it down Oswald!" said Badwin.

Oswald wrote, then asked: "Was it a big battle, my Lord?"

"Of course it was a big battle. It was the end of a long war between two Empires, not just a skirmish between petty kingdoms. Thousands died, and in the night animals came out to feed on the bodies." Oswald was listening keenly, but the other pupils, who did not regard their kingdoms as petty, looked sceptical. They clearly could not believe in a battle with thousands of casualties when, in English law, any group of more than thirty-five men is called an army. I thought it best to change the subject. "But you are here to study, not to listen to my memories. Are there any other words?"

Badwin looked sly again. "Not words exactly, but some of us were talking, and we are puzzled by the underlying principles."

"Of Leviticus?"

"Of the dietary rules. Why are so few things permitted, and such odd things forbidden?"

"Such as?"

"Well, it says here," he paused to find the place, "that we, the Jews I mean, should not eat pig or hare, which are both good meat, or ferrets, lizards, bats and weasels, which no one would eat unless they were desperate."

"Also," said Godric, "locusts and beetles seem to be allowed. That can't be right."

"The ruling principle," I replied, "is appropriate locomotion." They looked doubtful. "According, I think, to Isidore of Seville, permitted creatures should move in a way that is appropriate to their place. He tells us that land animals should walk properly on four legs, not creep or drag their bellies. They should have the right kind of feet. Fish should swim, not slither. Birds should fly, or, when on land walk on two legs. And so on. I think you will find that the forbidden creatures all have inappropriate forms of locomotion, such as creeping, not flying, in the case of birds, or having the wrong number of legs. Or having four legs and flying, like bats. Sessile creatures are, of course, completely forbidden. There is also the question of diet. On the whole, the permitted animals eat vegetable matter, the forbidden eat meat. Animals which scavenge or feed unwholesomely are also to be avoided."

"What about the locusts," said Godric. "Why are they permitted when they are so obviously disgusting?"

I could not remember whether Isidore of Seville had pronounced on the edibility or otherwise of locusts, but I spoke confidently:

"They feed cleanly on leaves, and have an appropriate form of locomotion. Six legged creatures should leap. Or fly, if they have wings."

"What about," Badwin paused while he studied the page, "these creatures that have *four* legs and wings? I've never seen anything like that."

"Then not eating them should not be troublesome."

"What about," Badwin looked downwards again, "these sea creatures without scales or fins. Does that mean we shouldn't eat oysters? Or lobsters?" His disappointed expression suggested that he did not share the cellarer's squeamishness.

"I think that you are all forgetting an important point," I said. "*We* are not bound by any of these rules. They were given to the Jews, to help lead them away from idolatry. Remember what Jesus said, when questioned by the Pharisees? Does anyone know the passage I have in mind? No? Will someone please find Matthew chapter 15, verse 11."

All looked downwards diligently, at whatever book was in front of them.

"I have found it."

"Read it out, please."

"It is not what goes into a man's mouth that defiles him. It is what comes out of the mouth that can defile him."

"There, I think the meaning is clear. Jesus taught that nothing is inherently impure or defiling. That must be true of God's creatures, however peculiar they may look. We can infer from this that we should not fear the world. We should not despise material things. Even if our vocations require us to set them aside, we should not make the mistake of thinking that they are inherently wicked. It is our words and deeds that make us pure. Or otherwise."

293

Godric, who had been reading during this, looked up and said:

"Surely we are bound by some of these rules. For instance: 'the man who commits adultery should be put to death'."

I was reminded of the attitude of the bishops at the Synod of Hertford, who had insisted that marriage be governed by inflexible laws.

"Of course we should not commit adultery," I said. "But as for being put to death, remember that Jesus taught forgiveness not vengeance."

"Here is another rule," Godric said. " 'If a man lies with a man, as he does with a woman, they have both committed an abomination, and should be put to death.' Surely that must be right?"

All the pupils looked expectantly. They knew, or thought they knew, the nature of my friendship with Hadrian. They were at just the age to be tormented by lustful thoughts, as I was in my youth. But they were luckier than I had been if they managed to banish those thoughts with books. While I tried to think of an answer, I looked at the animals carved on the furniture. Conforming to the stylistic conventions of the English, they writhed, as though in pain. A contorted eagle, its beak agape, topped a lectern, supporting a large open book with its ragged wings. A stag, stretched out as though on the huntsman's pole, perpetually escaped the hounds carved beside it on the lid of a book-chest. On the side of the chest, a boar thrust its tusked head from a chiselled thicket. The carver had tried to catch the animals' wildness and fix it in wood.

"Sometimes," I said, "our desires can be as fierce and uncontrollable as beasts." The pupils looked at me oddly, but none of them dared say anything. "Perhaps Isidore of Seville was wrong," I continued. He was, in fact, notoriously unreliable, but they did not know that. "Locomotion may not be the ruling principle. It may be that animals were permitted or forbidden, because of what they eat, and the manner in which they eat it. Both affect the passions."

"What do you mean?" asked Godric, looking puzzled, but

also hopeful, as though his question might after all lead in the direction he had initially intended.

"The permitted creatures, as we have observed, feed on grass. They do so calmly, without violence or passion. The forbidden creatures either feed uncleanly, or kill other animals and feed on their flesh. In doing so their passions are aroused, just as our passions are aroused by lust. Perhaps some animals were forbidden because they signify or provoke unruly desires. There are those who believe that, as monks, we should forgo all meat, just as we resist other temptations."

Godric said nothing. I stood up, and walked slowly to the door.

"Remember," I said. "It is not what goes into a man's mouth that defiles him."

I walked out into the bright sunlight of the courtyard. They waited a moment, but I heard them sniggering.

Later I told Hadrian what had happened.

"When I teach Latin," he said. "I sometimes get the pupils to speak in character. They take the part of a shepherd, a merchant, a cook, a fisherman or some other trade. It helps them to speak clearly and choose the right words. It also teaches me about English life. Recently, one of them spoke in the character of a huntsman. He told the class about hunting hares, stags and boar. He described how hounds are used to drive the prey into nets, where it can be killed."

"It sounds very bloodthirsty. I hope it didn't provoke unseemly excitement."

"No. I made another pupil speak in the character of a monk. That calmed them down. But my point is that Godric was acting like a huntsman."

"How?"

"You said yourself that they were probably all troubled by lustful thoughts. Perhaps Godric's thoughts were more lustful, or more troublesome, than most. His questions may have been an attempt to drive off those unwanted desires and trap them in debate, where they could be killed by mockery."

"Do the pupils ever mock you?" I asked.

"No."

Wilfred became puffed up with pride, or even more so. He thought himself a king-maker, above the petty rulers of England. After Etheldreda retired to her nunnery, King Egfrid had remarried. His new Queen disliked Wilfrid, and tried to persuade Egfrid that Wilfrid's holdings of land, and the military escort he had recruited, were a danger to the kingdom. Wilfrid responded by informing the King that, as Etheldreda was still alive, he was not free to marry again, and was committing adultery. He backed up his claim by referring to the Synod of Hertford, even though he had not attended it. Egfrid decided that Wilfrid had gone too far, and expelled him from Northumbria, dispossessing him of all his monasteries.

Wilfrid took refuge in Mercia, where he had previously founded a monastery, and where a group of his supporters, many of them armed, began to gather. He then wrote to me, pointing out that he had been illegally deposed and deprived of his property, and requiring me to support him against King Egfrid. Egfrid also wrote, claiming that Wilfrid had forfeited his see, and asking me to appoint a replacement.

I took the letters to Hadrian, who was writing in his room. His dark features were hard to make out in the feeble candlelight. He put down his reed-pen, and read the letters carefully, holding them close to his face.

"I think King Egfrid has done you a favour," he said, putting Wilfrid's letter on the table.

"Not entirely. He is not entitled to depose Wilfrid, or to replace him. Only I can do that."

"Then replace him. It's what Egfrid wants, and Egfrid is overlord of all England."

"For the moment. Aethilred's power is growing in Mercia. Remember how he sacked Rochester?"

"Kent is not as strong as Northumbria. Egfrid's power is secure, and you need him if the Church is to flourish in the North. Wilfrid is a liability. Take this chance to get rid of him."

"You have never liked him."

"And I was right. He has been nothing but trouble."

"He could cause more trouble from Mercia."

"He could, but who for?"

"Aethilred might take his side to provoke Egfrid. And that might upset my work in Mercia."

"He might, but kings don't like powerful bishops. Your division of Mercia served Aethilred's interest as well as the Church's. He won't act against you."

"But what will Wilfrid do if I back Egfrid and depose him?"

"What can he do? He has his monastery in Mercia, perhaps he will retire there."

"I hope you are right."

"So you will replace him?"

"Yes. Northumbria is too big. I will divide it."

I found three reliable men, consecrated them, and sent them north.

As soon as Wilfrid heard what I had done, he gathered his supporters and marched them to Kent. King Hlothhere, who might have objected to the armed retinue of a deposed bishop entering his territory, remembered that there were still some boar left in the forests of Sussex, and went back to hunt them. I was left to face Wilfrid alone. I ordered the gates of Canterbury closed, and had them guarded by men drawn from the cathedral and monastery estates. Wilfrid's party would have to come from London, approaching Canterbury from the west. The western walls of the city run along the banks of the River Stour, which forms a shallow moat. There is only one bridge still standing, which leads to the West Gate, where I posted lookouts. As soon as Wilfrid's entourage was sighted, I put on my vestments, draped the pallium over my shoulders, and walked to the gate.

Even though dispossessed, Wilfrid preserved the appearance of wealth. He arrived with nearly a hundred followers, an army by English standards, though many of them were servants. He rode at their head, on a chestnut horse with a soft, padded saddle over a fringed cloth. His grey cloak had been thrown back to show off a pure white linen tunic, edged with silvery silk. His hair and beard had turned grey, adding to the gravity of his bearing. It was nearly ten years since I had

installed him in York, and though he had aged, he was still handsome. He looked, no doubt deliberately, like a silver statue of a saint. With him were twenty or so young nobles, also mounted, who carried pennanted spears, and wore short swords hanging from their belts. The rest of the party were on foot, but many of them carried spears, and shields painted ostentatiously with crosses. It was difficult to tell whether they were capable of serious fighting, or merely enjoyed parading. In any case, though momentarily inspired by memories of old campaigns, I did not intend to fight. I ordered the gates open, and walked out onto the bridge, where I stood in Wilfrid's path. As I had instructed, the gates were closed behind me.

He rode forward, and without dismounting shouted out:

"You have robbed me of my office, my churches and my monasteries. I have come to get them back."

"I have robbed you of nothing. Egfrid exiled you."

"And you sent new bishops to take my territory."

"I cannot leave Northumbria without a bishop."

"You must restore me."

"You know that Egfrid will not have you back. You should not have provoked him."

"Is it wrong to remind an adulterer of his sins?"

"It may sometimes be unwise, especially if you are the one who advised his first wife to abandon him."

"Etheldreda chose to give her life to God."

"With your encouragement."

He drew breath to speak again, but I interrupted him.

"Do you want to stay here on the bridge, discussing the affairs of your patroness?"

"I have nothing to hide or fear from my followers. Open the gates and let us in."

"I will not let your followers in. Not with their weapons."

"We will not give up our weapons."

"Then we must talk here."

He looked back at his supporters, who had crowded forward to hear what we said.

"Tell me," he said, raising his voice. "Why have you

deposed me? Have I sinned, or committed any crime against the Church?"

"You have been proud and foolish. And you have disobeyed the decisions of the Synod of Hertford."

"You took those decisions behind my back."

"You were invited, but did not come."

"Duty kept me in York."

"Duty? Perhaps you were busy acquiring more monasteries, or enlarging your holdings of land."

"The monasteries help spread the word of God. The lands provide the means for charity."

"And enable you to live like a prince."

"It was you who made Chad ride when he would rather have walked. 'Bishops should not be too humble,' you said."

"You have certainly not been too humble. I will not accuse you of that."

"But will you restore me?"

"No."

"Then I will appeal to the Pope."

"His Holiness sent me here to govern the English Church. I am sure he will support my decisions."

"Pope Vitalian is dead."

"I am sure that his successors will continue his policies."

"We'll see." He turned his horse and rode back across the bridge, his followers quickly parting to let him through. On the other side he turned and shouted:

"I promise you this. I will return to York, and I will have all my properties back. And you will be sorry you did not support me."

Then he rode off with his followers, through the overgrown graveyard that fills the far bank, back towards London.

A few months later, in the spring of 678, a small group of monks arrived at the cathedral, bringing with them a wild and dishevelled man. His tunic was ripped and tattered, his hair was matted, and his face and long fingernails were crusted with dirt. He seemed to know me, and started to rant, accusing me of unintelligible crimes, until he was calmed down by

his companions. They begged for money to continue their journey, as pilgrims often do, but there was something odd, perhaps reproachful, in their manner.

"Who is this man?" I asked. I was prepared to be charitable, but his accusations, when they could be understood, were impertinent. He seemed to be suggesting that I was unfit to govern the Church. One of the pilgrims, cleaner than the madman, but almost as ragged, stepped forward and asked:

"Do you not know him, my Lord Archbishop?"

"No."

He shook his head sadly at my answer. "It is Wynfrid, my Lord."

"Wynfrid?"

"Wynfrid, whom you appointed to Lichfield, after the saintly Chad died."

It was hardly credible. Wynfrid, though disobedient later, had seemed intelligent and able when I first met him.

"How did he get into this condition?"

"You deposed him."

"I deposed Wilfrid, too, but it made him angry, not mad."

"It was what happened afterwards."

"I thought he retired to a monastery."

"He did." The speaker turned to his fellows and gave them a meaningful look. "Then he saw visions of the Holy Places, and gathered us up to follow him on a pilgrimage to Rome."

"God and Wynfrid be praised!" they all shouted. That started Wynfrid off again, and his ranting attracted a crowd of monks and idlers before his followers calmed him down.

"And did you get to Rome?" I felt exposed, surrounded by a rabble, who clearly hoped to hear me accused again.

"No we only got as far as France. We were arrested as soon as we landed at Étaples."

"By Ebroin's men?"

"How did you know that?" He glared at me suspiciously. There was some murmuring among the pilgrims, and I realised that they suspected me of conspiring with Ebroin.

"It is always Ebroin's men," I said quickly. "They detained me on my way to England." The pilgrims were silent. The

monks and idlers watched Wynfrid, hoping he would start ranting again. "Ebroin is my enemy," I said, to make my position clear.

"Ebroin's men thought Wynfrid was Wilfrid," the pilgrim said. "They were confused by the names. We tried to explain, but they wouldn't have it. They accused us of helping King Dagobert to usurp the throne. They accused you, too."

"That was Wilfrid."

"I know, my Lord. But they robbed us, stripped us naked and threw us into a filthy prison and starved us. Some of us died there. Wynfrid hasn't been the same since."

The pilgrims muttered angrily.

"How did you get away?"

"They realised that Wynfrid wasn't Wilfrid."

"How?"

"They discovered that Wilfrid was in Frisia. He was ship-wrecked there on his way to France, and stayed on to convert the pagans."

"So Ebroin released you?"

"Yes, but not straightaway. And we didn't get our belong-ings back. We had to beg a crossing back to England."

As he told the end of his story the pilgrims' spokesman lost his accusing manner. He seemed dejected. Wynfrid was clearly deranged, an extreme example, perhaps, of melancholy provoked by adverse circumstances. I knew of no cure for his condition. I gave them some money and they led Wynfrid away, back to his monastery in the Midlands.

Afterwards, though relieved that they had gone, I was puz-zled. Wynfrid's ranting, fortunately, was too incoherent to be taken seriously. The idlers had drifted away, disappointed. The pilgrims' spokesman had blamed me for Wynfrid's con-dition, and for their difficulties in France. There was no reason for that. They were merely confused. They had been demoral-ised by the capricious and enigmatic Ebroin, just as Hadrian and I had been, during our journey through France. My sup-port for Dagobert, though unwilling, had been aimed at Ebroin. He was, as I had made clear, my enemy. Yet it seemed that he was helping me, however inadvertently, by attempting

to arrest Wilfrid, who was also now my enemy. I found myself hoping that Ebroin would succeed, and prevent Wilfrid from reaching Rome. Power, I realised, pollutes all who hold it.

I learned later that Wilfrid quickly left Frisia and went to the Rhineland, where Dagobert had established himself as King.

"He may stay there," said Titillus, who had brought me the news. "King Dagobert has offered him the bishopric of Strasbourg."

"Has Wilfrid accepted."

"Not yet. He has let it be known that he considers himself to be legally Bishop of York."

"In that case, he probably intends to go on to Rome and lay a complaint against me."

"I cannot believe that his Holiness would uphold Wifrid's complaint," Titillus said. "Not if he knew how Wilfrid had behaved. And if the Pope does not support him, Wilfrid is unlikely to return to England. He may decide to accept the see of Strasbourg after all."

"I hope so. Then we will be free of him."

"We must draw up a case against him, my Lord, and send it to his Holiness." Smiling shyly, Titillus produced a bundle of documents from behind his back, and spread them out on the table. Then he drew up a stool and sat down beside me. That might have been impudent in anyone else of his rank, but he was a good and loyal secretary, and I did not rebuke him. "I thought we might begin with Wilfrid's encouragement of Etheldreda to leave King Egfrid," he said, picking up a letter from the table. I was impressed by his forethought, and that he seemed able to discuss Etheldreda without embarrassment, but I did not read the letter.

"We cannot hold that against him," I said. "She went into a monastery, and his Holiness can hardly object to that."

"But, my Lord, Wilfrid said publicly that Etheldreda was a virgin."

"Yes?" I studied Titillus's face for signs of redness.

"If she was a virgin, then her marriage with Egfrid was

invalid, and Wilfrid should not have accused the King of adultery." He did not blush.

"Provoking the King like that may have been foolish, but it was not uncanonical. I do not think the Pope will think it a sufficient reason to depose a bishop. I must put up a better defence than that."

"I have brought the agreement we drew up at Hertford," Titillus said, unrolling the stiff parchment. He weighted it with two of the carved masonry fragments I kept on my table for that purpose. "Look, my Lord," he said, pointing at the list of items I had persuaded my bishops to accept, only a few years earlier. "Bishop Wilfrid has broken every rule." Titillus drew himself up, sitting straight on his stool before reciting the charges. "He has interfered with the administration of monasteries, and acquired property from monasteries by unreasonable means. He has disputed territory with other bishops, and interfered in the affairs of other dioceses. He has claimed unwarranted precedence over other bishops, required excessive hospitality while touring his diocese, and refused to accept the division of his territory." Titillus took a deep breath. "And, Bishop Wilfrid has refused to accept the decisions of a synod. He may not have been at Hertford, but he was bound by the decisions made there."

"Thank you Titillus. You are right. He has broken every rule. He has even broken his monastic vows. He must once have promised poverty, humility, and obedience. The only thing he has not done is to break his vow of chastity. There is no evidence, is there, that he has been unchaste?"

"No, my Lord." Titillus hunched over the table, gathering up his documents, so I could not see his face.

"Will you draw up the charges, along the lines you have suggested?"

"Yes my Lord. Shall I include the matter of Queen Etheldreda?"

"I think not."

19

MIRACLES

A.D. 678–684

It was nearly two years before Wilfrid's case was resolved. By then, Titillus, though young, had relieved me of much of the burden of administering my province. I found that I was coming to depend on him almost more than I depended on Hadrian, who knew my faults too well to defer to me.

"We have received a letter from his Holiness Pope Agatho," Titillus said, pronouncing the name with pious reverence.

"Does it mention Wilfrid?"

"It does, my Lord. His Holiness says that he will consider the case if and when Wilfrid reaches Rome."

"Is that all?"

"That is all there is about Wilfrid, but there is another matter." Titillus unrolled the letter and studied its contents for a moment, even though we both knew that he had already read it. "His Holiness sends news from Constantinople," he said. "It seems that Constantine IV wishes to restore the Empire to orthodoxy."

"That is good news."

"But, my Lord, England is not subject to the Empire."

"No. But we are subject to the Church in Rome. And whether Rome is subject to Constantinople is a question that has been debated by greater men that us." Titillus looked blank. "You are too young to understand," I said. "And perhaps you have seen too little of the world. The Empire's troubles started long ago, before you were born, even before I was born. And it was because of those troubles that I left Constantinople and ended up here in England. The Empire was split by a heresy concerning the nature of Christ. There were people in the East, the monophysites, who thought He had only one nature. The orthodox position, which you

know well, Titillus, is that, though one person, He has two natures."

"Human and divine, my Lord, fused indivisibly, as body and soul are in us."

"Well done, Titillus. It is a simple idea, but some have tried to complicate it. The Emperor I served wanted to compromise with the heretics. He proposed the doctrine of monotheletism, according to which, Christ has two natures, but they are motivated by a single will." Titillus looked puzzled. "I expect you can see nothing wrong with monotheletism."

"Oh no, my Lord, I am sure it is very wrong indeed."

"The orthodox in the East certainly thought so. They rejected it just as firmly as the heretics did."

"So who *did* believe in it?"

"The Emperor Heraclius and his courtiers. When his grandson Constans became Emperor, we thought he would restore orthodoxy. But he avoided the issue, and refused even to allow it to be discussed."

"And that is why you left the Empire?"

"Partly. Rome was still orthodox. And I found happiness in Italy." I could see that Titillus was watching me expectantly. He liked to hear stories of my wanderings, but there were things I preferred not to tell him. "Constans died just as I was travelling to England," I said. "He was murdered."

"Murdered?" The Pope's letter hung loosely in Titillus's hands.

"In his bath, I believe. By a servant. That ought to have been the end of monotheletism, but I suppose Constantine was too busy fighting the Moslems to think about theology. Does that letter say how he intends to restore orthodoxy?"

Titillus looked quickly at the letter. "The Emperor is to summon a great council in Constantinople, where representatives of all parts of the Church will affirm their orthodoxy."

"And are we to send someone?"

"No, my Lord, his Holiness instructs you to hold a council of the English Church, and send him a declaration of its orthodoxy. There will be a council in Rome before that in Constantinople."

"I think, Titillus, that this may be the reason I was sent to England. My work here has been difficult, sometimes impossible, and some people have tried to undermine me. But here, at last, is a task I am uniquely fitted to carry out. I have been chosen for it."

"Yes, my Lord." Titillus smiled indulgently. "Shall I make the usual arrangements for a synod?"

Before I, or Titillus, could organise a Council, war broke out in the North, where the kings of Northumbria and Mercia were quarrelling over the province of Lindsey. Aethilred of Mercia summoned his allies from the lesser kingdoms, and Hlothhere, unable to escape by hunting, was obliged to lead the Kentish contingent in person. He made the best of it, and, mounted on his best bay horse, wearing a gilded helmet topped with the crested figure of a boar, and a rich, red cloak over his mail-coat, led his thegns out of Canterbury. He had been so unhelpful to me in the past that I refused to bless his troops.

A few weeks later Hlothhere and his men returned to Canterbury, waving dead men's swords, wearing plundered clothes, their wagons piled with booty. The Mercians and their allies had defeated the Northumbrians and annexed Lindsey. King Aethilred declared that he, not Egfrid, was overlord of all England. Hlothhere's men were overwhelmed with unexpected success, and spent weeks feasting and drinking, singing incoherently of their feats, and gambling away their loot.

I learned about the battle, not from them, but from Imma, a Northumbrian prisoner of war. Imma was brought to the monastery by a Frisian slave-trader, who had bought him from some Mercians. He claimed to have witnessed a miracle, so I had him brought to me. He was a well-made young man, tall and fair-haired, dressed in the brown unbelted tunic of a slave. One side of his otherwise handsome face was marred by an ugly scar. I asked him how he had got it.

"It was in the battle against the Mercians, my Lord Archbishop."

"What happened?"

"We met the Mercians at the River Trent, near Lincoln. It was a great battle. There were hundreds of us on each side."

"What was King Egfrid's strategy?" I asked, thinking I might impress him with my knowledge of war. Young men tend to think that the old have always been what they are, and that they know nothing of the world.

"Strategy?"

"Plan of battle."

"There was no plan, my Lord. None that I know of. Battles are not won by plans but by fate and courage. When we knew that the Mercians were near, we formed a shield-wall and advanced. When we saw them, we shouted our war cry and charged. When our two lines met we fought."

"On foot?"

"With respect, my Lord, you know little of war. No man would risk his horse in battle. It would be pointless. You can't use a sword or spear perched on a horse."

"I have seen it done," I said. "It was in the East."

He looked sceptical. "We fought on foot, as we always do. I killed two Mercians with my spear, before it broke, and would have killed more with my sword, if I'd had the chance. We were pushing them back. We'd have had them in the marshes. We knew the country and they didn't. But Aelfwin, King Egfrid's brother, was killed. It was just as Bishop Wilfrid prophesied.

"Wilfrid prophesied that?"

"Yes. When Egfrid exiled him. Wilfrid said that, a year from then, he would have his revenge, and the King would shed bitter tears. And it came to pass! God has vindicated the holy Wilfrid!"

I could not believe that God had obliged Wilfrid by sending the Mercians to defeat the King who had expelled him. It seemed much more likely that Wilfrid had contrived his own revenge, probably while on his way to confront me at Canterbury. He must have told Aethilred that Mercia was not big enough, not worthy of him, that he was the rightful King of all England. Perhaps Wilfrid repeated, or invented, some

Northumbrian insult, leaving Aethilred to brood on revenge until he was safely out of the way.

While I brooded on Wilfrid's meddling, Imma went on to tell me how, in the confusion after Aelfwin's death, he had been wounded and left for dead. When he recovered, he was alone on the battlefield, surrounded by stripped corpses.

"So you survived. Is that the miracle you have come to tell me of?"

"No, my Lord Archbishop. I am coming to that. When I realised what had happened, I washed my wound and bandaged it with moss and linen, then tried to escape into the marshes. I could see that other survivors had gone that way. But I was caught by one of King Aethilred's thegns."

"What made him spare you?"

"God forgive me, I told a lie. I said I was a peasant, serving in the baggage train. He would have killed me had he known I was Aelfwin's thegn."

"I think you may be forgiven for trying to save your life."

"I saved it, but I was enslaved. I was chained, and once my wound healed, they set me to work."

"There are worse things than work, even for a thegn."

"I know, my Lord. But it seems that God did not intend me to be slave."

"Why is that?"

"My chains kept falling off. That was the miracle."

"Chains rust. Fetters can work loose. You look a strong fellow, but your wrists and ankles are thin."

"It was a miracle my Lord. My brother is a priest. He must have thought I was dead. He would have said Mass for me. My chains always fell off at the hour of the Mass."

"So you think you were set free by divine intervention?"

"Not set free. Only unchained. When my captors saw what was happening, they accused me of working magic. I told him I was a good Christian, and that my brother was a priest. They kept a close watch on me after that, and they saw from my speech and manner that I was not a peasant. They made me tell them who I was. They were furious when they knew I was Aelfwin's thegn. They threatened to kill me."

"It does not sound much of a miracle."

"I haven't finished. They sold me to a Frisian. He took me to London, but he could not keep me chained. My fetters fell off, just as they did before."

"At the time of the Mass?"

"Yes."

"And the Frisian brought you here?"

"Yes my Lord. He is willing to free me, if I can raise a ransom."

If what Imma said was true, then I suppose it must have been a miracle. The story certainly impressed the Frisian, who demanded a high price for such a remarkable captive. I could not help thinking of Imma as a fellow victim of Wilfrid's schemes. I gave him some money and sent him to Hlothhere, who, made generous by victory, paid the rest.

Hadrian, though he had long ago warned me about Wilfrid, did not share my view of his ubiquitous influence.

"You make him sound like the Devil," he said. "And I seem to remember you warning me against attributing too much power to the Devil. It leads to Dualism, doesn't it?"

"When Wilfrid came here, and I faced him on the bridge, he said I would be sorry I did not support him. Now he's stirring up trouble, turning one part of my province against another. How can I convene the bishops and produce a statement of orthodoxy, with England at war with itself?"

"These English kings need no encouragement from Wilfrid to go to war. And now Egfrid will want his revenge. Doubtless he'll kill one of Aethilred's relatives. Then Egfrid will retaliate, and so on. There will be endless bloodshed, and England will slide back into chaos." Hadrian paused for a moment, thinking. "But you're right about one thing. Whether Wilfrid is behind all this or not, your work will be much more difficult now."

"Aethilred might pay blood money," I said. "The law allows that."

"Kings prefer warfare. There are more opportunities for looting and conquest. They won't end their quarrel peacefully

without persuasion. You must make peace. You must write to the two Kings and offer to mediate."

I did as Hadrian advised, and a few months later Egfrid, Aethilred and I, and a crowd of scribes and officials, met at a monastery in Ely. There, under a high-ridged roof, from which wisps of thatch kept falling, dislodged by a growing gale, the two Kings signed and sealed a treaty. Aethilred paid blood money to Egfrid, and the two Kings agreed to accept their present frontiers and end the war. The result, whether Wilfrid had stirred up the trouble or not, was several years of peace, increased authority for the see of Canterbury, and a growing acceptance of Christian rather than pagan means of settling disputes.

When I returned to Canterbury, I was met by Hadrian, who was waiting for me in the grassy outer courtyard, where geese wandered among the monks who were picking apples and piling them in baskets.

"Benedict is here," he said, as soon as I was inside the gates.

"In the monastery?"

"Yes. He has been here for a week, on his way back from Rome."

"From Rome? Again? Well, I suppose it is long way from there to Northumbria, and he must break his journey somewhere. But I didn't expect to see him here again."

"Neither did I. But he wants to see you, and he's not alone."

"Who is with him?"

"He has a brought a large retinue of monks. They are filling the guest rooms and eating our store of food. But he has also brought John, a singing teacher from Rome."

"A singing teacher! But I have written to His Holiness several times and not been sent a singing teacher."

"I know. And I don't think John is just a singing teacher. I think he is a spy."

"A spy? Surely His Holiness would not send a spy here?"

"Why not?"

"He trusts me. You saw his letter asking me to summon a council."

"He may trust your orthodoxy, but Wilfrid's complaints will have raised doubts about your government of the Church. And who knows what Wynfrid might have said while imprisoned in France."

"Do you think I have governed the Church badly?" I asked, perhaps a little too loudly. Hadrian looked around at the monks, who had stopped picking apples, and were watching us curiously.

"Of course not," he said, taking my arm. "No one could have governed it better than you. I know I couldn't, and it might have been me. But anyone in power makes enemies. There are always those who think that your power should have been theirs, or that you are exercising it unfairly. I know that from my time at Niridano. They were jealous when I was elected. Their rumours would have undermined me, had I stayed on." He stopped, and looked at me anxiously.

"So your Papal summons . . ." I began.

"Came just in time," he said, gripping my arm firmly. "Let us go to your room."

As we walked towards the inner courtyard he changed the subject: "John and Benedict have thoroughly inspected the monastery."

"That is understandable," I said, still thinking about what Hadrian had almost revealed. "We have improved the buildings since Benedict left, and he has his own monastery now. He may be looking to us for examples of good practice."

"I doubt it. He has made it clear that he does not approve of the way I rule the monastery."

We reached my room and sat down.

"John has been asking a lot of questions," Hadrian said. "He wanted to know what you were doing in Ely."

"He may be concerned about conditions in the North. England is an unknown and possibly dangerous country to him."

"They have also been to the cathedral. I think they questioned the clerks and poked around in the archives."

"They had no business doing that."

"I can't be certain that they did. But we must be careful."

We summoned Benedict and John to my room. Though it was ten years since we had first met, Benedict had not changed much. His hair was greyer and sparser, but he still wore fine linen clothes that hinted at his noble status without denying his monastic vocation. And he still spoke in a rush, assuming that all who heard him would be interested in his deeds and opinions.

"Theodore!" he said. "My lord Archbishop! How pleasant it is to be here, and how much you have improved the buildings! This room is just the same, though. You have not persuaded Hadrian to make it more comfortable for you. He should look after you better. Perhaps you should speak to King Hlothhere. As you know, King Egfrid has granted me land at Wearmouth and I have founded my own monastery. I hope to found another soon. Pope Agatho has granted me independence and immunity from royal or episcopal interference. I have his letter here. Thanks to King Egfrid's generosity, I have built a magnificent church. I had craftsmen sent from France and Italy. The glazing is magnificent, and you should see the vestments and vessels I had sent from Rome. But it is all to glorify God, of course. It is not done for our comfort. As you know, I do not care for luxury. I have brought some valuable books and relics from Rome. I have been there five times now. I have a book for you. It is a manual of liturgical singing. I thought you might find it useful. And having attended your church, I find that I was right."

"You are very kind," I said, taking the book.

"Unfortunately, I can't give you my singing teacher, though you evidently need him." He nodded towards John, a small, dark man dressed in grey, who had remained silent throughout Benedict's speech. "His Holiness has instructed me to take him to Northumbria, where he is to train my monks in plainchant. I hope we will soon have music worthy of my buildings."

"My lord Archbishop," said John, stepping forward. "I too have something for you. It is from his Holiness." He offered me a thick bundle of documents. "It is a copy of the decisions of the Council held in Rome by Pope Martin in 649."

"I remember it well." The council was called soon after I arrived in Italy.

"His Holiness wishes that you use these documents as the basis of your declaration of the orthodoxy of the Church in England."

Though glad to have tangible support from the Pope, I was affronted by his Holiness's assumption that I could not define orthodoxy or recognise heresy unaided.

It was not until the following year that I was able to organise the Council, which met in September 679, near Hatfield. Titillus chose the monastery, as it had a large assembly hall built of brick and stone, as well as the usual wooden buildings. He had the hall furnished with chairs, benches, and bales of straw, ready for the waiting crowd. Even so, many had to sit on the floor. None of the bishops who had attended the Synod of Hertford were there. All of my original appointments, and some of their successors, had died, been deposed, or retired to monasteries. Instead, among the company of monks, priests and teachers, I faced a dozen bishops, all recently appointed, of whom I could name only a few, though I had consecrated them all. My memory of recent events has become unreliable lately, though I can remember my youth clearly. The faces in front of me were all decades younger than I was. I knew that they would listen to me with respect. I had deposed Wynfrid and Wilfrid, divided dioceses when necessary, and made peace between the two most powerful Kings in England. Wilfrid, of course, was not there. He had gone to Rome to pursue his complaints against me. But I almost wished he was there, to witness my theological triumph. Even he would have had to admit that, of all the priests in England, I was uniquely fitted to identify and explain the heresies of the East.

I began by telling them of the monophysites, who denied Christ's human element, thinking Him wholly divine. I explained how denial of God's full presence in the world can lead to a rejection of worldly things, and even to Dualism. I did not mention my heretical youth, but pointed out that the Monophysites had been twice conquered, first by the Persians,

and then by the Moslems, by whom they were now ruled. I then described the meeting I had attended at Ani, in the mountains of Armenia, where Heraclius had proposed the doctrine of monoenergism, which he hoped would be accepted by both orthodox and monophysite Christians. As I spoke, my mind filled with memories of war, conquest, peace and disaster. I moved on to describe the last years of Heraclius. The Emperor and his Patriarch had realised that monoenergism had failed, and issued the Ecthesis, which set out the doctrine of monotheletism. That doctrine, I reminded the bishops, who were listening patiently, preserved the orthodox belief in Christ's two natures, but yoked them together with a single will. I recalled, sadly, the unhappy years in Constantinople, when, after the death of Heraclius, his son Constans had forbidden all discussion of Christ's nature or attributes.

I noticed that some of my audience looked rather drowsy. I woke them by banging a heavy document on the table. It was the copy of the decisions of the Council held in Rome by Pope Martin, that Pope Agatho had sent me. Most of the bishops had been boys then, and some not even born. They would not remember that Pope Martin had been arrested and exiled by Constans. His offence was to convoke over a hundred Italian bishops, who condemned monotheletism and excommunicated the patriarchs who had supported it. That Council, thirty years before, was the last time a Pope had dared openly to disagree with an Emperor in defence of orthodoxy. The Church had been split, though silently, since then. I finished my speech by reminding the bishops of the Council of Chalcedon, which in 451 had fixed the orthodox doctrine of Christ's nature:

"Christ is one person, composed of two natures. He is both human and divine. His two natures are indivisible, and each perfect in itself. He is both perfect man and perfect God."

The response was polite, but not enthusiastic. I had not expected disagreement, but hoped, perhaps, for earnest requests for elucidation, or a little more of the historical background with which I had illuminated my speech. There was so much more I could have told them. But the bishops

showed no desire to explore the matter, and declared their orthodoxy without further discussion.

We moved quickly on to the routine matters that were planned for the rest of the Council, and spent far longer discussing the boundaries of dioceses, or the jurisdiction of bishops over certain monasteries, than we had devoted to Christ's nature. Titillus drew up a declaration of orthodoxy, which we all signed. John the singing teacher attended the Council as an observer, and was due to return to Rome soon afterwards. He insisted on taking the declaration with him, and presenting it to the Pope. I sent Titillus with him, as he had said that he wished to make a pilgrimage. It was not easy sending him away, and I wondered how I would manage without him. But, though Titillus had ability, he lacked experience, and I knew that the journey to Rome, and the things he would see and do there would make him fitter to serve me, and, perhaps, one day, to succeed me.

Afterwards, I remarked to Hadrian that the bishops had shown little interest in my address.

"It wasn't your fault," he said. "I am sure you spoke beautifully, and no one could have explained the issues better than you."

"But they were bored."

"The English had their own heresy. Something about free will, if I remember rightly. And while the East was split by Monotheletism, the English were squabbling about how to calculate the correct date of Easter. It seemed more important to them. As you said yourself, it all happened a long time ago."

"So I am old and irrelevant?"

"No. You've done exactly what the Pope asked of you. And that's bound to count in your favour, when Wilfrid's case comes up."

Wilfrid's case was decided soon after we affirmed our orthodoxy in Hatfield, but it was some time before I learned the result. Titillus was delayed in France, not, as I feared, by Ebroin, but because John insisted on visiting Tours, where he

was taken ill and died. After John was buried, Titillus resumed the journey to Rome, carrying the declaration of orthodoxy he had drawn up. He arrived too late to attend Wilfrid's hearing, but spent a few weeks in Rome, where he hoped to visit the Holy Places, about which he had often asked me. The following March he returned to Canterbury, and I was surprised by the change in his manner and appearance. He seemed older, and more confident, almost handsome. His face, no longer concealed by a floppy fringe, was fuller and tanned by the sun. His body, too, had filled out.

I rose from my chair to greet him.

"I am sorry about the delay," he said looking at me directly. "I wrote to you from Tours. I hope the letter arrived." He had brought with him a bag of documents, which he placed on my table.

"Yes it did. I am sorry about John. But what happened in Rome? Did you meet Wilfrid?"

"He was waiting for me."

"Had his case been heard?"

"Yes. And he didn't need to tell me the result. I could see it in his face."

I could see the outcome in Titillus's face, too, even though he stared downwards, shuffling his feet. In his embarrassment, he was reverting to his old, maladroit self.

"He has won then?"

"I am afraid so." He looked up again. "His Holiness found Wilfrid innocent of all your charges, and ordered that he be restored to the see of York and given back all his property."

I felt weak and dizzy. The ground seemed to shift beneath me. Titillus gripped my arms and gently helped me back into my chair.

"His Holiness did support you in one matter."

"What was that?"

"He has agreed that Northumbria should remain divided."

"Well, that is something I suppose. But not much."

"Unfortunately, his Holiness has directed that the bishops you appointed be deposed, and that Wilfrid should choose their replacements."

"How can the Pope expect me to govern the English Church if he undermines me like this? How can he have found Wilfrid innocent? My charges made everything clear."

"Wilfrid made everything look far from clear."

"How?"

"He claimed that you bribed the King of the Lombards to stop him reaching Rome."

"The King of the Lombards! It was the Lombards who destroyed my monastery in Italy. They are heretics and barbarians. How could anyone believe that I would bribe their King, or that he would be influenced by me?"

"I don't know, but they did believe it, and the story won him a lot of sympathy in Rome."

"But Pope Agatho trusted me. He asked me to arrange our declaration of orthodoxy."

"And sent John to make sure you did."

"You have presented the declaration to his Holiness?"

"No. I couldn't. Wilfrid took it from me."

"And you let him? How could you?"

"He is a bishop, my Lord. I am a clerk."

"Of course. I am sorry. You had no choice. But why? What will he do? Hide it and claim that we are all heretics?"

"No. He has appointed himself the representative of the English Church. He intends to present the declaration to the Council."

"When will it meet?"

"Any time now."

"Could you not have stayed and witnessed it."

"No. Rome is a holy place, but Wilfrid made it seem tainted. He wandered the city with gold, buying books and relics, which he expected me to carry. He seemed to think I would be glad to be his servant, though he had plenty of followers with him. He made me write out labels for all the relics, with descriptions of the miracles each saint performed. Instead of seeing the Holy Places, I ended up cataloguing bones. Some of those bones didn't even look human. I couldn't stay. I thought it best to come back and warn you. Wilfrid will be

back soon, with the Pope's authority to take back his property and position."

On March 27 680, Pope Agatho held the Council in which representatives of all the Western Churches confirmed their orthodoxy, from which delegates were sent to a Council in Constantinople later that year. After that, the Church was unified, though I believe that some Greek theologians proposed a further compromise, maintaining that though Christ is motivated by two wills, the human will is always in perfect accord with the divine will, giving the appearance of a single will. If so, no one thought it worthwhile to disagree.

Wilfrid, who was improperly representing a minor province of the Western Church, managed to contribute to the Council in such a way that he was remembered for years afterwards as the bishop who made England orthodox. He left Rome triumphant, but, when he reached France, was arrested by Ebroin's men. Wilfrid swore that he had played no part in Dagobert's restoration, which he blamed entirely on me. He corroborated his story by telling the Franks how I had helped make an alliance between Dagobert's grandfather and the Empire. Perhaps I told him about it, when we first met, at York. He was a sympathetic listener, then, and most interested in tales from the East. But if I did tell him, I have no memory of it. And how odd fate is! Had I not made a fool of myself with a nomad horseman, so many years before, I would not have chanced across the information that led to the Frankish alliance, and Wilfrid would have lacked that telling detail to substantiate his lies. We pay for our follies in the end.

Wilfrid was released and resumed his journey to England, though he avoided Canterbury and went straight to Northumbria. Had he come to Canterbury, I do not think I could have spoken to him. I had decided that there was little I could do. I could not disobey the Pope, nor could I overrule King Egfrid, even though I had helped him make peace. I waited, thinking it unlikely that Egfrid would have Wilfrid back, whatever the Pope decided. When he reached York, Wilfrid showed Egfrid the Papal Bull requiring the King to restore all

his property, and the judgement that confirmed his bishopric. Egfrid, ignoring the seals and stamps that embellished the Papal documents, had Wilfrid imprisoned.

Wilfrid spent nine months in prison, and his supporters, of whom he has a surprising number, claim that he performed several miracles there, and was impossible to chain. But English chains seem to fail so often that one must suspect defective smithery rather than divine intervention. Wilfrid was eventually released, and exiled from Northumbria again. He set off with a band of followers and began to wander England. He was welcomed at first in Mercia, but not for long. He went to Wessex next, but was soon obliged to move on.

Wilfrid settled eventually in Sussex, beyond the vast forest that stretches from West Kent to the Isle of Wight. I have only seen the edge of the forest, but that was enough for me. It is dark and green, and full of fallen trees, soft drifts of leaves, and bramble thickets that make it difficult to cross. I thought it silent and empty, but I was assured that in clearings in its depths, and in the downlands beyond, live some of the last of the English to remain pagan. The South Saxons live as they must always have done, even before they arrived in Britain, in small, scattered villages surrounded by patches of farmland. Only a few monks have settled among them, looking more for solitude than for converts.

But Wilfrid was lucky, even in that wilderness. Aethilwalh, the King of Sussex, had just returned from Mercia, where he had been baptised. He asked Wilfrid to help convert his subjects, and offered him land to found a monastery. Ejected from every other kingdom in England, Wilfrid had little choice but to accept.

However, Wilfrid could not live in exile without attracting attention to himself. Not long after he settled in Sussex, he, or his followers, let it be known that he performed several more miracles, including ending a drought and feeding the victims of a famine. The second feat was achieved by remarkable means. Wilfrid noticed that the South Saxons, despite living by the sea, knew little of fishing, though they caught eels in the local rivers. Some of Wilfrid's men collected eel-nets from

the starving people, and threw them into the sea. When the nets were pulled out they were, by divine intervention, filled with fish of all types, which were distributed to the starving. It is typical of his presumption that he claims, not only to have fed a multitude, but to have done so by multiplying the number of available fish. I am only surprised that he did not give them loaves, as well.

Hearing of Wilfrid's putative miracle, I remembered the fishermen who fed me when I walked the Cilician coast, failing to reach Athens. Each evening they made soup out of the unsold portion of the day's catch. They used fish that were too small, ugly or tasteless to attract a buyer, or varieties that, because of their shape or markings, were considered unlucky. With some leeks or onions gently fried in oil, a jug of wine, and whatever herbs and vegetables came to hand, those fishermen used their skill and judgement to transform unprepossessing sea creatures into a delicious soup. That seemed to me a sort of miracle, though no natural law was violated.

I wrote down, in as much detail as I could, what I remembered of the fishermen's methods. Then I wrote out the instructions for stewing eels in red wine. I sent both recipes to Wilfrid, sure that, even in exile among the savage South Saxons, he would have with him a cook able to make good any defects in my instructions.

I think I am free of Wilfrid. The obstinate paganism of the South Saxons keeps him too busy to disrupt my work. He has the confidence of King Aethilwalh, can play the bishop, has founded a comfortable monastery, and those he has converted seem credulous enough to believe him a miracle worker. There seems to be no reason why he should leave Sussex and trouble me again. In his absence, my work has gone well. After my peacemaking between Northumbria and Mercia, England has enjoyed several years of calm, and the Church has flourished. I have done what Pope Vitalian sent me to do, despite his successors' lack of support, and Wilfrid's interference. I hope I will not be thought vain if I declare that my province is well organised, properly governed, and thoroughly orthodox.

It is also more learned than it was when I arrived. Hadrian's school has flourished. Many of our first pupils have become teachers, either joining the community at Canterbury, or returning to their own churches and monasteries to share their scholarship. Benedict's monastery, augmented by a second foundation at Jarrow, has spread learning and culture in the North. As well as importing books, we have begun to produce them, some good enough to have been well received in Rome.

I have devoted much of my time to writing a series of biblical commentaries, which is consoling work for an old man who knows that he will soon face death and Judgement. It is pleasant work, too, with Titillus beside me. He does not defer to me quite as much as he did, but he asks questions, clarifies my thoughts, and gently leads me back to the point— all services I performed for George the Pisidian when I was his age. Also, when Titillus is not around, I have been writing this book. He knows I am writing it, of course, though he may be disappointed that I have written most of it in Greek, a language he has not mastered. Perhaps he will learn Greek one day. He might even write my final chapter. There is not much left for me to do, and nothing more to tell. My health has declined, and there are days when I cannot get out of bed. Often, when I can, I cannot remember what it is I am meant to be doing, unless someone reminds me. I try to remember remedies, but there is no cure for having lived far longer than anyone else.

20

WILFRID'S REVENGE

A.D. 685–690

Hadrian came to my room, an icy wind following him through the door. Though it seemed only a few hours since dawn, the sun had already set, and Hadrian's face was feebly lit by the candle he shielded with a cupped hand. I was in bed, and he helped me to sit up, slipping a cushion behind my back. As he did so, his face came close to mine, and I saw how lined it was. He was nearly sixty, and the tight curls that ringed his shaven crown were quite grey. We had known each other for a long time. He sat on the bed and took my hand, reminding me of the time, more than thirty years before, when he crept onto my mattress after discussing Plato's *Symposium*. Though that night had seemed cold at the time, it was warm in comparison to the endless English winter. I remembered the years in Italy, when I picked grapes and drank wine, and when Hadrian was young. For a while, during that deceptively happy time, he was everything I had ever desired. But our feelings for each other had altered, ebbing and returning, like the tides that wash the English coast. Even before age reduced the urgency of all my appetites, my feelings for him had changed. He had, I thought, betrayed me while I languished in Rome. I was wrong to think that. All pupils become independent of their teachers, and the best outdo them. Hadrian was entitled to pursue his own vocation. My resentment was, perhaps, a result of my guilt and shock after the death of Abbot Hilarion. Later, when Hadrian reappeared in Rome, he too seemed afflicted by guilt, and I betrayed him by failing to understand his altered condition. I abandoned him in France, then despaired of being able to do my work without him. He had recovered his strength of mind after reaching England, and I had relied on him for support and

advice. We had, I thought, despite separation and misunderstanding, formed just such a bond as I had hoped for in my youth. The wish for that bond had proved stronger than our vows, though the bond itself had strengthened our vocations. I wondered, which is the most important: what we have promised to do, or how we have promised to do it? Had I kept all my vows, Hadrian would only have been my pupil, and I would have died, violently near Naples, or old and lonely in Rome.

Hadrian interrupted my thoughts with the news he had come to tell me.

"I've just been told that a Saxon army is approaching Canterbury."

Violent death no longer seemed hypothetical.

"I thought Wilfrid would be content to stay in Sussex," I said. "But he must be behind this. He has stirred up King Aethilwalh and turned him against Hlothhere."

"So it would seem."

"Is Hlothhere ready?"

"I hope so. But remember how he disappeared when Dagobert came. And when you faced Wilfrid on the bridge."

"Will he run away this time?"

"I don't think so. His thegns won't let him. They are strengthening the walls now."

"But we are outside the walls. How can we defend the monastery? And the cathedral?"

"I don't know. We can't summon men from the estates. Hlothhere has called them up."

"Have you asked him for help?"

"Yes, but he says we must defend ourselves."

"Do you remember how the Lombards took the monastery of Saint Anastasius and killed Hilarion?" I asked.

"I remember it very well. I was in Niridano at the time, and you were away in Rome."

"But I was there when they first came, and we could do nothing against a few armed men. How can we defend ourselves against a Saxon army?"

Hadrian gripped my hand. "I'll do what I can," he said. "I

will send some monks to secure the cathedral. Shall I leave the vestments and vessels there? Or bring them here?"

"Bring them here, I think."

I did not sleep well that night, but lay awake remembering Dvin, the city I had seen destroyed in Armenia. When I did sleep, I dreamed that I was endlessly piling stones, ready for the catapults that would demolish the city walls. Some time after dawn I was woken by a great shout from beyond the monastery walls. It was the battle cry of the two armies. The Saxons had reached Canterbury. I could not stay in bed. I called for help, and was dressed and taken up the stone steps to the refectory, where Hadrian had gathered most of the monks. From there we could see over the monastery walls, and watch some of what was happening beyond them.

The Saxons arrived from the west, and attacked that side of the city first. They had no catapults, and could only circle the city looking for weak spots. Hlothhere had nearly two miles of walls to defend, and only a few hundred men. He concentrated the best of them at the gates, and stationed a few men on each of the towers that, though crumbling, still rose above the walls. We could see the East Gate, which is only a few hundred feet from the monastery. The men defending its towers, armed with makeshift spears and slings, looked more like peasants than soldiers. When the first Saxons arrived, the defenders showered them with stones and spears, then hid behind their dilapidated ramparts. The Saxons were the most savage looking of all the English that I had seen. They wore mud-splattered leather trousers, and were wrapped in cloaks or animal skins, but despite the icy cold many were bare chested underneath. Shaggy hair and unkempt beards hung from under their helmets, which were topped with studded ridges or bristling crests. A few dozen of them rushed the gate, clashing their shields and shouting, "Out! Out! Out!" But the gates were firmly closed, and no one came out. The attackers hacked with swords and axes, but the barred and bossed oak was too strong, and they could achieve nothing. The defenders dislodged heavy stones from the towers and began to drop them on the Saxons, which made them withdraw,

unfortunately in our direction. They noticed the monastery gates then, and charged towards us. We could not see them after that, but we heard the noise they made, hammering and shoving against the heavy timbers. When the battering started, many of the monks in the refectory panicked, and began to wail and cry. Hadrian made them kneel and pray, asking for deliverance from the savage Saxons.

We were delivered, but by Hlothhere's men. Some archers, of whom he had only a few, were sent up the gate-towers and began to shoot at the Saxons, who had their backs towards them while they were attacking our gate. English archers, peasants equipped with clumsy longbows of rough elm, are not such good shots as the Persians or Khazars, but at that range Hlothhere's men could not fail to hit some of the Saxons. The battering stopped immediately, and we saw the Saxons rushing back towards the city. When we were sure that they had gone, we opened the postern, and found three wounded Saxons lying on the icy ground. They were brought in and, remembering what I had learned in the East, I advised on their treatment. Two of them died within hours. They wore no armour, and had wounds that no bandage or poultice could cure. The third was luckier. He had received a glancing wound to his leg, which we bandaged tightly to prevent him from losing too much blood. He survived, and spoke in our favour later.

Most of the fighting took place elsewhere. The main body of the Saxon army kept up its attack on the west of the city. Hlothhere had fortified the bridge by the West Gate, on which I had faced Wilfrid. But the Stour is shallow, and the Saxons were able to cross it easily. Small bands of Saxons continued to roam the walls, attacking weak spots and forcing Hlothhere to divide the defenders, sending his archers scurrying from one tower to another. After several hours of inconclusive manoeuvring, a small party of Saxons waded across the Stour by the old London Gate, which was disused, as the bridge to it had long ago collapsed. They managed to set fire to the gate, and soon more Saxons were forming up, ready to rush through when the timbers collapsed. Hlothhere,

seeing what was happening, opened the West Gate and led his men out to attack the Saxons. They crossed the bridge, cut through the few Saxons on the far bank, then circled through the old Roman graveyard to reach higher ground. Then they attacked the Saxons from the rear.

At first, Hlothhere's men had the advantage. They were charging downhill, and the Saxons were penned up against the Stour. But the Saxons formed a shield-wall and took the force of the Kentish attack without breaking. They slowly withdrew, and made a stand on the flat land to the south west. There, with a loop of the Stour behind them, they halted the Kentish army and began to drive it back. They fought for the rest of that short day, thrusting with swords and spears, punching with shield-bosses, hacking with axes, locking shields and shoving. By dusk, Hlothhere and most of his army were dead. While they fought, flames from the burning gate spread into the city, destroying a quarter of its wood and wicker buildings. That night, while Canterbury still burned, Eadric, Hlothhere's young nephew, whom the Saxons had brought with them, was given the Kentish throne.

The Saxon soldiers had to be allowed the rewards of victory, so the city's houses were looted, its women were raped and its livestock roasted. Late that night, long after I had gone to bed, I was woken by Hadrian. He wrapped me in a warm cloak and took me to the infirmary. There, bundled in a blanket, was a body. Caked blood covered the face, which was split by a sword blow from brow to chin.

"Who is it?" I asked.

"Titillus."

"Titillus?"

"I thought you would want to know."

"How did he die?"

"He was killed by a drunken Saxon."

"But why?"

"What reason do drunken Saxons need?"

"He was at the cathedral."

"He stayed there throughout the battle. He was killed on the way back."

"He was thirty-five years old."

"He seemed younger."

"He was a good scholar."

"He was."

"I had such hopes for him."

"Yes."

"I had hopes for England."

Flames from the burning town lit the sky, reddening the walls of the infirmary. Hadrian led me back to my bed.

Nearly a year after Hlothhere's death, Erconwald, Bishop of London, travelled to Canterbury to see me. The winter had undermined my health, and I received him in bed. He did not remove his cloak, but gathered it round him as he sat on the carved chair that, long ago, King Egbert had given me.

"My lord Archbishop, I can see that you are unwell."

"I am well enough, considering my age."

"Are you well enough to talk?"

"Of course."

"I have come to see you about Wilfrid."

"I would much rather not talk about him."

Erconwald only paused for a moment. "You know he was behind Aethilwalh's invasion of Kent?"

"I know."

"Well, King Aethilwalh is dead."

That sounded like good news, considering the damage Aethilwalh had done to Canterbury, but Erconwald's expression warned me that he did not share that view. "How?" I asked.

"He was killed by Caedwalla."

"Who is he?"

"Caedwalla is a pagan prince, my Lord. He was exiled from Wessex, and has stirred up his fellow unbelievers against Aethilwalh's policy of conversion."

"That will make things difficult for Wilfrid."

"It might, but for one thing."

"Which is?"

"Wilfrid has made friends with Caedwalla."

My mind was still befuddled by sleep and illness. What Erconwald told me did not seem to make sense. "Made friends?" I asked. "With the man who killed his patron? With a pagan?"

"It seems that Wilfrid can be very forgiving, when he wants to. And he knows what is to his advantage. He has become Caedwalla's spiritual adviser. I believe Wilfrid hopes to convert him."

"This Caedwalla does not sound like a promising convert."

"Perhaps not. But he will listen to Wilfrid, if Wilfrid tells him what he wants to hear. And he is obviously telling Caedwalla that he is the rightful King of all the Saxons. Caedwalla has led his men into Sussex, and they are killing everyone who resists them."

"Why should I care what one Saxon does to another? They are all savages."

Erconwald's look reproached me for the unchristian sentiments I had expressed. "I am afraid, my Lord, that Caedwalla will attack London next, or Kent. It will not be good for the Church."

"I thought he would forget," I said. "But Wilfrid is having the revenge he promised before he went to Rome."

"It would have been much better if Wilfrid had gone back to York, as his Holiness instructed."

"It was not my doing. King Egfrid would not have him back."

"With respect, my Lord, everyone knew of your quarrel with Wilfrid. Perhaps Egfrid might have accepted him if you had restored him to his see. In any case, Egfrid is dead now. He was killed fighting the Picts."

"It makes no difference. If I had restored Wilfrid, then half the bishops in England would have been deposed as a consequence."

"It might have been worth it."

"It was too high a price. I must govern the Church, not him."

"You must make your peace with him, or the Church will suffer."

"I could never do that. He lied about me in Rome and France. He is trying to destroy all my work."

"And he will succeed, with Caedwalla's support."

"I cannot forgive him."

"I am sorry, my Lord," said Erconwald, standing up. "But I must speak my mind. The truth is, that if you will not forgive him, then you are just as proud as he is, and just as foolish." He went to the door, then turned back. "Please, make your peace. For the good of the Church."

Heated by illness, bile drove out my habitual melancholy and filled me with bitterness and anger. I lay in a fever for days, imagining that Wilfrid was there at my bedside, taunting me and promising further revenge. He appeared in visions, silver and saintly, smugly reciting all my sins. Sometimes he seemed a demon, leading a pack of half-men who burned books and destroyed churches. We had nightmare arguments, which he always won. Hadrian sat with me until the worst of the fever passed, feeding me on seethed ram's brains to ease the symptoms. I recovered, and as the weather grew warmer, felt stronger than I had for some time.

That spring, we heard that Caedwalla had made himself King of Wessex, then attacked and conquered the Isle of Wight. Wilfrid was given land on the island, began to convert its inhabitants, and appeared to think himself the rightful bishop of Wessex. I thought that Wilfrid would be fully occupied, and that there would be no need to make a humiliating peace with him. But Caedwalla found an excuse to invade Kent, causing terrible damage and provoking a civil war among the nobles. Canterbury was attacked several times. Many of its wooden buildings were burned or pulled down, and it was alternately abandoned, or filled with refugees and their flocks. Church and monastery lands were plundered, crops were destroyed, and animals killed or stolen. Many of the monks ran away to escape, or join, the armies that were ravaging Kent. Few new pupils arrived at the school, and some of our teachers discovered vocations in their distant homelands.

Hadrian came to me and said:

"We can't go on like this. We will soon have no monks and no school."

"Surely it can't be that bad."

"It is. And it can only get worse, unless we do something."

"But what can we do?"

"Erconwald was right. You will have to make peace with Wilfrid."

"I don't think I can. You know what he has done. It was you who warned me against him."

"You will still have to be reconciled with him."

"But would it do any good? Would it end the destruction? How much influence does Wilfrid really have with Caedwalla?"

"Enough, I think. Erconwald seemed to think so. You must take his advice."

"Have you spoken to him?"

"After he spoke to you."

"I wish Titillus was still with us. He understood the English. He knew how to find things out."

"Erconwald is English. He is also a noble. He has influence."

"He accused me of pride. Do you think me proud?"

"Not proud, exactly." He waited a moment before going on. "You are too full of self-doubt to be proud in the way that Wilfrid is proud. He has never doubted himself, and knows that he is always right. You know he is wrong, and cannot forgive him for that. But by not forgiving him, you are letting him undermine your work. I would call that stubbornness rather than pride."

"So I am stubborn?" It was not how I thought of myself.

"Perhaps you are not proud enough. If you were more proud of what you have achieved, you might see that its survival depends on compromise."

"Will Wilfrid compromise?"

"Let me write to Erconwald," Hadrian said. "He can arrange a synod."

"A synod? If it must be done, I would rather it was done privately."

"If you meet in private, Wilfrid will be able claim anything about what was said."

"But a synod? All the bishops will see me give in to him."

"They will see you do the right thing. And they will witness what you say to Wilfrid. Let me write to Erconwald. He can arrange terms with Wilfrid. Then we will summon the bishops to London."

I had a wagon fitted out with a soft seat and a canopy, but the journey was not comfortable. The old roads are so rutted and uneven that riders prefer to travel beside them, and my wagon slid and jolted until I feared it would fall apart. Even Hadrian preferred to ride than to sit with me. Our escort was smaller than I would have liked, as many of the men we might have called on were dead, exiled or embroiled in the civil war. It took a week to reach London, during which I felt much as Heraclius must have done as he was carried by litter from Antioch to Chalcedon. He had gone mad, and never really recovered. I hoped to avoid that fate, but it was hard not to feel disappointed as we travelled though the ruined land of Kent to Wilfrid's triumph in London.

We left the wagon, our horses, and some of the escort, on the south bank, and were ferried across the Thames, landing among the beached boats of foreign merchants. Despite the disorder in Kent and Wessex, merchants from France and Frisia were still trading, and we clambered ashore among barrels and sacks and bustling dockers. Above the banks were warehouses and shops, where English wool, hides and metal were sold or exchanged for wine, pottery or glassware from France. The Frisians seemed to trade mainly in slaves. Commerce had brought foreign customs, and there were a few taverns and wine shops, such as I had not seen elsewhere in England. But the merchants' quarter, spreading outwards west of the walls, was misleading. Old London, within the walls, was mostly abandoned. There was a collapsed amphitheatre, some ruined government buildings, a few small churches, and a waste-land thick with brambles and nettles. There were few houses, and no one had attempted to cultivate the empty ground. Here

and there, near the western walls, were a few halls built by kings or merchants, where business could be done, or oaths sworn, in the company of fellow-countrymen. I had arranged to stay in the King of Kent's hall, though it was not clear who the rightful king was. It was the usual barn-like wooden building, roofed with thatch and walled with wicker, but the hall-keeper did his best to make us comfortable.

That evening, after I had rested, Hadrian and I went back to the merchants' quarter and wandered, our escort, puzzled, a few paces behind. I wanted to smell tavern food, and watch sailors drinking wine, and be reminded, however faintly, of the commercial bustle that distinguishes a real town. I remembered Constantinople, Antioch and Rome, and though I had not been particularly happy in those cities, each seemed a Paradise. We watched the sun set over the Thames. The mud shone like gold, turned red, then black. In the darkness, Hadrian took my arm and led me back to the hall. Neither of us spoke.

We met in the church of Saint Paul, which was built inexpertly from brick and stone salvaged from the ruins that still littered the slopes below it. It was not a large church, and a dozen bishops, with their attendant deacons, abbots, monks and clerks, and the resident clergy of London, were enough to fill it. The standard of church music had improved since my arrival in England, though not, I confess, through my own efforts, and it was good to hear the clarity and order of the chant. After the service, which was conducted by Erconwald, we went to the hall, which Hadrian had prepared for the meeting. There was some preliminary business, but no one paid it much attention. We all knew why we had come. When the time came, I stood up and spoke.

"Brother bishops. When, nearly twenty years ago, I came to England, I found the Church in an unhappy state. War and plague had killed or driven out bishops and priests, leaving their churches empty and their people unprotected. Parts of the country had reverted to paganism. It was my hope that, by appointing suitable bishops to the empty dioceses, order and

harmony might be restored, and the Church would be able to continue its work of bringing orthodoxy and enlightenment to the English. One of my first acts was to install Wilfrid in the see of York. He seemed an able man, who would serve the Church well. Unfortunately, after a few years, King Egfrid turned against Wilfrid and expelled him from Northumbria. Wilfrid came to me and asked to be restored to his see and his property. It is with great regret that I confess that I refused to help him.

"I had my reasons. Northumbria is a big kingdom, which I thought it best to split into three dioceses, and in that Pope Agatho agreed with me. But his Holiness did not uphold my deposal of Wilfrid, which I now see was a mistake. When, after his misfortunes in France, Wilfrid returned to York, King Egfrid would still not have him back, and subjected him to imprisonment and further exile. I regret that I did not intervene and try to get King Egfrid to reinstate Wilfrid. It is, after all, a bishop's duty to give good advice to kings, whatever the consequences, something Wilfrid knows well.

"During his exile Wilfrid has worked hard among the Saxons, and brought many new converts to the Church. It is to be hoped that, one day, King Caedwalla might be induced to accept baptism, and the peaceful ways of a Christian king. I regret that I did not install Wilfrid as bishop of the South Saxons."

Wilfrid was smiling, and looking around in a rather self-satisfied way. Despite that, I carried on.

"It seemed to me, a few years ago, that the Church had achieved the order and harmony I hoped for. We have agreed at a synod how to govern the Church. We have affirmed our orthodoxy, and are at one with Rome and Constantinople. But the recent wars have caused much damage, and threaten to undermine our work. It is my hope that, given appropriate guidance, Caedwalla might lose his taste for war, and allow England, and the Church, to recover. It is with that in mind that I confess my mistakes, and ask Wilfrid for forgiveness."

I sat down, my legs stiff and aching. Wilfrid stood, elegantly dressed as usual, and paused for a moment, as though thinking.

He was over fifty, and his hair and beard were almost white, but his blue eyes still had the power to attract. He smiled sadly at the bishops, then looked at me and began:

"May God forgive you for all you have done. I have only ever wished to spread the faith, yet others, who claim the same aim, have thwarted me. I cannot explain why, though it has always been a comfort to know that his Holiness the Pope has supported me. Because of the opposition of others, I have lost both position and property. I only wish to have what I have lost restored to me."

Then he sat down.

I could not believe it. According to our agreement, he was supposed to apologise to me for disobedience and bearing false witness. I was about to protest, but I felt Hadrian gripping my arm. I turned to him, but his expression warned me not to say anything. Erconwald quickly stood up and said:

"Brother bishops, we have heard a moving confession and apology. We are none of us diminished when we admit our failings and ask for forgiveness. It is to be hoped now that Wilfrid and Theodore will be at peace with one another, and that the injustices of the past will be put right. Now that King Egfrid is dead, there can be no obstacle to Wilfrid's return to York." He turned to me: "I understand, my lord Archbishop, that you have agreed to write to King Aldfrid in Northumbria, and ask him to restore Wilfrid to all his former property and positions."

Hadrian nudged me, and I just managed to mumble my assent. Then Wilfrid stood again and said:

"I am glad of your agreement. You have set an example of leadership of the Church which I can only hope to follow."

Afterwards I asked Hadrian why he had prevented me from replying to Wilfrid.

"Because if you had, we would have had no peace."

"Did you arrange all that with Erconwald?"

"We had an idea Wilfrid might not keep his word."

"And you let him get away with it?"

"There was no choice."

"What about me? Am I just an old fool, to be tricked for the sake of peace and quiet?"

"No one thinks you an old fool. But don't forget that pride is a sin."

"You said I was not proud enough."

"It is never too late to discover a new sin."

Only now has peace, of a sort, come to Canterbury. But it is too late for me. Wilfrid has triumphed. He has got almost everything he wanted without making any concessions. He has not apologised, or admitted that he has ever done anything wrong. He has even claimed that I have chosen him as my successor. Or rather, his supporters have claimed it, and he has modestly said that he is unworthy.

Like Heraclius, the Emperor I once served, I have lived to see my achievements undone by an unexpected enemy.

I am somewhere else. I can see candles and crosses round my bed. It must be the infirmary. Outside the circle of light, monks are waiting. I can see their pale faces, and their shadows, swaying and fluttering on the far wall. I have an audience. They have been chanting psalms, but they will listen to this. They will not miss my final hours, or my final words. They hope to be touched by sanctity, which comes from death, not life.

Hadrian is writing down my words.

I have known men who were called saintly. They were mad or incompetent. Their indifference to worldly things made them seem holy. But the unworldly can do little good. Chad was an example of that. I have known men who sought saint-hood. I will not mention their names. The dying should not speak ill of those who may remember them.

Would-be saints are proud and selfish. They manipulate others, thinking of little but their own virtue. They are not indifferent to worldly things, whatever they pretend. Their faults, which are conspicuous, might seem to bar them from what they desire. But you have read the lives of saints. You know that perfection is not necessary. Bishops, missionaries,

wandering monks, hermits, virgins: all become saints, whatever their flaws, which will be explained away by their admirers. Just as gold is dug from the earth and separated from the worthless rock that surrounds it, their lives are mined, sifted, refined, and shaped into objects of beauty. Saints' lives become perfect, even if they were not.

A priest whose name I cannot remember has given me communion. I am not expected to last long. When I tasted the communion bread, I remembered my father's bakery. According to my parents' beliefs, Christ could not be present in bread or wine, which they thought material and corrupt. They were Dualists.

The shadows on the wall are shifting again, imperfectly representing those who watch me. I can hear muttering. You seem surprised. You did not know that your Archbishop was born a heretic. My parents believed that life is a battle between the forces of spirit and matter. Between light and darkness. To them, a life was like one of these candles.

Bring one near.

Look! It flickers. The slightest breeze will blow it out. It burns briefly and illuminates little. Beyond, all is dark.

My parents worshipped God, but knew the power of evil. They strove to lead good lives. They helped others free themselves from the grip of matter. They reduced, not just the evil in themselves, but the accumulated evil of the world. Their life, while it lasted, was not a bad one, even by Christian standards. Had they not been heretics, they might have been saints.

I do not know what happened to them.

What is the most valuable thing that saints leave behind them?

It is their bones.

There is a ready market for relics. Men will pay with gold for bones. Bones bring pilgrims to churches, and pilgrims bring money. I have seen it in Rome. I have taken part in the bone trade. I helped discover the relics of Saint Anastasius. I carried his humerus to Italy. But it was not his bone. I have seen old bones bought and sold, paraded round cities, waved

over diseased limbs, ground up and used as medicine, worn as talismans, pointed at enemies, and sworn on by liars. All because their owner, in life, did a little good, and nothing so bad that it could not be overlooked.

I will soon be bones.

Hadrian? I can't see you.

Come into the light. Take my hand.

Have we sinned?

I know that we have all sinned.

Have we sinned, together? Have we done anything so bad that it cannot be overlooked?

Is breaking a vow worse than chastely achieving nothing?

I have achieved something, I think. But will it last?

Or will it be overturned because, though humble, poor and obedient, I was not chaste?

I could not have done what I did without you, Hadrian.

The shadows are shifting again.

I will soon be bones.

I have done what I said I would not do. Like Augustine, I have catalogued my doubts, failings and follies.

But I hope I have made my defects clear.

I do not want to be a saint.

I do not want my bones sheathed in silver and mauled by the sick.

POSTSCRIPT

I was with Theodore at the end, and recorded his last thoughts. He died on 19 September 690, in the monastery of Saints Peter and Paul, just outside the walls of Canterbury, where we had lived for twenty-one years. He was eighty-eight years old, and had been ill for several years. He is buried here in the monastery, close to the tomb of Saint Augustine, whom he did not admire.

His last words puzzled those who heard them, who are already describing him as a saint. They attribute to him things he never said or did. He was not the stern moralist they wanted him to be. He performed no miracles. Spectacular acts were not in his nature, which was better adapted to steady and regular work, usually in the background. In some ways he was like the other Saint Augustine, the African one, whose *Confessions* he disliked. Both tended to exaggerate their faults, but, though Augustine did it to throw his later, saintly, self into greater contrast, Theodore did it because he was naturally modest. For example, Theodore constantly accused himself of idleness, but I never knew him to be idle. When he thought that he was wasting time, he was talking, thinking, reading or planning, and his achievements would have been impossible without that preparation. He accused himself of idleness because he felt inferior to those who acted quickly, without self-doubt, though he knew well enough that the results of such unconsidered actions are seldom lasting. He was also a pessimist, and his hopes were always undermined by the fear that they would come to nothing.

It was typical of Theodore that he died at the lowest point in Kentish history, when it looked as though the kingdom

would collapse, leaving Canterbury defenceless and without influence. It was also the moment when Wilfrid seemed finally to have triumphed, and to have regained nearly all his power and property in Northumbria. The confusion in Kent prevented the choice of a successor to Theodore for two years. Wilfrid, disappointed at not being chosen, and always ambitious, renewed his claim for the whole of Northumbria, and was expelled from that kingdom yet again. After several years of exile in Mercia, he protested to the Pope, who referred the complaint to an English synod. The synod, sick of the disruption caused by Wilfrid's constant complaining, found against him, and required him to retire to his monastery at Ripon. He refused, and set off on another trip to Rome, where he found that the new Archbishop of Canterbury, Berhtwald, had lodged complaints against him. Wilfrid, when not complaining, was known to the Papacy as an upholder of orthodoxy. Pope John VI, knowing of Wilfrid's rôle in the Council of 680, avoided making a decision, and referred the dispute back to yet another English synod. On his way back to England, Wilfrid was taken ill at Meaux, where I was imprisoned while Theodore was in Paris, nearly forty years ago. Perhaps the illness made Wilfrid a little more humble, as, when he reached England, he was willing to compromise. At a synod called by Berhtwald, he abandoned his claim on the whole of Northumbria, and was given his monasteries at Ripon and Hexham, where he became bishop. He died earlier this year, not as triumphant as Theodore feared.

Now I am unwell, and am unlikely to last the winter, having lived for nearly twenty lonely years after Theodore's death. Had I obeyed Pope Vitalian's request, I would have been Archbishop in Theodore's place, but I could not have done the job as well as he did. His melancholy and pessimism, though they seemed disabling, were a kind of armour, protecting him from disappointment. Though he did not think so, he has succeeded where his predecessors failed. He has reformed the Church and planted literacy and learning in England.

Lately, I have been pestered by a monk called Bede. He writes from Benedict's monastery at Jarrow, asking me for memories of Theodore. I will send him something, but not, I think, this book.

Hadrian
Monastery of Saints Peter and Paul
Canterbury
Christmas 709

Contemporary Literature from Dedalus

The Experience of the Night – Marcel Béalu £8.99
Music, in a Foreign Language – Andrew Crumey £7.99
D'Alembert's Principle – Andrew Crumey £7.99
Pfitz – Andrew Crumey £7.99
The Acts of the Apostates – Geoffrey Farrington £6.99
The Revenants – Geoffrey Farrington £3.95
The Man in Flames – Serge Filippini £10.99
The Book of Nights – Sylvie Germain £8.99
Days of Anger – Sylvie Germain £8.99
Infinite Possibilities – Sylvie Germain £8.99
The Medusa Child – Sylvie Germain £8.99
Night of Amber – Sylvie Germain £8.99
The Weeping Woman – Sylvie Germain £6.99
The Cat – Pat Gray £6.99
Theodore – Christopher Harris £8.99
The Black Cauldron – William Heinesen £8.99
The Arabian Nightmare – Robert Irwin £6.99
Exquisite Corpse – Robert Irwin £14.99
The Limits of Vision – Robert Irwin £5.99
The Mysteries of Algiers – Robert Irwin £6.99
Prayer-Cushions of the Flesh – Robert Irwin £6.99
Satan Wants Me – Robert Irwin £14.99
The Great Bagarozy – Helmut Krausser £7.99
Primordial Soup – Christine Leunens £7.99
Confessions of a Flesh-Eater – David Madsen £7.99
Memoirs of a Gnostic Dwarf – David Madsen £8.99
Portrait of an Englishman in his Chateau – Mandiargues
£7.99
Enigma – Rezvani £8.99
The Architect of Ruins – Herbert Rosendorfer £8.99
Letters Back to Ancient China – Herbert Rosendorfer
£9.99
Stefanie – Herbert Rosendorfer £7.99
Zaire – Harry Smart £8.99

Bad to the Bone – James Waddington £7.99
Eroticon – Yoryis Yatromanolakis £8.99
The History of a Vendetta – Yoryis Yatromanolakis £6.99
A Report of a Murder – Yoryis Yatromanolakis £8.99

Memoirs of a Gnostic Dwarf – David Madsen

'A pungent historical fiction on a par with Patrick Suskind's Perfume.'
The Independent on Sunday Summer Reading Selection

'David Madsen's first novel *Memoirs of a Gnostic Dwarf* opens with stomach-turning description of the state of Pope Leo's backside. The narrator is a hunchbacked dwarf and it is his job to read aloud from St Augustine while salves and unguents are applied to the Papal posterior. Born of humble stock, and at one time the inmate of a freak show, the dwarf now moves in the highest circles of holy skulduggery and buggery. Madsen's book is essentially a romp, although an unusually erudite one, and his scatological and bloody look at the Renaissance is grotesque, fruity and filthy. The publisher has a special interest in decadence; they must be pleased with this glittering toad of a novel.'
Phil Baker in The Sunday Times

'. . . witty, decadent and immensely enjoyable.'
Gay Times Book of the Month

'There are books which, arriving at precisely the right moment, are like life-belts thrown to one when one is drowning – such a book for me was *Memoirs of a Gnostic Dwarf*.'
Francis King

'. . . its main attraction is the vivid tour it offers of Renaissance Italy. From the gutters of Trastevere, via a circus freakshow, all the way to the majestic halls of the Vatican, it always looks like the real thing. Every character, real or fictional, is pungently drawn, the crowds are as anarchic as a Bruegel painting and the author effortlessly cannons from heartbreaking tragedy to sharp wit, most of it of a bawdy or scatological nature. The whole thing mixes up its sex, violence, religion and art in a very pleasing, wholly credible manner.'
Eugene Byrne in Venue

'. . . a hugely enjoyable romp.'
Jeremy Beadle in Gay Times Books of the Year

'The most outrageous novel of the year was David Madsen's erudite and witty *Memoirs of a Gnostic Dwarf.* Unalloyed pleasure.'
Peter Burton in Gay Times Books of the Year

'this is a rigorous and at times horrifying read, with something darker and deeper in store than the camp excess of the opening chapters.'
Suzi Feay in The Independent on Sunday

'Madsen's tale of how Peppe becomes the Pope's companion and is forced to choose between his master and his beliefs displays both erudition and a real storyteller's gift.'
Erica Wagner in The Times

'Madsen's narrative moves from hilarity to pathos with meticulous skill leaving the reader stunned and breathless. The evocation of Italy is wonderful with detailed descriptions ranging from political problems to Leo's sexual proclivities. The novel is so hard to place in any definite genre because it straddles so many; historical novel, mystery and erotica – it is simply unique.'
Steve Blackburn in The Crack

'not your conventional art-historical view of the Renaissance Pope Leo X, usually perceived as supercultivated, if worldly, patron of Raphael and Michelangelo. Here, he's kin to Robert Nye's earthy, lusty personae of Falstaff and Faust, with Rabelasian verve, both scatological and venereal. Strangely shards of gnostic thought emerge from the dwarf's swampish mind. In any case, the narrative of this novel blisters along with a Blackadderish cunning.'
The Observer

'If you're into villainy, perversion, religious pomp, the inquisi-
tion, torture, freaks and a smattering of sex, guess what . . . this
Gnostic Dwarf has got the lot. Not only that, but the writer
weaves a bloody good tale into the proceedings as well.'
All Points North

'This is what historical novels should be like, rendering the
transitory world views of the historical and fictional charac-
ters, as believable as their more intrinsic characteristics of hate,
greed, love and loyalty. Forget Martin Bloody Amis, *Memoirs*
will make you laugh, cry – it may even impart a little
wisdom.'
David Kendall in Impact Magazine

'Some books make their way by stealth; a buzz develops, a cult
is formed. Take *Memoirs of a Gnostic Dwarf*, published by Deda-
lus in 1995. The opening paragraphs paint an unforgettable
picture of poor portly Leo having unguents applied to his
suppurating anus after one too many buggerings from his
catamite. Then comes the killer pay off line: "Leo is Pope,
after all." You can't not read on after that. I took it on holiday
and was transported to the Vatican of the Renaissance; Pepe,
the heretical dwarf of the title, became more real than the
amiable pair of windsurfers I'd taken with me.'
Suzi Feay in New Stateman & Society

'*Memoirs of a Gnostic Dwarf* was overwhelmingly the most
popular choice of Gay Times reviewers in last year's Books of
the Year. Reprinted now this outrageous tale of the Renais-
sance papacy, heretics, circus freaks and sex should be at the
top of everyone's "must read" list.'
Jonathan Hales in Gay Times

'the best opening to a novel ever written was published in 1995 by a man who uses a pseudonymn. It's Rome in the year 1518 and it goes like this:

> "This morning His Holiness summoned me to read from St. Augustine while the physician applied unguents and salves to his suppurating arse; one in particular, which was apparently concocted from virgin's piss and a rare herb from the private *hortus siccus* of Bonet de Lattes, the pope's Jewish physician-in-chief, stank abominably. Still, it was no worse than the nauseating stench of the festering pustules and weeping ulcers adorning His Holiness's cilicious posterior. With his alb pulled up over his hips, and his underdraws down around his ankles, the most powerful man in the world lay sprawled on his bed like a catamite waiting to be well and truly buggered.
>
> "He has been buggered, plenty of times – hence the state of his arse. His Holiness, in case you are unaware of the fact, likes to play the womanly role, thrashing and squealing beneath some musclebound youth, like a bride being penetrated for the the first time. Not that I've any personal objection to such behaviour – Leo is pope after all." '

Eugene Byrne in The Venue Interview of David Madsen

£8.99 ISBN 1 873982 71 2 336pp. B Format

The Man in Flames – Serge Filippini

"Now to mark the 400th anniversary of Bruno's slow torture and death, the French writer, Serge Filippini, has produced a compact historical novel. The result of 15 years hard labour, it is a remarkably original creation.

The Man in Flames is written in the first person by the fictional Bruno. Exactly one week before being taken to the Campo dei Fiori, he begins to write his memoirs. Filippini's imagined Bruno is not and nor can he be a child of his time. His philosophical ideas are far too audacious and have inspired the writer, who encircles them with a deeper, fuller-blooded and equally advanced code of personal conduct. A fiction based on the life of a real person is always a difficult reconstruction, but Filippini succeeds in evoking the tense atmosphere of the period as well as the intellectual dilemmas and emotional traumas.

His descriptions of sexual brutality are as finely observed as the lyrical passages on homosexual love. The enemies of light, then as now, will find little joy in Bruno's passionate attachment to the English aristocrat, Cecil, a nephew of the Earl of Leicester, a one time favourite of Elizabeth 1. Forbidden love is aligned to forbidden ideas. Filippini handles the history well."

Tariq Ali in The Financial Times

"Dedalus are well known for publishing wonderfully decadent novels, and *The Man in Flames* is no exception. Excellently translated from the French by Liz Nash, this is the tale, set in the late 16th century, of philosopher and poet Giordano Bruno – excommunicated by the Pope, wanted by the Inquisition and loved by the wily, elegant Cecil. Not only is it a romp of the first order, it is also a stimulating account of tyranny of the Church over anyone who believed in and attempted to promote freedom of speech. Another Dedalus classic."

Sebastian Beaumont in The Gay Times

£10.99 ISBN 1 873982 24 0 367pp B Format